MOVING TARGETS

MOVING TARGETS: A USER'S GUIDE TO BRITISH ART NOW

LOUISA BUCK

TATE GALLERY PUBLISHING

Cover:
Fiona Rae, *Untitled (emergency room)* 1996 (detail)
© The artist, courtesy Waddington Galleries, London

ISBN 1 85437 223 8
A catalogue record for this book is available from the British Library

Published by order of the Trustees of the Tate Gallery by Tate Gallery Publishing Limited, Millbank, London SW1P 4RG

Editor: Melissa Larner
Designer: Stuart Smith

Printed in Great Britain by BAS, Over Wallop, Hampshire

ACKNOWLEDGEMENTS

In the face of extended deadlines and endless alterations to content and format, I owe Tate Gallery Publishing a debt of gratitude for their flexibility and forbearance. My thanks to Celia Clear, Judith Severne, Frances Croxford and Emma Neill for their good humour and commitment, and to Mark Eastment for his constant enthusiasm. I am grateful to Richard Humphreys for first approaching me with the idea for a guide to contemporary British art; and for his valuable input throughout. Sandy Nairne has been continuously supportive and I very much appreciate his hard work on my behalf.

The writing – and reading – of this book would have been a very different experience without the keen eye and clear head of Melissa Larner. Her contribution goes way beyond beyond exemplary copy editing, picture researching and fact checking – and I am indebted to her patience and generosity. Thanks also to Helen Hayward for her exhaustive – and exhausting – research; to Stuart Smith for his lucid and inspired design; to Krzysztof Cieszkowski, Meg Duff and Clare Storey at the Tate Gallery LIbrary; and to Marq Kearey and Judy Breakell for crucial behind-the-scenes backup. Throughout the gestation and birth of this book I have bent a multitude of ears and received invaluable advice and information. To all those who have been on the receiving end of this stream of requests, my apologies and heartfelt thanks.

Lastly, I would like to dedicate this book to Tom Dewe Mathews, for more reasons than I can write here.

ACKNOWLEDGEMENTS FOR ILLUSTRATED WORKS

© Richard Hamilton 1997 / All rights reserved DACS 1997 (20)
All other works copyright the artist or the estate of the artist

COLLECTIONS

The artist, courtesy Anthony d'Offay Gallery, London (19, 25); The artist, courtesy Anthony Reynolds Gallery, London (61, 88); The artist, courtesy Waddington Galleries, London (59); Arts Council Collection, London (36); Astrup Fearley Museum, Oslo (48); Bonnefanten Museum, Maastricht (50); Fondation Cartier pour l'art contemporain, Paris (40); Courtesy Lisson Gallery, London (31, 69); Musée d'art contemporain de Montréal (Commission) (45); David Notarius (14); Courtesy Maureen Paley / Interim Art (94); Private Collections (16, 52, 67, 84); Private Collection, Berlin, courtesy Galerie Thaddaeus Ropac, Paris (42); Queensland Art Gallery (63); Saatchi Collection, London (72, 80, 92, 139); Stedelijk Van Abbemuseum, Eindhoven (11); Tate Gallery (21, 23, 55, 57); The Whitworth Art Gallery, University of Manchester (28)

PHOTOGRAPHIC CREDITS

Illustrations supplied courtesy of: Acquavella Contemporary Art Inc., New York (16); Anthony d'Offay Gallery, London (19, 21, 25, 63, 86); Anthony Reynolds Gallery, London (61, 88); © Arts Council / Catherine Yass (155); Cabinet Gallery, London (67); Christian Boltanksi and the Henry Moore Sculpture Trust, Leeds (169); © The Condé Nast PL/British Vogue (148); © The Condé Nast PL/GQ (111); Frieze (166); FXP (52); Hales Gallery, London (174); Iain Irving projects (184); Ikon Gallery, Birmingham (105); Imprint 93 (164); Jay Jopling, London (45, 50, 78, 90, 92); Laing Art Gallery, Newcastle upon Tyne (57); Lisson Gallery, London (31, 40, 55, 69); © Locus+ (160); Matt's Gallery, London (23, 34, 36, 65, 76); Maureen Paley/Interim Art, London (94); Orchard Gallery, Derry (184); The Paragon Press (165); Pier Arts Centre, Stromness (187); Prudence Cuming Associates Ltd, London (19); Prudence Cuming Associates Ltd / Marlborough Fine Art Ltd, London (28); Prudence Cuming Associates Ltd, London / Waddington Galleries, London (59); Saatchi Gallery, London (126, 177); Sadie Coles HQ Ltd, London (80); Stedlijk Van Abbemuseum, Eindhoven (11); © Steve McQueen / Courtesy Anthony Reynolds Gallery, London (82); Tate Gallery, London (182); Thomas Dane (74); Tramway, Glasgow (186); Victoria Miro Gallery, London (72, 84)

INTRODUCTION: MOVING TARGETS AND ALTERED STATES

More than at any other time in its history, British art is booming. For several years critics, curators and collectors from across the globe have been converging on the UK – especially London and Glasgow – to admire, to purchase and to select from Britain's artistic boldest and best. At home, a fully fledged mythology has grown up around the phenomenon of the Young British Artist as an uncouth entrepreneurial species that emerged fully formed from Goldsmiths College in south London with Damien Hirst at its head, to fly in the face of orthodoxy and the art establishment.

Inevitably, the truth is more complicated. Yes, the Goldsmiths year of '88 produced an exceptional line-up of talent, and yes, their blend of cool, knowing chutzpah has undoubtedly impacted on artistic attitudes, but the best art that is being made in Britain at the moment is not restricted to age, art school or agenda. The artists featured in this book are of all generations and backgrounds: Francis Bacon, now dead, but still a far-reaching influence on much British art; Helen Chadwick, also no longer alive, yet hugely inspirational to younger generations; many more in the middle of their careers, and some recently out of college. Paula Rego – a grandmother – is currently making her most risky and provocative paintings to date. Richard Wentworth, part of the 'New British Sculpture' boom of the early 1980s continues to zero in on details of urban life in order to investigate and subvert sculptural traditions, while artists in or barely out of their twenties such as Steve McQueen and Sam Taylor-Wood are using the camera to make work of surprisingly mature complexity and restraint.

Perhaps the most distinctive feature of the artists who are defining British art in the 1990s is the very fact that they do not share a common style or medium. They produce figurative and abstract paintings, ready-made and hand-made sculptures, photography and text, videos, installations and CD ROMs – sometimes simultaneously. Gary Hume, Rachel Whiteread or Cathy de Monchaux, for example, make radical artworks using traditional skills. Mat Collishaw and Christine Borland employ cutting-edge technology from other fields to ponder notions of memory, value and nostalgia. Some work in isolation, others operate within interconnected communities, and many are loath to be given any label, whether personal, artistic or national.

What the artists selected for inclusion in this book (as well as many others besides) do share is the desire to use whatever means are at their disposal – paint, celluloid, ballistics, needlework or forensic science – to make work that speaks of what it is to be human and to live in this world. This is what the best art has always attempted to do. And just as the world has changed, so, inevitably, has the way in which artists express their experience of it.

The art that this book singles out for scrutiny reflects our contradictory, uncertain times with an edgy ambiguity and a refusal to take anything at face value. This work patrols the uncertain territory between art and science, body and mind, high and popular culture, emotion and intellect, beauty and kitsch. It can be funny, poetic and profound, and can get uncomfortably, even annoyingly, under the skin. It is not afraid to engage with big issues such as love, death, sex or spirituality, but it doesn't bash you over the head with polemic. For when this art appears to be at its most casually flip and throwaway, it is usually deadly serious, and when it seems to be at its most throat-grabbingly blatant, it is generally operating on the most subtle and complex levels.

To an extent, all art is about other art, but when these artists embrace time-honoured traditions and techniques it is not for their sake alone, but for what they can be made to say about the here and now. In British art of the 1990s, Postmodern plundering has given way to selective sampling, where everything has a purpose, and the seemingly casual or arbitrary is usually deceptive. Surface appearances are often designed for immediate impact, but they are only part of the story. Gavin Turk's self portrait as Sid Vicious in the style of Elvis as portrayed by Andy Warhol, for example, is as much about identity and memory as it is to do with the art-quoting bad boy; and it is no accident that Lucian Freud's painting of Leigh Bowery under a skylight assumes the pedestal-based pose of Michelangelo's David to become a preposterous, majestic and poignant icon for our times.

The art world that both sustains and has grown up around this scene is equally shifting and ambiguous. The entries in *Moving Targets* confirm that boundaries are permeable here, and categories seem to exist only to be breached. In these hybrid times, the roles of artist, curator and critic are no longer mutually exclusive and often one person – Martin Maloney or Adrian Searle, for example – can be all three. Many of today's artists, young or old, as well as some of our leading curators and commentators, also play a crucial role within the best of Britain's art schools, as part of a unique educational system that has done much to nurture successive generations by adhering to a widespread policy of exposing the artists of the future to the leading figures in the current scene.

Much has been made of the fact that even while they are still students, artists have become increasingly adept at organising their own exhibitions. Over the past few years, however, this practice has evolved from an ad-hoc (if highly professional) enterprise into an ongoing, vital process. Artists' collectives, whether in London, Glasgow, Manchester, Belfast or Reading,

are running purpose-built spaces attached to their studio complexes, and individual figures – Kirsty Ogg In Norwich, Daniel Sancisi in London, to name but two – display works in a multitude of off-beat and unofficial venues, including their own homes, or in the case of Matthew Higgs' *Imprint 93*, send them through the post in an A5 envelope.

With many of our institutions being too underfunded or beset by caution to respond to the recent upsurge in risky and provocative art, it has been largely left up to the dealers to take the lead in promoting the most demanding work of the moment. While artist-run shows may provide an important testing ground, it is the commercial sector that has mainly been responsible for taking up many of Britain's brightest and best, and for presenting them to a wider audience. And some commercial galleries now have the appearance of mini-museums in their own right: several of our leading art dealers, including Nicholas Logsdail and Maureen Paley, originally began their professional life as artists, and now put together exhibitions with the status of institutional shows. Add to this a collector such as Charles Saatchi whose holdings in current British art of all generations rivals those of most major museums across the globe, and whose private gallery enjoys the unofficial status of an institution, and notions of public and private, official and alternative tend to melt, merge and become increasingly irrelevant.

Of course, the artists, individuals and institutions scrutinised in *Moving Targets* make up only a small part of the contemporary art world in Britain. Just as there are artists who choose not to respond to the edgy spirit of the times, so there are a great many dealers, curators and critics who do not venture out of their appointed places. However, the subject of this book is the art that sets out to make us look at the world – and ourselves – with new eyes, along with the infrastructure that supports it. Even taking this into consideration though, in every category of what is a highly selective guide the entries should be read as an indication rather than a representation of what is taking place at the moment; as a way in, rather than a definitive view. For what is so dynamic about British art today is its refusal to be pinned down and categorised – this very slipperiness is evidence of its vitality. But its paradoxical, problematic nature doesn't prevent it from being accessible and exhilarating: today's art explosion is open to all comers. Hopefully, this book will make it easier to negotiate the range of moving targets that make up British art now.

THE MAKERS:
PRESIDING FORCES

FRANCIS BACON

b. 1909 Dublin d. 1992 Madrid, Spain
Marlborough Gallery

Towards the end of his life Francis Bacon declared: 'The greatest art always returns you to the vulnerability of the human situation', and certainly no one has made human life look more nasty, brutish and short than this maverick self-taught painter. While the debate rumbles on as to whether Bacon's later work was infused with serene stateliness or had lapsed into repetitive formula, the screaming popes, snapping Furies, contorted portraits and convulsive figures that he painted up to the mid-1960s have established his mythic status as the quintessential painter of our fragmented, contradictory and morally ambiguous existence.

However, Bacon himself totally denied any such ambitions. With characteristic evasiveness he repeatedly insisted that he was a reporter rather than an interpreter; a rigorous realist whose images deliberately short-circuited any narrative reading in order to work directly on the nervous system. 'One brings the sensation and feeling of life over the only way one can', he once said, and apparently it was this quest for an immediate human essence that gave rise to the bloody scenarios of writhing bodies and mutating forms he doggedly chose to discuss in terms of artistic problem-solving.

Perhaps Bacon's own tongue was somewhat in his cheek when he claimed that his obsession with the screaming mouth had less to do with horror and more to do with its 'glitter and colour' – his declared ambition was to paint the mouth 'like Monet painted the sunset'. But this refusal to provide any

solution, resolution (or redemption) both sets him apart from his contemporaries and anticipates an ambivalence that is now common in much of today's art. Bacon's victims do not ask you to pity them. They are presented for our clinical scrutiny in transparent tanks, laid out on plinths or pinned to mattresses in the controlled vacuum of an empty room. To increase this distance, Bacon liked even his largest canvases to be shown behind glass, their energy trapped. In the face of this sensational (some say sensationalist) objectivity, in an art that is so immediate but also so detached, it comes as no great surprise to learn that one of the few specific influences that Damien Hirst has consistently acknowledged is Francis Bacon.

The bloody carcasses and bodies that morph into raw lumps of meat in such works as *Three Studies for a Crucifixion* (1962) are there because,

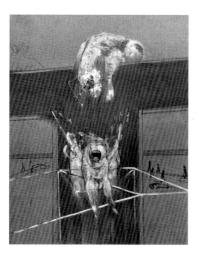

according to this artist, that's what we are. But, with a characteristic reluctance to be committed to any philosophical standpoint – another quality that Damien Hirst was to pick up on a couple of decades later – Bacon could flip from a breezy nihilism ('of course we are meat, we are potential carcasses. If I go into a butcher's shop I always think its surprising that I wasn't there instead of the animal') to a tender profundity ('when you go into a butcher's shop and see how beautiful meat can be and then you think about it, you can think of the whole horror of life – of one thing living off another').

Francis Bacon set himself apart from much of twentieth-century art by citing grand, art-historical influences. While his British contemporaries were experimenting with abstraction and Surrealism, he was taking the classic forms of Western European art – the crucifix, the triptych, the icon – and twisting them to his own purpose. But it is revealing that (in addition to Picasso and Giacometti), one of the few twentieth-century artists whom Bacon admitted to admiring was Marcel Duchamp, a figure who, albeit through a very different set of strategies, also set great store by an erotically charged art, was provocatively immune to easy interpretation, and also considered artistic creativity to be some kind of supernatural force.

Although he might not have been so eager to admit it, in 'the pulverising machine' of Bacon's imagination, film and photography were as prominent as Velázquez, Rembrandt and Picasso. Photographic material ranging from Eadweard Muybridge's studies of bodies in motion to medical textbooks and

newspaper cuttings provided both reference points and triggers for ideas; and Bacon again showed himself to be ahead of his time in his early awareness of the challenges posed to the artist by the mass media. He loved films, and this obsession went beyond individual images, though his most commonly cited source is Sergei Eisenstein's *Battleship Potemkin* (1925).

Throughout his life Bacon steeped his canvases in the language of film: the still, the zoomed-in detail and the panning shot. His *Triptych Inspired by T.S. Eliot's Poem 'Sweeney Agonistes'* (1967), for example, is charged with the way in which the experience of cinema can simultaneously engulf and distance the viewer. (Later on, the movies were to repay the compliment: Bacon's paintings of the 1940s were a direct source for the designer H.R. Giger's nightmarish monster in Ridley Scott's cult 1979 movie *Alien*; and the caged, muzzled Hannibal Lecter in *The Silence of the Lambs*, directed by Jonathan Demme in 1991, owes more than a passing glance to Bacon's boxed-in popes.)

Unfortunately, however, in the last two decades of Bacon's life the complex friction between knowing and feeling that he had generated in his work occurred less and less. The distortions became increasingly predictable, and the settings too slickly theatrical – bringing to mind his previous career as a designer of art deco rugs and furniture. At the same time the introduction of bizarre new imagery – such as the series of truncated figures in cricket pads – found him veering dangerously close to kitsch. But Bacon's weary replays of his earlier creations, and his increasingly frequent lapses into schlock horror do not detract from his unequalled achievement in fusing art-historical tradition and utter modernity in order to speak of how and why we live today.

HELEN CHADWICK

b. 1953 Croydon d. 1996 London
1973-76 Brighton Polytechnic; 1976-77 Chelsea School of Art
Zelda Cheatle Gallery

When Helen Chadwick died unexpectedly in 1996 she was working on *Cameos*, a series of sculptural photopieces that continued a career-long quest to investigate every aspect of who and what we are. From the sculptural clothes she made as a student in the mid-1970s by painting latex onto women's bodies, through to this last – uncompleted – series in which photographs showing medical specimen heads of a chimpanzee and a deformed 'cyclops' human

foetus were mounted into circular, three-dimensional settings, Chadwick's work splices the provocative with the profound in order to probe scientific, subjective and spiritual notions of identity. Using fur, flesh, offal, and melted chocolate, her art makes a point of questioning traditional categories of beauty, normality, and acceptability, and the way in which she challenged conventions and stretched possibilities has fed into the work of many of today's most progressive artists.

It is now commonplace for artists to take whatever means or medium they can in order to express themselves, but it was Chadwick's fusion of unconventional materials that helped to open up these artistic options. As far as she was concerned, everything was up for grabs – and her influences spanned art history, myth, science and anatomy, and extended to grooming, gardening and cooking. Whether she was casting a tower of lamb's tongues in bronze (*Glossolalia* 1993), photographing flowers clustered on the surface of domestic fluids (*Wreaths to Pleasure* 1992-3), working with cutting-edge digital technology, or commissioning specially woven carpets (*Rachel/Jude* 1995-6), Chadwick prodded the boundaries of art in order to give physical form to the complexity of human experience.

Although her work deals with ambiguity, it is never in itself ambiguous. Probably her most notorious recent piece is *Cacao* (1994), the pungent fountain of molten chocolate that bubbles and farts down a central stalk and into a circular pool in a way that wreaks havoc with notions of attraction and revulsion and sends all the senses into a tailspin. The overwhelming presence of *Cacao* deliberately defies any single response or reading and is part of Chadwick's long and complex investigation into how art can capture sensation and reflect states of being while still remaining immediate and accessible.

The internal human landscape, bodily fluids and the preserved carcasses of animals now all make regular appearances in the world of art, and Chadwick was among the first to employ such visceral artistic material. She was also an early exponent of the use of one's own body as a means to investigate subjectivity. *The Oval Court* (1984-6) is an extravaganza of collaged photocopies of the artist's adorned body set adrift amongst a mass of animal and vegetable matter, first shown alongside *Carcass* (1986), a vertical glass compost heap containing their rotting reality. Later, references to self became more oblique but no less immediate: in their exquisitely photographed arrangements of meat and offal, *The Meat Abstracts* (1989) and *The Meat Lamps* series (1989-91) remind us what we are really made of, while the twelve hermaphrodite blooms of Chadwick's *Piss Flowers* (1991-2), which she made in collaboration with her partner, audaciously turn male into female and vice versa by casting in bronze

Self Portrait
1991
Cibachrome
transparency,
glass,
aluminium,
electrics
45 × 51 × 13 cm
Photo: Helen
Chadwick and Edward
Woodman

the stamen and corolla-like patterns made by male and female urine in the snow.

Helen Chadwick's celebration of physical decay and entropy as an intrinsic and positive part of life reverberates in the work of a number of younger artists including Anya Gallaccio and Damien Hirst; as does her practice of arranging volatile and potentially chaotic materials within a rigorously formalist framework. Whether in the hard-edged rectangular geometry of *Carcass*, or the circular white tub that houses the bubbling mass of *Cacao*, it is the tension – and friction – between these opposing images of order and chaos that gives her work much of its impact and metaphorical richness. Chadwick also pre-empted today's toyings with good and bad taste by her frequent use of a sheen of kitsch: the round, metal frames enclosing her *Wreaths to Pleasure* are the synthetic colours of cheap confectionery, while the knobbly cast stalactites of her *Piss Flowers* are cut into the shape of Mary Quant daisies and mounted on bulbous white stalks more appropriate to plastic 1960s table bases than plinths for sculpture.

However, Chadwick used unexpected and engaging forms as a vehicle for ever more serious concerns. In the months just before her death, her repeated scrutiny of the mystery of the life cycle and its processes of growth and decay had literally taken her to the very origins of our existence – as well as to the forefront of medical ethics. *Unnatural Selection* (1996) is a series of photo-pieces created during a residency at the Assisted Conception Unit of King's College Hospital in London, which used non-living, human, pre-implantation embryos that would otherwise have been left to perish. With a characteristic lightness of touch, Chadwick juggled and made complex our notions of nature, artifice, individuality and interdependence by arranging these jewel-like microphotographs of human embryos (still at cell-cluster stage) into glittering Perspex settings that took the form of a necklace, a ring and a brooch. In this last completed series of work, Helen Chadwick confirmed her national and international status with a highly topical image of our many-faceted human potential, set within a permeable world where nothing is fixed or finite.

LUCIAN FREUD

b. 1922 Berlin, Germany
1938-9 Central School of Arts and Crafts, London; 1939-42 East Anglian
School of Painting and Drawing, Dedham; 1942-3 Goldsmiths College,
London
Acquavella Contemporary Art Inc., New York
Lives and works in London

The human body may be at the forefront of art today, but the jury is still out
on the painted studio nude. Several art schools have discontinued their life
classes, and the practice of working directly from a live model is regarded by
many younger artists as an obsolete, antiquated activity, no longer valid as a
legitimate form of artistic enquiry and useful only as the focus for theoretical
debates around paradigms of male and female beauty and the politics of the
gaze. However, in other quarters it is in revival: a Drawing Professorship has
been introduced at the Royal College of Art, and artists such as Paula Rego and
Jenny Saville are working from the live model and turning it to their own ends.

None of this bothers Lucian Freud. For over half a century he has been
painting the human form with an obsessive and unwavering intensity, and
his pictures of bodies old and young, male and female, in all their flabby,
fleshy, blue-veined rawness have earned him the title of greatest living realist
painter – as well as the Establishment accolade of Companion of Honour
(1983). Yet at the same time he remains a maverick, outside the styles and
movements of the art world, but with admirers and detractors in all its camps.
In many ways Freud is the epitome of the old-fashioned artist: he admires
Frans Hals and John Constable, not Marcel Duchamp and Bruce Nauman;
his sittings go on for hours and continue over years; he has loved and painted
a multitude of women, and he is rarely available for interview.

Then there's the paint. For some, the thickly rendered, painterly physical-
ity of Freud's naked individuals – who loll against mattresses, lean among
rags, and sprawl on the floorboards of his grimy studio – borders on the
repulsive. He has been condemned for subjecting the bared bodies of his
sitters to such clinical scrutiny that both they and the viewer are compromised.
In the current climate, when artists are more apt to analyse the expressive
power of paint than to make claims for it, such Freudianisms as 'The paint is
the person. I want it to work for me as flesh does', or 'I would wish my portraits
to be of the people not like them', seem somewhat out of kilter with the know-
ingness of the times. Yet however tangled his paint surfaces, explicit his poses,

Leigh Under the
Skylight
1994
Oil on canvas
297 × 121 cm
Photo: Scott Bowron

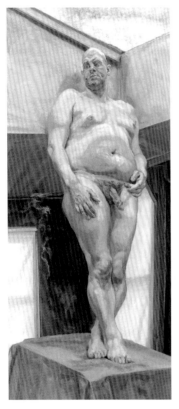

or focused his painterly explorations, in this ability to allow many readings – all, none, or some, of which may be true – his is a very contemporary art.

Almost perversely, Freud can be both grungily modern and agelessly grand. *Leigh Under the Skylight* (1994), Freud's full-length painting of Leigh Bowery, the designer, performer and constantly mutating symbol of London's clubland, never looked better than when it resided for a brief spell in London's Dulwich Picture Gallery, hung next to Rubens' *Venus, Mars and Cupid*; while his paintings of the vast bulk of Big Sue (the claimants officer who has become an increasingly regular presence in Freud's work since Bowery's death in 1996) would look at home alongside the most voluptuous odalisques of art history.

The best of his paintings send your eye running across the surface, from detail to detail, with many points of focus to chose from but no decisions made for you. In *Pluto and the Bateman Sisters* (1995-6), a girl, a sleeping dog and the cropped-off bottom half of another female are both unified and distinct, bathed in harsh top light but calmly occupying their own physical and psychological space. The nature of their relationship is for them to know and for you only to guess at.

Like his close friend Francis Bacon, Freud claims simply to be presenting the facts of life. Unlike Bacon, however, he does not conjure up psychodramas – or not intentionally, anyway. Underpinning all his work, from the hard-edged miniaturist paintings of the 1940s and early 1950s, to his current painterly swoops and dabs, is an obsessive and highly complex objectivity. Freud doesn't paint nudes, he paints bodies. They are not idealised, they are not arranged (his sitters choose their own poses), they are simply there.

When he describes the head as 'just another limb', by this he means that every bit of the human anatomy – whether the inside of a splayed female thigh, the connection between an eyebrow and a cheekbone, or a belly jutting above a limp penis – is of equal importance. He declares that he wants his paintings to be factual, not literal – 'with the nude, not of the nude' – and he gains these visual 'facts' over exhaustive periods of time and in close collaboration with sitters whom he is either instinctively drawn to, or knows well. (He repeatedly paints his many children.) Freud's realism is not a photographic verisimilitude, nor is it purely a process of psychological scrutiny.

Essentially, Lucian Freud paints skin; he doesn't want to get inside it. And it is this battle to remain detached from, while at the same time being intensely involved with, his subjects that makes him – reclining naked figures, antique gold frames and all – an artist of our times. His sombre, slathered paint surfaces in muted shades of epidermis, mattress and floorboard may seem worlds away from the shiny, visual candy of Gary Hume, but both in their different ways are painters of surfaces who refuse to dig deeper. By restricting themselves only to what is externally evident they leave any storytelling up to us. For Freud, as for so many younger artists, there are no barriers between art and life, just uneasy relationships. But then, as he has said, 'the task of the artist is to make the human being uncomfortable'.

GILBERT AND GEORGE

Gilbert Proesch: b. 1943 Dolomites, Italy
1967-70 St Martins School of Art
George Pasmore: b. 1942 Devon
1967-70 St Martins School of Art
Anthony d'Offay Gallery
Live and work in London

They may have won the Turner Prize in 1986, their shows may attract record audiences from Moscow to Beijing, and they may – along with Damien Hirst and David Hockney – be Britain's best-known living artists, but in this country feelings are still mixed about Gilbert and George.

Is their fused artistic persona an ongoing continuation of their 1960s decision to become 'Living Sculpture', or an attention-seeking joke at the world's expense? Are their massive photopieces a celebration, or a critique, of all things English? In a career spanning some thirty years, the living logo that is G & G has followed in the footsteps of Andy Warhol in achieving the three-way formula for contemporary artistic success: ubiquity, inscrutability and – above all – controversy.

These days, it's difficult for art to be transgressive, but Gilbert and George manage to cause offence in all quarters. Conservative critics object both to the form and the content of their lurid, often scatological billboard-sized photopieces, while many liberals are made uncomfortable by such subject matter as swastikas, cruciforms and provocatively posed Asian and Afro-Caribbean boys. To them, the style and scale of Gilbert and George's work carries

unnervingly authoritarian overtones, whatever their claims for making a democratic 'Art for All'. In addition, there's the inseparable duo's repeatedly professed admiration for Lady Thatcher, their quaintly strangled little-Englander syntax, and their identical 1930s office-clerk dress style – all of which is guaranteed to provoke and play off the prejudices of every strata of the British class system.

From the beginning of their joint career, Gilbert and George have embraced extremes of tastelessness in a way that is regularly condemned as gratuitous and sensationalist. But where Gilbert and George are more transgressive is in the way in which they splice outrage with ambiguity. Often, the more crudely shocking the content, the more mixed the message. From the early *Magazine Sculpture* of collaged photographs showing the laughing, youthful artists labelled as *GEORGE THE CUNT AND GILBERT THE SHIT* (1970); to photo-pieces such as *PAKI* (1978), where the artists stand on either side of a young Asian man; through a multitude of works with titles like *SPERM EATERS*, *FRIENDSHIP PISSING* and *HOLY COCK*; to the monumental cruciform turds of the *NAKED SHIT PICTURES* (1994), their work tempts, mocks, and threatens – often simultaneously.

The constant appearance of the artists in their own works only adds to the uncertainty. Whether they are bronze-painted and singing 'Underneath the Arches' for eight hours at a stretch in the now infamous 'Singing Sculpture' marathons that they began when students at St Martins; divulging the minutiae of their daily lives in the postal sculptures of the 1970s; or appearing as a ubiquitous element in the hundreds of photopieces they have been making since 1974, their role hovers between participator and observer, author and actor, motif and presence. Like increasingly ageing Lords of Misrule, Gilbert and George preside over their lurid panoramas of high-rises and bad behaviour, delivering no judgements and providing no answers – a silent Greek chorus of two for our inner cities.

Gilbert and George may pride themselves on an 'unarty', emblematic style, but the throat-grabbing immediacy and lasting impact of their work relies as much on a complex web of visual strategies as it does on the garish shockingness of their photographic images. Their technicolour grids skew the sensibilities of viewers of all inclinations by playing off the scale, grandeur and vividness of Victorian ecclesiastical stained glass and the figure compositions of religious paintings in order to present a problematic form of visual propaganda that is at the same time disquietingly totalitarian and twentieth-century in appearance. With source imagery ranging from Christian, Eastern, heraldic and Islamic, to that of their own east London surroundings, the work can, perversely, be said

SHITTY
Part 1 of SHITTY
NAKED
HUMAN
WORLD
1994
Photopiece
Each part
338 × 639 cm

to live up to its claim to be an 'Art for All', while also depending for its often stunning arrangements of forms and saturated colour on the artists' virtuoso technical skills and 'arty' formalism.

So what then, lies behind these deadpan depictions of the unacceptable? Gilbert and George make lofty claims for their work as 'de-shocking' the spurious taboos of fine art and polite society. They state that they are striking a universal chord by addressing 'the subjects that are inside every single person wherever they are: death, hope, life, fear'. While this seems to be a little mega-lomaniac, there's no doubt that, through compositional skill, high production values and sheer chutzpah Gilbert and George can neutralise and transform some of the least appealing aspects of our existence. Who else could line an entire room with wraparound photographs of their own excrement and get away with it?

Their aim is surely to subvert rather than convert. In this respect, they

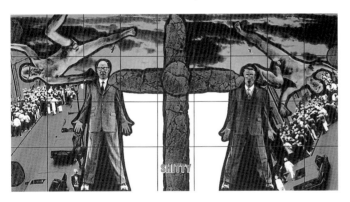

have much in common with the Surrealist René Magritte, whose bank-clerk appearance both concealed and comple-mented his transgressive spirit, and who felt that he could communicate more directly by painting in the style of a lumpen commercial illustrator.

Yet whereas Magritte wanted to act on the viewer's subconscious, the art of Gilbert and George forces an uncompromising engagement with, and consid-eration of, the complexities of the grittily immediate, and perhaps this is their greatest achievement.

Currently, it is expected of art that it should dismantle traditional distinc-tions between painting, sculpture and performance, and a whole range of artists are embracing urban contemporary life, frequently appearing in their own art while simultaneously remaining aloof from a specific personal and political stance. Whatever wider claims they may make for their art, the example of Gilbert and George has been taken up by a whole spectrum of contemporary artists from Damien Hirst and Sarah Lucas, to Tracey Emin, Mark Wallinger and Gary Hume, all of whom – in multifarious ways – use seeming rawness as a mask for extreme sophistication, and do not balk at defying expectations of probity and appropriateness.

RICHARD HAMILTON

b. 1922 London

1938-40 Royal Academy Schools; 1948-51 Slade School of Fine Art

Anthony d'Offay Gallery

Lives and works in Oxfordshire

Just what is it that makes today's homes so different, so appealing? enquired Richard Hamilton in a revolutionary 1956 collage of Mr and Mrs Perfect preening their flawless bodies in a Modernist home stuffed with the latest in consumer durables. Some forty years later, the work has become a Pop art icon, the art world groans with a glut of appliances and pop references, and Hamilton is still bedazzled by the high-tech paraphernalia that dominates our lives.

It is now common convention for art, advertising and the mass media to indulge in mutual cross-dressing, and for artists to use their work as a process of enquiry into the meretricious world we occupy. But while his ideas can sometimes seem to be several steps ahead of the images that emerge from them, the best of Hamilton's work continues to feed off double standards by simultaneously celebrating and criticising the art-as-mass-media bandwagon that he himself rolled into the 1960s as a pioneer of Pop art.

His numerous splicings of art and popular culture include a TV commercial advertising his Marcel Duchamp-meets-Jasper-Johns 'assisted readymade' of dentures and electric toothbrush (*The critic laughs* 1971-2); a painting based on advertisements for Andrex toilet paper (*Soft pink landscape* 1971-2); and a specially designed, fully functioning stereo amplifier that mutates into an abstract painting (*Study for 'Lux 50' IV* 1976). With a mixture of wonder and knowingness that has been adopted by today's younger artists Hamilton also employs state-of-the-art image-manipulation technology to investigate the three-way traffic between politics, mass media and the making of myths. His paintings of an ascetic, Christ-like figure *(The citizen* 1982-3), a sashed and bowlered Orangeman (*The subject* 1988-90), and a camouflaged solider (*The state* 1992-3), each originated from the television screen. With the help of a Quantel Paintbox, Hamilton turned a film of the IRA hunger striker Raymond McCartney, a televised Orangeman march, and footage of a British soldier on patrol into three painted, quasi-religious diptychs that, whether separately or as a series, encompass and transcend their politically specific subject matter.

Like his friend and hero Marcel Duchamp, Hamilton has remained devoted to undermining traditional categories of 'fine art', and this is often

The state
1992-3
Oil, Humbrol
enamel and
mixed media on
Cibachrome on
canvas
2 parts, each
200 × 100 cm

combined with an updated spin on Dada's ironic, ambiguous view of the machine. Whereas Duchamp's dysfunctional mechanisms doubled up as a metaphor for human foibles, Hamilton's ambivalent mechanical marriages have ranged from an exquisite painted collage of the voluptuous curves of a classic Chrysler car (*Hommage à Chrysler Corp.* 1957); a series of self portraits made by scanning Polaroids into a Quantel Paintbox; and a specially designed Diab DS-101 mini computer (1985-9). In this context it's hard not to think of Hamilton as the granddaddy of a multitude of subsequent artistic forays into the world of product design, whether Steven Pippin's Heath Robinson contraptions, or Damien Hirst's balloon-blowing machines.

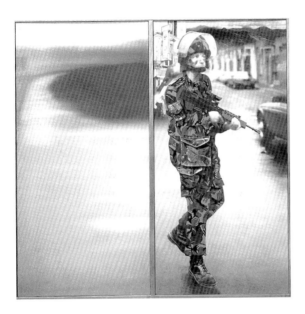

A founder member of the Independent Group, which was formed at the ICA in 1952 to discuss all aspects of popular culture, Hamilton was instrumental in organising and contributing to a series of ground-breaking exhibitions, including *This Is Tomorrow*, which opened at the Whitechapel Art Gallery in 1956 with Hamilton's then outrageous installation of a jukebox blasting out popular records; a life-sized photographic still of Marilyn Monroe from Billy Wilder's *The Seven Year Itch*, (released a year earlier); and – most shocking of all – a 5-metre-high portrait of Robbie the Robot, hero of the science-fiction film *Forbidden Planet* (directed by Nicholas Nayfack, 1956).

He may have been speaking in 1957, but Hamilton could have been echoing the aspirations of many of today's artists when he called for an art that was 'Popular ... Low Cost, Mass-Produced, Young ... Witty, Sexy ... Glamorous, Big Business'. In his desire to present a true art of the twentieth century, not only did Hamilton collaborate with Marcel Duchamp (he reconstructed his *Large Glass* in 1965-6), but he has taken up from where Duchamp left off and forged the way for many of today's young artists to find rich possibilities in the worlds of art, design, technology, movies and TV, and to move easily between whatever media they consider best equipped for what they want to say.

SUSAN HILLER

b. 1940 Carson City, Nevada, USA
1961-5 Smith College, Massachusetts, USA; 1965 Tulane University,
New Orleans, USA
Lives and works in London

It is significant that Susan Hiller practised as an anthropologist in South and Central America before she started making art. She has described her work as 'retrieving and reassembling a collection of fragments', and an anthropological curiosity underpins the way in which she seeks out overlooked and undervalued aspects of our familiar environment – photobooth portraits, seaside postcards, tacky wallpaper or cow-shaped milk jugs. Yet Hiller abandoned the world of anthropology in the late 1960s because she felt disillusioned with its finite methods and assumptions; and when she employs scientific processes of assembling, labelling and categorising it is to challenge, not to add to, fixed 'scientific' notions of truth, history, identity and meaning.

For Hiller, divisions between rational and irrational, present and past, fact and memory are ones that are manmade (and the gender distinction is deliberate). As far as she is concerned, reality is just as likely to lie outside official parameters, and she uses whatever means she can to connect her audience into areas of collective personal experience. The result can be spectacular: *An Entertainment* (1990) is a video installation in which scenes taken from over thirty Punch and Judy shows are projected onto immense screens that engulf and dwarf the viewer. On this scale the relentless violence of this classic children's entertainment of wife beating and infanticide is both hard to take and perversely intoxicating – there's no moral message here (there never is in her work) but Hiller succeeds in re-presenting seemingly familiar territory as dark, unfathomable and full of paradox.

Long before a younger generation of artists had begun to use the rigours of science and Minimalism as a foil for an unruly subjectivity, Hiller was employing orderly geometric forms and systematic processes in order to express what was the very antithesis of objective and finite. Her series of anti-monumental monuments go beyond their specific subjects and neat, carefully assembled appearance to deal with wider, more untidy complexities of death and commemoration. The geometric grid of *Sentimental Representations in Memory of my Grandmothers (Part II for Rose Hiller)* (1980-1) consists of eighty small squares, lovingly built up from single preserved rose petals; while *Dedicated to the Unknown Artists* (1972-6) sent out powerful contradictory

An Entertainment
1990
Installation at
Matt's Gallery,
London, using 4
video projectors,
quadrophonic
sound and 4
interlocking,
26-minute video
programmes
Photo: Edward
Woodman

messages of remembrance, association and nostalgia in the unlikely form of hundreds of common 'rough sea' postcards sent and collected from resorts around Britain and organised in sober blocks with accompanying analytical charts and a map locating their origins.

Hiller's obsession with the marginal and overlooked has led to her 'excavation' and reinstatement of processes that are commonly dismissed as irrational, unreliable and without credibility. She has investigated dream imagery, and worked extensively with automatic writing, messages through spiritualists, and other unexplained transmissions. (While she is loath to bang a feminist drum, Hiller is also aware that such activities are given a respectable artistic and scientific provenance when practised by men, but are traditionally linked with madness and mediumship in women.) With its projected circles

of pure, primary-coloured light, *Magic Lantern* (1987) not only left confusing after-images on the retina, but caused further disorientation through a soundtrack that combined the artist's improvised chanting with recordings made in empty rooms by 1960s psychologist Konstantin Raudive in order to capture the 'voices of the dead'.

These forays into the so-called supernatural are not intended to confirm or deny the existence of extra-terrestrial forces, and nor is Hiller a contemporary Surrealist trying to harness the subconscious to find the key to our existence. For Hiller, as for subsequent artists who have benefited from her freeing-up of such material – whether Gavin Turk's experiments with levitation, Jane and Louise Wilson's dual hypnosis or Mat Collishaw's images of angels and fairies – the emphasis is on process as much as product, to point out new areas of human potential and creativity, and to look at what these phenomena mean personally to each of us.

Susan Hiller's art strives to be open-ended but also refuses to take anything for granted. Every element is exhaustively (and sometimes exhaustingly) interrogated and shown to be in a state of flux. At times, the wealth of reference and density of these enquiries can threaten to overwhelm: her ongoing installation *At the Freud Museum* (begun in 1992) finds Hiller rather

overdoing her quasi-anthropological collecting, and it can feel as if there's little space for the audience to negotiate its own routes though her boxes full of ephemera, relics and writings. But this is the exception rather than the rule.

More often her work rises above its dense layers of meaning to stir the senses and capture the imagination. We see light used to dissolve the clarity of the world as well as to fix it, texts that both conceal and reveal, while language emerges as a process of restriction as well as freedom. Again and again her work stresses the now very contemporary notion that 'one person is many voices but there is no bounded unit who contains them', and there is no doubt that Susan Hiller's insistent probing of the certainties upon which we build our lives and identities raises issues that are crucial to all of us.

BRUCE MCLEAN

b. 1944 Glasgow
1961-3 Glasgow School of Art; 1963-6 St Martins School of Art
Anthony d'Offay Gallery
Lives and works in London

Whether he's draping himself across a plinth, painting a giant picture, or shooting a movie, Bruce McLean believes that art should both feed off and feed into the world in which we live. McLean makes big art out of small details – the gestures, styles and mannerisms that, whether we like it or not, orchestrate our lives and obsess us all. This concern with seemingly trivial aspects of appearance and body language, and how they inform the different identities we knowingly and subconsciously assume, is one shared by many younger artists working at the moment – it's perhaps no coincidence that Bruce McLean was one of Douglas Gordon's tutors at the Slade – and McLean has also consistently demonstrated to subsequent generations that art can be serious without taking itself too seriously.

When McLean arrived in London from Glasgow in 1963 to study sculpture at St Martins, the school was rapidly establishing its reputation as a forcing-ground for the off-the-plinth, arc-welded, no-nonsense 'New British Sculpture'. The presiding Patron Saint was Anthony Caro, and a spirit of serious sculptural enquiry prevailed. While McLean felt little empathy with rigorous aesthetic discussions around the nature of art, he – along with an exceptional line-up of fellow students that included Gilbert and George, Richard Long, Barry Flanagan and Tim Head – was exhilarated by the idea that sculpture need

no longer be tied down by tradition, and that anything and everything was possible. But for McLean, the earnest enquiries (as well as the unintentionally comical bending, squinting and pacing) of the participants in St Martins' sculpture seminars also threw up another proposition: that what went on around art could often be more interesting than the art itself.

Although he first made his reputation with performance, McLean has always considered himself a sculptor; but that didn't stop him sending up centuries of sculptural tradition with works such as his *Installations for Various Parts of the Body and Pieces of Clothing* (1969) or *Pose Works for Plinths* (1970), which further fuzzed interdisciplinary boundaries by evolving into photo-pieces in their own right. With the formation in 1971 of Nice Style, 'the World's First Pose Band', McLean went on to parody human behaviour per se. Wear-

ing straight faces and immaculate evening dress, McLean and friends regaled audiences with often farcical enactments of every permutation of Western urban pose – from the quest for the perfect Bogartian mack-intosh crease, to the rhythmic banging of deep-freeze lids. Nice Style folded in 1975, but an obsession with live gesture and a preoccu-pation with the minutiae of human behaviour – both inside and beyond the art world – has remained at the core of McLean's subsequent activities; even when appearances might seem to suggest otherwise. Sometimes this may manifest itself in architectural projects, such as his 55-metre painting, the length of the platform at Tottenham Hale train station, north London, designed in 1991 in collaboration with the architect Will Alsop, or in full-scale performance/opera pieces such as *The Masterwork Award Winning Fishknife* at London's Riverside Studios in 1979.

McLean's modus operandi is to keep – often manically – on the move. During the 1980s he was swept up in the painting revival that gripped the decade, while, with characteristic perversity, denying that he was a painter at all. Nevertheless he was widely exhibited alongside such pigment-splattered,

Neo-Expressionist heroes as Julian Schnabel, Georg Baselitz and Rainer Fetting (as well as being corralled into the school of muscular figuration that was emerging out of his native Glasgow), even though his large, splashy Matissean pictures, with their vivid fields of colour and scratchy figures, were more expressions of the outside world than of Neo-Expressionist introspection; more gesture than gestural.

But however much McLean is playing the court jester, even his detractors acknowledge his exceptional ability to orchestrate form and colour, and his bravura paintings demonstrate a genuine love of the medium that goes beyond pose. Posing, both personal and professional, is often a disguise for something more serious. Despite (or maybe because of) the jokiness, the easy-viewing canvases, the stylish ceramics, and the designs for chic fireplaces and trendy bars, which seem to embrace the very world they originally set out to parody, McLean's intensity of feeling can sometimes catch you – and maybe him – unawares. The 1980s were his glory years, but while McLean's copious outpourings on canvas, ceramic, even carpet, had made him one of Britain's most successful and visible artists, his attitude to the decade of plenty was ambivalent to say the least. Works such as *Going for Gucci* (1984), which depicted a crucifixion attended by figures wearing handbags on their heads; or the black-grounded *Red Wine Sea* (1985), complete with scratched-in battleship, belied their titles to show, with McLeanean obliqueness, that there was a dark underbelly beneath all the frivolity and conspicuous consumption.

Never one for restraint, in 1996 McLean caused more art-world consternation by combining all his obsessions and concerns in a feature-length video. *Urban Turban* ran for nearly two hours, with McLean, his paintings, members of the art world, poses galore, hats in abundance, friends in attendance, slabs of colour and scattered fragments of storyline all projected simultaneously onto three screens and accompanied by a deafeningly rhythmic soundtrack composed by Dave Stewart. Some found it unwatchable, some found it trivial, some applauded its exhilarating freedom from convention – it was certainly unforgettable. McLean's definitions ranged from 'A comedy, a tragedy, a prediction, an artfilm, a sexual film, probably the first architectural movie' to 'perhaps the first real hat movie'.

Long before Damien Hirst's multifarious engagements with the world of style, fashion and pop culture, Bruce McLean had paved the way, and the extraordinary outpourings of *Urban Turban* continue to confirm that the younger members of the current art scene do not have the monopoly on cheek and effrontery.

PAULA REGO

b. 1935 Lisbon, Portugal
1952-6 Slade School of Fine Art
Marlborough Fine Art
Lives and works in London

In today's post-Postmodern climate, 'narrative' is no longer a dirty word in contemporary art. Subjective stories have now become the artistic norm – the more offbeat and open-ended the better – from the bizarre, vox-pop rantings recorded by Gillian Wearing, to the autobiographical extravaganzas of Georgina Starr, and the fractured fictions of Sam Taylor-Wood. But the doyenne of skewed narration is Paula Rego, who, for over forty years, has trawled her own myths and memories to conjure up ever more psychologically complex scenarios where it iss up to the viewer to decide what is taking place – if they can bear it.

Starting points for Rego's paintings, prints and pastels can be whatever captures, or has lodged itself in, her imagination. Traditional stories remembered from her Portuguese childhood, a newspaper item, a movie, or any amount of seemingly mundane personal occurrences all act to trigger and fuel the storylines that run through her work. Yet she is no illustrator. In a series of large pastels from 1995, *Snow White* becomes a Freudian psychodrama that hones in on the sexual tension between Snow White, her absent father and her vampish stepmother, with not a dwarf nor animal in sight. The action unfolding in *The Family* (1988) may not be from any recognisably familiar tale, but that doesn't stop the viewer from being sucked into an uncomfortable complicity with the intricate and highly ambiguous relationships between the woman, the two stocky girls and the man whom they are pinning to the bed.

For Rego, stories both familiar and imagined, whether expressed in full-blown set-pieces or merely hinted at through individual characters or details, are sites of shared experience that we can all, in our particular ways, recognise and understand. It may be maddening that what looks so explicit can also be so obscure, but that is the point: how you read these goings-on is up to you. Rego cuts through the contemporary sentimentality of fairy stories and nursery rhymes to tap into their dark, transgressive origins where symbols of authority are toppled, the 'natural' order of things is reversed, and mayhem and violence can erupt. Her *Three Blind Mice* (1989) scrabble in wall-eyed terror as a sinister farmer's wife brandishes a savage blade, while versions of other children's classics such as *Baa Baa Black Sheep* and

Snow White and
her Stepmother
1995
Pastel on paper
mounted on
aluminium
170 × 150 cm

Little Miss Muffet (both 1989) are fraught with the darkest of sexual innuendo.

There's nothing nostalgic about Rego's child's-eye view, which plunges unblinkingly into the darker side of childhood on which no one likes to dwell, yet it is often affectionate. Her children may be monsters but she doesn't demonise them, and she makes it hard to distinguish between the brutality of playfulness and the playfulness of savagery. This murky psychological minefield lies beneath the action-packed anarchy and vivid cartoonish figures of canvases like *The Bride* (1985), and lurks closer to the surface in elaborate theatrical scenarios such as *The Maids* (1987), and *Caritas* (1993-4) where sly, lumpen children enter into more troubled relationships with animals and adults.

Childhood associations permeate the style as well as the content of Rego's work. At times she has plundered infantile

doodlings, cartoons, and – most famously – children's storybook illustration. There is also an abundance of old-masterly 'high art' sources including Giotto, Goya and Tintoretto, and the volume and scale of her colossal tumbling figures can lend some of Rego's works the unexpected appearance of High Renaissance altarpieces. Her desire to give form to the most atavistic of feelings has resulted in a disregard of artistic trends and the art world's enduring hunger for a signature style. Rego throws herself into the physical processes of painting, etching and drawing as a means to unleash her imagination, not to comment on the state of contemporary art. Collaged cut-outs of the 1960s and lurid cartoon romps of the early 1980s show the influence of untrained 'Outsider' art as well the free-association techniques of Surrealism, while the ungainly volumetric figures and stagy settings of works from the 1980s and early 1990s show direct and deliberate borrowings from the illustrations of Sir John Tenniel, Arthur Rackham and Beatrix Potter.

But just as Rego was establishing an impressive reputation for presenting complicated goings-on in a pointedly illustrative style, in 1994 her work made another stylistic shift. She committed what is to the avant-garde the ultimate crime of making large, academic life drawings in coloured pastel, and then compounded the offence by extolling the voluptuous pleasures of the physical act of drawing. Yet, typically, things were not quite as they seemed. In an

idiosyncratic twist on the interchange between animals and humans that runs throughout her work, these highly finished, anatomically correct images of squatting, sitting and sleeping women communicate the intensity of human emotion and existence by assuming the uncannily accurate gestures and demeanour of dogs. Her *Dog Women* (1994) hunch, grovel and snarl in poses that are both submissive and defensive, appealing and ungainly. In 1995 Rego continued to use the life model for anthropomorphic crossover in a series of gallumphing ballet dancers inspired by the ostriches in Walt Disney's *Fantasia*.

Women may predominate in Rego's work – and men often get their come-uppance – but this has nothing to do with feminist polemic. Rego doesn't take sides or express opinions, and her sympathy for her protagonists is always highly ambivalent. From the earlier paintings through to *Snow White*, women and girls are often unspeakably (or at least potentially) cruel to each other, as well as to those in their charge. The *Dog Women* are a welter of conflicting emotions, and the *Ostriches* series both celebrates and pokes fun at notions of femininity.

In common with many younger artists working at the moment, Rego views identity not as a clear-cut entity but as something to be constantly struggled towards and reassessed. In this context stories can mean different things to different people, and act as a springboard for the discussion of human nature, power and relationships – however scary they may be. Paula Rego walks a fine line between whimsicality and melodrama, but she's prepared to carry on taking risks. She may relish games, but she knows that play is also deadly serious – as she once said: 'I paint to give fear a face'.

RICHARD WENTWORTH

b. 1947 Samoa, Africa
1965-6 Hornsey School of Art; 1966-70 Royal College of Art
Lisson Gallery
Lives and works in London

Richard Wentworth first emerged in the late 1970s as part of a group of sculptors who were breathing life into British abstract sculpture via an irreverent use of materials more commonly associated with the skip or the DIY shop than the world of high art. Never mind that the main factor uniting these disparate practitioners of the so-called 'New British Sculpture' was

their international outlook, there's still no doubt that their focus on everyday objects and their belief in humour and playfulness has been crucial in opening up the option for the current generation of British artists, many of whom now endeavour to make serious points while using tacky, up-to-the-minute source material.

However, unlike Tony Cragg, Richard Deacon and Bill Woodrow, whose earlier transformations of urban detritus seem to have metamorphosed into sculpture that risks becoming as monumental, formalist and self-referential as the Henry Moores and Anthony Caros they were originally reacting against, Richard Wentworth's investigations of the everyday world continue to reflect the irreverent, questioning spirit of our times. It is significant that for sixteen years he was a tutor at Goldsmiths College, up until 1987 – the year before second-year student Damien Hirst curated the landmark *Freeze* exhibition – and evidence of Wentworth's influence can be spotted throughout today's art world, whether in Julian Opie and Grenville Davey's explorations of the shapes and messages of functional objects, or in the deadpan humour of Simon Patterson's free-association word games.

Wentworth generally works with ordinary objects whose forms are dictated by their function. Ladders, chairs, pillows, galvanised and corrugated steel, and a variety of containers such as buckets, ladles, dishes, cups and cans all feature prominently and it is this very familiarity that provides a starting point for sculpture that makes the most mundane of objects acquire new identities and uses. Sometimes this is achieved with the minimum of artistic intervention: *Pair of Paper Bags with Large & Small Buckets* (1982) is just that: two metal buckets wrapped in brown paper and exhibited as purchased. Other pieces can be more complex: *Mercator* (1990) inserts three small soldered steel houses through curved slices of corrugated steel; and the epic *Drift* (1993) fills an entire room with a higgledy-piggledy maze of twenty-seven steel-mesh cages containing various characteristic Wentworth items such as mirrors, lightbulbs, bricks and tyres.

There's no doubt that Wentworth relishes the abstract qualities of his materials: concrete against mesh, metal against fabric, the timeless, universal shapes of beaker, box and bowl. He also enjoys a Dadaist joke. Yet what distinguishes Wentworth from his artistic antecedents is the human, hand-made, hand-held element that permeates his work. Inextricably intertwined with the appearance of the objects he favours are the associations they conjure up in all of us. Technical skill is a crucial component: for his sculpture to succeed it has to appear easy and inevitable, but at the same time remain up-front about how it has been constructed. 'I try very hard to make my work appear matter of fact'

Aide Memoire
1991
Galvanised steel;
galvanised steel
painted with
brass; plastic
52.5 × 56 × 32 cm
Photo: Mike Parsons

he says. Associations, oblique and overt, are tweaked, teased and confounded in works such as *Surd* (1991), where a bollard-shaped blob of granite rises out of the floor and is joined by a tin ladle whose bowl is sealed by a soldered disc of brass and penetrated by corks; or *World Soup* (1991), in which the upper rims of nine opened food tins, their labels still intact, are immaculately fitted into a sheet of galvanised metal, which they both pierce and support.

A crucial subtext to all Wentworth's work is an ongoing series of photographs that he has been taking since the 1970s, entitled *Making Do and Getting By*. Described by the artist as records of 'situations that attracted me', these thousands of photographs celebrate the ingenious and often almost

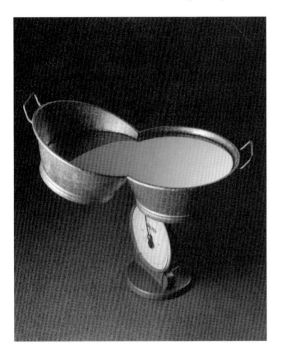

unthinking ways in which people adjust their surroundings and possessions to suit the necessities of the moment: a ladder becomes a barrier, a doormat wedges a door open, a folded cigarette packet stabilises a table leg, a cardboard box blocks a road, curly railings support a discarded Styrofoam cup. Improvised solutions to urban life, they form what Wentworth calls 'an international language of signs' that operates in cities across the world, while at the same time being particular to a specific place, time and need. He doesn't copy them directly, but they provide the conceptual underpinning to his work. It is the lightness, rightness and also the incongruity of *Making Do and Getting By* that permeates the best of Wentworth's sculpture, and constitutes a crucial shift in emphasis away from Marcel Duchamp's 'assisted readymades', or from a quasi-Surrealist search for weirdness in the streets.

Similarly, while there seems to be a strong element of Surrealist provocation in Wentworth's playful – and often complicative – choice of titles, which can carry a multitude of different readings, they also show an interest in everyday linguistic solutions. Titles such as *Mould* (1991) – for an inverted empty metal house shape, its inner and outer surfaces blurred by a layer of steel mesh – or *Buttress* (1990) – for a flimsy section of wooden ladder straddling a pair of bricks – have as much to do with the puns, gags and narratives that sit at the

core of British culture and humour as with any desire to assign true meaning.

With his love of games, wordplay and the serendipitous recording of spontaneous examples of human ingenuity – not to mention a penchant for manufactured objects that hark back to an era of welded, riveted manufacture – Richard Wentworth inevitably lays himself open to accusations of folksiness and whimsicalilty. But he keeps on his guard. He salutes the unknown makers-do and getters-by without mythologising them or classifying his discoveries, and this open-ended pragmatism feeds into the sharp-edged clarity of his sculpture. In spite of some quaint raw material, Wentworth's pristine finish and formal rigour usually succeeds in keeping nostalgia at bay, while at the same time the nimble humanity and humour of these leaning ladles, balancing dinner plates and dangling ballcocks flies in the face of arid objectification.

Richard Wentworth describes his combinations of materials as 'emulsion' where, like oil and vinegar in salad dressing, the elements bind but do not lose their distinct character. Occasionally, when this process fails to take place, his art can seem obdurately cryptic. Yet there are also times when Wentworth mischievously makes the relationship between object and title appear so screamingly obvious that you refuse to take it at face value and are led to conjure up an alternative range of elaborate interpretations. If Wentworth gives one message to his audience it is this: keep looking, keep wondering, and consider all options.

CURRENT CONTENDERS

BRIAN CATLING

b. 1948 London
1968-71 North East London Polytechnic; 1971-4 Royal College of Art
Matt's Gallery
Lives and works in Oxford

Poet, performer, sculptor, installation artist – Brian Catling is as difficult to categorise as his work is to describe in print or capture on film. What he does depends on the location in which he is working, and he draws on past and present aspects of his surroundings as a major inspiration for his unpredictable combinations of written texts, live performances and collections of objects. The outcome can be spectacular and dramatic, or so low key as to be barely noticeable, but a crucial component is always the live presence of the artist himself, sometimes performing, sometimes just occupying the space, while projecting a range of personae that can ricochet between Mr Normal, Idiot Savant, Mad Professor or Malevolent Mobster.

Catling rejects what he calls 'a fossilised studio practice' for a more spontaneous (and risky) engagement with the energy and essence of a specific place. The results are as various as the locations themselves. His response to a decaying spa building in the market town of Aachen, Germany (*Atrium* 1988) included distressing a metal bowl with acrid sulphur, assembling a 'library' of the multifarious loaves of bread produced by the surrounding bakeries, creating a carpet out of 27,000 locally made needles, and casting a bell from the chocolate-like mud of the region. During a nine-day marathon at London's Serpentine Gallery (*The Blindings* 1994) the artist used his own words, objects and actions to commune with the space and memories of the gallery and its environs – from the manholes in the floors to the blue whale in the Natural History Museum. His eight-hour video projection *Cyclops*, at the South London Gallery in 1996, came into its own at dusk when the eerie whispering

presence, invisible in the natural daylight, seemed to suck in the last glimmer of light to reveal a monstrous image of the artist, with mirror pressed against one eye – an alienated Cyclops for our times.

Catling may possess a rich command of language and the ability to conjure up the presence of Caliban crossed with a Kray brother, but it is not literature or theatre that lies at the core of his work. Although the objects that populate and punctuate his pieces rarely survive a single showing, and despite the fact that he is well known for his published books, sculpture is the metaphor linking Catling's many modes. He is currently Head of Sculpture at the Ruskin School in Oxford, and throughout the 1980s taught sculpture at a number of art schools including Camberwell and the Royal College of Art. His graphite-coated publication *The Stumbling Block* (1990) was 'a direct attempt to write sculpture', and the forms he casts, carves, assembles and arranges – whether the hide of a deer, a dish of Perspex, or a smoked fish coated in clay – act as lightening rods for the emotional charge of his environments and performances; or, as Catling puts it, 'poultices to draw out meaning'.

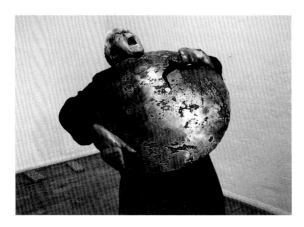

Today, the immediacy of Performance art has, to a great extent, been deflected into video or time-based work. But Brian Catling bridges the gap. Although he was a student during the heyday of 1970s Live Art and draws on cultures both beyond and before our own, his is not a hippie sensibility. And while his work can be placed within a metaphysical artistic tradition that extends from Joseph Beuys' view of the artist as shaman through to Marcel Duchamp's notion of the artist as a form of medium, it also has a directness, subjectivity and pragmatism that is very much of the here and now.

Catling's idiosyncratic approach, his open-ended, metaphoric view of making art, has influenced and continues to respond to wider artistic concerns. He reflects a very contemporary desire to push at the boundaries of what art can and should do, yet he also maintains his outsider status by rejecting the art market. 'I'm interested in the phenomena the work creates rather than the work itself. I think that once you remove it as an object, once you remove it as a commodity, and you actually say "you can't have this but

it's yours anyway", a different thing occurs in the work.'

Catling's projects are governed by creating dialogues rather than individual objects, and the actual activity of making art and the materials he uses are part and parcel of the outcome: 'substance – stuff, the manipulation process, making things – is a very important part of my understanding of the world.' When asked about his occasional use of video projection for example, Catling could have been speaking for an entire generation of hands-on young artists when he declared: 'I don't want to be a video artist. It's just an appropriate thing at the time.'

WILLIE DOHERTY

b. 1959 Derry
1977-81 Ulster Polytechnic
Matt's Gallery
Lives and works in Derry

'I've tried to give a voice to what has been unspeakable', said Willie Doherty in 1994, just after the government lifted its media ban on Sinn Fein inNorthern Ireland. 'My work is trying to undermine various notions about what opposites might be, and to show how the media's perceptions of Ireland are completely unreliable.' Today, the peace process is still fragile, and press coverage of Northern Ireland continues to favour easy demonisation and the quick soundbite. As a lifelong resident of (London)Derry – a city whose very name is a bone of sectarian contention – Willie Doherty immerses his art in the complexities and contradictions of the Northern Irish situation; but the issues he raises extend beyond a specific time and place to remind us that several truths can exist at the same time.

Doherty first attracted art-world attention in the late 1980s with a series of black and white photographs showing bleak panoramas of Derry and its surroundings, devoid of any human presence but charged with the suggestive words and phrases printed across their surfaces. 'My starting point was the way political and physical landscapes were fused' he declared. In such works as *Undercover/Unseen Derry* (1985), where innocuous images of a footpath through tangled undergrowth and an empty road are paired with the accompanying inscriptions UNDERCOVER/BY THE RIVER and UNSEEN/TO THE BORDER; or *The Other Side* (1988), which emblazons a dour panorama of the Foyle valley taken from the east bank with a trio of captions WEST IS SOUTH/

Same Difference
1990
Slide projection
with text
installed at Matt's
Gallery, London

EAST IS NORTH/THE OTHER SIDE, texts and images play off each other to show how easily emphasis can be shifted and certainty overturned.

Rather than attempting to explain what is taking place in Northern Ireland, Doherty goes beyond sectarian specifics to destabilise the role of photography within a situation that is both saturated by photographic images and dominated by scrutiny of all kinds. A public billboard project of 1992, displayed on hoardings throughout Great Britain and the North of Ireland, showed a blown-up newsprint detail of a man's eyes overlaid with the statements 'I am ruthless and cruel. It's written all over my face. I am proud and dedicated'. In 1990, the slide installation *Same Difference* juxtaposed two identical television images

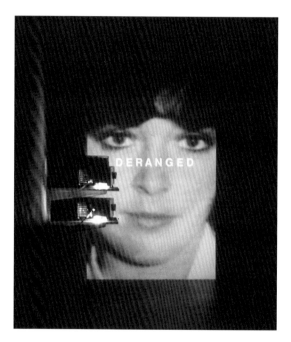

of IRA suspect Donna MacGuire, one identifying her as 'MURDERER ... PITILESS ... MURDERER ... MISGUIDED ... MURDERER ... EVIL', the other as 'VOLUNTEER ... SENTIMENTAL ... NOSTALGIC ... VOLUNTEER ... WILD ...'

More recent Cibachrome prints, Doherty's own pictures of blockades, bullet holes and burnt out cars, comment on the standard line-up of images that is now automatically associated with Northern Ireland: 'A lot of stuff I present already exists in the wider consciousness' he says, 'even Sinn Fein and the Northern Ireland Office often end up using the same images'. But Doherty doesn't just want to bandy about interchangeable emblems of warfare. His series *No Smoke Without Fire* (1994) scrutinises the environs of Derry with such forensic intensity that even an empty road, a tyre-tread or a parked car become rife with potential danger, while the rich tones and luxurious quality of these large-scale photographs emphasises their status as artworks and fires them with a problematic beauty.

In their openness to opposing interpretations, Doherty's works do more than throw up the divided certainties that identify one person's terrorist as another's freedom-fighter: they destabilise the language, both visual and verbal, that allows such rigid distinctions to be made. Nowhere is this more evident than in Doherty's video installation *The Only Good One is a Dead One*

(1993), which engulfs the viewer in two video projections: one shot from a moving car at night, driving along a winding country road, and the other taken from a parked car in a city street, also at night. The ambiguity between target and terrorist, surveillant and stalker is further compounded by a soundtrack of a male Irish voice vacillating back and forth between the fear of being a victim and the fantasy of being an assassin. 'It's possible for the perpetrator to be the victim and the victim to be the perpetrator', Doherty comments. 'The aggressor and the victim are after all mutually dependent on each other.' Such subtleties were lost on the English press who, when this piece was exhibited at the Tate Gallery in 1994, branded Doherty an 'IRA artist'.

Paradoxically, it is precisely because Willie Doherty has decided to work within the context of Northern Ireland that his art is able to transcend its specific geographical and political location. By drawing on artistic antecedents ranging from the language-art of Americans Jenny Holzer and Barbara Kruger to the photographic re-presentations of Europeans Christian Boltanski and Gerhard Richter, as well as the photo-text combinations of British Conceptual artists such as Richard Long and Hamish Fulton, and by applying these strategies to the precise and loaded context of a war zone, Doherty produces images that have a universal, rather than a local reading. After all, it's not just on the subject of Northern Ireland that the media determines our preconceptions and tells us what to think.

ANYA GALLACCIO

b. 1963 Glasgow
1985-8 Goldsmiths College
Lives and works in London

Most artists intend and expect their art to outlive them, but Anya Gallaccio isn't interested in immortalising herself for posterity. Her work rots, melts, decomposes and ends up in the bin. A ton of fresh oranges strewn on a warehouse floor pungently putrefies to the point of soggy unrecognisability in front of a wall papered with perfect silk-screened specimens (*tense* 1990); sunflower heads pressed between sheets of glass ooze a sinister black goo before they dry out (*preserve 'sunflower'* 1991); threaded chains of vivid gerberas droop and darken (*head over heals* 1995); and walls painted with liquid chocolate either whiten (*stroke* 1994), or sprout technicolour mould (*couverture* 1994).

intensities and
surfaces
1996
35 tons of ice, 1/2
ton rock salt
300 × 400 ×
400 cm
Installation at
Wapping
Pumping Station,
London
Photo: Anya Gallaccio

Gallaccio sees this exposure to the physical processes of decay less as a reminder of our own deterioration and inevitable demise than as a reflection of what it means to be alive. Her art is a multi-sensory adventure that can only be experienced at first hand, in the here-and-now. In her work, as in real life, time cannot be made to stand still, and whatever precautions are taken it is never absolutely certain how things will turn out. Light and moisture can speed up decay as well as throw up unexpected new life forms; a piece of glass can simultaneously preserve and destroy.

She has stated that 'For me, a lot of the history of art is about men imposing their will on material. I'm more interested in a collaboration between me and the material … it's like a relationship'. Yet although she eschews traditional art practices by deliberately putting herself at the mercy of her materials, her

pieces are always underpinned by meticulous preparation and a keen formal eye. In both content and appearance Gallaccio's work has a rich and knowing relationship with its art-historical antecedents. The poetic use of non-traditional sculptural materials pioneered by the Italian Arte Povera movement of the 1960s is an important and acknowledged influence; as is American Minimalist sculpture. But while Gallaccio's work often assumes the configurations of Donald Judd, Carl Andre et al, in common with other artists of her generation such as Rachel Whiteread and Damien Hirst – and with a hard look at Helen Chadwick – Gallaccio adopts and adapts the procedures of Minimalism to her own more emotionally charged ends.

Whereas the heavy-metal heroes of Minimalism were concerned with expressing the objective qualities of their materials to the exclusion of any subjective storyline, Gallaccio takes the opposite view. Works such as the 35-ton, 3- metre-high block of ice in *intensities and surfaces* (1996); or the dense carpet of severed red rose heads resting on their leaves and stalks, *red on green* (1992) present physical stuff arranged in simple geometric forms, but because Gallaccio chooses material that perishes – often spectacularly – over the passage of time, the correspondence between an initial order and ensuing decomposition elicits a complex and highly individual response.

For a contemporary female artist to indulge in such stereotypical activities as working with flowers, dealing in emotion and pronouncing herself to be 'romantic' and 'poetic' is to flirt with prejudice and misinterpretation. However, Gallaccio relishes juggling the ambiguities of what is, and is not, deemed suitable artistic subject matter. While her flower works deliberately play with clichéd 'female' activities of flower pressing and arranging, and the choice of chocolate is also rich in luxurious, indulgent connotations that have been traditionally associated with feminine sensuality and excess, there is nothing charming or decorative in the processes of decay they present. By her rejection of both traditional and contemporary notions of beauty and propriety in art, Gallaccio presents a view where categories of seduction and repulsion, subjective and objective blend, bond and ultimately become irrelevant in the face of the work itself.

DOUGLAS GORDON

b. 1966 Glasgow
1984-8 Glasgow School of Art; 1988-90 Slade School of Fine Art
Lisson Gallery
Lives and works in Glasgow

A prominent member of Glasgow's 'Scotia Nostra' arts scene, which is acknowledged worldwide if not in Glasgow's new gallery of Modern Art, Douglas Gordon is best known for winning the 1996 Turner Prize by making art out of other people's films. His 24 Hour Psycho (1993) was a projection of Alfred Hitchcock's famous movie slowed down to last an entire day; while his Confessions of a Justified Sinner (1996) showed footage from Rouben Mamoulian's 1939 version of Dr Jekyll and Mr Hyde on two free-standing screens, slowed down, enlarged and alternating between positive and negative prints.

For Gordon, movies are just like any other artistic material: there to be altered, cut into, changed and displayed in a new context. Their original authorship is not concealed; it is crucial to the piece. Like so many of his contemporaries, he sees film as part of the shared landscape of the modern imagination, and an effective means to probe the troubled territory of the human psyche: how do we give meaning to what we experience? What do we remember and why?

Silently back-projected at two frames per second onto a screen that can

be walked around and viewed from either side, Hitchcock's *Psycho* (1960)
takes on a new life. Each sequence becomes a mini-movie – the shower scene
lasts for over half an hour – but instead of a film buff's banquet, what emerges
is what Gordon describes as the 'unconscious content' of this celebrated study
of voyeurism, desire and suspense – unexpected tensions, narratives and
details that have little or no relation to the film everyone thinks they know so
well. Yet what makes *24 Hour Psycho* more than just a clever dissection, is the
way in which its presentation forces us to interrogate and challenge how we
think we remember and understand those familiar images.

A fascination with the functions (and dysfunctions) of memory runs right
back through Gordon's work in all media. In 1990 he exhibited *List of Names*,
a wall text compiling 1,440 names of everyone he had ever met and could
remember; while the installation *Something Between My Mouth and Your Ear*

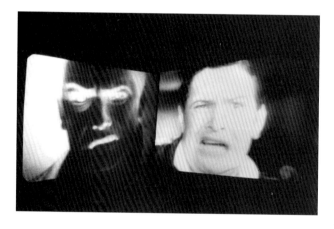

(1994) harnessed the power
of music as a psychological
trigger by placing the viewer
in a dreamy, blue-painted
room that resounded to what
could be the soundtrack to the
artist's earliest memories:
thirty pop songs that were on
the airwaves during the nine
months between January and
September 1966.

Gordon's desire to unearth
what is subliminal and uncon-
sciously thought has sometimes brought him dangerously close to Beadle
territory. *Speaker Project* (1992), involved anonymously telephoning targeted
strangers in an Italian bar with messages such as 'you can't hide your love
for ever' and 'I won't breathe a word (to anyone)'. And a series of signed letters
sent to members of the art world between 1991 and 1994 bearing such state-
ments as 'I forgive you', or 'I am aware of what you have done', was variously
regarded as innocuous, threatening and plain irritating.

Overall, Gordon's work is most effective when it uses the seductive power
of the moving image to force us to question what we think we know. Just as
he used Hitchcock's movie as bait to draw us in and force us to reassess our
preconceptions, so his *Predictable Situation in Unfamiliar Surroundings* (1993)
selected extracts of *Star Trek*, which, slowed down, dwelt on a darker side of
Captain Kirk as the purveyor of a most unchivalrous sexual violence. In works

such as *Trigger Finger* and *10ms⁻¹* (both 1994), and *Hysterical* (1995), fragments of vintage medical films documenting various kinds of psychological malfunction become fraught with mixed messages surrounding power, voyeurism and potential victimisation.

Our shifting, unreliable readings of all that we see, and the co-existence of such apparent opposites as good and evil, truth and fiction, hero and villain, all come under scrutiny in Douglas Gordon's re-rendering of another celluloid classic: the 1930s *Dr Jekyll and Mr Hyde*, starring Fredric March as the doomed doctor. *Confessions of a Justified Sinner* (1996) showed three scenes where good Jekyll merges into fiendish Hyde, but the torturous speed and silent grimacings, projected simultaneously in positive and negative, muddle the boundaries between man and monster. Here, the forces of light and darkness literally and metaphorically slug it out.

This binary theme is picked up by Gordon in *The Divided Self* (1996), a deceptively simple video installation where a pair of TV monitors show two hands writhing, gripping, and pressing on what looks like a bed. On one screen, the hairy arm seems to be dominant, on the other the smooth arm appears to be winning; nothing is resolved. Out of these simple components elaborate relationships and power structures emerge. But beware any easy interpretation: both arms are the artist's own.

ANTONY GORMLEY

b. 1950 London
1968-71 Trinity College, Cambridge University; 1975-7 Goldsmiths
College; 1977-79 Slade School of Fine Art
White Cube
Lives and works in London

At the beginning of the 1980s, when his contemporaries were busy putting Britain on the international art map by playing with the form and content of abstract sculpture, Antony Gormley did the unfashionable thing and started making three-dimensional work about the human body. Now, nearly two decades later, when most of the so-called 'New British Sculptors' are fast becoming Grand Old Men, contemporary art is awash with bodily concerns, and Gormley's own corporeal works have won him innumerable shows across the world as well as the 1994 Turner Prize.

While the human figure – usually his own – forms the starting point of

Close I
1992
Lead, fibreglass,
plaster and air
25 × 192
× 186 cm
Photo: Antony
Gormley

Antony Gormley's sculpture, it is absence rather than presence that animates his work. *Bed* (1981) consisted of a mattress of stacked 'Mother's Pride' sliced white bread with two Gormley-shaped hollows literally eaten by the artist out of its surface; and the human form has remained both conspicuous and absent ever since. The blank-faced humanoids upon which his reputation was launched may have a powerful – even unnerving – physical presence, but they are hollow cases, described by the artist as 'vessels that both contain and occupy space'.

In order to make these smooth-edged, robotic figures that strike their enigmatic poses on the floors, walls and ceilings of galleries across the world, Gormley puts himself through a laborious, ritualistic casting process whereby his naked body is wrapped first in clingfilm and then in scrim (an open-weave cloth) and plaster. When this has set, he is cut out of the mould, which is then encased in an outer skin of lead (or more recently, cast-iron) sheets, beaten

over the contours and soldered together in a grid of seam-linked sections. The artist endures this voluntary mummification not because he wants to produce a perfect self portrait – in fact all identifiable details are deliberately smoothed out – but because he is as concerned with the human interior as he is with its outside. 'I am trying to make a sculpture from the inside, by using my body as the instrument and the material', he states. 'I concentrate very hard on maintaining my position and the form comes from this concentration'. A Catholic upbringing, a degree in Anthropology and History of Art (his thesis was on that mystic outsider Stanley Spencer), and time spent in India studying with the Buddhist meditation teacher Goenka have all played their part in shaping an art that attempts to marry the physical with the spiritual and the specific with the universal, or what Gormley describes as 'whatever it is that connects space and the imagination'.

A preoccupation with the interrelationship of inside and outside spaces extends to an alliance of buildings with bodies, and vice versa. One of several box pieces made in the late 1980s, *Room II* (1987) consists of vertically stacked cubes of concrete given human reference by the inclusion of holes for mouth,

ears, anus and penis – a cell for the body but also a metaphor for inner consciousness. As Gormley puts it: 'what is that space you inhabit when you close your eyes?' Later concrete works are closer to the lead body shells: *Sense* (1991) is a concrete block with a man-shaped void inside (made by casting a wax model of the artist's body and then melting it out of its case), the only clue to the inner presence provided by the delicate imprinted holes left by the extremities that protruded – in this case the hands and the top of the head.

This subjective desire to evoke human experience via the body's 'intimate architecture' sits somewhat uncomfortably with the sculpture's appearance of rigorous – even ruthless – objectivity. Gormley has declared that he is tired of 'art about art', but he also states that 'I look at the body with the same fascination that I look at a cube of polished copper', and it has been suggested that his sculptural concerns are not that far removed from über-Minimalist Richard Serra's arrangements of mighty slabs of steel. Even though they perform the familiar motions of humanity: standing, squatting, crouching, lying spread-eagled – one even gazes down at its own erect penis – Gormley's faceless, fingerless, metal men are more form than figure, more emblem than image, their subjective origins belied by their apparent lack of consciousness. By becoming everyman they risk ending up in a no-man's land.

Gormley intends all his work – especially that in public places – to act as a kind of 'poultice' or 'catalyst for healing', but the impassive uniformity of his sculpture can appear more confrontational than comforting. In 1987 he attracted considerable hostility with *Sculpture for Derry Walls* – three identical, cruciform, cast-iron figures, each composed of two body-casts joined back to back, and sealed except for eye holes – which were placed at symbolic and politically sensitive points on the fortified walls of the Northern Irish town. Two years later his 100-foot-tall, brick colossus was refused planning permission by Leeds City Council. Only time will tell whether the 20-metre-high, steel *Angel of the North*, to be erected by the A1 in December 1997, dominating the approach to Tyneside with its massive slab-like wings, will manage to overcome local unease in order to fulfil its creator's shamanistic aims.

There's a more effective fusion of individual and collective, subject and object, instinct and intellect in what has become probably Gormley's most famous piece: the floor-level sea of up to 40,000 densely packed figurines that make up the various versions of *Field* (the first was produced in 1989). Working on site with communities in Mexico, the Amazonian rain forest, Sweden and, most recently, St Helen's in Lancashire, from 1991 onwards, the artist has directed groups of up to 100 people to make hand-sized figures from the local clay.

Some find Gormley's role in this project problematic (he has always taken pains to acknowledge everyone involved, but the piece is repeatedly exhibited under his name). However, whether it is community art or a truly public sculpture, of all Gormley's work *Field* comes closest to his aim of communicating the general and the specific experiences that link us all. It is impossible not to feel both immense and insignificant in the face of this miniature multitude, an essentially human landscape that is both of and from the land and which manages to be simultaneously timely and timeless.

MONA HATOUM

b. 1952 Beirut, Lebanon
1975-9 Byam Shaw School of Art; 1979-81 Slade School of Fine Art
White Cube
Lives and works in London

Just looking at Mona Hatoum's work is not enough. Her sculptures and installations have a powerful, theatrical presence that deliberately invites participation and puts the senses into overdrive. A major concern is with power and the forms it takes, and her various interpretations of this broad subject extend through surveillance, oppression and voyeurism to pleasure, seduction and playfulness. Whether she is playing off the effects of heat, light, movement or magnetic fields, this is an art of total immersion that revolves around the human body – both ours and hers – in order to engage with broader issues of identity and experience.

Just because she often uses her body as raw material, it doesn't follow that the work is specifically about Hatoum herself. *Recollection* (1995) presents thousands of her own hairs – hanging singly from the ceiling, stuck in soap and drifting in balls across the floor – in order to spin and tangle sensations of pleasure and disgust. And in what has become her best-known piece, *Corps étranger* (Foreign Body 1994), Hatoum submitted the most intimate parts of her body to intense endoscopic and coloscopic scrutiny, not to present a personal point of view but to provoke powerful and conflicting responses to how we view our physicality and ourselves. The impact of *Corps étranger's* fleshy Cresta Run through Hatoum's body, which took the form of a video piece projected onto the floor of a cylindrical viewing chamber and accompanied by a soundtrack of heartbeat and breathing, was especially intense and problematic. By turns intimate and alienating, enthralling and

Socle du Monde
1992-3
Wood, metal
sheets, magnets
and iron filings
Edition of 2
164 × 200
× 200 cm

repulsive, objective and voyeuristic, *Corps étranger* seemed less a view of the female anatomy and more a high-speed 'fantastic voyage' through an unfamiliar, distorted bodyscape where the term 'foreign body' could equally be applied to artist, viewer and lens.

Hatoum's earliest works were performances, and although she has now shifted from these 'live' events to video, installation and sculpture, there continues to be much cross-referencing between pieces and over time. The best of her more recent work communicates the intensity of earlier self-imposed ordeals while extending its psychological possibilities by substituting actual for potential danger. *Corps étranger* can be partially traced back to a performance work of 1980 during which Hatoum filmed both herself and her audience; while the seductively hazardous clear glass *Marbles Carpet* (1995) could be read as an elegant distillation of the excruciating *Under Siege* (1982),

where Hatoum enclosed herself for seven hours in an upright Perspex box, her naked body so slippery with wet clay that whenever she tried to stand up she fell over.

Hatoum was born in Beirut, a British subject of Palestinian parents, and when war broke out in the Lebanon in 1975 she settled in London. While early pieces were overtly political, (*Under Siege*, for example, was accompanied by revolutionary songs, news reports and statements in Arabic, English and French), it's too easy to read her work simply as a continuing response to war and exile. Hatoum's art may confine, unsettle, and flirt with dread and danger, but her strength as an artist is in the way in which she fusess aesthetic with political issues so that nothing is too obviously stated. The grids and linear structures that appear in so many pieces (notably *Light Sentence* 1992, in which two rows of lockers made from wire are lit by a single bulb whose almost imperceptible rise and fall enhances the mesh of shadows it casts) undoubtedly conjure up connotations of containment and repression. But they also have their origins in the honed-down language of Minimalism – and Hatoum is eager to stress the importance of artistic as well as personal influences in her work.

In common with many of her peers, she uses the rigour of minimal forms but charges their sober neutrality with near-traumatic psychological

significance. Whether it is a barred gate of electrical elements glowing red hot at the end of a darkened room (*The Light at the End* 1989); a 2-metre cube covered in a ridged magnetic fur of iron filings (*Socle du Monde* 1992-3); or the perfect Corbusian cylinder whose floor pulsates with the moist mayhem of human innards (*Corps étranger*), it is the tension between these mixed messages of order and coercion that frames and animates Hatoum's work. The result can, if you allow it, alter the way you see the world – even if that world lies within your own skin.

DAMIEN HIRST

b. 1965 Bristol
1986-9 Goldsmiths College
White Cube
Lives and works in London

Contemporary artists rarely achieve the fame of actors, footballers or rock stars. But Damien Hirst's rise to celebrity has been as rapid, dramatic (and potentially fragile) as the ping-pong ball dancing on top of a column of air that he exhibited at the ICA in London in his annus mirabilis of 1991-2, under the prophetic title of *I want to spend the rest of my life everywhere, with everyone, one to one, always, forever, now*. At the same time, on show across town was another piece that was to assure the artist his now ubiquitous star status: *The Physical Impossibility of Death in the Mind of Someone Living* – a 4-metre tiger shark suspended in a greenish tank of formaldehyde, commissioned by Charles Saatchi for a reputed fee of £25,000.

Since then, Hirst has rarely been out of the public eye and his now-familiar motifs of cows, flies, butterflies, cigarettes, hovering balls, and sliced tanks have either been elevated to near iconic status or – depending on how you regard such things – repetitively recycled to the point of meaninglessness. The trouble with being a famous master of spectacle is that however much you up the ante, everyone just wants more. It was therefore not all that surprising that Hirst's first solo show in America, *No Sense of Absolute Corruption*, at the Gagosian Gallery in 1996, attracted more celebrities than the Oscars and was then slammed for being a mini retrospective of his greatest hits: the giant ashtray full of butt ends and bar room detritus (*Party Time* 1995); the two cows sliced into twelve tanked-up, walk-around vertical sections (*Some Comfort Gained From the Acceptance of the Inherent Lies in Everything* 1996); the wall

of whirling spin paintings; and the floating beach ball, *Loving in a World of Desire* (1996).

But there's more to Hirst's reputation than a catchy output and an engaging way with the popular press. He is a serious – and in many ways, traditional – artist who knows his art history well enough to employ a keen formalism and sense of scale, and who still believes that art should grapple with the hefty issues of what it is to be human, to live and to face death. From the shark to the ping pong ball, Hirst's work covers the extremes and anomalies of our existence – 'the unbearable lightness and the ineffable heaviness of being' – as one critic has put it. Sometimes, as in the case of his mechanical spin paintings, Hirst's work can indeed seem unbearably light, but his installation *In and Out of Love* (1991) – where live tropical butterflies flew around a gallery and settled on the audience – or the bisected cow and calf of *Mother and Child, Divided* (1993), confirm that he can also make something poetic and profound that lodges itself in the psyche. When Hirst declares 'Art is about life, and it can't really be anything else. There isn't anything else', he isn't being glib, he means it.

Like his hero Francis Bacon, Hirst also intends his images to act directly on the nervous system. But as a child of his times, he spent his formative years watching television and listening to Pop music. Therefore, whether he is using a preserved animal, a cabinet of pharmaceutical drugs, or shooting a feature film, he doesn't balk at employing carefully orchestrated spectacle and slick production values to grab the audience's attention and force an engagement. His first mini-feature film, *Hanging Around* (1996) was shot in the style of a soap opera, and he repeatedly uses cinematic devices to frame and present his images: the giant glass cases containing empty chairs and brimming ashtrays present these mysterious scenarios with the haunting intensity of film stills.

Although there's nothing new in Hirst's promiscuous plundering of what are often the naffest of sources, his work can still reduce some traditional elements within the art world to a state of near apoplexy. What particularly seems to rankle is the non-hierarchical audacity with which he mixes up disparate elements from TV series, children's toys and mainstream movies with such art historical influences as the outsized Pop sculptures of Claes Oldenburg, the pristine Minimalism of Donald Judd, the floating basketballs of Jeff Koons, or the geometrically framed fleshiness of Bacon. Hirst doesn't make great claims for his art: like a true child of Warhol he professes to be happy with any response. He once summed up the shark as 'a thing to describe a feeling'. And just as Bacon declared 'you are reporting fact not as

Mother and
Child, Divided
(detail)
1993
Steel, GRP
composite, glass,
silicone sealants,
cow, calf and
formaldehyde
solution
2 tanks, each 190
× 323 × 109 cm;
2 tanks, each 103
× 169 × 63 cm
Installation at
Tate Gallery,
London

simple fact, but on many different levels, where you unlock the areas of feeling which lead to a deeper sense of the reality of the image', so Hirst also defies any single interpretation by describing his works as 'universal triggers ... situations that make people try and find meanings ... physical objects which can be intellectualised'. He has famously declared: 'sometimes I have nothing to say. I often want to communicate this.'

The work may have an instant impact, but it is deliberately riddled with contradictions. It is as simple or as complex and you want it to be – and that's another reason why it irritates so many people. His hand-made spot paintings look mechanical, and his mechanical spin paintings tap into the whole history of angst-ridden brush strokes. His titles intentionally ask more questions than they can answer. The preserved animals in the ongoing *Natural History* series carry art history's tradition of the memento mori as well as the irony that they

were killed in order to be preserved while simultaneously gaining eternal life through a deadly poisonous liquid.

This friction between insoluble realities lies at the heart of Hirst's art. Both physically and symbolically his work and methods revolve around relationships: how they are made and how they can be expressed. As a student he made collages from pieces of collected flotsam and began his career by curating the legendary *Freeze* exhibition in 1988, when he was in his second year at Goldsmiths College. Subsequently he has insisted that his art practice continues to be a process of assembling, containing, and framing – albeit in a highly controlled form. 'I curate my own work as if I were a group of artists', Hirst has said, and he cites as a crucial early influence on his recurring themes of ordering, containment and proliferation a reclusive neighbour who, in an inadvertent rerun of Kurt Schwitters' Dadaist *Merzbau*, crammed his house from floor to ceiling with decades worth of carefully hoarded objects and then, when there was no more space left in this three-dimensional collage, vanished without trace.

At the heart of Hirst's success – or, according to some, his fatal flaw – is his impudent updating of Marcel Duchamp's conviction that anything can be art if the artist says so. According to Hirst, the only artistic parameters that exist are those you draw up for yourself. Whether he is making a video for the

Britpop band Blur, producing artwork for a Dave Stewart album, decorating a fashionable restaurant, or slicing up a pig to make a sculpture, it is all art. 'I just wanted to find out where the boundaries were', he says. 'So far I've found out there aren't any. I wanted to be stopped, and no one will stop me.'

GARY HUME

b. 1962 Kent
1985-8 Goldsmiths College
White Cube
Lives and works in London

Gary Hume's career reads like a blueprint for contemporary art stardom. In his last year at Goldsmiths College he took part in the seminal 1988 *Freeze* exhibition, curated by fellow-student Damien Hirst, and was accordingly catapulted into the international art world. Sell-out shows in London and New York followed, he was selected for the survey British Art Shows of 1990 and 1995, shortlisted for the Turner Prize in 1996, and was voraciously collected by Charles Saatchi.

But this cursory skip through Hume's CV ignores two key factors: first, a change of artistic direction that threatened to scupper his career, and most importantly, the problematic nature of his paintings. He first attracted the full glare of art-world attention with a seemingly perpetual series of works based on the institutional double swing doors that punctuate our hospitals, schools, offices and prisons, their windows, press panels and kick-plates lovingly reproduced in gleaming layers of institutional-coloured household gloss. What looked like large, abstract works were in fact life-sized depictions of these overlooked symbols of everyday existence through which every rite of human passage takes place.

Critics and collectors loved them. Were they paintings of doors or paintings as doors? Here was the modern aesthetic debate about art and reality neatly encapsulated, as well as a refreshing alternative to the hot and heavy Neo-Expressionist painting that had clogged up the 1980s. These works were smart and knowing, with blank unyielding surfaces that – literally and metaphorically – shut themselves in your face but also dematerialised into mirrored surfaces. Hume painted multicoloured versions, free-standing versions, highly reflective, unphotographable versions. He got other people to decide on colours. The results could flip between glamorous and tacky

Innocence and
Stupidity
1996
Gloss on
aluminium panel
2 panels, each
170 × 221 cm
Photo: Stephen White

(the sticky, highly reflective *Dolphin Painting 1* 1990-1); threatening (*Stop* 1991, a three-panel symbol of faceless authority in shades of grey); or ironically humorous (as in the institutional pinky magnolia of *Four Subtle Doors* 1989-90). But just as Hume's doors seemed to be moving ominously close to becoming the purely abstract paintings they weren't intended to be, he stopped making them.

What followed was a hiatus in which he took stock, created sculpture from assembled objects, and, perhaps cathartically, made a notorious and provocative video of himself, sitting fully clothed in an overflowing tin bath, mumbling the legend of King Canute and wearing a cardboard Burger King crown (*Me as King Cnut* 1994). 'I couldn't think what it was that I wanted to describe. So during that process I was making things I actually didn't want to describe.' While staring that endgame in the face Hume had returned to

painting and in the process opened up the mute surfaces of his doors to let in the world outside – but only through the filter of his very particular and perverse vision.

The brightly coloured, fluid shapes of the post-Pop paintings that he first exhibited at the ICA and White Cube gallery in 1995 may be easy on the eye, but their maker refuses to offer any explanation. Hume once remarked 'all you ever get from me is the surface' and he is adamant that once he has completed a painting he is also just a viewer and the audience's interpretation of the work is as valid as his own. Whether this is an act of democracy or a cop-out is open to debate; it is perhaps telling that the first image to come off these smooth, gleaming pools of household paint is the viewer's own reflection.

It is hard to tell where the paintings end and the world begins: everything is deliberately slippery; no perspective, no shading, just slinky generic forms that are deceptively simple and knowingly evasive. Hume tantalisingly describes his subjects as 'embarrassingly personal' and it is hard to discern whether the artist is keeping a straight face when he declares that these Poppy, bittersweet images are chosen 'for their ability to describe beauty and pathos'. What is in no doubt is that the starting point can be anything that takes Hume's

fancy – pictures taken from magazines, the shape of a child's toy, or the head in a Flemish masterpiece by Petrus Christus.

Once they have percolated through Hume's imagination, these silkily inscrutable works may be given specific titles and may form instantly recognisable generic shapes, but they tickle the subconscious in their ability to look and feel like something completely different at the same time: Tony Blackburn, tragi-comic with the face of a shamrock; two sets of bare feet making a Rorschach blot-like silhouette; a puppy dog mask sprouting a goatee beard. Hume's titles can provide clues for alternative interpretation or act as booby traps for the unwary. With its decadent shades of green, sinuous shapes and velvety smoothness *Whistler* (1996), for example, conjures up the opiated aura of Aesthete dandy artist James McNeill Whistler (and let's not forget the famous *fin-de-siècle* feud between Whistler and the critic John Ruskin, which according to many, inaugurated the polarity that has plagued the British art world ever since). However, effete art-historical footnoting is confounded by the painting's depiction of a very literal 'whistler', the woozy, liquid shapes making up the image of a heavy-lidded, beauty-spotted female with her fingers in her mouth and – for that extra touch of blatancy – the word 'blow' spelt backwards.

In common with many of his contemporaries, Gary Hume revels in seductive colours, forms and textures, which, in more traditional fine-art circles, would be dismissed as 'decorative'. He relishes the instant appeal of the unashamedly aesthetic, describing himself as 'a beauty terrorist', and these paintings hold the senses hostage by showing how the most innocuous shapes and substances can be simultaneously vacuous and brimming with semi-conscious meaning. Perhaps it is the obstinate, unsettling dumbness of Gary Hume's pretty paintings that is their profundity: they may be hard to understand, but they are even more difficult to forget.

CATHY DE MONCHAUX

b. 1960 London
1980-3 Camberwell College of Arts; 1985-7 Goldsmiths College
Sean Kelly Gallery New York; Galerie Jennifer Flay, Paris
Lives and works in London

With so many of today's artists making spins on the geometric austerity of Minimalism and skimming their subject matter off the surface of our daily existence, Cathy de Monchaux's intricately detailed, painstakingly fashioned

sculpture seems out of kilter, if not perverse. Even when she uses mechanical assistance, the message of these labyrinthine lattices of metal, traceries of fine patterning, threading of ribbon and tucking and pleating of leather and velvet is one of obsessive – almost insane – industry. And that's before you've even registered the suggestive shapes thrown up by these unholy alliances of unexpected materials: the teeth of metal biting into dusty, fleshy calfskin; the slices of velvet licking riveted brass; the ceremonial sheets of glass carrying a series of shadowy paper cut-outs across a wall.

Yet although these elaborate confections bristle with association and innuendo, the very ornateness that pulls you into the work also acts to deflect

any single reading. The sculpture seethes with sexual reference, but despite the fact that the forms are often outrageously genital, there's too much going on to interpret them in simple sexual terms. What, for example, are we to make of *Evidently not* (1995), where rolled folds of pink leather are both restrained by, and grow around, the row of gleaming, riveted brass brackets that clamp them to the wall? Like many of the artists currently working in the gap between Freud and feminism, de Monchaux is more elliptical than her feminist forebears. The erotic charge that ignites her sculpture draws its power from highlighting the contrary desires that simultaneously divide, unite and define us all.

In early pieces such as *Ferment* (1988), where she lined riveted lead pipes with ruched crimson velvet, de Monchaux subverted the no-nonsense associations of everyday, utilitarian hardware with sly slivers of fabric; and with ever-increasing audacity, she continues to tweak the tension between opposites. Whether in extravagantly ornamental pieces such as the wall-mounted brass rosettes of *Holding back from nothing* and *Scarring the wound* (both 1993), which sprout baroque spikes and curls, flutter with threaded ribbons, and seep velvet from between their metal plates; or the mutant leather coils of *I thought you said you loved me* (1996), which split open to reveal fleshy interiors and spill down from claw-like metal clamps into a heap on the

floor, de Monchaux conjures up multifarious and contradictory readings.

Yet all this juggling of beauty and cruelty, attraction and revulsion, pleasure and pain carries considerable artistic risks. Too much exquisiteness can lead to an empty decorative beauty, and an excess of fleshy innards can look like a piece of early feminist womb art or a sci-fi special effect. De Monchaux has become increasingly aware of the nimbleness required to negotiate this hazardous territory, and while in many ways her sculpture has become more audacious in appearance, she has also refined her strategies to keep its meanings on the move and to damp down excess with what she calls a 'minimalist fundamentalism'. Scale and materials are manipulated to ensure that the larger the work, the more fragile and elusive its appearance, whereas smaller pieces carry a physical presence that is almost overwhelmingly intense. Strips, lumps and bumps of even the most ornately embellished calfskin settle into harmonious arrangements of horizontal and vertical; expanses of pattern are rhythmically repeated almost to the point of invisibility; and although some pieces have expanded to an architectural scale, they are the most evanescent. The eight-sided, walk-in *Confessional* (1997), for example, hovers like a phantasm of milky white painted glass.

Beauty continues to be both a bait and a defence, but de Monchaux often blights and confuses it by tarnishing once-gleaming metals with corrosive chemicals and dusting sharp edges and intricate folds with a film of white powder. Pieces such as *Cruising disaster* (1996) – which consists of 111 small, spiky, metal parts, jutting from the wall like sprung traps, each baring a bulging leather centre – become even more ambiguous when treated with a powdery substance that has connotations both of spore-like fecundity and ashy old age and decay. Not only does de Monchaux's dust blur boundaries, calm hectic surfaces and mix meaning, it can also emerge as a material in its own right: the delicate white *Dust carpet* (1997) is a tracery of fine chalk powder, a shadowy residue that gains its own substance.

De Monchaux's work is therefore more to do with evoking atmosphere and suggesting feeling than with telling stories and setting agendas. It is highly formal but doesn't lend itself to formal analysis; it is fabricated with intense precision but at the same time has the perplexing appearance of an autonomous organism that has continued to evolve according to its own rules; and its titles are as likely to pre-empt responses as to offer up meaning. When, for example, she defiantly christens an elaborate brass ruff with slicks of scarlet velvet suppressed between metal plates and secured by sturdy straps of black leather *Once upon a fuck, once upon a Duchamp, once upon a lifetime* (1993), de Monchaux demonstrates that she is all too wearily aware of the

gamut of obvious interpretations that have been applied to many of her works. At her 1997 solo show at the Whitechapel Art Gallery she drove this point home by etching her titles onto brass plates and then partially obliterating them with a layer of white paint. By so successfully covering her tracks Cathy de Monchaux opens up her sculpture for us to negotiate.

JULIAN OPIE

b. 1958 London
1979-82 Goldsmiths College
Lisson Gallery
Lives and works in London

Subsequent waves of Hirst-hype have tended to obscure the fact that Goldsmiths College was already attracting attention several years before the class of '88 put together a show called *Freeze*. Opie was still a student there when he was selected to exhibit his painted sheet-metal sculptures alongside works by Keith Haring, Jenny Holzer, and Anish Kapoor at the Lisson Gallery in 1982; and his one-man Lisson show the following year launched him into the art world as the youngest practitioner of the so-called 'New British Sculpture' that caused such a stir during the early 1980s. This seamless transition from studenthood to international art world status was keenly noted by later generations of Goldsmiths students, and Opie compounded his influence by returning to teach on the Goldsmiths degree course between 1990 and 1993.

Opie's work doesn't conform to a single style or lend itself to easy classification. By the late 1980s he had surprised the art world by moving from his distinctive, folded-steel sculptures with their sloshily painted *trompe l'oeil* surfaces depicting toppling domestic objects and appliances, to produce hard-edged, coolly minimal pieces that looked more like the appliances themselves. Since then he has become increasingly multifarious – and slick – in his cross-referencing of art, architecture, industry, technology and children's toys and games. He has recently tapped into all of these categories to produce walk-through arrangements of sculptures and wall-mounted vistas that distil our everyday surroundings – roads, cars, buildings and the landscape – into the smoothed-out, Legoland reality of the driving simulator, or computer game.

But whether he is making a boxy, life-sized replica of a Volvo 440, a miniature model castle, or a minimalist light box, Opie has remained pretty consistent in his concerns. Everything he produces is underpinned by a

You are in a car
(Volvo 440)
1996
Oil-based paint
on wood
131 × 138 ×
395 cm
You see an office
building (nos.
2,3,4,5)
1996
Oil-based paint
on wood, each
184 × 157 × 45 cm
Installation at
Lisson Gallery,
London, 1996
Photo: John Riddy

preoccupation with how we negotiate and experience the modern world: its forms, its spaces, its places and its non-places. And this has in turn led to a whole gamut of visual and conceptual spins on the affinities shared by, as well as the distinctions between, the world of art and the world at large.

Early pieces like *A Pile of Old Masters* (1983), or *Legend of Europa* (1984) presented the clobber we carry around in our heads and in our lives. Their aggressively hand-made fusions of steel and paint, surface and form, cock a bombastic snook at conventional distinctions between painting, sculpture and fabricated objects. Since then, Opie has become more smooth in his forms and oblique in his ideas, but even if he is giving Minimalism a re-run by making sculptures that resemble elegant high-tech air conditioning vents, refrigeration cabinets and display units, or taking Mondrian to Texas Homecare via arrangements of brightly painted concrete blocks, he continues to hand-make his own work and use his art to depict the world with clear-eyed, even innocent, directness.

At least that's the idea. Opie's work may sometimes look as if it comes from the Early Learning Centre, but getting its message can be far from child's play. Bright colours and simple shapes are no guarantee that Opie believes the world can – or should – be tidied up; he's too cool and ambivalent to be either utopian or judgemental. He likes the mind to boggle. *There are 1800 electrical storms in the earth's atmosphere at any one time* (1991), is a two-metre column made from fused, brightly painted strips of the wooden decorative moulding that can be bought at any builders' merchants. But take a closer look at this giant, 3D, vertical bar code, and its clarity breaks down into a bumpy, curvy, tubular surface which cannot be seen all at once and where form and colour conspire to confuse the eye. The world according to Opie is one of infinitely changeable systems, and he shows this again in the series of paintings and sculptures *Imagine you can order these* (1992), where he exploits the limitless visual potential offered by a group of coloured blocks.

Oddly, Opie's work is most communicative when it is at its most abstract. His representations of specific, recognisable objects can become strangely mute. The 1996 installation *You are in a car*, for example, fails precisely because it is so successful in conjuring up the mind-numbing anonymity of European motorway travel. It clams up in the face of other interpretations.

No matter that these Legoland cars and buildings and wraparound wall paintings of roads and countryside had their origins in specific places, and that their lack of detail is meant to express a high-speed view, they still look like the hard-copy taken from a computer screen. Strangely static, these roads to nowhere possess all the shiny artificial inhumanity, but none of the excitement, of a computer game.

In many ways, Opie's entire output can be read as simulations of simulations, always at one, or sometimes several, removes: whether paintings of paintings, sculptures of sculptures, models of models, or places that are reproductions of places. Sometimes this consistently cool presentation can offer up a stimulating range of possibilities of what art can do and say, but too much neutral detachment can lead to art that gives off a sterile sense of inertia. Opie has to be wary of immersing himself in too much blandness – it has a way of sticking.

CORNELIA PARKER

b. 1956 Cheshire
1975-8 Wolverhampton Polytechnic; 1980-2 Reading University
Frith Street Gallery
Lives and works in London

In the summer of 1995, 21,000 visitors poured into the Serpentine Gallery during a single week to see actress Tilda Swinton sleeping in a glass box. She was one of the bizarre exhibits on show in the installation: *The Maybe,* her collaboration with Cornelia Parker. The other items were identified by their captions as having once belonged to a range of historical figures: the rug and cushion from Freud's couch, Arthur Askey's suit, the half-smoked cigar dropped by Winston Churchill when he heard that the Germans were suing for peace, Queen Victoria's stockings, and the headgear worn by Stanley and Livingstone at their historic meeting in the Congo. In this complex, poetic meditation on memory, mortality, posterity and value, these evocative curios – both worthless and priceless – conjured up their dead owners with an uncanny immediacy (Wallis Simpson's shiny black ice-skates provided a more accurate portrait than any Cecil Beaton photograph), and paradoxically communicated more physical presence than the one living, but inanimate exhibit.

Whether she is blowing up a garden shed, sending a meteorite back into space, or gathering the whorls of vinyl after a record has been cut, Cornelia Parker is devoted to throwing up the levels of meaning that lie beneath the

Cold Dark
Matter: An
Exploded View
1991
Exploded shed
and contents
Dimensions
variable

surface of things. By interfering in the material world she also prods at our mental structures: mounted on a plinth in the Serpentine Gallery and labelled as part of the aircraft in which Lindbergh crossed the Atlantic in 1927, a tatty piece of canvas is transformed into something magical. A loopy tangle of glinting thread also carries a very different set of associations when you learn that it consists of two wedding rings stretched to echo the contours of a living room (*Wedding Ring Drawing* 1996).

This ever-inventive ability to make the ordinary extraordinary often results in the lucid depiction of the seemingly unfathomable – in her words 'using something visible that everyone recognises to describe the indescribable'.

Though highly idiosyncratic, these interpretations of life's imponderables possess a peculiar logic of their own. Drawing on procedures that owe as much to the whizz-bang re-arrangement of children's cartoons as to the alchemist's search for truth from base ingredients, Parker combines method and mayhem to make the physical world that surrounds us yield up its secrets.

The term 'Cold Dark Matter' is the name for the stuff that makes up a large part of the universe and keeps it in balance, and which science has so far failed to define; but this did not deter Parker from using this mind-boggling intangible as the starting point for one of her most famous pieces. In *Cold Dark Matter: An Exploded View* (1991) she conjured up an entire parallel universe by first blowing up a wooden garden shed stuffed with everyday odds and ends, and then pain-stakingly suspending its contents in a constellation-cum-swarm, in orbit around a single domestic lightbulb.

Just as 'exploded view' diagrams in technical manuals and encyclopaedias deconstruct engines, mountains and organisms in order to explain their structure, so Parker works to make sense of the world by wreaking havoc with familiar objects and then rearranging them on her terms. Yet this deliberate use of the banal items with which we structure our lives also destabilises any expectations we might entertain about them – or by implication, ourselves. When a multitude of chalk strokes swarm over the walls of an entire school building (*Exhaled School* 1990), sea-smoothed remnants of bricks and mortar

rear up into the shape of a house *(Neither from nor towards* 1992), or eroded miniature lead models of historical landmarks are drawn into a point like a termite's nest *(Fleeting Monument* 1985), nothing, it seems, can be taken for granted.

For Cornelia Parker, everything is open to investigation and disruption, and the most prosaic manufacturing processes can be hijacked and plundered for the poetic and the phenomenal. Removed from the production line of the Colt Firearms Factory at the earliest stage, a pair of *Embryo Firearms* (1995) are simply two pistol-shaped blocks of gunmetal; yet in this harmless, arrested state they are still redolent with the menace of their potential future, and our imaginations can easily turn them into the finished product. Conversely, a series of *Pornographic Drawings* (1996), made from image-sensitive ferric oxide removed from pornographic video tapes, suspended in solvent and pressed between sheets of high-quality art paper, forms an unexpectedly exquisite by-product of a debased industry. There is no easy explanation for the unerring way in which these images, reminiscent of Rorschach ink-blots, repeatedly form the delicate, shadowy shapes of breasts and genitals. In Cornelia Parker's open-ended – exploded – view of the universe, laws of reason, science and art are set free and woven into a network of contingent properties where anything and everything is possible.

FIONA RAE

b. 1963 Hong Kong
1984-7 Goldsmiths College
Waddington Galleries
Lives and works in London

Fiona Rae makes paintings about painting. But there is nothing dry or analytical about the jumbled shapes, wandering brushstrokes and patches of vivid – sometimes livid – colour that inhabit her canvases. Looking at one of Rae's paintings – especially one made around 1990 – is like being taken on a ram-raid through art history, grabbing handfuls of popular culture on the way. Whether in canvases such as *Untitled, triptych (purple and orange)* (1994), where a flat fragment of a Matisse cut-out can mutate into a biomorphic blob courtesy of Joan Miró and then get zapped by a juicy smear of late De Kooning and a fragment of Krazy Kat; or in the more syncopated discs, smears and scribbles of *Untitled (yellow with circles)* (1996), there are no hierarchies –

Untitled
(parliament)
1996
Oil on canvas
275 × 244 cm

anything can come along for the ride, provided it keeps on the move.

Like her Goldsmiths College contemporary Gary Hume, Fiona Rae plays with our expectations of painting and the cultural baggage it carries. In the same way that Hume's puddles of candy-coloured household gloss sail riskily close to sickly kitsch, so Rae deliberately dices with danger with her disrupted compositional devices and a synthetically shaded palette that she has described as 'seventies airport lounge'. Very occasionally, this can result in a technicolour yawn – but Rae is generally too nimble to let her canvases become the arena for art-historical train-spotting, and nothing in her sampling of images and styles is quite what it seems. 'If anything starts to look too recognisable then I scupper it' says the artist whose, paintings – in both form and content – rely for their

impact on a risky, edgy, teetering uncertainty whereby smears, patches, doodles and dribbles are not allowed to reveal too much of themselves, become blandly generalised, or to unravel into mayhem.

In her quest for what she has called 'the right kind of chaos', Rae devises formal (but never formalist) ground rules for her paintings, but only in order to test and depart from them. Increasingly she has shifted from works that display a cartoonish collision course to compositions governed by a syncopated, uneasy rhythm. A series shown at Waddington Galleries in 1995, for instance, had the narrow, horizontal proportions of Cinemascope screens or viewing slits, and was orchestrated and underpinned by a repeated geometric structure of large and small compass-drawn circles, slicing into, or contained by, the picture plane. This potentially restrictive composition became a springboard for more flights of fancy, with smeared, hooped and solid circular shapes suggesting a multitude of possible readings – whether as holes, planets, windows or targets; eclipsed, veiled, shimmying or exploding; as static as a full stop or as dynamic as a circular saw.

There are more perverse games with potential systems in the suggestive non-forms and unhelpful titles of *Untitled (emergency room); Untitled (parliament) and Untitled (phaser)* (all 1996). Circles again dominate in these works, where anxiety prevails and nothing is resolved. Solid discs that could be planets, saucers, or even liquorice allsorts, punctuate and emerge

out of a densely stippled black and white surface in a way that is both precise and highly ambiguous. Like cogs in a pinball machine they send the eye shooting across this marbled, smeared ground, which itself boils with possibility and looks as if it is about to mutate into something else. It is no coincidence that one of the works in this series is called *Untitled (T1000)* after the liquid metal android in the movie *Terminator 2*, which can assume the exact shape and appearance of anything with which it comes into contact.

With her continuing use of contrasting marks and methods, Rae stands in sharp contrast to many of today's artists who restrict themselves to a single specific painterly process – whether pouring, layering or stripping away – in order to explore its nuances and possibilities. Such purity of practice would be anathema to Fiona Rae. She relishes everything that paint can do; and it is by this combination of intellectual enquiry and sheer gusto that her canvases bear out the continuing validity of Le Corbusier's maxim that a painting 'is a machine for creating emotion'.

MARK WALLINGER

b. 1959 Essex
1978-81 Chelsea School of Art; 1983-5 Goldsmiths College
Anthony Reynolds Gallery
Lives and works in London

The theme of cultural identity is a common one among contemporary artists, but Mark Wallinger is probably best known for the way in which his particular take on the subject resulted in one of the most unorthodox artworks of recent years: a chestnut filly who ran in the 1994 flat season, registered under the name of *A Real Work of Art*. It didn't matter that this equine artwork didn't perform as well as expected (the horse now belongs to a German collector); she nonetheless formed the culmination of a multifaceted examination into the intertwined worlds of horse racing and the thoroughbred, which in turn comprised an important part of Wallinger's continuing interrogation of the political and cultural territory occupied by us all.

A racecourse regular since childhood, Wallinger first turned his personal enthusiasm into an artistic preoccupation in 1992, with *Race, Class, Sex* – four life-sized paintings of thoroughbred stallions directly descended from Eclipse, a horse painted in the eighteenth century by George Stubbs. Other explorations of the richly symbolic – and symbiotic – territory of breeders, punters and

blood stock included four composite paintings that joined the back half of one thoroughbred stallion to the front section of another (*Half-Brother* 1994-5); and a wall-sized video projection of the chillingly controlled, ritualised 'covering' of a mare by a stallion (*National Stud* 1995).

For Wallinger, therefore, the metamorphosis of living horseflesh into 'real' artwork was an easy, almost inevitable one. He has described *A Real Work of Art* as 'a history of aesthetics in microcosm' – no species in the world being more closely documented, artificially bred and subject to cold financial considerations than the racing thoroughbred. He extended the artistic analogy via some playful linkage with racing 'colours' and art traditions, producing a series of paintings (*Brown's* 1993) based on the registered colours of all the owners called Brown (the shade that would result from mixing all the pigments on the palette). Wallinger not only subverted the male bastion of the Jockey

Club by registering his own animal in the violet, green and white colours of the Suffragette Movement, but he then compounded this act by putting on the colours and posing in drag at the exact spot where Suffragette Emily Davison threw herself in front of King George V's horse at the Epsom Derby in 1913 (*Self Portrait as Emily Davison* 1993).

Another personal passion that Wallinger has integrated into his work is the world of football. In the name of art he has been photographed among the crowds leaving Wembley, brandishing a Union Jack banner emblazoned with his own name; he has constructed a fake marble memorial to the 1966 World Cup (*They think it's all over ... it is now* (1988), and in 1996 he exhibited a giant supporter's scarf for his team Manchester United, arranged in a double helix to give a biological twist to the notion of *Man United* (1996). By taking the position both of critic and fan, Wallinger is particularly effective in splicing the cerebral with the accessible while showing that England and its inhabitants are complicated, contradictory and not as Merrie as some of us may have thought.

Wallinger doesn't deal in heavy polemic but that doesn't stop him taking a sharp and trenchant look at the flaws, contradictions and preconceptions thrown up by the culture that surrounds us. His variety of media and subject

matter can range from a reversed video of Tommy Cooper performing his hat trick (with the aptly palindromic title *Regard a Mere Mad Rager* 1993); to a single hose trickling water in leaky homage to Duchamp's urinal through a gallery window into the street outside (*Fountain* 1992), and a series of intricate one-point perspectives of his Chigwell secondary modern school, drawn in chalk on blackboard and illuminated by a single lightbulb. In Wallinger's work a seeming one-liner can speak volumes. Whether he's re-framing a horse as *A Real Work of Art*, or re-colouring the Union Jack in the green, white and orange of the Irish Tricolour and calling the result *Oxymoron* (1996), Wallinger confirms that the biggest and most complex ideas can be carried in the most instant and accessible forms.

RACHEL WHITEREAD

b. 1963 London
1982-5 Brighton Polytechnic; 1985-7 Slade School of Fine Art
Anthony d'Offay Gallery
Lives and works in London

Rachel Whiteread first shot to fame in 1993 when she made a concrete mould of the space inside a Victorian terraced house in east London. *House* may have had a life-span of only two and a half months (it was demolished by a hostile local council in January 1994, who had refused to extend the temporary permission for the public work), but it attracted tens of thousands of visitors, heated debate, questions in Parliament – and helped Whiteread win the 1993 Turner Prize. As the last survivor of a street of such houses, and as an intimate container of ordinary lives, the three-storey sculpture expressed both individual memory and collective public consciousness, and became in turn the focus of a surprising range of grievances against the Government's housing policy, the aesthetics of public sculpture, the British class system and contemporary art in general.

Like all Whiteread's sculptures, *House* sent out disconcertingly mixed messages. At once modest and grand, this three-tier pile of room-sized blocks, with its surfaces delicately moulded by reversed indentations of windows, skirting boards and even light switches, evoked everything a house should be – a shelter, a sanctuary and a space for human drama. But at the same time it denied any sense of homeliness by presenting a cool, strange cenotaph of impregnable, outward-facing cubes and strangely bulging fireplace cavities.

This tension between the mundane and the monumental is central to Whiteread's work, and *House* was just one element in a continuing exploration of the intimate, overlooked spaces that encompass daily life. There's much more to Whiteread's sculpture than a filling in of blanks. Not only does she take casts from objects that are part of our everyday world: beds, chairs, tables, hot-water bottles, entire rooms, as well as morgue slabs and benches, but her casting also goes beyond the objects themselves to objectify the spaces in, on, around, and below them. Not so much 'inside out' as 'outside of inside', these slabs, chunks, and blocks in plaster, concrete, resin and rubber owe their form to a space that previously had no form, but was instead the emptiness between objects, walls, or the sides of containers.

This consistent concern with solidifying space extends back to early pieces such as *Closet* (1988), in which Whiteread created a sinister, sectioned chunk of darkness by covering a plaster cast of the inside of a child's wardrobe with black felt; through to the gleaming, jelly-like blocks of *Untitled (One Hundred Spaces)* 1995, which result from casting the gaps underneath stools and chairs in translucent resins the colour of antique glass. It also governs the form of Whiteread's two most ambitious public works to date: the concrete cast of a library designed to stand in Vienna's Judenplatz as a permanent monument and memorial to the 65,000 Austrian Jews who died at the hands of the Nazis; and the water tower cast in semi-transparent resin for lower SoHo in New York City (May 1988).

The activity of making moulds and taking casts, the starting point for all her sculpture, may be within a time-honoured artistic tradition, but Whiteread is no traditionalist. Nor, despite what her detractors may believe, is she mechanically trotting out a tried-and-true device. In the same way a painter such as Fiona Rae will explore and express precedents, processes and possibilities thrown up by her chosen medium, so Whiteread is highly attuned to the aesthetic, conceptual and art historical implications of her capture of space.

She herself has compared her process to the making of a death mask, the conjuring-up of an absence. Another part of her working practice involves

photographing the numerous gaps, chasms and chinks that she encounters around the world: structures, grids and objects that can range from the rows of crosses in a war cemetery to the space between two tropical huts, or the cage of girders around a council block in east London's Commercial Road. She's also well aware of American artist Bruce Nauman's 1965 snub to the matter-obsessed Minimalists in the form of a concrete cast of the space under his chair – thirty years later she was to make her own multiple version in *Untitled (One Hundred Spaces)* – and it's hard not to view Whiteread's glittering, dark-green resin cast of the underside of floorboards as a wryly poetic antidote to arch-Minimalist Carl Andre's floorbound wooden sleepers.

While it's certainly no accident that Whiteread's choice of material and pre-sentation transforms a cast-iron bath tub into an ancient alabaster sarcophagus (*Ether* 1990); or that a humble Victorian room (*Ghost* 1992) cast in blocks of plaster can resemble an Etruscan burial chamber, her deliberate choice of objects that have been designed for, and used by, ordinary people also gives her sculpture a physical, human presence. Propped up against a wall, the sagging underside of a bed moulded in amber rubber seems to echo the bodies it once supported, a cast hot-water bottle becomes a poignant torso, the plaster underside of a sink bulges suggestively, a concrete library invites you to thumb its pages. These are sculptures that we all can, and do, inhabit.

RICHARD WILSON

b. 1953 London
1971-4 Hornsey College of Art; 1974-6 Reading University
Matt's Gallery
Lives and works in London

No one can disrupt a gallery like Richard Wilson. He's still best known for the glassy, pungent expanse of sump oil that, since 1987, has filled galleries from Edinburgh to Los Angeles (its permanent home is in London's Saatchi Collection) with a surface so disorientatingly reflective that it is almost impossible to judge where the reflection stops and the surface begins. The initial impact of *20:50* (the title refers to the viscosity of standard engine oil) derives from the way in which it deceives the senses. Even when you reach the very end of the rising, narrowing platform that leads into its centre, it's still not clear whether you are buoyantly suspended in space, or claustrophobically hemmed-in by a filthy, potentially lethal mass of darkness.

At once devastatingly simple and poetically rife with contradictory readings and associations, *20:50* has now entered the annals of art history along with Walter de Maria's *Earth Room* (1977) in New York, or James Turrell's sky-gazing *Air Mass* (1993) as a classic piece of installation art. Yet *20:50* is just one high-profile element within Wilson's continuing process of questioning the spaces and structures that contain art, and by wider implication, society.

This has often involved the use of the buildings themselves as sculpture – 'Any space that's given over for an artwork could become the work in itself through manipulation in some way' – and in Wilson's hands, these manipulations can be radical. He has pulled in heating systems from the margins of a room, reinstating them as the subject of the piece (*Return to Sender* 1992; *I've Started so I'll Finish* 1992-3); he has cut out window frames and thrust them inside to be looked at rather than through (*She Came in through the Bathroom Window* 1989); and his adjustments to

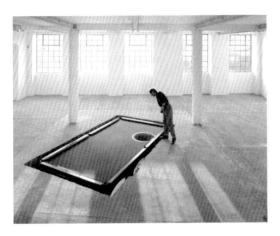

floors include tilting wooden floorboards sharply upwards and outwards to form an impromptu balcony (*All Mod Cons* 1990). In *watertable* (1994) he dug down to the actual watertable beneath Matt's Gallery and then meticulously filled the trench with a green baize billiard table, its surface flush with the floor and a cement pipe fitted into one corner.

During the 1980s Wilson was a member of the Bow Gamelan Ensemble, a group who staged extravagant live events involving industrial debris as musical instruments, pyrotechnics, steam, and even remote-controlled miniature helicopters. Although he no longer gives live performances, his work continues to invite a very physical participation; a theatrical use of spectacle, designed to put all the instincts on alert and to illuminate and often to destabilise many of the things we take for granted, remains at the core of everything he makes.

The use of mundane raw material has also remained a constant theme. When 'tampering' with architecture he frequently introduces other common-place structures into the gallery space, making them perform in highly irregular ways. A domestic greenhouse pierces and penetrates seemingly solid partition walls (*High Rise* 1989); a garden chalet is tipped upside down and tilted on its pitched roof like a discarded toy (*Lodger* 1991); a bright blue, kidney-shaped swimming pool is upended, seemingly balanced on its tubular stair rails, its

drainage pipe extended upwards to puncture the gallery's roof into the air outside (*Deep End* 1994).

However, Wilson is no demolition man. His works may be constructed in situ rather than in the studio, they may even draw on the imagery of the building site – *Jamming Gears* at the Serpentine Gallery in 1996 comprised forklift trucks, tilted site sheds and core-drilling – but they are all meticulously conceived, choreographed, and completed with an obsessive eye for detail and finish. As a result, his displacements extend beyond the directly physical into more subtle disruptions of given notions of inside/outside, public/private, permanent/temporary, secure/precarious, familiar/unfamiliar. In a way that is uniquely his own, Wilson harnesses the epic scope of American 1970s Land art, and, in particular, the architectural sculpture of US artist Gordon Matta-Clark, to produce an art that is intrinsically British but has no limits to its horizons.

RISING STARS

SIMON BILL

b. 1958, Kingston upon Thames
1977-80 BA Central St Martins College of Art and Design; 1982-5 MA Royal College of Art
Cabinet Gallery
Lives and works in London

The world of Simon Bill is a dysfunctional one where bad things happen. It is a place where Evil Dead goes to Toys R Us and takes no prisoners. Often using a combination of oil paint, tufts of hair and translucent wax, Bill paints large, luminously nasty paintings of cuddly icons gone to the bad. In *Abbadon the Destroyer* (1994), Mr Blobby has mutated into a septic spectre with an ejaculating forefinger; a cutesy troll with one eye missing, its head twisted the wrong

way round, *Exorcist*-style, is grafted onto the back of a classic nude odalisque (*Guppy* 1994); and in *The God of Drug Abuse* (1993), a teddy bear sprouts a dangling penis and a trail of intestines while simultaneously playing host to a misshapen foetus. Gone are the bright, sickly colours with which we associate these cheery Children's Hour characters, re-presented here as faded ectoplasmic presences, drained of innocence as well as colour, but nevertheless ominously eager to please.

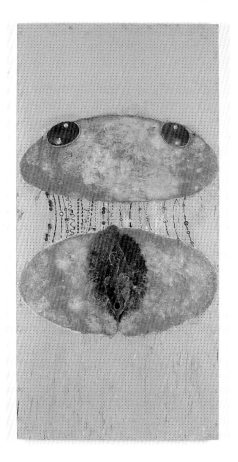

The scale of these works, and the way in which they often exploit the fragile, translucent medium of wax encaustic to form surfaces that are simultaneously repulsive and exquisite, takes them beyond mere sensationalism. By resurrecting one of the most ancient of painting traditions, Bill gives these abjectly horrible images, trawled from the most banal corners of contemporary culture, a poignant and melancholy delicacy that is in direct contradiction to their crude, low-rent origins. Even when he's not mixing wax into his paint, the surfaces of works such as *My Friend* (1997) – where the character Big Bird from the classic children's TV series Sesame Street shimmers like a storm cloud in shades of grey – are so skilfully and seductively applied that they seem to draw you in. These works have nothing to do with the current vogue for amateurish technique and so-called 'Bad Painting', instead what we have here are disquietingly beautiful – and highly manipulative – paintings of the bad.

What is also scary is that we know this territory very well. Bill's world is our own. His gremlins may run through a checklist of nastiness but they have a perky psychopathic innocence – they don't realise how unpleasant they really are, and that makes them even more frightening. They are often strangely touching and vulnerable in appearance, a quality that is exacerbated by their humour. *Mork's Mother* (1996) hits an all-time cultural low by dredging up memories of Robin Williams' 1970s sitcom alien, suggesting that he was spawned by a breezily obscene pair of floating flying saucers armed only with a couple of poignant eyeballs and a vagina.

Painted directly on the brown pegboard of a collective primary school past, these mucus-coloured monsters are accompanied by marker-pen graffiti from the muddled id of a masturbatory, Heavy Metal, pseudo-satanic acid-head – it's no coincidence that in one especially revolting painting the face of Beavis leers out of the murky layers. This parallel universe emerges from the sort of dumbly sadistic slacker-babble you see scrawled in the pub toilets and shopping malls of bored towns – the kind of towns where atrocities happen.

By taking a subject that pushes the boundaries of good taste to breaking point and beyond, while at the same time luring the viewer with his traditional painterly skills, Simon Bill shows how fluid our notions of taste and decorum are capable of being. Real evil can be crass, humorous and horrible – often all at the same time. These sophisticated, disquieting paintings implicate us all and show that, even in our high-tech, special-effects culture, art – and more specifically paint – can still be an effective medium to conjure up demons and present them for contemplation.

CHRISTINE BORLAND

b. 1965 Ayreshire
1983-7 Glasgow School of Art; 1987-8 University of Ulster, Belfast
Lisson Gallery
Lives and works in Glasgow

The ongoing legacy of Marcel Duchamp continues to manifest itself in contemporary works that cross-dress with an ever more unexpected range of activities and specialist practices. Scottish artist Christine Borland's projects with experts from the world of ballistics, forensic science, and archaeology have sometimes seemed so close to these disciplines as to be indistinguishable as art; but, unlike her collaborators, she is not in search of conclusions or certainties. Instead, she employs their processes of classification, reconstruction, and presentation to show that all systems are intrinsically arbitrary and unreliable, and to point to more profound questions and doubts.

For *A Place Where Nothing Has Happened* (1993), Borland took local police officers to a piece of wasteland in central Newcastle where they carried out all the procedures of a routine investigation – combing the area for potential clues, and displaying their finds in a Portacabin placed within the area under scrutiny. However, what was being investigated here was not a crime, but the investigation itself. In this seemingly forensic laying out of pieces of evidence

– shards of glass, tyre-tread casts, empty cans – as the traces of a non-crime, Borland forces an examination of the fragile and mundane substances upon which decisions of guilt or innocence are so often based. She also throws up some surprising similarities between the random and intuitive systems relied upon by both art and policing, which, albeit for different reasons, are designed to make us look and look again.

This desire to investigate the shifting status of objects has led Borland into an engagement with that most powerful of twentieth-century icons: the gun. In the name of art she has shot at porcelain, bed sheets, apples and melons and

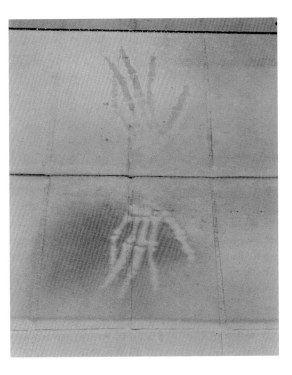

coolly presented the aftermath. The jagged holes in *Shot Glass* (1993) show what happens to human-sized pieces of plate glass after they have been fired-on by Berlin police marksmen using a selection of weapons commonly issued to NATO and Warsaw Pact forces; while *Blanket Used on Police Firing Range, Berlin, Repaired* (1993), was just that, peppered with neatly darned bullet holes and folded on the floor.

The guns and their handlers may be absent, but their effects are all too evident. The artist is well aware that an apparently factual presentation of the aftermath of a violent act only increases the viewers' desire to conjure up their own stories around such suggestive symbols as a small hole in a bed sheet or a splintered shard of timber. As with Willie Doherty's enlarged photographs of bullet holes taken in Northern Ireland, the absence of any perpetrator actually serves to heighten the menace and suggestiveness.

There's no easy moral message here. All Borland's work hovers between a number of equally convincing and often contradictory readings that put the onus on her audience to decide what she – and they – want to feel. On the one hand, one shouldn't be deceived by each piece's appearance of detached, business-like objectivity. From the slatted crates, custom-built to support the upright tilted panes of shot glass, to the odd conversations between forensic

samples, or the abject pathos of a darned blanket, Borland's objects and scenarios are meticulously arranged and orchestrated like the installations of sculpture that they are. Yet on the other hand, since so much of her work can only be made with the full co-operation of agencies – security forces, ballistics experts – that many people find unpalatable, it can seem irrevocably tainted by undesirable associations; and she makes no attempt to resolve this ambiguity.

In Borland's enquiries into the substance of things, deadpan presentation belies extreme emotion and an often bleak, black humour. The body may be absent, but it is never far away – and sometimes it is nearer than you may think. The deceptively minimal display of *To Dust We Will Return* (1996), becomes something else altogether in the knowledge that the two spot-lit haloes of dust seeping around the edges of circular plates of glass are in fact the powdered bones of a male and female chest, being wafted into the air with the help of two whirring electric fans. What once acted to protect the human respiratory system has now ended up as part of the cocktail of airborne particles that we ingest with every breath.

From Life (1994) found Borland building up rather than paring down as she worked with experts in osteology, facial reconstruction and computer technology to recover the identity of a human skeleton purchased from a medical supplier. The ultimate result of these elaborate processes was twofold: a 'traditional' cast-bronze portrait bust modelled by medical artists, and a text describing the scientifically reconstructed identity of the skeleton: 'Female/Asian/23-25 years old/5ft 2in tall/At least one advanced pregnancy.' Here, in these two 'likenesses' of the same person, each in their own way equally suggestive – and inadequate – our expectations of art and science, subjectivity and objectivity, are irrevocably destabilised. No amount of number-crunching can replace the human intuition that ensures the most accurate modelling of a missing nose or a cheek, yet human history cannot be charted without these kinds of facts and figures.

Marcel Duchamp's readymades may have given the artist the freedom to nominate any object as an artwork, but by extending art into the most surprising areas of life Christine Borland shows that it has often been there all along. Parallels can be drawn with the way in which Helen Chadwick's *Stilled Lives* pointed to the central role of aesthetic judgement in the science of embryology, and thus to a more interconnected, unstable way of looking at seeming certainties. Like Chadwick, and a range of other artists such as Cornelia Parker, Richard Wentworth and Sarah Lucas, Christine Borland shifts the emphasis away from the Duchampian notion of choice to the transformation of the objects themselves as they move between different contexts. In doing so she shows the limitations of closed systems, artistic and otherwise.

JAKE AND DINOS CHAPMAN

Dinos Chapman: b. 1962 London
1979-81 Ravensbourne College of Art; 1988-90 Royal College of Art
Jake Chapman: b. 1966 Cheltenham
1985-88 North East London Polytechnic; 1988-90 Royal College of Art
Victoria Miro Gallery
Live and work in London

'We are sore-eyed scopophiliac oxymorons. Or at least, we are disenfranchised aristocrats, under siege from our feudal heritage ... our bread is buttered on both sides ... ' With this, and more of the same, cleanly stencilled onto a mess of brown paint smeared faecally over a white gallery wall (*We Are Artists*), Jake and Dinos Chapman launched themselves into the British art world in November 1992. And, sticking to the letter of their initial, ironically inflammatory manifesto, Chapman & Chapman have been busily cultivating their status as art-world bad boys ever since.

Like contemporary art's other famous double act, Gilbert and George (for whom they worked as assistants), the Chapmans have benefited from the PR advantages of presenting a twinned front. They are not shy of courting scandal and outrage by creating images that many people find offensive – childish mannequins with misplaced adult genitals, a facsimile of Steven Hawkin marooned on a rocky outcrop (*übermensch* 1995) – while declaring that they are only dealing with what is already floating in the cultural ether. More significantly, however, the Chapmans have followed the example of Gilbert and George by presenting often outrageously transgressive subject matter in a way that appears mechanical and pristine, of the world, not apart from it – thus further distancing themselves from the work.

But unlike Gilbert and George, whose slogan is an overtly low brow 'Art for All', the Chapmans use art history and theory to support what they have dubbed their 'scatological aesthetics for the tired of seeing'. They began in 1993 by reworking Goya's classic *Disasters of War* etchings into the form of miniature figures, meticulously altering and painting toy soldiers to produce eighty-three tiny tableaux of atrocity, each mounted on an individual island-plinth of artificial grass. In this scaled-down state, more reminiscent of a model railway than an artwork, Goya's indictment of war became a chilling comment on today's aestheticised amorality. This was compounded when

Zygotic
1996
Fibreglass, resin,
paint
170 × 210
× 100 cm

the Chapmans focused on one notorious image from Goya's portfolio – the three mutilated resistance fighters of *Great Deeds Against the Dead* – which they reworked first as miniature toytown multiples, then upscaled as elegantly coifed, life-sized male mannequins (*Great Deeds Against the Dead* 1 and 2 1994), and most recently, as freckled androgynous children, gambolling on a Disneyesque tree stump (*Year Zero* 1996).

However, while these reworkings of Goya's images remain among their best pieces, what has attracted the most attention has been Jake and Dinos Chapman's strategy of an ever more audacious manipulation of commercial

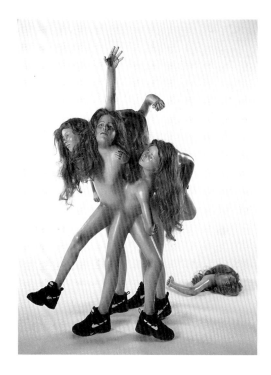

mannequins to present a perverted, post-Freudian playground where anything seems possible. Sometimes disturbing, often plain daft, 'Chapmanworld' (as they called their first major public exhibition at the ICA in 1996), is an amoral bio-mayhem where genetic engineering has gone horribly wrong. Fully formed adult genitals crop up in strange places on smooth prepubescent bodies, and good taste is further jettisoned in the deliberate vulgarity of such bluntly self-explanatory titles as *Fuckface* (1994) and *Two Faced Cunt* (1996), or in works such as the inverted, silver cyber-victim gushing and pumping stage blood (*Cyber-Iconic Man* 1996), and the mannequin bodies of *Mummy Chapman and Daddy Chapman* (1994), in which Mummy Chapman sprouts vaginas and penises and Daddy has developed a nasty rash of sphincters.

But amidst the pranks and the posturing, one mannequin work comes close to fulfilling its taboo-busting brief. *Zygotic acceleration, biogenetic de-sublimated libidinal model (enlarged x 1,000)* (1995) shows the Chapmans synthesising their freely plundered influences – from Picasso's scrambled anatomies, to Cindy Sherman's prosthetic sexual parts, and the erotically charged mannequins of Charles Ray – in order to produce an image worthy of their much-cited heroes Antonin Artaud and Georges Bataille. This life-sized, fused circle of sixteen bland, genderless, child mannequins, wearing nothing but immaculate trainers, their faces obscenely disfigured by misplaced adult

genitals, presents a chillingly contemporary consumerist spin on the monsters spawned by Surrealism's sexual fantasies: Salvador Dalí's *The Great Masturbator* (1929), René Magritte's *The Rape* (1934) or Hans Bellmer's festishistic articulated dolls. Whether the collective id of the Chapman brothers can repeat this moment of spectacular transgression remains to be seen.

MAT COLLISHAW

b. 1966 Nottingham
1986-9 Goldsmiths College
Lisson Gallery
Lives and works in London

In his self portrait *Narcissus* (1991), Mat Collishaw, stripped to the waist, reclines in a bleak urban setting, contemplating his reflection not in a limpid pool, but in a muddy puddle. This closed circuit of all-absorbing artistic self regard is broken by the camera-shutter release button, which Collishaw grips in his left hand in an almost masturbatory fashion. The message about the dishonesty of the photographic image and the erroneous objectivity of art comes over loud and clear; and it stands as a visual manifesto for an artist whose work revolves around questions regarding the essence of our surrounding reality, and the ambivalent position of the artist within it.

Collishaw was yet another Goldsmiths student who achieved an early notoriety with his contribution to the 1988 *Freeze* exhibition curated by Damien Hirst. He exhibited *Bullet Hole*, a photograph of what appeared to be a bloody head wound, displayed in the form of a 366 × 244 cm grid of fifteen separate light-boxes. In this highly aestheticised format there was a deliberate disjunction between the subject and its presentation that both accentuated and neutralised the nastiness of the image: on the one hand it was a huge raw vortex surrounded by hair; on the other, an abstract arrangement of warm browns and reds.

For a while Collishaw carried on exploring the problematics of the image by using composition and design to contradict – and therefore complicate – responses to deliberately loaded subject matter: whether sado-masochistic pinups, colour pictures of women using sanitary towels, photographed from the waist down, or images rephotographed from police files of suicides. Lately, however, he has side-stepped accusations of sensationalism by becoming more light-footed – although in many ways more provocative – in his quest to

Catching Fairies
1994
Colour
photograph
Edition of 1

45 × 65 cm

see things as they really are. 'Our emotions are being manipulated so much that problems begin to occur', he has commented. 'What is true feeling? What makes a genuine response? And these same problems occur with the vast deluge of imagery churned out every day. Representations of degradation and suffering no longer have an effect on us.'

To drive home the point that we are increasingly more affected by the quality of the image than by its content, he began to produce works that represent but pass no judgement on these double standards. *Snowstorm* (1994), and the related *Small Comfort* (1995), present projected images of the contemporary homeless trapped inside a kitsch, Victorian-style glass dome in which snow-flakes swirl to the twinkling backdrop of Yuletide music. Less about making a precise political point, and more an expression of the almost surreal visual paradoxes that are encountered by us all on a daily basis, it aims to 'instigate

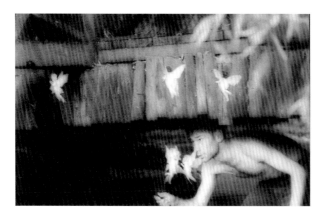

dilemma in the viewer'. These works acknowledge our – and the artist's – complicity in a situation where emotions can swing towards a vagrant in a doorway one minute, and be diverted by a toyshop window display the next.

In *Snowstorm* and *Small Comfort* Collishaw researches and updates the nineteenth-century praxinoscope, and Victorian references and optical toys frequently crop up in his work. He does not use these merely as appeal-ingly unfashionable attention-seeking devices, but employs them for their ability to evoke a lost time when the mechanics of illusion were more obvious and – we might like to think – more innocent. *Enchanted Wardrobe* (1994) explores key Collishaw themes of illusion and desire (with specific reference to C.S. Lewis' classic 'Narnia' stories) by taking an old-fashioned wardrobe, replacing the mirror on the front with a two-way reflective surface, and project-ing a photograph of a forest glade inside. However, the viewer's curiosity can never be satisfied: if you get too close a sensor shuts off the light. There's more tantalising artifice in Collishaw's hand-tinted series of self-portrait photos, *Catching Fairies* (1994), which, in presenting the artist as a stalker of the super-natural, also pays homage to a famous hoax in 1917 whereby a pair of children convinced an adult population that their pictures of fairies were genuine. Yet

the evocative nostalgia of these storybook images is also tinged with malev-olence: why is he stalking these fluttery figures? What does he intend to do with them?

This preoccupation with our ever increasing detachment from the real world has taken Collishaw from images of the past to the latest in computer technology. Digitally manipulated photographs of flowers with petals of animal fur or lividly diseased human flesh present perfect images that are decadent, disgusting and delicious all at once. Their unnatural beauty stands, like Helen Chadwick's *Bad Blooms* or *Wreaths to Pleasure*, as a fitting symbol of our biologically blighted times, as well as reminding us that the word 'art' has its origins in 'artifice'.

MELANIE COUNSELL

b. 1964 Cardiff
1983-6 South Glamorgan Institute; 1986-8 Slade School of Fine Art
Matt's Gallery
Lives and works in London

Installation art tends to be associated more with spectacle than subtlety, but Melanie Counsell has built a reputation on work that can either be so austere as to be virtually indistinguishable from its surroundings, or that can combine the most mundane of elements with an informality that appears to border on the casual. Described in terms of basic components, Counsell's art doesn't seem much, and the titles only tell you the date and venue of the work: a curtain of chintz hitched up above a roll of sodden carpet sitting in a shallow trough of stagnant water (*Matt's Gallery, London, 1989*); an empty room with a glazed-over doorway (*Sydney Biennale, 1993*); a flooded gallery divided by a bobbled glass wall (*Galerie Jennifer Flay, Paris 1991*); a film made from hurling a camera from the top of a sixteen-storey tower block (*110 Euston Road, London, 1996*).

Yet while Counsell's low-key vision has provoked inevitable hostility from those who see most of today's contemporary art in terms of the Emperor's New Clothes, with this artist, appearances – or lack of them – are deceptive. Often Counsell's interventions are large-scale and drastic – even if it takes a while to realise it; and they are meticulously planned with painstaking attention to form and detail. At Matt's Gallery in 1995 she exhibited what looked like an empty space – until you realised that she had sandblasted the columns and installed a low, false ceiling of absorbent, toffee-coloured insulation board that stopped

just short of the windows and was edged along this open end with sheets of reflective black Perspex. It may not have been immediately apparent what had taken place, but as the light changed, the transformations in the proportions, textures and volumes of the gallery inspired corresponding shifts in mood, atmosphere and association – with the added, paradoxical effect of making you all the more aware of what the space had looked like before.

The term 'site specific' has become overused, but Melanie Counsell is one of the few artists to whom it can legitimately be applied. She's not some austere formalist and the appearance and content of her work is always meticulously determined by the physical, social and often historical details and connotations of its surroundings. In her most successful pieces the resulting experience can be a rich one, where a profound sense of a particular place extends out into more general concerns of human mood, emotion, and the passing of time. In Derry in 1990 Counsell both incorporated and transcended the specifics of the

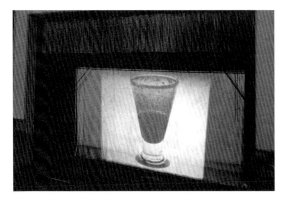

immediate political situation with a traditional tin whistle tune, repeatedly played on a record player placed in a marquee on the site of the factory where it had originally been manufactured (*TSWA Four Cities Project, Derry, 1990*); while in a derelict 1930s cinema in London's East End she reactivated notions of audience participation by screening a half-hour film of an evapo-rating glass of liquid to a group of visitors huddled in the one place where the view was not obscured by a screen of textured bathroom glass(*Coronet Cinema, London, 1993*).

Probably the only other British artist whose work is so dependant on its location is Richard Wilson, and although Wilson's flamboyant architectural interjections may seem the polar opposite of Counsell's quieter interventions, the two also have a surprising amount in common. Both – at their best – extract rich readings from the most mundane materials, each needs to work directly on site, and in each case surroundings are altered in order to reveal what had always been there. Most importantly, both, in distinct but comple-mentary ways, make work that avoids nostalgia, and where poetry emerges from a no-nonsense pragmatism.

At times, however, Counsell's minimal approach can leave viewers wanting rather more than she has given them. Her work is uncompromising, demand-ing and requires a commitment that is at odds with the instantaneous impact

of so much current art. Perhaps it may seem surprising that Melanie Counsell has described her work as 'humanistic', and her installations as 'symbolic containers for unacknowledged emotion', but – if you are prepared to let them – her suggestive interactions of sites and substances, fluids, smells and sounds, can form a meeting ground for feelings as well as thoughts, and can be interpreted and experienced in a way that is physical and psychological, aesthetic and intellectual. At a time when so much art provides a brash, quick fix, sometimes a quieter voice can be more enduring.

TRACEY EMIN

b. 1963 London
1986-88 Maidstone College of Art; 1987-9 Royal College of Art
White Cube
Lives and works in London

It is rare for an artist who is alive, female and still in her thirties to have an entire museum devoted to her life and work; but the foundation of the Tracey Emin Museum in 1995 at 221 Waterloo Road, London SE1 was a logical step for an artist who always uses her life as the source and subject matter for her art. Part studio, part showcase, part performance space, part social centre, this idiosyncratic establishment is less an art house than a site of memory and obsession along the lines of the John Soane or Pitt Rivers museums, and forms a component of a wider body of work that crosses all media but is underpinned by Emin's direct chronicling of her own highly personal experiences.

Emin graduated with an MA in painting from the Royal College of Art, but her artistic direction emerged out of a period of crisis when, having destroyed all her canvases and abandoned her studio, she wrote to friends and acquaintances inviting them to 'invest in her creative potential' for £10. Fifty did, and received in return personal letters from the artist. In 1993 Emin joined forces with fellow artist Sarah Lucas to run The Shop in the East End of London which, for six months, sold objects made by them both and acted as the most lively artistic meeting place in London. The following year Emin had her first solo show entitled *My Major Retrospective*, which consisted of a mass of personal memorabilia – a shrine to a barely begun life, ranging from toy trolls and teenage diaries to the Benson & Hedges packet her uncle was clutching when he was decapitated in a car crash.

Intimate revelations are always risky territory, but Emin usually pulls it off.

Unlike many artists who populate their own work, there is no ambiguity about whose story is being told – the narratives she spins are emphatically her own; but while her accounts of, say, a botched abortion or a failed suicide attempt can be uncomfortable to hear, they are not self indulgent or narcissistic. She may have trained as an artist, but the power of Emin's particular kind of self portraiture is achieved more through her personal presence and storytelling skills.

Why I Never Became a Dancer (1995) is a video piece that recounts how, as a teenager, she was jeered off a dance-floor by a gang of local boys, all of whom she'd had sex with, and ends with Emin dancing alone and vindicated ('Shane, Eddie, Tony, Richard, Doug, this one's for you!', declares the final voice-over). It could be toe-curling but is actually strangely compelling and moving, as is her book *Exploration of the Soul* (1994) with which she crossed America, giving readings in a special chair given to her by her grandmother and decorated with embroidery and appliqué (*There's a Lot of Money in Chairs* 1994). Whether she

is writing, performing or making videos, these highly specific accounts of a life that is both ordinary and extraordinary, manage, like the poetry of Patti Smith or the paintings of Frida Kahlo to go beyond an individual context and refer to a wider consciousness.

The title of Emin's solo show at the South London Gallery in April 1997 was *I Need Art Like I Need God* and such is the obsessiveness with which Emin immerses herself in her art-as-life, you don't doubt it. She acknowledges that her art is a form of personal catharsis, but she also takes knowing sideswipes at the world of art and its abundance of self-mythologised heroes. *The Exorcism of the Last Painting I Ever Made* (1996) found her naked in a Stockholm gallery, where visitors could view her at work through a peephole containing a fish-eye lens, while her hand-written slogans become enduring sculptures in pink or red neon – *Kiss me, Kiss me, Cover my Body in Love* (1996); *It's Not Me That's Screaming, It's My Soul* (1997).

Some of Emin's artworks, lacking her emphatic physical presence and powerfully direct use of language, have trouble in rising above their role as pieces of memorabilia or stage props to back up her unfolding narratives. But in pieces such as the series of spiky monoprints of teenage excesses in her native town (*Margate. What Made Me What I Am*), or the igloo-shaped tent lined with the appliquéd names of *Everyone I Have Ever Slept With – 1963-1995*

(1995), which includes an in-utero twin brother, school friends, lovers and two aborted foetuses, Tracey Emin shows that she doesn't have to be face to face with her audience in order to achieve her emotionally charged quest to 'start with myself but end up with the universe'.

SARAH LUCAS

b. 1962 London
1984-7 Goldsmiths College
Sadie Coles HQ
Lives and works in London

Sarah Lucas' attitude can be summed up by one work: the life-sized, pink plaster cast of her middle finger, sitting on a high white pedestal and raised in that time-honoured gesture of 'up yours!' Its title, *Receptacle of Lurid Things* (1991) could also stand as a description of this artist's imagination. Lucas is known as the rudest artist on the British block – her work is calculatedly casual, tasteless, in-your-face, and full of vulgar visual/verbal puns.

At its best, Lucas' knockabout bawdiness masks more serious concerns. In *Two Fried Eggs and a Kebab* (1992) she both paraphrases and parodies the female body – not to mention the unsavoury term for a woman, 'two fried eggs and a kipper' – by placing a pair of fried eggs and a doner kebab (nestling in its labial folds of pitta bread) on the top of a cheap wooden table, and propping a photograph of this greasy still life in place of a face. In *Bitch* (1994) she makes the same point by dressing another second-hand table in a tight white t-shirt containing two pendulous melons and hanging a vacuum-packed kipper round the back. Men's most blatant desires and women's deepest fears thus find an audacious and unholy union in these two slangy contemporary spins on Surrealist René Magritte's famous 1934 painting *The Rape*, which puts a naked body in place of a woman's face.

In front of a Magritte it is often difficult to know whether to smile or scream, but Sarah Lucas' work is more affable. She doesn't pass judgements but plays off the pleasure and predicament of being a woman in the 1990s by seizing the basest of prejudice and throwing it back in her audience's face. She prefers to provoke you to think by making you laugh – albeit uneasily. *Figleaf in the Ointment* (1991) consists of white plaster casts of Lucas' armpits, complete with hair: mini monuments to what she has described as 'that tension between disgust and desire'; and she's equally merciless to machismo in pieces such as

Get Off Your Horse and Drink Your Milk (1994), a series of photos depicting a faceless naked male covering his crotch with a pint bottle of milk and a pair of digestive biscuits.

As far as Lucas is concerned, what you see is what you get – it just depends on how you want to look at it. But her cheap and cheerful aim to 'make images that are instantly accessible' can work against her. Pieces such as *One Armed Bandits (Mae West)* (1995) – where a plumbed-in toilet, a cigarette end floating in its dingy bowl, is paired with a man's singlet and underpants draped over a chair with an erect wax candle penis rising from its seat – wobble on that fine line between engaging humour and gratuitous gross-out. Other works like the grotty brown Ford Capri with a rear end that bumps up and down (*Solid Gold Easy Action* 1997) or the A5 photocopies of pages lifted directly from the now defunct *Sunday Sport* newspaper, *Fat, Forty and Fabulous* and *Sod You Gits* (both 1990) lack the lightness of touch that enables Lucas' straightforwardness to act as a conduit for greater complexity.

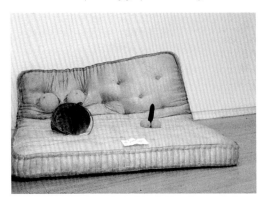

More deceptive in its simplicity is the series of photographic images that Lucas has been making since 1990, when she took a picture of herself eating a banana. Since then she has exhibited self portraits in which she is lounging, drinking, or standing in front of a washing line full of women's underwear. In all she is clad in her trademark wardrobe of mannish workman's clothes – baggy jeans, Dr Martens, a beaten-up leather jacket, no makeup. Her hair is straight and stringy, her gaze is steady and she doesn't smile. Sometimes she looks like a pretty boy, at others like a butch girl, sometimes aggressive, sometimes bored – and always in control. Unlike Tracey Emin's work, in these seemingly candid images the boundaries between truth and fiction blur and crumble as Lucas explores myth-making by playing herself.

In all her work the throwaway, flung-together materials and methods belie serious formal concerns. Lucas is just one of many young artists who have absorbed the crucial influence of the group of 'New British Sculptors' – most notably Bill Woodrow, Tony Cragg, Richard Deacon and Richard Wentworth – whose work of the 1980s played with notions of 'high' and 'low' art. Her often quite drastic alterations of seamy everyday items – the burnt out armchair with its legs supported on cigarette packs, and motorbike helmet made of cigarattes of *Is Suicide Genetic* (1996) for example – are reminiscent both of Woodrow's

early carvings-up of skip-salvaged household appliances and Richard Wentworth's ongoing investigations into the most mundane of functional items. But Lucas' emphasis on our most basic habits and desires is very much her own.

At their most effective, these seemingly unaesthetic arrangements of objects carry an instant, epigrammatic punch by looking exactly like themselves while at the same time suggesting something subversively different. Works such as *Is Suicide Genetic* or the disquietingly fleshy pair of stuffed tights that droop with oddly touching vulnerability from the seat of a plywood chair (*Bunny* 1997) manage to transcend the visual pun to convey intense and often profound qualities of terror, tenderness and poignancy.

This strategy looks back to the legacy of the 'assisted readymades' that emerged out of Dada and Surrealism. Many of Lucas' sculptures could perhaps be seen as contemporary salutes to historic pieces such as Man Ray's *Gift* (1921/73), a flat iron whose smooth surface is menacingly violated by a single row of tin tacks. By producing art that insolently refuses to look like art, that flicks its finger at craft, class and connoisseurship, Sarah Lucas plays with the national prejudice against contemporary art. When she gets it right, this prejudice is both confronted and confounded by her work.

STEVE MCQUEEN

b. 1969 London
1989-90 Chelsea School of Art; 1990-3 Goldsmiths College; 1993-4
Tisch School of the Arts, New York University, USA
Anthony Reynolds Gallery
Lives and works in London

On leaving art school Steve McQueen wanted to make feature films. However, a year at NYU film school among Scorcese and Spielberg wannabes brought him back to London and fine art. Yet the very nature of film itself remains at the core of his work. It's not just that the camera is his means of expression: of all the artists currently working with the moving image, McQueen is unsurpassed in his profound engagement with film as a particular visual medium, as well as with the many messages it carries.

The ten-minute *Bear*, part of a trilogy of short films, was first shown in London in 1995. Two naked black men engage in a highly ambiguous encounter, resembling a cross between a mating dance and a wrestling bout,

where nothing is resolved. Shot from low down, with a suffocatingly close camera tracing the shifting patterns of emotion as revealed by facial expression and body language, this almost excruciatingly physical scenario provides a more complex take on familiar race and gender debates – especially since the artist himself is one of the protagonists.

Like so many of his contemporaries, McQueen steers clear of offering directives. Instead, his films both conjure up and confound stereotypes about representations of black, male sexuality, and ask us to look more closely at our own preconceptions and prejudices and what we each read into such subject matter. The ante is further upped in *Stage* (1996), the third film in the series, where a black man (again, McQueen) and a white woman seem to be stalking each other but never actually meet. Although each remains within their own portion of the vertically split screen, a format that runs the risk of being read

literally in terms of black and white, any such interpretation is instantly complicated by the way in which both, and neither of, the protagonists is victim or predator. The man crawls on all fours, baring his anus, the woman tiptoes down stairs; their glances could be read as full of foreboding – or simply inquisitive. As in *Bear*, ambiguous, human, emotional contradictions are on show, and you interpret them as you wish.

Equally important to McQueen are the very specific ways in which film can present and manipulate images. In *Bear*, content, form, framing and lighting combine in an intense study of erotic power, and this transcendent sexuality extends the film's ambiguity while McQueen's meticulous pacing and editing further complicate the viewer's reading. A shameless relishing of the language and magic of cinema is especially evident in the middle film of the series, *Five Easy Pieces* (1995), where distinct sequences break up the frame like the rhythms and patterns of abstract painting. But this is no abstract study of forms in motion. In true McQueen style, visual rigour oozes with psychological tensions and mood shifts: a shoe sole bites into a tightrope and a female tightrope walker picks her way above our heads; five male hula-hoopers bump and grind in a Russian Constructivist-style formation, before one of them falters and the scene switches to a single figure who whips out his penis and urinates directly

down onto the camera lens in glittering circular ripples – pissing, if you like, on any attempt to read the work in terms of either theory or aesthetics.

McQueen's vision is therefore both rich and restrained. He revels in the form of cinema with a voluptuous austerity. By the third film of his trilogy, *Stage*, virtually nothing happens at all, but the viewer is still swept up in its non-narrative; and McQueen becomes even more minimal in his 1996 *Just above my Head*, which is simply that: a film of the artist walking along, shot from above. This projection, which fills an entire wall of a darkened room with an expanse of sky and a single bobbing head disappearing and reappearing at floor level, can be seen as alluding to the black artist both at the margins and at the centre of things. It also shows that art doesn't have to be elaborate and grandiose in order to make us aware of our individual hopes and fears.

CHRIS OFILI

b. 1968 Manchester
1988-91 Chelsea School of Art; 1991-3 Royal College of Art
Victoria Miro Gallery
Lives and works in London

There's a time-honoured tradition of ordure in art: Piero Manzoni, the pioneer of the Italian Arte Povera movement canned and sold his own excrement; American Mike Kelley has made drawings of huge beribboned turds; while in the autumn of 1995 Gilbert and George devoted an entire exhibition to giant photopieces featuring some of their finest specimens. Now, thanks to Chris Ofili, elephant dung has entered British art practice. Protruding from the vivid, densely patterned surfaces of his paintings are great boulders of resin-coated elephant dung, often studded with bead-like map pins. Down on the floor, more can be found, supporting the canvases like the reassuring ball-feet of a Victorian sofa.

It was on a British Council Travelling Scholarship to Zimbabwe in 1992, while studying for his MA at the Royal College of Art, that this Manchester-born son of Nigerian parents discovered what has now become his trademark medium. In an exasperated attempt to make his anecdotal acrylic paintings of black, English, urban life reflect the intensity of this new experience, Ofili stuck a lump of dried dung onto an abstract canvas. He liked what he saw: a piece of real Africa fused to a Western surface, the ultimate in ugliness in collision with conventional beauty, the gesture complicating

Captain Shit and
the Legend of the
Black Stars
1996
Mixed media on
canvas
244 × 183 cm

notions of both. Shit, he realised, is a great signifier.

For a while Ofili made exclusive use of his unorthodox new medium, displaying it in street markets in Berlin and London (in Berlin they thought he was a witch doctor, in London a drug dealer), making a dung self portrait crowned with his severed dreadlocks (*Shithead* 1993), and even rolling enormous spliffs of the stuff. It soon became established as a crucial element in his paintings, where it has remained ever since, along with an intricate dotted painting style adopted after a visit to the ancient cave paintings in Zimbabwe's Matopos Hills.

But there's nothing folksy about these psychedelic canvases, where beauty meets kitsch in scatterings of glitter, flamboyant patterning and magazine cutouts, and where issues of identity, ethnicity and exoticism all dip and dive between translucent layers of clear resin. Ofili began by splashing patches of shiny varnish onto conventional acrylic paint surfaces, but in 1996 he opened up a new seam of possibility by trapping and sandwiching richly painted details in surfaces of transparent resin, and he has continued to explore visual and interpretive possibilities with the jewel-like colours and enamelled textures of paintings that can be milky or translucent, tarry or opaque.

Now Ofili's audacity seems to know no bounds. Whether he's presenting an African-style goddess baring a beaded elephant turd breast amidst a shower of female genitals snipped from porno mags (*The Holy Virgin Mary* 1996), or a collaged pantheon of black heroes – each with their own 1970s Afro hairstyle – emerging from a welter of pattern (*Afrodizzia* 1996), Chris Ofili stands apart from previous generations of black British artists in his savagely humorous refusal to be pinned down by polemic. Instead, he knowingly plays with prejudice and preconception as part of a polyglot, late-twentieth-century existence, where being black is just part of his story, even if other people don't see it that way.

In Ofili's painting of *Captain Shit and the Legend of the Black Stars* (1996), the hero is a black Captain Fantastic, proud and wary, awesome and ridiculous with his bared chest, bulging crotch and padded shoulders. He hovers like a translucent spectre emerging out of a background splattered with inky black

stars – but each of those stars has a watchful pair of eyes. *Captain Shit* provides another knowing take on Ofili's ironic statement about the perils of the black artist: 'I'll give you drugs, I'll give you dreads, I'll give you ethno-decoration. I'll give you beads, Yoruba and voodoo, I'll give you Badness, I'm a real Magicien de la terre'.

GRAYSON PERRY

b. 1960 Chelmsford
1979-82 Fine Art Portsmouth Polytechnic
Anthony d'Offay Gallery
Lives and works in London

Some artists may use it as a playful sideline, but pottery is not a medium usually associated with contemporary or even fine art; and that's precisely why it is so appealing to Grayson Perry. He describes himself as 'a self-confessed hater of contemporary ceramics who only keeps on using clay because pottery is held in such low esteem in the art world'; and his pots and vases both subvert and play off conventions of art and craft in order to launch a more general assault on British culture, class, sexuality and taste.

In both form and content Perry's pieces are designed to provoke, perplex and offend. From a distance they appear to be handsome, classically shaped vessels; richly patterned, interestingly textured, and glittering with coloured and metallic glazes. But close up these impressive funerary urns, luxurious Oriental-style jars and giant vases teem with obscene scenes of perversion, mutilation and depravity – where no one, not even Perry himself, is spared. *Me Wanking Off* (1996) measures in at nearly a metre and would look at home on a country house mantelpiece – until you notice that the gold motif on its lid is a howling naked gremlin and its richly glazed and lustrous surface is etched with scenes of the most appalling sado-masochism, elegantly spliced with the naffest commercial transfers of roses, country cottages and willow-pattern chinoiserie.

Perry learnt his ceramic skills at evening school, and he cherishes his amateur status as one of his most effective weapons. Although he has been making ceramics for well over a decade, he rejects the reverential rituals surrounding the potter's wheel and persists in the beginner's technique of building up his pieces coil by coil, or slab by slab. His pots may have become increasingly showy, but their combination of elaborate decoration and

cack-handed wonkiness deliberately flouts the potter's traditional quest for perfection, as do their hectic, overcrowded surfaces, which combine childish incised graffiti and tacky transfers with time-honoured techniques of raku, painted slipware and sprig moulding.

Modestly sized, shakily executed early pieces such as the ornamental plate *Our Power is in Fun* (1987), both parody and undermine domestic folksiness and craft-shop gentility in their fusion of olde English techniques and motifs, cryptic slogans and crude cartoonish drawings that embrace every taboo in a parade of gun-toting babies, satanic rites, multiple dismemberments and knife-wielding hermaphrodite housewives from hell. Conflicting visions of

Albion continue to collide in large pots such as the squat bulk of *Sunset Through Net Curtain* (1996) whose surfaces heave with a multicoloured welter of petrol stations, wild flowers, deviant sex and kitsch transfers of hunting scenes, water mills and Gainsborough ladies.

Perry spreads his invective far and wide, but a constant theme is his Essex background, which provides a stream of outrageous and often hilarious vilification of all things British and 'normal', and regularly features Perry's transvestite alter ego Claire, whom he describes as 'a forty-something in a Barratt Home'. Another long-standing target has been the art world, and here Perry persistently bites the hand that feeds him, only to watch it inevitably come back for more.

In the 1980s he mocked his audience with plates emblazoned with sales pitches, and titles such as *Exportware* (1985) and *Trendy and Proud* (1996), and his attacks on the current art scene have increased in proportion to his success within it. *Bad Art Bad Pottery* is the title of a lumpy pear-shaped vase made in 1996, its surface crammed with tasteless photographic transfers, patches of gold lustre and overlaid with drawings of a trussed-up housewife executed in Perry's trademark incised, graffiti-like style; while *Oiks, Tarts, Weirdos and Contemporary Art*, and the Japanese-style lidded vessel *Who Am I?* (both 1996) zone in on the confessional theme of so much recent contemporary 'Britpack' art. Yet, on display in a fashionable London gallery, Perry's satirical pots come

ominously close to becoming the very thing they seek to undermine, and he has to be on his guard that his art attacks don't become indistinguishable from their targets.

It is perhaps for this reason that Perry is now setting his sights on another undervalued craft activity: embroidery and appliqué. *Costume for the Mother of All Battles* (1997) looks like an Eastern European peasant outfit with its brightly decorated skirt, shirt and bolero waistcoat, but a closer look at the schematic decorative details reveals what nationalism is capable of unleashing as a bus explodes inside a Star of David, a soldier with an erect penis shoots a baby, a pregnant cruciform figure is contained in the shape of a flaming fighter plane. Another twist is that, in spite of their folk-art appearance, all these emblematic images are computer generated, and machine applied. Whether using fabric or his vexed vessels, Grayson Perry walks in the footsteps of Hogarth and Gilray by piling on the parody and horror overload, and thus forcing us to accept some unpalatable truths.

GEORGINA STARR

b. 1968 Leeds
1987-9 Middlesex Polytechnic; 1990-2 Slade School of Fine Art;
1993-4 Rijksakademie Van Beeldende Kunst, Amsterdam, Holland
Anthony Reynolds Gallery
Lives and works in London

Georgina Starr plunders her past and her present in a way that deliberately conflates fact, fiction and fantasy. She does not search for – or provide – answers and conclusions, but instead transports her audience into a complicated parallel universe – which they then have to negotiate for themselves. Starr is a born storyteller; her starting point may be a chance event or a half-remembered personal detail, but what saves her work from being an exclusive, self-regarding exercise is the way in which it takes on a dramatic, unexpected and frequently excessive life of its own.

Often, her art appears to have come out of almost nothing: a sudden flood of tears, puffs of wind blowing up rubbish, a boring stay in a hotel room. But these random beginnings are the starting point for an intricate, quasi-scientific process that evolves according to its own bizarre logic. For *Eddy 1/Whistle* (1992), made while still at the Slade, Starr threw about a hundred paper darts into eddies produced by currents of wind on the public

concourse of Euston station and photographed them in mid-air. She then laid a musical score over the photograph, marking the position of the darts on the staves. This produced a piece of music that she could whistle. Having made it into a 45 rpm record, she played it in the Slade building. As passers-by started spontaneously to hum it, they revealed how easily the unconscious can be tricked into an erroneous sense of familiarity. Similarly *Erik* (1993) – which began with a note to a stranger picked up in an Amsterdam street, and resulted in a CD of passages from the replies Starr received from a newspaper adver-tisement asking to hear from people who knew Erik – acts as testament to an instinctive human urge to share experience. 'They all assumed the Erik they knew was the one we were looking for', Starr commented.

Specific incidents, often involving the artist herself, may appear to be the subject of the work, but it is never that simple. Increasingly Starr chooses to

leave it unclear whether she is being 'herself' or merging with the identity of others. Even when precise parts of her life are explored they usually turn into something else. One of her best-known pieces, *Visit to a Small Planet* (1994-5), revolved around an old Jerry Lewis movie of the same name, which had captured Starr's childhood imagination. The result-ing extravaganza of video pieces, installations, drawn story boards and elaborate published film script turned out to have little to do with the original film: the true subject of the piece was not a specific movie but Starr's completely inaccurate memory of it.

In these lavish and often loony scenarios Starr uses every means at her dis-posal to hook and captivate her audience; as far as she is concerned, more – not less – is more. Film and fantasy, magic and madness all featured in her epic installation *Hypnodreamdruff* (1996) where props, TV monitors and video pro-jections enabled the visitor to sit down at the dinky, detritus-strewn tables of The Hungry Brain nightclub and observe its dysfunctional clientele; to squat in a re-creation of Starr's teenage bedroom and observe her acting out the main female parts of *Grease*; to eavesdrop in the eat-in kitchen of three ill-suited flat-mates; and (most disturbingly) to enter the claustrophobic trailer home and the intimate life of its occupant Dave, aspirant magician and Lionel Ritchie fan.

Like many of her contemporaries, Georgina Starr is not squeamish about jettisoning good taste and decorum in these elaborate mind games in order to destabilise carefully guarded certainties and securities. Yet she doesn't just want to immerse the viewer in kitsch recall. There's a frenzied fragility in her intricate, overloaded vision; and this sense of insecurity is compounded by the ambiguous proximity of filmed events and vacated sets, real props and fictional narratives. In her art the trivial and mundane are not relegated but highlighted as the key to our memories and emotions: after all, it is the pop song rather than the political event that lodges itself in our collective memory.

SAM TAYLOR-WOOD

b. 1967 London
1988-90 Goldsmiths College
White Cube
Lives and works in London

In the scenarios conjured up by Sam Taylor-Wood's films, videos and photographs, any display of intense emotion is no guarantee of reality or truthfulness. When does acting stop and reality begin? Who is exploiting whom? What, precisely, is going on? As with the work of so many of her artistic contemporaries, nothing is exactly what it seems, or is ever resolved, and that is the point – we have to complete the story.

In her films, videos, and photographs Taylor-Wood deliberately plays off discrepancies between form and content, appearance and intention, sound and vision. Provocatively – and often maddeningly – she avoids traceable narrative, interchanges actors with friends, and selects her film-stock and soundtracks for a very precise, if uneasy relationship with the action. Whether she's using home video to present a solitary, naked man dancing in a domestic interior, his manic gyrations set in slo-mo and overlaid with the orchestral sweep of Samuel Barber's *Adagio For Strings* – the theme music for Oliver Stone's 1986 movie *Platoon* – (*Brontosaurus* 1995); or dividing two walls of a gallery between a couple immersed in a protracted domestic battle, set to a backdrop of channel-hopping musak (*Travesty of a Mockery* 1995), Taylor-Wood's work deliberately encourages a sense of dislocation and anomaly. This is epitomised by the savagely ironic photographic images of the artist herself. These range from *Slut* (1994), where she is professionally shot in full glamour makeup, her confident smile and closed eyes further complicated by

Travesty of a
Mockery
1995
Colour projection
with sound
(10 minutes)
Edition of 3
Dimensions
variable

a neck-full of livid love bites; to an image where she strikes a spoof Venus de Milo pose, wearing her trousers around her ankles and a t-shirt bearing the words *Fuck Suck Spank Wank* (1993).

Often, these films and photographs seem straightforward enough, but at the same time they appear to be hiding something – a mysterious intrigue or violent event that has either occurred just before the shutter was clicked, or will take place directly afterwards. Her photographs function like stills for a film that can't settle on a plot. In *Dog* (1995), a young woman in a white dress crawls on all fours across a vast field, the sky above her shimmering with eerie light; while in her series *Five Revolutionary Seconds* (1995-7), five photographic dioramas present a seamless space punctuated by groups of people who argue, play the piano, stand in doorways, look out of windows, have sex. In spite of their apparent proximity, they seem to be completely oblivious to each other,

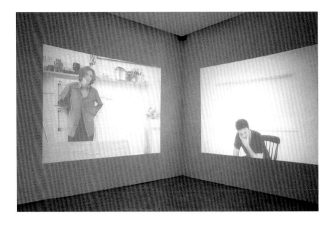

and a soundtrack of background noise and snippets of conversation underlines the futility of trying to make these individuals fit into an unfolding sequence of events.

A more ambitious, if less successful, investigation into dislocation and fractured narrative was Taylor-Wood's installation *Pent Up* (1996), which filled an entire wall of Chisenhale Gallery with a row of film projections, each showing a huge individual immersed in an intense personal monologue. Shot in different styles and separate environments – one actor seated in Rodin-like contemplation, one striding down a street, another gloomily sozzled in a bar – these angst-ridden giants would suddenly jump out of their isolation by appearing to have inter-screen conversations before lapsing back into their separate ruminations. The trouble is, Taylor-Wood, for the time being at least, is more adept with image and soundtrack than with words, and in this case the script didn't quite rise to the occasion. Nevertheless, the possibility that these divided beings may, in fact, have been talking to each other as much as to themselves inevitably raised new narrative possibilities and coloured the way in which the viewer related and responded to what each was saying, although, as usual, nothing was confirmed or denied.

Evidently Taylor-Wood has looked long and hard at the ambiguous,

emotionally intense video work of American artists Bruce Nauman and Bill Viola, but her heroes are as much from the movies as art history. The high-octane, psyche-obsessed films of Cassavetes, Coppola, Cimino and Scorcese, as well as the voyeuristic lens of Andy Warhol and the kinky narratives of Alfred Hitchcock, all fuel Sam Taylor-Wood's art of altered states, while a spell working backstage at London's Royal Opera House has also made its mark in providing a crucial insight into how even the most stylised and 'inauthentic' form of expression can be a lie that turns out to tell the truth.

GAVIN TURK

b.1967 Surrey
1986-9 Chelsea School of Art; 1989-91 Royal College of Art
White Cube
Lives and works in London

Gavin Turk's career began with what appeared to be its end. For his degree show at the Royal College of Art in 1991 he presented *Cave*, a cleaned-out sculpture studio, empty except for a blue ceramic English Heritage plaque fixed high on the back wall that read: 'Borough of Kensington/Gavin Turk Sculptor/Worked Here 1989-1991'. This simple comment on the myth of the artist, the exclusivity of creativity, reputation, and the death of art in general was lost on the authorities of the Royal College who decided that Turk had displayed insufficient work to pass his MA degree. His response was to re-christen the plaque *Relic* (1991-3) and to mount it in a reverential glass case to denote its 'significance' as an artwork and its symbolic role as a salute to all the artists – Joseph Beuys in particular – who have mythologised their own lives and created their own legacies.

Just as his career was born with a memorial, Turk's reverse progress con-tinued when his first solo exhibition was staged as a full-blown retrospective. *Gavin Turk Collected Works 1989-93* occupied an entire building with works in all media, including various versions of the artist's own signature. By creating the ironic fictitious persona of Gavin Turk the artist, and staging re-runs of iconic artworks of the past, Turk continues to play with and parody the manner in which reputation is gained and status conferred, as well as the way in which we still need artists to be heroes. To this end he has mounted balls of his chewing gum in a museum-style glass case (*Floater* 1993), exhibited the silk-screened *Gavin Turk Right Hand and Forearm* (1992), and – most famously –

Pop
1993
Glass, brass,
MDF, fibreglass,
wax, clothing,
gun
279 × 115 × 115 cm
Photo:
Hugo Glendinning

presented himself in life-sized, waxwork form as Sid Vicious, shooting from the hip in the same pose as that in which Andy Warhol depicted Elvis Presley in 1963 (*Pop* 1993).

By portraying himself as a Sid/Elvis hybrid out of Andy Warhol and the Great Rock 'n' Roll Swindle (via Madame Tussauds and the Rock Circus), Turk was not only presenting a multi-referential statement about how our culture both reveres and neutralises any authentic expression of rebellion, he also chose Vicious 'because he's an icon of modern Britain, but at the same time such an incredible loser'. In a seemingly cynical world, compassion can be conjured up in the most unexpected of places.

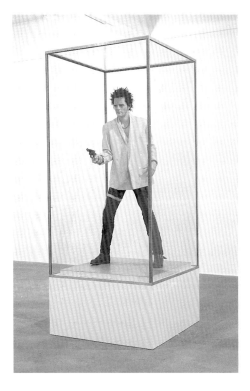

While there's nothing new in making art about the idea of art – or art about art about art for that matter – Turk's multilayered spins on key works of the past display a directness and a poetry that goes beyond Postmodern reference spotting. They are charged with a self-effacing humour that is uniquely British in character. He clouds the pristine clarity of American Minimalist Robert Morris' mirrored cubes by picturesquely distressing them with mildew (*Robert Morris Untitled 1965-1972* 1990); while his liquorice pipe cast in bronze (*pipe* 1991) may be a multiple homage to René Magritte, Jasper Johns, Le Corbusier, van Gogh et al, but marooned on its huge plinth, it belies these art historical antecedents with its poignant sweetie-shop status. With his black-painted, steel replica builder's skip, *Pimp* 1996, Turk unleashes yet another volley of deliberately mixed references. Whether he's tipping his hat to the readymades of Duchamp (whose urinal was after all, just another everyday container for waste) or to the no-nonsense utlitarian aesthetic of the Minimalists, as the viewer's reflection shimmers off the various facets of *Pimp's* perfectly reflective bulk, it is not clear to whom its title is meant to refer: artist, object or viewer.

GILLIAN WEARING

b. 1963 Birmingham
1987-90 Goldsmiths College
Interim Art
Lives and works in London

Gillian Wearing engages directly with the reality (and fantasy) of everyday English life. Drawing on the social anthropology of the 1930s Mass Observation Movement as well as more recent practices of market research and 1970s fly-on-the-wall TV documentaries, her videos, films and photographs present members of the public in guises ranging from the banal to the bizarre. Yet, whether she is photographing passers-by holding placards inscribed with their thoughts and feelings – *Signs that say what you want them to say not signs that say what someone else wants you to say'* (1992-3) – filming strangers in bizarre masks baring their souls to camera – *Confess all on video. Don't worry you will be in disguise. Intrigued? Call Gillian ...* (1994) – or presenting seemingly staid citizens painstakingly blowing tunes from the necks of bottles – *I'd Like to Teach the World to Sing* (1995) – the view presented generally comes over as an affectionate one, the subjects inviting empathy rather than ridicule.

While there's no doubt that this documentary format plays off an innate and universal curiosity about people's lives, Wearing's work usually manages to go beyond the straightforward vox pop or the pruriently voyeuristic to become a more complex study of individual, collective and artistic identity. By entering into an open and collaborative partnership with those she depicts she may make people's private experiences public, but she does so on their terms as much as her own. She chooses how to frame these slivers of 1990s Britain, but offers no judgement – it is up to the viewer to decide what is being shown. This work presents no programme, no political agenda, beyond a commitment – in the artist's words: 'to gauge what makes us live, breathe and tick using my own methods.'

The fact that she cannot control what these strangers choose to reveal, and offers no explanation as to why they agreed to participate, presents an uncomfortable reality fraught with mixed messages, ambiguity and an overwhelming sense of isolation. A man replies to a magazine advertisement, dons a grinning rubber Neil Kinnock mask and, on camera, confesses his theft of some computer equipment to a stranger; a besuited young man wears a smug smile but holds a placard declaring I'M DESPERATE; heavy metal fans are filmed frantically strumming their air guitars in the safe havens of their bedrooms.

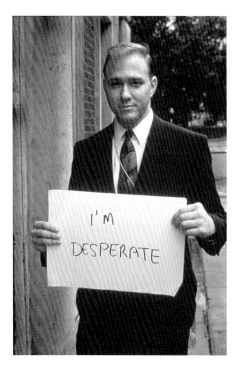

Signs ...
1992-3
C-print mounted
on aluminium
30 × 41 cm

One series of work made in 1996 displays photographs of a range of partici-
pants alongside reproductions of their hand-written replies to her request to
look back over their lives and forward to the millennium. In these immaculately
presented combinations of text and image our immediate first impressions are
both undermined and enriched by their individual thoughts, hopes and fears.

There's more friction between appearance, expectation and apparent actu-
ality in Wearing's *10 – 16* (1997) where, in seven short films, back-projected
onto a 5½-metre screen, adult actors lip-synch to a soundtrack taken from
Wearing's interviews with children aged between ten and sixteen. The sight
and sound of childish voices relaying their
hopes, fears and preoccupations through the
mouths of sometimes unlikely looking adults
can be arresting, disquieting and often very
funny. At best, the disjunction between what is
being said and who is saying it encourages the
audience to look and listen in new ways, and to
reassess the baggage we all bring to notions of
youth and age. However, Wearing has always to
be on her guard against charges of exploiting
her subjects, and in the sequence where a naked
adult dwarf in a bathroom talks in the voice of
a thirteen-year-old child of his hatred for his
lesbian mother and her girlfriend, there's a
risk of veering into voyeuristic territory.

Often, Wearing further complicates the
distinction between subject and object by
physically putting herself into the work. For
Take your top off (1993), Wearing photographed
herself in bed with three transsexuals, subject-
ing her own sexuality to the same analysis as
those depicted with her; while in her video projection *Homage to the Woman
with the Bandaged Face I saw Yesterday Down Walworth Road* (1995), she took
the eponymous role herself, bandaging her own face and filming the reactions
of people she walked past. In *Dancing in Peckham* (1994), Wearing danced for
twenty-five minutes, non-stop, in the middle of a newly erected south London
shopping precinct. In spite of her energetic display of 1970s disco steps, there
was no music. Watching the filmed reactions (or non-reactions) of passers-by
to this odd spectacle was an uncomfortable experience – did we feel sorry for
Wearing putting herself through this ordeal, angry with a society that has cut

itself off from so much surrounding it, or sympathetic to the desire of many Peckham shoppers just to keep their eyes down and walk by as quickly as possible?

Gillian Wearing's more elaborate scenarios may require careful orchestration, but they carry the same uncertain tension between real life and artifice, truth and fiction as the rest of her work. In autumn 1995 she was commissioned by the Hayward Gallery to create a work that would make use of the gallery between exhibitions, and the result was *Western Security*, a filmed 'shoot-out' between posses of weekend cowboys from south London, careering through the gallery's empty spaces, with uniformed security guards trussing up the 'corpses' in bubble wrap. Screened on a bank of TV monitors facing out from the foyer, this bizarre battle was all the more unnerving since it appeared to be coming directly from the gallery's security cameras – where did fantasy stop and reality begin? In Gillian Wearing's art, as in life, it's anyone's guess.

THE PLAYERS

THE GUARDIANS OF THE FLAME

THROUGHOUT THE UK, CURATORS, GALLERY DIRECTORS AND TEACHERS ARE FOSTERING THE NEW SPIRIT IN CONTEMPORARY ART. BELOW ARE SOME OF THE MOST SIGNIFICANT FIGURES OF RECENT YEARS WHOSE INFLUENCE EXTENDS BEYOND THE ORGANISATIONS THEY CURRENTLY REPRESENT.

IWONA BLAZWICK

Curator, Tate Gallery of Modern Art, London

As Director of the now defunct AIR gallery in London during the 1980s, and later as Director of Exhibitions at the Institute of Contemporary Arts (1987-93), Iwona Blazwick has forged an important link between the British and the international art worlds, as well as extending the audience for contemporary art at home. An early promoter of the innovative, at the AIR gallery Blazwick

curated shows ranging from Steven Pippin's first exhibition to the multimedia Gamma City installation by the radical architects NATØ. During her years at the ICA it was Blazwick who gave Damien Hirst his first major public show in 1992, within a programme that combined risk-taking solo exhibitions of young British artists with significant historical re-evaluations such as *Meret Oppenheim 'Retrospective'* and *The International Situationists* (both 1989), and exhibitions that afforded early exposure in the UK to key international figures including the Americans Nancy Spero and Jenny Holzer, Swiss video-artists Peter Fischli and David Weiss, the Cherokee Indian Postmodernist Jimmie Durham, and Zairian painter Cheri Samba.

Between leaving the ICA and taking up her current post organising modern and contemporary exhibitions at the new Tate Gallery of Modern Art at Bankside, Blazwick went freelance as a curator and became Commissioning Editor of Contemporary Art at Phaidon Press. All this only increased her cool, scholarly presence within the art world. Her love of the unorthodox and interest in cross-fertilisation between different forms monographs for Phaidon, and in the ambitious exhibitions that she curated in Britain and elsewhere. The international survey show *Now Here: Work in Progress* at the Louisiana Museum, Denmark, curated by Blazwick in 1996, for example, shook up artistic and cultural distinctions by juxtaposing the works of established figures such as Susan Hiller and Mary Kelly with paintings by a younger generation of artists including Chris Ofili, Stephanie Smith and Edward Stewart, and a plethora of low cost pieces by the multifarious artists who work under the umbrella of *Imprint 93*. *Body of Evidence,* at the Toyama Museum of Modern Art, Tokyo (1995), focused on video ranging from Mona Hatoum's often overlooked pieces from the 1970s to new work by Lucy Gunning and Steve McQueen.

Back home in Britain Blazwick's wide-angled view has given rise to such distinctive exhibitions as *Ha-Ha* in 1993, which colonised an eighteenth-century National Trust park with up-to-the-minute pieces including Vong Phaophanit's neon wall-piece in Laotian script, Georgina Starr's audio-guide, and Antony Gormley's cast-iron figure mounted on an oak trunk. As one of the guest curators chosen to take part in *Art Transpennine 98*, the major exhibition of international visual art stretching throughout Britain's transpennine region and organised by Tate Gallery Liverpool and the Henry Moore Sculpture Trust, she is responsible for site-specific pieces by Mark Dion, Jessica Stockholder, Regina Möller and Joseph Grigely, which range from a glossy magazine to a rotunda library and a walled garden shaped like a tree.

MICHAEL CRAIG-MARTIN

Artist, Millard Professor of Fine Art, Goldsmiths College, London

Michael Craig-
Martin
Photo: Gautier
Deblonde

In any account of the current British art scene, the name Michael Craig-Martin receives prominent billing. A tutor at Goldsmiths College between 1974 and 1988, and Millard Professor since 1994 (a senior position named after early Principal Pat Millard), Craig-Martin is most commonly cited as the *éminence grise* behind the band of Goldsmiths students who emerged in the late 1980s to take the art world by storm. He continues to be credited – as well as condemned – for the cool confidence, conceptual sophistication and entrepreneurial chutzpah that still defines the attitude of young British artists at the end of the 1990s.

The truth, though, is inevitably more complicated. Quite apart from the fact that the current creative boom cannot be tagged neatly to a single source, style or generation, Craig-Martin is also the first to acknowledge that he is just one among many radical influences that have made Goldsmiths an important source of artistic talent – both before and since the 1980s. For it was Jon Thompson, Head of Fine Art at Goldsmiths between 1971 and 1991 who made the decision to abolish divisions between departments so that, since the early 1970s, Goldsmiths students have been free to move between any medium they choose. It was also Thompson who was instrumental in creating Goldsmiths' famous climate of intellectual activity and interrogation where, via an intensive programme of individual tutorials, seminars and group meetings, every student's work is comprehensively discussed against a background of current theories and issues. Add to all this a rich roster of visiting artist-tutors including Richard Wentworth, Basil Beattie, Tim Head, Avis Newman, Simon Linke and Lisa Milroy, and it can be seen that the college's tradition of experiment and enquiry extends way beyond the input of any one individual.

Nonetheless, when Michael Craig-Martin was invited by Jon Thompson to teach at Goldsmiths back in 1974, he was an appropriate addition to its mould-breaking environment. Born in Dublin and raised in Washington DC, Craig-Martin had completed a BA and an MA at Yale, and had then come to England in 1966, where while teaching at art schools in Canterbury and Bath, he was also building up an international reputation as an artist at the cutting edge of Conceptualism. Not only did Craig-Martin reinforce Goldsmiths' links with

developments in art across the Atlantic, he also brought to the south London college his experience of the progressive art programme devised by Bauhaus artist and teacher Josef Albers, which, during the 1960s, had transformed Yale into the most radical art school in America.

Albers famously asserted that art cannot be taught – that the purpose of a teacher was to 'open eyes' – and this view has become central to Goldsmiths' philosophy. (In his inaugural lecture as Millard Professor at Goldsmiths Craig-Martin was to declare 'I have been a useful teacher because I have never seen myself as a teacher'.) Much of the confidence emanating from Goldsmiths today is the direct result of a continuing policy to treat the BA students as artists from the word go, the function of the teaching staff being to offer critical support, both practical and theoretical.

The impact of Craig-Martin's early Yale experience, with its emphasis on attitude rather than style, cannot be underestimated. 'I learned that ... art could be talked about in straightforward and understandable terms, that art needed to be rooted in the very experience of ordinary life I had thought it sought to escape, that contemporary art existed in a context as demanding and complex as that of any earlier historical period. I also learnt the obvious: that, for an artist, art needed to be approached as work.' This philosophy was further refined during an additional spell as a Yale MA student during the mid-1960s when Pop, Minimalism and Conceptual art were all gathering momentum, the perameters of art production were being interrogated, and Yale's visiting tutors included Frank Stella, Jim Dine, Alex Katz and James Rosenquist.

As an artist Craig Martin has always been given the label Conceptual, but that hasn't prevented his work from being rooted in the visual and the intuitive: for over thirty years he has taken perceived truths and systematically interrogated them with a forensic thoroughness that Albers would be proud of. Probably Craig-Martin's best known and most notorious piece is *An oak tree*, made in the Conceptual heyday of 1973 when he took up where Duchamp had left off to present the ultimate Conceptual endgame. Placing on a glass shelf an ordinary tumbler, two-thirds full of water, he claimed via an accompanying text in the form of an auto-interview to have 'changed' it into an oak tree without altering its appearance.

Taking to heart Albers' emphasis on 'maximum effect from minimal means', Craig-Martin has always attempted to give the plainest, most lucid expression to subtle and complex observations of how and why we look at things, and what art can say to us. Behind a deliberately deadpan, mechanistic appearance lies a rigorous, extensive process of enquiry based on empirical observation. He has patrolled the boundaries between painting, sculpture and

installation with assembled objects, prints, books, painted walls, and sculptures that look like wall drawings. For the last two decades, however, Craig-Martin has used as the vehicle for his ideas the uniform images of some 200 carefully selected but utterly ordinary functional objects. Reproduced as perspectival drawings made directly on the wall in black and red tape, Craig-Martin's various combinations of chairs, tables, filing cabinets, shoes, electric fans or ladders explore the possibilities of sculptural presence without mass. But when they are flatly painted onto vivid, plain-coloured grounds, each with their own distinct perspective and coloured-in with no attention to their 'real' appearance, the same sets of objects bring to our attention all the elements that we take for granted in painting – and seeing.

In his person as well as in his art, Michael Craig-Martin uses modest delivery and straightforward syntax in order to communicate the most elusive and complex of subject matter. He is a down-to-earth idealist, a passionate pragmatist, whose influence extends from the heart of the art establishment (as a Tate artist-Trustee he has been closely involved in the development of the Tate Gallery of Modern Art at Bankside) to each annual intake of students at Goldsmiths. He may not have single-handedly launched an artistic generation, but his ideas and his example have certainly helped to inspire the attitude that encouraged it to succeed.

CARL FREEDMAN

Curator and writer

Carl Freedman
in video still
from **English
Rose** 1996

Popular mythology may have it otherwise, but it was in fact, not one, but a cluster of slickly presented shows held in industrial spaces during the late 1980s and early 1990s that fired the art world with the spirit of enterprise and helped to project several careers into the stratosphere. In March 1990, some eighteen months after putting together *Freeze* (which, being held in the middle of summer 1988, did not attract the high audience figures its subsequent reputation has implied), Damien Hirst joined forces with Carl Freedman, his friend from back home in Leeds, to curate *Modern Medicine*. This exhibition of eight young artists was held in Building One, a disused biscuit factory in Bermondsey. Soon afterwards Freedman used the same venue as the setting for two further ambitious and

audacious exhibitions – the group show *Gambler* (July 1990) and Michael Landy's *Market* (October 1990).

Carl Freedman didn't go to Goldsmiths. He studied Anthropology at University College London, and first approached curating almost as a kind of social experiment. He remembers that it was 'the structure of art and how the different value mechanisms operated' that interested him, as much as the art itself; and he lists his aims for the early exhibitions he organised as 'scale, impact, professionalism and power'. *Modern Medicine*, *Gambler* and *Market* displayed all of the above in abundance. With their slick catalogues, prominent sponsors and art that resembled fully formed museum pieces – whether Damien Hirst's *A Thousand Years* (1990), a mini-eco system of hatching, breeding and dying flies, bought by Charles Saatchi for around £5,000; or Michael Landy's Neo-Minimalist installation, which filled an entire space with arrangements of metal frames, bread crates and Astroturf – these exhibitions played a crucial part in promoting a new attitude towards the making and showing of art.

Now, alternative gallery spaces have become a staple of the art world, and several colleges have introduced curating courses. As the economy has shrunk, it tends to be empty shops and repossessed flats that are the sites of more modestly entrepreneurial art exhibitions. Yet, although times have changed, Carl Freedman – among a number of similarly versatile curator/writers including Jeremy Millar and Gregor Muir – continues to make his presence felt within the current scene. His earlier preoccupation with the mechanics of the art world has increasingly given way to a close association with artists and their work; as well as curating exhibitions he also writes about them in arts and mainstream publications.

Minky Manky, the mixed show organised by Freedman for the South London Gallery (1995), which then toured to Arnolfini, Bristol, not only provided a rare chance to view the progression of many of the original artists who had shown together in those warehouse groupings, but also placed them in a wider context alongside earlier work by Gilbert and George and pieces by other British artists of the same age such as Tracey Emin and Steven Pippin. For *Life/Live* (1996) at the Musée d'Art Moderne de la Ville de Paris, one of the largest group shows of British art to date, Freedman contributed *English Rose* (1996), a video work made in collaboration with Tracey Emin, Georgina Starr and Gillian Wearing. Simultaneously parodying and reinforcing the social, artistic and personal cross-dressing underpinning the British art world, each artist acted out the other's persona in a way that was often savage, hilarious and maddening.

ROBIN KLASSNIK

Director, Matt's Gallery, London

Robin Klassnik trained as a painter, then exhibited a selection of Mail Art objects at the ICA and a group of photographic/text pieces at the Whitechapel Art Gallery ('I couldn't paint'), before turning his east London studio into an exhibition space in 1979. Since then, Matt's Gallery (named after his Old English sheep dog, Matt E. Mulsion) has become recognised as a crucial venue for artists to make and show work that many mainstream galleries couldn't – or wouldn't – accommodate. For Klassnik is an idiosyncratic figure within the British art world: he's not a dealer (what he does isn't commercial, despite the fact that some of the works do sell); he's not a public-sector curator (although he does get public funding) and he's not a dilettante (for many years he supported the enterprise with his teaching income, along with whatever grants he could muster). Instead, he is the founder and director of a gallery run solely from artistic motives.

'I was dissatisfied with the facilities available for artists to show work. I took it upon myself to open my space – not to show my own work but other people's. I made the conscious decision that I would work with each artist – it was to be more than a space in which art was shown. The work would involve the artist and myself.' It still does. Klassnik chooses the artists he wants to show – these have included Richard Wilson, Susan Hiller, Willie Doherty, Brian Catling, Jimmie Durham and Melanie Counsell – raises the necessary funds, allows them as much time as they want to realise their work, and directly collaborates with them on the gestation, conception and often the physical construction of projects that have ranged from paintings and wall drawings to video projections and installations.

Once he has committed himself to an idea Klassnik will move heaven and earth (and if necessary walls, ceilings, floors and windows) to make it happen. His commitment is legendary – if somewhat autocratic at times. Richard Wilson, whose 20:50 oil piece made its debut at Matt's Gallery, has described this involvement as 'verging on the fanatical', and even though the venue now has proper funding and administration, and often sells work to the Tate and the Saatchi collection, Klassnik continues to view the whole enterprise primarily as a highly personal artistic collaboration.

Klassnik's close working relationship with artists, his determination to show new work by side-stepping the mainstream (the first Matt's Gallery was buried within a labyrinthine complex of artists' studios in Hackney, now it is

in an old warehouse by the side of a canal in Bow), and the in-house publications that accompany most exhibitions have directly influenced the current plethora of artist-led project spaces. Few, however, have a director with a vision as distinct, dedicated and downright dogged.

JAMES LINGWOOD

Co-Director, Artangel, London, and independent curator

Facilitator, writer and freelance curator, James Lingwood has been a crucial influence both in opening up some of the most experimental forms of contemporary art to a wider British audience, and in providing unusual venues for artists to make and show work. As Co-Director and the visual arts specialist of the Artangel Trust, the organisation that commissions, fund-raises and facilitates works by artists outside the confines of the gallery, Lingwood was instrumental in bringing about Rachel Whiteread's *House* (1993), as well as overseeing other Artangel projects such as a phallic biker movie by American artist Matthew Barney (*Cremaster 4*, 1994-5), Robert Wilson and Hans Peter Kuhn's eerie time-travel installation in south London's Clink Street Vaults (1995), or the occupation of a disused gentleman's club in Piccadilly by the Mexican artist Gabriel Orozco in 1996.

 After graduating from Oxford, Lingwood worked first at the Plymouth Arts Centre and then as Curator of Exhibitions at the ICA. It was during this time that he paved the way for his subsequent Artangel activities by liaising with a network of artists, sponsors and city authorities to organise two ambitious exhibitions that helped redefine the nature of public art by presenting an extraordinary range of temporary pieces in unexpected places. *TSWA-3D* (1986-7) took the work of fourteen artists to nine British cities and included Richard Wilson's suspended machine parts in the south tower of the Tyne Bridge; Edward Allington's cheeky baroque scroll peeping out of the portico of St Martin-in-the-Fields near Trafalgar Square; and Antony Gormley's double-faced cruciform figures on the walls of Derry. *The TSWA Four Cities Project* (1989-90) put more artists in fewer places by focusing on Derry, Newcastle, Glasgow and Plymouth. The twenty-eight pieces included Nancy Spero's paintings on an end-of-terrace wall in the Bogside in Derry, Mona Hatoum's chair made from heating elements placed in an underground tunnel in Byker, Newcastle, and Richard Deacon's huge, girder-like sculpture on a pair of disused railway piers in Plymouth.

At the same time Lingwood was also inside the gallery working on exhibitions at the ICA, a venue with which he had an ongoing relationship for ten years. Significant exhibitions with which he was involved include Gerhard Richter's Baader Meinhof series (1988), *Possible Worlds: New Sculpture from Europe* (1990),and *The Independent Group: Postwar Britain and the Aesthetics of Plenty* (1990-1). Since then he has gone on to make his mark both at home and internationally with exhibitions of Juan Muñoz in Dublin and Madrid (1994-6); Thomas Schütte in London and Tilburg; Robert Smithson in Valencia, Brussels and Marseilles (1993-4), and at the Hayward Gallery, London, a major show of contemporary photography *The Epic and the Everyday* (1994). Sometimes, he admits, he has the urge to go back in time and curate an old master exhibition, but for the time being at least, James Lingwood provides a crucial resource for today's artists and audiences to immerse themselves in the land of the living.

DECLAN MCGONAGLE

Director, Irish Museum of Modern Art, Kilmainham

Declan McGonagle is renowned for his ability to turn a problem into an opportunity. When in 1978 he took over the Orchard Gallery's converted basement spaces in his native city of Derry, he was working as an artist and teacher who freely admits that he had 'no qualifications for the job ... and no conscious idea how to run a gallery'. Yet by the time he left Derry in 1984 for a two-year stint as exhibitions director at the ICA in London (where one of his shows was to be Helen Chadwick's 1986 *Of Mutability*), McGonagle's 'empirical' approach had put Derry – and the Orchard Gallery – firmly on the international art map.

Such was his ability to attract leading artists from across the globe (including Leon Golub, Richard Hamilton, A.R. Penck and Jimmie Durham), who showed in and around the gallery, and to weave arts activities into the heart of the city's divided community, that, on his return to Derry as visual arts officer for the City Council in 1987, McGonagle became one of only two curators ever to be shortlisted for the Turner Prize.

In 1989 McGonagle was appointed Director of the first *Tyne International: A New Necessity*, which took place on the National Garden Festival site in Gateshead, at the Laing Gallery in Newcastle and in various urban locations in both cities. Setting out to redefine relationships between artists and

non-artists it included Jeff Wall, Geneviève Cadieux, Jon Bewley, Christo, Nancy Spero, Chris Mainwright and Muntadas.

A different set of challenges awaited McGonagle, however, when he was appointed Director of the newly established Irish Museum of Modern Art, which opened in May 1991 at the seventeenth-century Royal Hospital, Kilmainham, on the outskirts of Dublin. Many curators would have found setting up from scratch an Irish Museum of Modern Art in the middle of a recession something of a headache; McGonagle, characteristically, found it advantageous. ('It means that we have to acquire works by loans or commissioning rather than purchase, and we're not stuck with all the historical baggage about what a museum of modern art should be', he said at the time.) The museum's inaugural exhibition *Inheritance and Transformation* included key historical works, new projects by contemporary artists, and studio projects by younger artists that celebrated process as well as product. In 1994 this principle was restated in *From Beyond the Pale,* which shook up artistic preconceptions with an eclectic selection of classic works by Pablo Picasso, Marcel Duchamp and Joseph Beuys shown alongside Andy Warhol and Jeff Koons, ancient Irish Sheelah-na-Gig carvings, Willie Doherty's photopieces, and cow-udder sculptures by Irish artist Dorothy Cross.

McGonagle's dynamic, questioning, hands-on approach to art presentation and IMMA's ability to be, in McGonagle's words, 'of the world but with an accent' continue to mark it as a place where the latest British, Irish and global works can spark off each other in an exceptional and inspiring context.

Elizabeth A. Macgregor

ELIZABETH A MACGREGOR

Director, Ikon Gallery, Birmingham

Elizabeth A. Macgregor is a refreshingly forthright presence in the often reticent ranks of the contemporary art world. After completing an academic training in Art History and Curatorship at Edinburgh and Manchester Universities, Macgregor spent the first three weeks of her career passing her Heavy Goods Vehicle test, and her first three years in the arts as curator/driver of the Scottish Arts Council's travelling gallery, organising exhibitions and driving them in a converted bus to places other galleries rarely reach: Highland villages, inner city estates,

schools, factories, hospitals and prisons.

Taking progressive art to the people has remained an abiding concern. As an officer for the Arts Council of Great Britain during the 1980s she was responsible for establishing a special programme to encourage and assist more local authority galleries outside London to promote the work of living artists; and since she became Director of the Ikon Gallery in Birmingham in 1989 it has become one of Britain's foremost venues for international and home-grown contemporary art. As well as programming major international exhibitions of Russian, American, African and Latin American art, Macgregor has also been responsible for commissioning solo shows of British artists from a variety of cultural backgrounds, including Keith Piper, Amikam Toren, Victor Grippo, Zarina Bhimji and Permindar Kaur.

This interest in the relationship between art and audiences has meant that Macgregor has attracted new and youthful visitors to the gallery by advertising Ikon exhibitions in Birmingham nightclubs and on music radio. At the same time she gained sufficient establishment approval to land one of the first lottery grants in the visual arts. This £3.7 million has enabled the Ikon to move into a dramatically restored new building designed by the architect Levitt Bernstein architects in tandem with artist Tania Kovats. Appropriately for a gallery director who has always set so much store by education, the Ikon's new home is a converted school.

JULIA PEYTON-JONES
Director, Serpentine Gallery, London

Julia Peyton-Jones' powers of persuasion are legendary. When she took over as Director of the Serpentine in 1991 it was a somewhat dilapidated former tea pavilion in the middle of Kensington Gardens, which the Department of Heritage wanted to shut down (one minister threatened to turn it into an indoor riding school). Now it's one of London's key exhibition spaces, synonymous with a string of must-see shows, celebrity-studded annual gala dinners, and the recipient of a £3 million lottery makeover. Having Princess Diana as patron from 1993 to 1996 certainly made the sponsors sit up. So did the worldwide press when, with Julia Peyton-Jones at her side (who had quietly arranged it all), the Princess became the first royal ever to visit the Venice Biennale, contemporary art's most important international showcase.

Yet Peyton-Jones' elegant PR skills should not obscure her intense

commitment to the art itself. She has endeared herself to many of the artists who have shown at the Serpentine by being as happy to paint walls and stick on labels as to glad-hand the great and the good. But then Peyton-Jones' own background was in art practice, not promotion. She studied painting at the Royal College of Art in the 1970s, and then collaborated on various film and dance projects before teaching briefly at Edinburgh Art College. From there she had a spell running a gallery attached to an artists' materials supplier in London's East End. However, funding her own art production career gradually gave way to raising cash for the annual Space open studios and then a move to the Arts Council where she showed her range by helping to find sponsorship and to organise shows of Raoul Dufy, Andy Warhol and Leonardo da Vinci at the Hayward Gallery.

Julia Peyton-Jones therefore came to the Serpentine with more experience as a fund-raiser than as a director and she herself – with characteristic self deprecation – has admitted that she was surprised when she got the job. ('I didn't think I was a front runner.') This modesty is not well founded. What is probably her greatest achievement is that she has managed to retain the Serpentine's identity as a venue for radical art while also making it attractive to the establishment – an enviable coup.

NICHOLAS SEROTA

Director, Tate Gallery, London

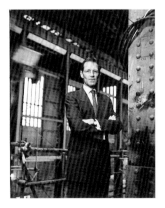

When the Civil Service Commission advertised late in 1987 for a new Director of the Tate Gallery it asked for someone with 'a deep and scholarly knowledge' of contemporary art as well as the flair to embark on 'an important building project and major fund-raising activities'. Nicholas Serota was the obvious man for the job.

The son of an engineer and a prominent London Councillor who became a Labour life peer, at twenty-seven Serota was appointed Director of the Museum of Modern Art in Oxford where he gave important exhibitions to Howard Hodgkin, Carl Andre and Joseph Beuys. This was followed by twelve years as Director of the Whitechapel Art Gallery in east London between 1976 and 1988. His exhibition programme combined the historical – Max Beckmann, Fernand Léger and twentieth-century British sculpture –

Nicholas Serota at Bankside Power Station

Photo: Hugo Glendinning

with up-to-the-minute contemporary shows of Anselm Kiefer, Georg Baselitz, Jannis Kounellis, Gerhard Richter, Richard Long and Julian Schnabel. Such a line-up, along with a much-praised £1.7 million extension to the gallery, amply confirmed Serota's status as an internationalist and champion of the most modern of art – and a nifty fund-raiser into the bargain. Combine this track record with the solid British art credentials of a Cambridge BA thesis on the soberly realistic Euston Road school, and a Courtauld MA dissertation on J.M.W. Turner, the anchor-man of the Tate's historic British collection, and it begins to look as though Serota had spent his entire adult life preparing himself for this post.

Now, with £100 million-plus earmarked for a new Tate Gallery of Modern Art at Bankside, there's no doubt that Serota has lived up to the promise of his early track record. In addition, his reorganisation and refurbishment of the existing Millbank galleries, along with his personal status within the international art world, have helped to make the Tate a stopping-off point for major touring exhibitions such as the recent Cézanne and De Kooning retrospectives. At home, Channel 4's ongoing sponsorship of the Turner Prize has meant that the profile of Serota and the Tate, not to mention contemporary art in general, has become consistently – if often controversially – high.

For, whether he likes it or not – and he professes not to – Nicholas Serota has become the personification of the Tate Gallery, and as such he is also the focus for everyone's particular art gripe. Some see him as an austere and elitist advocate of the most inaccessible of contemporary art, others take the view that he has remained in a 1980s time-warp and that, in spite of his expressed desire to make the Tate into 'a great museum of late-twentieth-century art', he has lagged behind other institutions in America and Europe in responding to the 1990s boom in young British artists. And there are still more who feel that Serota has been responsible for turning art appreciation into art as spectacle: a trendy public relations exercise where labels, explanatory films and celebrity-studded TV coverage have become a substitute for private contemplation.

In order to deal with these compound criticisms, Serota has had to hone his political skills. However much friends and colleagues may insist on his teamwork abilities and on his behind-the-scenes humour and affability, there's no doubt that the move from modest east London gallery to national institution has resulted in a more aloof leadership style. Exposure to the public eye has given Serota a reputation for reticence and reserve: he has become particularly adept at dodging questions about his personal taste in art – or in anything else for that matter – and in spite of what looks like a conscious effort to smile more in public, his sombre appearance has been much commented

upon (one art-world wag has memorably described him as 'a Jansenist dressed by Comme des Garçons').

But what is often overlooked is that Serota's ascetic image masks a vision that is exacting, rather than austere and – like the man himself – can be unexpectedly audacious. His personal preferences weren't in much doubt when, in 1991, he recommended that the Trustees authorise the Tate's £700,000 acquisition of thirty-one giant basalt blocks by Joseph Beuys; or when, after stripping back the Tate's central Duveen sculpture galleries to their grand, bare, original state, he then liaised with the artist Richard Long in 1990 to fill them with a huge circle of flints and snaking coils of painted river mud; or when two years later he had the floors reinforced to bear Richard Serra's specially commissioned blocks of welded steel. Since then, the Duveen's sculpture programme has included 'shouting' videos and flashing neon by Bruce Nauman, and Rebecca Horn's rivers of mercury, live electrical currents and exploding grand piano. These provide a counterpoint to the Duveen's more restrained displays of works by Henry Moore, Anthony Caro and Carl Andre.

No less radical has been Serota's controversial introduction of annual re-hangs, which rotate the permanent collection and discourage any single view of either the Tate's holdings or the history of twentieth-century art in general. He's long been devoted to bringing art to a wider public – in Oxford he and Sandy Nairne set up one of the first schools' programmes dealing directly with contemporary art – and although the Tate's all-change policy still provokes apoplexy in some members of the public when they discover that their favourite painting has been banished to the basement (there was much distress when David Hockney's painting of *Mr and Mrs Clark and Percy* 1970-1 vanished in the first New Display of 1990), the perpetual motion of the gallery's holdings shows no sign of stopping.

For Nicholas Serota is at his happiest when dealing directly with artists and their work. Unlike some of his predecessors at the Tate, he is not by choice an academic, and rather than writing catalogue essays or publishing books he'd prefer to visit artists in their studios or go to galleries to look at art. This hands-on approach also extends to Serota's exceptional ability to hang a show. The earliest rehangs of the Tate's collection were entirely his own work, and his famous – some say infamous – perfectionism continues to impact significantly on the appearance of the Tate's temporary exhibitions – especially those of living artists. Virtually no show is installed without some input from the Director and, however packed his schedule, he always devotes time to suggesting alterations and making adjustments – whether the curators involved like it or not.

Serota's concern with the appearance of things will undoubtedly find its fullest expression in Giles Gilbert Scott's disused power station at Bankside as it evolves into the new Tate Gallery of Modern Art. Having conceived and delivered the project, he sees Bankside as very much his baby, and there is much speculation as to how he will organise its management. Whatever form it takes, there's little doubt that Nicholas Serota will go down in British art history as one of its great museum directors for achieving such an awesome feat. It is also likely that he'll be on site, fine-tuning the position of each exhibit, up until the very last minute.

THE DEALERS

TO A GREAT EXTENT IT HAS BEEN THE COMMERCIAL GALLERIES WHO HAVE TAKEN THE LEAD IN SHOWING THE RADICAL ART OF THE MOMENT. THE FOLLOWING IS A SAMPLE OF THE MOST PROMINENT DEALERS.

JAY JOPLING

Director, White Cube Gallery, London

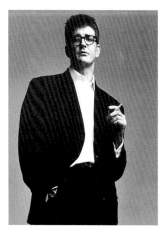

The rise of Jay Jopling can only be described as meteoric. From selling secondary-market Minimalism out of a small house in Brixton in the late 1980s, he is now one of the key figures on the current British art scene.

Although he's best known as the dealer of Damien Hirst, Jopling has also been instrumental in launching the careers of Marc Quinn, Tracey Emin and Gavin Turk, before cannily adding some ballast to his reputation at home and abroad by taking on two older, widely respected artists, Antony Gormley and Mona Hatoum. In addition, Jopling continues to work both ends of the art world to his advantage by using his small but perfectly formed gallery, White

Cube, as a project space for young newcomers such as Winchester School of Art graduate Darren Almond (who, in February 1997 filled it with an outsize ceiling fan) as well as the setting for specially invited shows of international heavyweights like Richard Prince, Gary Hill and Lari Pittman.

It was while he was studying History of Art at Edinburgh University that Jeremy Jopling first got the chance to flex his entrepreneurial muscles. In April 1986 – the same year as 'Band Aid' – he and two friends staged 'New Art, New World', a charity art auction held in London and beamed live by satellite to New York, which raised £500,000 for Save the Children. One of Jopling's jobs had been to visit New York to persuade the likes of Julian Schnabel, Keith Haring and Jean-Michel Basquiat to donate works, and the twenty-one year old student found a natural affinity with the edgy glamour of 1980s Manhattan, as well as in the cut and thrust of the then booming contemporary art world.

After a brief flirtation with film production ('it was incredibly frustrating and didn't satisfy my need to make things happen'), Jopling turned his attention to art dealing. Having no money to set up shop he made some shrewd deals in 1970s and 1980s Minimalism, while at the same time closely observing the new generation of young artists who were coming out of Goldsmiths College and were putting on slick shows in empty industrial buildings in and around London's docklands. Suddenly it seemed a positive advantage not to be tied to a gallery space. 'I realised that I wanted to work with artists on a project-by-project basis.' His debut as a contemporary dealer was made in 1988 when he put on a warehouse show of bronze sculptures by Marc Quinn, the artist who was later to gain widespread notoriety by making a self-portrait head out of eight pints of his own frozen blood.

But Jopling's real turning point can be summed up in two words: Damien Hirst. They met at an art opening, discovered that they both lived in Brixton and loved Leeds United, and the lanky old-Etonian and the rude boy from Leeds became inseparable. 'Damien was very, very difficult to deal with, and finding Jay was fantastic for him' remembers Michael Craig- Martin, who had taught Hirst at Goldsmiths College. 'When Damien had a mad idea that was ridiculously expensive to realise, Jay would simply go about getting the money so that it could be done, rather than figure out how to do it on the cheap'.

That was back in 1991, and Jopling has lost none of his capacity to pull off ambitious projects. As well as encouraging Hirst's elaborate forays into animal preservation, in 1993, in the midst of the recession, Jopling gave unknown Goldsmiths graduate Itai Doron his first show in a vast Canary Wharf warehouse, which the young Israeli artist transformed into a spectacular sci-fi fantasy, complete with snowstorms, space ships and mutant mannequins;

LEFT:
Jay Jopling
Photo: Fergus Greer

and when Gavin Turk created a life-size waxwork of himself as a composite of Sid Vicious and Elvis, it was Jopling who raised the fabrication funds and then sold the piece to Charles Saatchi – just one of many such successful transactions between this dealer and the collector.

Alongside the sharp-suited Jopling's slick, impresario activities and his evident relish for deal-making, however, stands the power of his enthusiasm and a near-legendary ability to persuade the most unlikely people to believe and invest in what he promotes. He's undoubtedly an operator yet no one questions his commitment to his artists; and it is his genius for taking the more experimental areas of art practice into the bosom of the establishment that has enabled Jay Jopling to evolve into a respected, major-league dealer. It is testament to his success that Hirst is now just one of several major figures on the books, and as the director of an increasingly heavyweight stable, it seems likely that Jay Jopling will very soon be finding himself at least one more, bigger and better white cube.

NICHOLAS LOGSDAIL

Director, Lisson Gallery, London

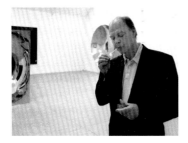

Nicholas Logsdail
in the Lisson
Gallery
Photo: Andrew
Dunkley

The fact that the Lisson Gallery has survived and flourished for over thirty years is due to the single-mindedness (some may say bloody-mindedness) of its founder-director Nicholas Logsdail. The Lisson may now be a major presence in the international art market, but Logsdail continues to treat it as a personal obsession as much as a commercial venture. The forty or so artists he represents – from Sol Lewitt to Douglas Gordon – reflect his long-standing crusade to promote the most hard-line Minimal and Conceptual art and its contemporary legacy. He's the man who represents the so-called 'New British Sculptors' who sprang to international prominence in the early 1980s – Richard Wentworth, Tony Cragg, Richard Deacon, Anish Kapoor and Julian Opie are all on his books. And while he's not complaining that members of his stable keep walking off with the Turner Prize, Logsdail's approach is more akin to that of an evangelical museum director than an art dealer – in his book, speculative buying is strictly a no-no: 'art is not a commodity, it is a cultural artefact'.

There's no doubting Logsdail's historical role in today's art world as the

fervent internationalist who gave early British exposure to such Conceptual and Minimalist luminaries as Sol LeWitt, Robert Ryman, Carl Andre, Donald Judd, Dan Graham and Dan Flavin, to name but a few. But just as crucial is Logsdail's obdurate Englishness, which has led to an equally forcible and influential demonstration that the modernist traffic between America and Europe can flow both ways. His house is furnished not with pieces of high-modernist Bauhaus, Corbusian chrome, or even chairs and tables by Donald Judd as one might expect, but with the progressive, Edwardian Arts and Crafts furniture that pointed the way to all of them. This is in keeping with the tendency of many of his chosen artists to combine the legacy of austere international art movements with eccentric details of British domesticity – whether the lowliest of DIY-store carpet and linoleum, pots of household paint and galvanised steel buckets, or lurid wrappers from a range of chocolate bars.

Logsdail's intensely personal connection to his gallery has deep roots. He describes its origins as 'a student adventure' that began in April 1967 when, depressed by London's dearth of contemporary art spaces, Logsdail and a group of fellow Slade school students – including Derek Jarman with whom he had shown in *New Contemporaries* that year – decided to hold some informal shows of their work in a dilapidated building at 68 Bell Street, near Marylebone Station. What has now become standard practice for young artists was less usual back in 1967: as a direct result of organising his first exhibition Logsdail lost his place at the Slade. However, as the Bell Street building was his home, he continued to put on shows that even in the gallery's first year pointed to his future ambitions by mixing art-school friends with such internationally active figures as Yoko Ono and David Medalla.

'I had no formal business training and still don't ... the structure of this place was very much my own individual creation. It has broken many of the rules and successfully done so maybe because I didn't know what the rules were.' These quirky origins are still embedded in the Lisson Gallery's philosophy. The boss may no longer be an artist but it's not difficult to see the direction in which these impulses have been transferred. Sometimes his obsessive devotion to the gallery can drive his staff mad. For many years he actually lived there, and his current house is still just a few blocks further along the persistently down-at-heel Bell Street, which continues to be the gallery's home.

The extent to which the Lisson is a law unto itself and its director was confirmed in November 1991 when Logsdail celebrated the gallery's twenty-fifth anniversary by opening, without any backing and in the middle of a major recession, five floors of a brand new, purpose-built space designed by Tony Fretton that looks more like a public museum than a commercial gallery. As

has so often been the case with Nicholas Logsdail, a seemingly kamikaze act evolved into a sound career move. It seems that if you create the ambience of a museum, then museum curators are more likely to respond by buying from you, and the big collectors follow suit.

ANTHONY D'OFFAY

Director, Anthony d'Offay Gallery, London

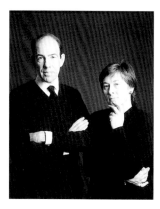

Anthony and Anne d'Offay
Photo: Timothy Greenfield-Sanders

Anthony d'Offay launched his commercial career in 1961 when he used £260 compensation money awarded for a swimming pool accident to buy up the books and papers of two obscure, *fin-de-siècle* poets from the circle of Oscar Wilde. The twenty-one year old son of a surgeon was then a student of modern languages at Edinburgh University and, having used his summer holidays to produce a meticulous catalogue, he subsequently sold the material on, very successfully. Now the likes of Susan Sontag and David Sylvester write his catalogues, and he represents artists from Jasper Johns, Andy Warhol and Joseph Beuys to Gilbert and George, Jeff Koons and Rachel Whiteread. But d'Offay has always maintained both his ability to seize the moment, and his astute awareness of the profits to be made by establishing a historical context.

Anthony d'Offay's route to his current status as Britain's foremost dealer in international contemporary art has been a circuitous one that has found him drawing on a complex web of interests and opportunities. He opened his first gallery in 1965 in a few tiny rooms in Vigo Street, Piccadilly, where his focus moved from archive collections and small shows of Symbolist art to the kind of early twentieth-century British work that he'd first encountered as a child when visiting the local museum in his home town of Leicester. 'I was moved by the Epstein sculptures at the Museum, and I loved the English paintings from the Camden Town School.'

In the 1960s, British art from the late nineteenth- and early twentieth-century was largely overlooked, and therefore cheap to purchase, and d'Offay scoured the country buying up the estates of dead artists and the works of live ones. He opened his new gallery at 9 Dering Street in 1969 with the exhibition *Abstract Art in England, 1913-1915* – the first major show of Vorticist art for over fifty years; and over the next decade he established himself by specialising in

and reviving the reputation of the forgotten artistic figures of Bloomsbury, Camden Town and Vorticism such as Duncan Grant, William Roberts and John Nash, with his usual mixture of intense personal interest and keen financial acumen.

Although in the early 1970s he had begun to represent some younger living artists – Lucian Freud, Michael Andrews, Cecil Collins and William Coldstream – what shifted d'Offay's vision into the present, and his gallery into international success, was his marriage in 1977 to Anne Seymour. An assistant keeper at the Tate Gallery, she had been a moving force in the Tate's acquisition of a Minimalist and Conceptual art collection in the early 1970s and had also organised the influential *The New Art* exhibition at the Hayward Gallery in 1972, whose line-up included Art & Language, Victor Burgin, Michael Craig-Martin, Barry Flanagan, Gilbert and George, Hamish Fulton and Richard Long. Seymour left the Tate for Dering Street, and d'Offay moved from early twentieth-century British art to the international avant garde. 'It was extremely difficult to change my thinking about art radically' he later recalled. 'I had to ask myself if Gilbert and George, Richard Long and Joseph Beuys were as important to me as Wyndham Lewis, David Bomberg and Stanley Spencer. In the end I decided they were more important.'

Since then, the only way has been up. Anthony d'Offay's gallery has expanded into four different buildings in Dering Street, and although Freud is no longer on the books – he left the gallery in 1982 – the line-up reads like a roll call of major figures from every decade from the 1950s up to now. The d'Offays live in a stucco Nash town house overlooking Regent's Park in London. They also own the house designed by Philip Johnson to accommodate Blanchette Rockefeller's collection of contemporary art, which is located near New York's Museum of Modern Art. What began as a livelihood has become a life – both buildings are as much like museum spaces as homes.

For all his major-league artists, hosting of big dinners and throwing his homes open to the art world, Anthony d'Offay remains a reserved, softly spoken, even mysterious figure. He is reputedly an accessible – if demanding – employer, and his sober, conventional appearance and reputation for steely shrewdness run counter to such factors as a 1989 Gilbert and George exhibition at the d'Offay Gallery that raised £565,000 for Cruisaid, or his occasional tendency to stand up and deliver unexpectedly passionate eulogies at the parties he throws for exhibiting artists. Perhaps it is inevitable that the man who has built up such a wide-reaching enterprise without the involvement of any family fortune or behind-the-scenes backing should make a point of avoiding easy categorisation.

MAUREEN PALEY

Director, Interim Art, London

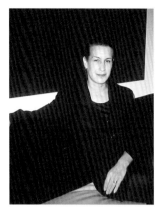

Maureen Paley
Photo: Nancy Webber

It's now commonplace for the latest and most progressive art to be presented in small-scale, domestic surroundings, but when Maureen Paley opened Interim Art in her home in 1984 she was developing a practice that would provide artists with an alternative to the conventional gallery system, as well as playing an important part in putting the East End of London on the contemporary art map. Not that Paley saw it that way at the time. When she came to London as an Ivy League graduate in the late 1970s it was not to run an art gallery but to enrol at the Royal College of Art: 'I had already worked for a year in Sweden making super-8 films on a grant from Polaroid, and at the Royal College I was involved in the extended area of sculpture that spills into photography, performance, installation and film.' She also wanted to get first-hand experience of Punk rock: 'my interest at the time had more to do with the music scene and what people looked like in the streets than the art world', she remembers. Interim Art got its first write-up, not in the arts press, but in the *NME*.

Paley acquired the terraced artisan's cottage in Beck Road, Hackney, for living and darkroom space from the ACME housing association in 1979. The first shows were informal events put on in the years leading up to the 1980s boom and inspired by what Paley has described as 'a climate of closure'. 'I just wanted to get as many people on the map as possible – my notion was to fling everything into the pot.'

Although Paley has described Interim Art as 'an elaborate experiment that I've been forced to conduct in public', she and her gallery rapidly shed their ad-hoc beginnings to put on shows of often surprisingly major figures from Britain, the United States and Europe: the galleries that represent Jenny Holzer, Georg Herold, Richard Deacon and Charles Ray were all persuaded to collaborate with what was then an unknown space in an out-of-the-way part of London. Now Interim Art has become a permanent fixture, and both gallery and director continue to flourish in their latest incarnation as a showcase for younger artists – many of whom Paley takes on straight from art school.

Paley no longer makes art herself – 'I made a very sharp decision that I was not going to be an artist' – but her preference for the experimental blending of categories is often to be found in the kind of art she favours – whether metal

plaques by Jenny Holzer, collaborative paintings by Tim Rollins + KOS, films of all kinds by Gillian Wearing, paintings, cartoons and a board game by Paul Noble. It also continues to manifest itself in her own activities. Art dealers don't usually cross over into curating shows for public institutions (Paley's have included *Wall to Wall* 1995, a large-scale touring exhibition of wall drawings by international artists, and a show of work by young British sculptors for the Henry Moore Sculpture Trust in 1996), and it's even rarer for them to review art exhibitions on national radio.

Yet however unorthodox her activities, from the outset Paley established an unshakeable reputation for rigour and attention to detail that continues to permeate everything she does – from her pristine exhibitions to an immaculately chic personal appearance – and these fastidious presentation skills provide an especially effective counterpoint to the often unruly works she presents.

KARSTEN SCHUBERT
Art Dealer

It is an inevitable, if regrettable fact of art-world life that artists outgrow their galleries. When, in November 1996 Rachel Whiteread left the one-space Karsten Schubert Gallery (which had represented her since 1990) for the three-building Anthony d'Offay gallery, accustomed to catering for a stable of internationally acclaimed artists, no one was especially surprised. What did rock the art world, however, was Karsten Schubert's simultaneous decision radically to reduce his operations 'due to unforeseen circumstances' and hone his stable of artists to the three most established – Briget Riley, the abstract painter and Op-art pioneer, the sculptor Alison Wilding, and Glenn Brown, who paints meticulous copies of already-famous artworks from photographic reproductions. Even more shocking, was the news in October 1997 that the dealer who had provided a major showcase for up-and-coming artists in the late 1980s and early 1990s had made the decision, due to rising rents, to close down his gallery altogether.

Yet whatever his current situation, there can be no doubting Karsten Schubert's role in the early promotion and success of many of the *Freeze* generation. Among the British artists who had their first one-person exhibitions in the gallery were Mat Collishaw, Gary Hume, Michael Landy, Abigail Lane, Anya Gallaccio and Zebedee Jones; while, in keeping with a spirit of generational cross-referencing, there have also been exhibitions of

Louise Bourgeois, Dan Flavin, Piero Manzoni, as well as Riley and Wilding.

Schubert, who is from Berlin, started collecting as a child – he bought his first Joseph Beuys at the age of twelve – and having studied art history decided that there was more scope working as a dealer ('to work as a curator or a critic is always responding to other people's choices'). He cut his commercial teeth with a three-year apprenticeship at Nicholas Logsdail's Lisson Gallery, before an abrupt departure in 1987 at the age of twenty-five to set up his own gallery, initially in partnership with Richard Salmon, in a two-storey building in Charlotte Street. It was here that Gary Hume showed his door paintings, (although the artist and dealer were to part company over Hume's subsequent change of style), Anya Gallaccio's gerberas gently rotted between sheets of window glass, and Michael Landy, in his 1992 installation *Closing Down Sale*, memorably filled the gallery with the gaudy hand-written signs that were by then a ubiquitous sight throughout a recession-ravaged UK. Landy's show was perhaps prophetic: just over a year later Schubert was forced to downscale to the one-room space in Foley Street.

The mixed fortunes of the Karsten Schubert Gallery are indicative of the precariousness of dealing in contemporary art – especially experimental art that is demanding and difficult to sell – and the problems of keeping the artists in your stable. (Gary Hume, Michael Landy and Anya Gallaccio had already left the gallery by the end of 1996.) However, as co-founder of the publishing outfit Ridinghouse Editions, which produces artists' books, multiples and editions, Karsten Schubert has always been adept at making associations and sharing shows with a series of older dealers and collectors including Leslie Waddington, and it doesn't seem likely that he will remain out in the wilderness for long.

LESLIE WADDINGTON
Director, Waddington Galleries, London

Such is the roller-coaster of art dealing that, at the height of the art boom in 1989, Leslie Waddington's after-tax profits were £22 million, but within two years he was making a paper loss of £1.2 million, only to bounce back into the official black in 1994. Whatever his fortunes, Waddington has always been secure in the knowledge that even in his darkest hour his assets have exceeded his liabilities to the tune of £12 million.

Despite the fact that the focus of the British art world has dispersed way beyond Cork Street, Leslie Waddington obdurately remains there – even

after paring down his operation he still runs his gallery out of Numbers 11, 12 and 34. With the return of a cluster of new contemporary galleries to the area he has now reasserted his position as *the* Cork Street dealer, selling both contemporary art and the big names of the twentieth century.

Apart from its size, what distinguishes Waddington's operation from most other leading dealers of contemporary art is that there is no such thing as a Waddington artist. Beyond a broad twentieth-century, Modernist tradition, he has never set himself up as the champion of a particular strain of art practice – although the first wave of artists he took on were from St Ives – and he has declared a preference for: 'a certain sensuous or sensual quality that goes back to Picasso or Matisse, an American or French tradition – I'm a great believer in a catholicity of taste – though I don't like the word "taste".' Because he prefers to hunt out the best works within a certain genre, rather than discriminating between the genres themselves, his stable of artists can encompass such disparate figures as Peter Blake, Patrick Caulfield, Antoni Tàpies, Barry Flanagan and Michael Craig-Martin, as well as younger painters Ian Davenport, Zebedee Jones and Fiona Rae. In 1994 he described the latter as 'the only artist of the younger generation who instinctively knew what Picasso and Miró were about, and mixed it with Pop culture'.

Many dealers swell their profit margins behind the scenes, publicly presenting solo exhibitions of the artists they represent whilst doing secondary market deals in the back room. Waddington, characteristically up-front, puts both on display. His gallery spaces are often filled with an eclectic range of stock rare for galleries in this country: museum quality, classic work by Picasso, Miró, Dubuffet, Willem De Kooning, Max Ernst and Ben Nicholson rubbing shoulders with a selection of older and younger British artists. This desire to put the contemporary and the local into a broader historical and geographical context is in line with Leslie Waddington's personal history: he trained as an art historian at the Ecole de Louvre in Paris, before coming to London in 1957 where he worked in the gallery of his father, Victor Waddington, for nearly a decade before setting up his own enterprise.

Although Waddington is a vociferous critic of some aspects of British culture ('The people in charge of the quangos and committees go back to the country every weekend, back to the eighteenth century. They don't realise that the greatest asset of the twentieth century is in its urban centres') and bemoans our punitive tax system, which slaps 17.5 per cent VAT on any purchase of a living artist's work ('modern art in this country automatically costs 12 per cent more than in Paris') – but, in the foreseeable future at least, he seems unlikely to change his address.

THE PATRONS

SOME ART BUYERS PREFER TO REMAIN ANONYMOUS
BUT THE FOLLOWING ARE AMONG THE MOST
ADVENTUROUS PUBLICLY KNOWN COLLECTORS.

DAVID BOWIE
Musician and Art Collector

David Bowie
(left) with
Damien Hirst
Photo: Iman

From Peter Blake's 'Sergeant Pepper' LP cover for the Beatles, to Damien Hirst's video for Blur and his artwork for Dave Stewart's 'Greetings from the Gutter' album, pop musicians and contemporary artists have often enjoyed a symbiotic relationship. Damien Hirst and Blur guitarists Alex James and Graham Coxon were at Goldsmiths together, and ex-Central St Martins student Jarvis Cocker was happy to ham it up for the cameras at the 1996 Turner Prize, but in spite of the frequent comparisons that have been made between Britpop and Britart, the connections between the latest in British art and music remain surprisingly few.

Instead, it seems to be the older statesmen of rock 'n' roll who are more consistently involved in the art world. Pet Shop Boy Neil Tennant is a Patron of New Art at the Tate; Dave Stewart owns work by Damien Hirst, Sarah Lucas, Tim Head and Marc Quinn; while in 1995 Brian Eno collaborated with Royal College of Art students and American artist Laurie Anderson on the Artangel project 'Self Storage' and made an ambient sound work especially for Jay Jopling's White Cube gallery in May 1997. Then there's Malcolm McLaren, who is a persistent presence, if an intermittent buyer, at every fashionable art event.

However, probably the most conspicuous pop musician to contribute regularly to the world of art has been David Bowie, who first started collecting Arts and Crafts and Jugenstil in the late 1960s. He later amassed a major collection of woodblock prints by the German Expressionist group Die Brücke, including important works by Erich Heckel and Emil Nolde. Several

years later he teamed up with British Pop artist Derek Boshier for the cover of the 'Lodger' album, and for his most recent record, 'Earthling' (1997), he collaborated with the American artist Tony Oursler.

Since the mid-1990s Bowie appears to have been dedicated to creating a reputation for himself as a collector, art writer and artist. He was brought in by his friend the art dealer Bernard Jacobson to sit alongside the likes of Lord Gowrie on the board of *Modern Painters* magazine, to which he has also contributed interviews with artists such as Balthus, Tracey Emin and Damien Hirst, and idiosyncratic reviews of exhibitions including Jean-Michel Basquiat and the first South African Biennale. In 1997 he co-founded the art publishing house, 21 (with *Modern Painters* editor Karen Wright, Sir Timothy Sainsbury and Bernard Jacobson). Two years earlier he hired a Cork Street gallery for *New Afro/Pagan*, a show of his own drawings, prints, paintings and sculptures that left no doubt as to the Thin White Duke's shamelessness as a voracious style-sampler whose line-up included heavy Neo-Expressionist charcoal drawings, chrome-plated African heads, and even a computer-generated wallpaper print where mini-reproductions of a Lucian Freud self portrait glared out from inside rows of Damien Hirst-style tanks.

Either through genuine obliviousness or with an insouciance born of decades of super-stardom, Bowie seems unconcerned both by the fogeyish reputation of *Modern Painters* and the chilly critical response to his own output. After all, when you generate enough income to float yourself on the stock exchange you can call the shots. Art commentators may have sneered at – or ignored – *New Afro/Pagan* but Bowie's enduring commitment to the visual arts lends high-profile support to a world that, in the current cultural and economic climate needs all the help it can get.

With characteristically eccentric eclecticism, Bowie is not afraid to invest heavily in his own collection of modern and contemporary British art. In 1994, for instance, he paid £18,000 for *Croatian and Muslim*, a controversial rape scene by Peter Howson, Britain's official war artist in Bosnia, when the Imperial War Museum wouldn't take it. He also owns the Damien Hirst spin painting *Beautiful Shattering Splashing Violent Pinky Hacking Sphincter Painting*, which he purchased whilst collaborating with the artist on a similar work, *Beautiful Hello Space-boy Painting* (both 1995). Since the mid-1980s, Bowie has systematically built up his British collection, starting with artists such as Frank Auerbach, David Bomberg and Peter Lanyon and then branching out to more work by Gilbert and George, Patrick Caulfield, Julian Opie, Hadrian Piggott and Ken Currie.

In his house in New York Bowie also keeps a seriously heavyweight old

master collection containing works by Rubens and Tintoretto. And perhaps it is these wide-reaching artistic enthusiasms that confirm him as a genuinely committed lover and supporter of art rather than a follower of fleeting fashions.

RALPH BURNET

Chairman and Chief Executive, Burnet Financial Group

It is widely acknowledged that the most exciting contemporary art of recent years comes from Britain; but the sad fact is that there are very few people in this country prepared to buy it. With a few notable exceptions the British still seem to be more comfortable buying from the past rather than investing in the future, and this innate conservatism (along with an enduring national confusion of art with interior decor) has left the field open for a number of collectors in America and Europe to build up substantial holdings in the most recent British art.

One such individual is the American collector Ralph Burnet who, with his wife Peggy, has been buying the work of young British artists since the early 1990s when he first joined the board of the Walker Art Center in Minnesota – the venue that organised the important exhibition *'Brilliant!' New Art From London* in 1995. Burnet, whose Minnesota-based Burnet Financial Group manages real estate, insurance and mortgages throughout the American Mid-West, feels sufficiently at home with his confrontational British works to integrate them into his existing collection and to live among them.

The Burnets have been collecting art for more than twelve years. They buy for pleasure rather than investment and tend to focus on single artists in depth (they own nine Bruce Naumans and eight works by Gerhard Richter as well as pieces by Willem De Kooning, Ellsworth Kelly and Jasper Johns). Now, these internationally established names are being mixed with a punchy British selection that includes ten sculptures and paintings by Damien Hirst; Sarah Lucas' mobile of photographic self portraits (*Bucket of Tea* 1994), and her sculpture of aggressively crossed plastic arms (*Get a Hold of This* 1994-5); several works by Sam Taylor-Wood; as well as a ring of fused, genitally displaced infant mannequins by Jake and Dinos Chapman (*Zygotic* 1996).

Add to that works by Chris Ofili, Marc Quinn, Mona Hatoum, Tracey Emin and one of Rachel Whiteread's most important pieces, *Untitled (Double Rubber Plinth)* 1996 (a cast of the space beneath an autopsy table); as well as the Chapmans' spectacular *Year Zero* of 1996, a work that the Burnets have

donated to the Walker Art Center, in which the blasted tree from Goya's *Disasters of War* is draped not with dismembered corpses but with freckle-nosed children, and the commitment of these collectors is confirmed.

STUART EVANS

Partner, Simmons & Simmons; Chairman, Patrons of New Art, Tate Gallery

When companies decide to acquire art they usually employ consultants or appoint a purchasing committee. But the now extensive collection of inter-national law firm Simmons & Simmons is the sole responsibility of one of its corporate finance partners. Stuart Evans has been passionate about art since his schooldays (his early interest was encouraged by a sympathetic teacher, William Feaver, now art critic of the *Observer*). He was already collecting 'art done in my lifetime' for himself when, over ten years ago, he started buying for his firm modest works by early twentieth-century British artists as well as prints by such established contemporary British and American artists as Howard Hodgkin, Leon Kossoff, Roy Lichtenstein and Claes Oldenburg.

The construction of a new suite of conference rooms at the firm's London offices in 1994 provided the starting point for a fresh departure in what Evans has described as 'a collection that reflected some of the energy, commitment and diversity of the emerging young British artists I had begun to see in ... and around London'. In under three years he had, with help from private art dealer Thomas Dane, assembled a collection of forty-four paintings, works on paper and photographs. Although the collection includes the Scottish painter Callum Innes it goes under the collective title of 'Made in London' and certainly fulfils Evans' desire to 'challenge the somewhat reactionary tradition of English corporate collecting'.

Meetings at Simmons & Simmons' London HQ are now enlivened by Mat Collishaw's computer-generated photographs of furry lilies (*Tiger*, *Leopard* and *Zebra Skin Lily*, all 1995); Angus Fairhurst's four large colour photographs of the back of Damien Hirst's neck, bristling with plastic price tags – *Man who wants to know what the back of his head looks like* (1992) – and Abigail Lane's image of a contritely muzzled pit bull terrier, *For His Own Good* (1996). Although some partners have blanched at this unorthodox line-up, Evans is adamant that such challenging work is utterly in keeping with the role of corporate lawyers: as 'merchants of solutions ... we have to achieve objectives for people in powerful positions, and they expect us to be able to deliver. Part

of that solution can be looking at things in a way that hasn't been done before.'

As Simmons & Simmons continue to expand their London premises, Stuart Evans continues to buy work. After 'Made in London' he has put together a British and North American print collection, and is currently selecting a new group of contemporary photographs by, among others, Sarah Jones and Bridget Smith. At the same time, his private collection continues to grow. Abstract paintings of the 1950s and 1960s by Eduardo Paolozzi, Alan Davie and Gillian Ayres have been joined by an increasingly impressive selection of works by younger British artists from Rachel Whiteread's plaster casts of bookshelves, to Mat Collishaw's 1991 photograph of himself as *Narcissus*, a series of monoprints by Tracey Emin from 1989 (Evans was one of the first collectors of her work), and carved breeze-block houses by Jonathan Callan. Recent acquisitions include sculpture by Miroslaw Balka and Pep Duran.

Perhaps surprisingly, Stuart Evans' increasing involvement in the art world has also been a source of business. In 1991 Simmons & Simmons provided Damien Hirst with legal advice on the venue for his memorable live butterfly installation *In and Out of Love*; Tracey Emin gave the company a copy of her book *Exploration of the Soul* and a photograph of herself reading it in Monument Valley, USA, for organising the lease on the Tracey Emin Museum in 1995; and Abigail Lane's canine photograph was donated in return for legal work on her new studio. On a larger scale, Simmons & Simmons has also become an advisor to the Tate Gallery on the structuring and financing of the new Tate Gallery of Modern Art at Bankside. With Stuart Evans as chairman of their Patrons of New Art until the year 2000, it seems that the Tate Gallery has won itself a committed ally.

PETER FLEISSIG
nvisible museum

In putting together his collection, Peter Fleissig has concentrated on sculptors' drawings and early works by younger artists: 'not the biggest or the shiniest works ... the price never more than a second hand Saab.' What these pieces have in common, he says, is their 'spirituality and concern with invisible spaces'. Ranging from drawings by Richard Long and Marc Quinn to Simon Patterson's classic renaming of the stops on the London Underground map *The Great Bear* (1992), and Damien Hirst's drawing for his shark piece *The Physical Impossibility of Death in the Mind of Someone Living* (1992-4) they can't,

however, be seen in one place. They are scattered across London in the houses of friends and the studios of artists, creating what Fleissig has described as 'an invisible mental museum – inspired by André Malraux's concept of a museum without walls. It is a way of thinking of the city itself as a museum.'

This open-ended approach to art distribution is closely related to Fleissig's activities during the 1980s as a member of NATØ (Narrative Architecture Today), an anarchic architecture group founded by Nigel Coates. Eschewing pure spaces and technical diagrams, NATØ advocated an architecture that meshed with the circumstances of everyday life in the city, whether design, fashion, art or popular culture. It was while he was making his salvaged 'Savage Furniture' and promoting this heady, multi-layered view of a city in motion that Fleissig was also buying the drawings of sculptors, many of whom – Edward Allington, Richard Deacon, Kate Blacker, for example – were also incorporating the detritus of the city into their work.

Several nvisible museum acquisitions in the 1990s have provided a crucial fillip to early careers – his version of Steve McQueen's *Five Easy Pieces* was the first work sold by the artist; he has a very early Mark Wallinger painting (*Battling for Britain* 1985), and he bought a unique text piece from Douglas Gordon's first solo show at the Lisson Gallery in 1994-5. Even though Fleissig has described his pieces as 'the kind of works that museums wouldn't buy', several have subsequently made very visible museum appearances, including a 1995 Callum Innes painting that went on show as part of his Turner Prize exhibition of the same year, and an important early Rachel Whiteread sculpture *Fort* 1989, made from a kneehole desk. Recently, Fleissig has been concentrating on videos, such as Georgina Starr's 1993 work, *Crying*, and pieces by Simon Starling.

Within the art world Fleissig may prefer to remain a mysterious (though omnipresent) figure, but he's not averse to the nvisible museum coming out of its various closets from time to time – it was shown in a Clerkenwell warehouse in 1994 under the title *Seeing the unseen*; and in 1998 it is expected to reappear under the guise of *Infra-Slim Spaces*. With the passing of time, it seems, the nvisible museum is making its presence increasingly known.

ERIC FRANCK
Art Collector

'I'd rather buy one good piece than many works by the same artist – I don't collect for resale', Eric Franck has said. His collection of contemporary British

art, which embraces works by Mat Collishaw, Tacita Dean, Tracey Emin, Craigie Horsfield,Gary Hume, Jaki Irvine, Cathy de Monchaux and Gavin Turk is in fact the third that he's put together. The son of a Belgian banker who was himself a major collector of Impressionist paintings and Expressionist works by James Ensor, the sixteen-year-old Franck started to buy prints by Edouard Manet while he was still at school in the 1950s and soon built up the second-biggest collection of Manet prints in the world. ('The first-biggest wouldn't sell to me or me to them, so I sold the lot at Sotheby's'.)

While working for a Swiss bank, Franck turned his attention to amassing Pop art works of the early 1960s, before selling them off to fund movies by German film-makers such as Rainer Werner Fassbinder. In 1978, Franck quit banking for good and after serving a four-year art apprenticeship at the Galerie Maeght in Paris (the gallery of Miró, Chagall, Giacometti, Calder and Kandinsky), he set up his own galleries in Geneva and then Berlin where he was an early champion of Rebecca Horn and Alighiero Boetti amongst others. He also staged one of the first epic events by the multimedia American artist Robert Wilson, who remains a close friend.

Franck's interest in the latest British art was kindled when, on moving to London in 1993, he was taken to *A Fete Worse than Death*, one of the annual all-day, into-the-night, art extravaganzas in Hoxton, east London, organised by the late Joshua Compston (1970-1996), where among the side-shows was Damien Hirst, dressed as a clown and making mini-versions of his spin paintings. Since then, the lofty, besuited Franck has become a regular presence on the British art scene – he was on the acquisitions committee of the Tate's Patrons of New Art between 1995-6; he is a patron of Camden Arts Centre, the Serpentine and the Whitechapel Art Gallery; and behind the scenes he is also a discreet bene-factor, often helping younger artists with the cost of both making and showing their work.

CHARLES SAATCHI

Founder, Saatchi & Saatchi, M & C Saatchi

What Cosimo de Medici was to quattrocento Florence, Charles Saatchi is to late twentieth-century London. His

collection is one of the largest in the world (it currently stands at some 1,500 works) and certainly one of the most conspicuous. He buys work in bulk, and displays that of luckier artists in his showcase gallery in St John's Wood, which, since it opened in 1985, has been visited by over a million people and has assumed the status of this country's unofficial museum of contemporary art.

Although the more spectacular manifestations of the current art scene may only form a comparatively small proportion of his overall holdings, Saatchi's taste for these works has been crucial in launching the careers of individual artists. His acquisitions over the last decade – whether Damien Hirst's preserved shark (which he commissioned), Marc Quinn's *Blood Head*, the mannequins of Jake and Dinos Chapman, or Richard Wilson's *20:50* oil piece (which he keeps on permanent display) – have also been instrumental in raising awareness of British contemporary art both at home and abroad.

As the director of the advertising agency Saatchi & Saatchi, which he set up with his younger brother Maurice in 1970, Charles was personally responsible for originating the 'cut in the silk' Silk Cut cigarette campaign that doubled the market share of that brand. It is perhaps inevitable that the man who himself is a genius at visual communication should feel an affinity with artists such as Hirst and Lucas whose work relies on a similar ability to distil complex ideas into a powerful and accessible message. For his part, Hirst has acknowledged that 'I get a lot of inspiration from ads in order to communicate my ideas as an artist and of course Charles is very close to all that.'

Too close, some may say. It was Saatchi & Saatchi's 'Labour isn't working' advertisement with its snaking dole queue that sold Margaret Thatcher to Britain in 1979, and they were then employed by the Conservative Party for another three victorious election campaigns. In 1997, the legendary creative skills of Charles – now as half of the new breakaway agency M & C Saatchi – were enlisted again in order to try and salvage the election campaign for John Major. These allegiances, however, seem to arouse little comment in the largely leftish art world. But then, as the Medicis were well aware, art investment is a great image-enhancer: the Catholic church was quick to forgive the banking dynasty the sin of usury, just as the contemporary art world – especially in Britain – is in no position to be picky about the politics of those who patronise it.

In spite of his current role as the presiding patron of the contemporary British art boom, Charles Saatchi has owned not one, but three collections. His first art purchase, made in 1970, was a Sol LeWitt drawing, bought for £100. During the next decade, as the advertising business boomed Saatchi, along with his wife Doris, built up major holdings in American Minimalism,

collecting large-scale works by LeWitt, Carl Andre, Donald Judd, Brice Marden and Robert Ryman. During the 1980s, Charles and Doris Saatchi followed this up by assembling a world-class collection of fashionable contemporary art ranging from the Neo-Expressionism of Julian Schnabel and Anselm Kiefer, to the slickly subversive work of Ashley Bickerton and Jeff Koons. It was only at the end of the decade, after his divorce from Doris in 1988, and the stock market crash in 1989, that Charles Saatchi sold off most of his blue chip works to become young British art's most enthusiastic champion.

Saatchi's influence throughout the contemporary art world cannot be overestimated. When, in March 1985, Saatchi opened up 30,000 square feet of dazzling white space designed by Max Gordon, he provided a completely new way of looking at art in this country. It wasn't just that he gave Britain its first wholesale showing of such internationally established figures as Cy Twombly, Andy Warhol, John Chamberlain, Dan Flavin, Sol LeWitt, Bruce Nauman and Richard Serra – as well as younger figures like Jeff Koons, Ashley Bickerton and Robert Gober – it was that he did so in an exemplary setting that showed the work off to its very best advantage. The upcoming generation of artists who were to become part of Saatchi's third, ongoing collection, came, admired, and took note.

The gallery's profile may be high, but Charles Saatchi keeps its inner workings and the exact contents of his collection a secret. He compounds this enigmatic image by rarely appearing in public or showing up at his own openings. Occasionally, however, he pops up when least expected, such as when he presented the 1994 Turner Prize to Antony Gormley on live TV with a jokey speech ('I'm not sure what today's young artists are putting in their porridge in the mornings but it seems to be working'). This perversely paradoxical behaviour inevitably makes Saatchi all the more intriguing and his buyings, sellings and seeming changes in taste are scrutinised by artists, dealers and other collectors like an alternative stock exchange.

Just as he tends to buy in bulk, so he has attracted criticism for offloading chunks of his collection. Italian artist Sandro Chia claimed that his own career was hurt by such a fall from grace; and Sean Scully and others have protested that they had offered prize pieces to Saatchi in the belief that they would be enshrined in a permanent collection. 'The market was overheated and it was a good time to sell' was Saatchi's laconic explanation of his 1989-91 sell-off, and while 1996 company records indicated that his Conarco partnership had made at least $42 million worth of profit by dealing in works of art, he has claimed that he doesn't buy art for investment: '90 per cent of the art I buy will be worthless in ten years time to anyone but me. If I was buying art to make

money, I'd buy very different art'. He has also made the point that it would be inappropriate to go on endlessly buying for twenty-five years without attempting to keep the gallery self-financing, fresh, and on the cutting edge.

Whatever he buys or sells, and for however much, there is no doubting Saatchi's enthusiasm for the art itself. He may not socialise with the artists, but he is personally involved in the installation of every show in his gallery: visitors to the Saatchi collection a few days before the opening will find him moving works around, hanging pictures and altering the lighting. Typically, he never attends openings at other galleries but buys from studios (often at reduced prices) or arrives at exhibitions the day before the other collectors arrive. Nor is his collection merely devoted to the outrageously unconventional: he owns twelve works by Lucian Freud and is a major buyer of Paula Rego's work. In addition to his important painting by Rego from the 1980s, in 1996 he purchased ten of her *Fantasia* and *Snow White* pictures, simply, according to the artist, because he wanted to keep them all together.

BERNHARD STARKMANN

Owner, Starkmann Ltd

Bernhard Starkmann is a rare species – in this country at least. His company collection eschews the easily decorative or the corporate status symbol to focus on the kind of Minimalist and Conceptual work that the British traditionally find most problematic. For some twenty years Starkmann has been educating his company and his colleagues (who distribute scientific and humanities literature published in Britain, America, Holland and Germany to academic libraries throughout Europe) by assembling important works from the 1960s and 1970s as well as recent pieces from the latest generation of young British artists. His collection – which spans from Carl Andre, Dan Flavin and Christo to Christine Borland, Liam Gillick and Georgina Starr – is one that deals with 'current issues and ideas'.

Instead of tailoring the collection to fit its surroundings, Starkmann has had his business premises renovated to accommodate the art. In 1988 Milanese architect Claudio Silvestrin (who later designed Jay Jopling's White Cube) successfully met his brief to create a space within a former dairy depot just off Lisson Grove where the art and the daily business of the company could be incorporated to interact with one another.

But this doesn't mean choosing easy pieces to hang on a beautifully

designed wall: a distinctive feature of this collection is that many of its components require careful installation and maintenance while still forming part of an active working environment. Works have included a pair of pigment-covered Anish Kapoor sculptures (*1000 Names (No. 27)* 1980-81; *1000 Names* 1985) on the wall and floor of a much-used thoroughfare; a sound-activated light piece by Angela Bulloch (*What's Said is Seen* 1991) in the operations area; Craig Wood's polyurethane-covered boardroom table, *Boardroom* (1991); and Douglas Gordon's sound and light installation *Something Between my Mouth and your Ear* (1994), housed in an interview room.

In keeping with this museum-style approach, the works on show change roughly every six months when they are replaced by a rigorously curated new exhibition (complete with title and catalogue) that combines a selection of work from the collection with special commissions or installations by individual artists. This all-encompassing philosophy extends to inviting artists to contribute to the company's bibliographies and brochures, sent to universities and research libraries in Europe and overseas. Starkmann's 1996-7 brochure for science, technology and medicine, for example, must have cheered up the sober ranks of academia with a cover and centre spread sporting epic watery images from Peter Newman's surfing film *God's Speed* (1996). As Bernhard Starkmann says, 'With some imagination, determination and lateral thinking it must be possible to bring the creativity of artists to the boardrooms, and to the offices of corporations – not as status symbols but to enrich the daily life of everyone sharing in the enterprise'.

THE OPERATORS

BEHIND EVERY EXHIBITION IS A TEAM OF UNSUNG BUT CRUCIAL ENABLERS. HERE ARE JUST SOME OF THE SPONSORSHIP AND PUBLICITY AGENTS, FRAMERS, FABRICATORS, INSTALLERS AND PHOTOGRAPHERS WITHOUT WHOM SHOWS COULD NOT BE BROUGHT TO THE PUBLIC EYE.

ERICA BOLTON AND JANE QUINN

Erica Bolton and Jane Quinn Ltd

In Britain it is notoriously difficult to obtain press exposure for exhibitions of contemporary art. And when you do, it's usually the wrong kind. Unless there is a sensation, a scandal or a silly-season absence of news, many sectors of the mainstream press just don't want to know, and even the most committed of art critics need to be steered, prodded and cajoled – as well as furnished with the facts. That's where Erica Bolton and Jane Quinn come in. Since the company's foundation in 1981, Bolton and Quinn have established themselves as the dual doyennes of arts publicity – although they prefer to call themselves a 'cultural communications consultancy'.

Certainly what they do goes way beyond PR. While they can lay on a press trip or a launch party with the best of them, each of their enterprises involves very different treatment: artists, sponsors, local authorities and gallery staff often have to be carefully handled – and that's before the press have even entered the picture. Probably their greatest achievement is an ability to cross over from the heart of the establishment into the wilder shores of art practice: clients/projects can range from the Tate Gallery (its architectural projects at Bankside, Millbank and St Ives, in addition to its exhibitions, such as the recent Cézanne retrospective) to *BT New Contemporaries*, the Millennium Bridge from St Paul's to Bankside, and Artangel's multifarious events. Since

1995, in order to promote British-based activities internationally, Bolton and Quinn have also been affiliated with New York consultancy Ruder Finn Arts & Communications, as well as being involved with projects taking place overseas, such as the new Guggenheim Museum in Bilbao.

While they may only cover a small fraction of art activity in this country, Bolton & Quinn have had considerable impact over the years. Ironically, they have become famous as profile raisers despite the fact that they have a strong aversion to publicity about themselves. Not only has their light-footed mode of operation enabled many individual projects to reach a successful fruition, but their ability to deliver the goods and understanding of the intricate machinations and manifestations of the art world has had a knock-on effect for a more widespread and intelligent awareness of contemporary art in the general national consciousness.

MARK DARBYSHIRE
Darbyshire Framemakers

These days, art may come in myriad forms, but how it is framed and presented is as important as ever. For today's artists the frame is more than a finishing touch, it is a crucial part of the work itself. This applies equally to Sarah Lucas' tough-girl self-portrait photographs encased in industrial MDF; the vast Perspex frame for Sam Taylor-Wood's four-metre-long photograph *Wrecked* (1996); or Tracey Emin's shrine-like arrangement of tiny, blue-sprayed votive receptacles that contained her teeth, diary pages, medical reports and IUD in the South London Gallery's *Minky Manky* exhibition in 1995.

All of the above were produced by Mark Darbyshire who custom-makes frames, cases and even furniture for artists ranging from Rachel Whiteread and Antony Gormley to Damien Hirst and Gillian Wearing. What makes Darbyshire so attuned to the needs of artists is that he is one himself. After completing a BA in Fine Art at Goldsmiths in 1986, he spent five years creating his own paintings before gradually moving into more and more framing work initially just for his friends and then for an increasing number of galleries and individuals from Interim Art to the Tate. The artist Glen Seator recently set the company one of its more challenging tasks by requesting a full-size reproduction of the entrance to White Cube to be built within the gallery space itself.

Although they may be made in unusual shapes and materials, Mark

Darbyshire's frames still have to meet the conventional exacting archive standards: they must preserve as well as contain the artworks. The inside of Sarah Lucas' MDF frames, therefore, had to be treated with a neutral, water-based sealant to protect the photograph from chemicals leeching out of the wood, just as the Formica frames for Damien Hirst's butterfly paintings also contained mothballs and desiccating silica crystals to keep all forms of disintegration at bay.

ANTHONY FAWCETT

Founder/Director, Anthony Fawcett Consultants

Anthony
Fawcett
Photo: Peter Fleissig

Go to almost any contemporary art event, whether it's a performance in a Soho basement by Angus Fairhurst's art band Lowest Expectations, or the latest large-scale project by Artangel, and what everyone will be drinking will invariably be Beck's Bier. Over the last decade the British art world has been engulfed in a tide of this Bremen-brewed beverage while the Beck's logo has become the ubiquitous symbol of the latest and trendiest in contemporary art. Even when the Walker Art Center in Minneapolis put on its British art blockbuster *'Brilliant! New Art From London* in 1995, it was Beck's who were the corporate sponsor.

The man behind this fruitful marriage of British art and German beer is arts consultant Anthony Fawcett. In 1985 he was taken on by Scottish and Newcastle Breweries to find a stylish, youthful market for a little-known German pilsner that they had started to import into Britain the year before. Now the softly spoken, sharp-suited Fawcett is one of the most powerful and courted figures in the art world, handling an annual budget of over £500,000; which, as far as Beck's is concerned, is a small price to pay for a marketing coup that continues to keep their brand up with the top three bottled beers in the country – without having to pay for too many lavish commercials and billboard campaigns.

Pale of face and slight of stature, Fawcett doesn't look like a typical PR man – and he isn't. He has carved out a very particular niche in today's hybrid culture where art, style and popular culture all – with the right handling – can be made to mix, match and make money. Having dropped out of studying Art and Art History at Oxford's Ruskin School, Fawcett switched to writing art

criticism for *Vogue* before his enthusiasm for Yoko Ono's Fluxus work resulted in two years' employment as John and Yoko's right-hand man, art advisor, and orchestrator of John Lennon's Peace Campaign of 1969-70. 'If anyone in the world wanted to get to John Lennon, whether it was Salvador Dalí or Harold Wilson, they had to come through me ... a very strange position for someone who was only twenty years old.' This was followed by a spell in Los Angeles, doing PR for rock performers such as Crosby, Stills, Nash and Young, The Eagles and Joni Mitchell, before Fawcett returned to England where he paved the way for a seamless transition into arts sponsorship by writing art criticism for the newly launched style bible, *The Face*.

In the financially booming, image-obsessed 1980s, focusing on art was a canny commercial strategy. However, art sponsors come and go – and in the contentious sphere of avant-garde art they tend to do more of the latter. But thanks to Fawcett's astute choices of project (the sponsorship programme really took off when Beck's backed Gilbert and George's hugely successful 1987 Hayward Gallery exhibition), as well as bright ideas like commissioning limited-edition bottles with artist-designed labels, Beck's Bier has proved to be not just a stayer but a heavy investor in the future. In addition to the complimentary crates that lubricate opening nights across the UK, and financial backing for selected shows at prominent public galleries, Beck's has taken the unprecedented step of instigating new work. Since 1993 it has been committed to commissioning an annual project from the Artangel Trust, of which Rachel Whiteread's *House* was the first.

Now that he has tied in Beck's US launch with the sponsorship of America's leading contemporary art showcase, the Whitney Biennial, as well as collaborating with New York's Public Art Fund on the financing of Rachel Whiteread's 1998 translucent resin watertower on the corner of Manhattan's Grand and West Broadway, Anthony Fawcett's influence in the international, as well as the British, art world continues to expand, along with his Beck's budget. However, Fawcett's particular brand of what he calls 'cultural engineering', which in the past has led to collaborations between his friend Dave Stewart and Damien Hirst, and the sponsorship of Richard Wilson's radical 1996 Serpentine Gallery show by the department store Selfridges, means that his very particular powers of persuasion will continue to extend beyond the promotion of small green bottles.

JIM MOYES

Founder and Chairman, Momart, PLC

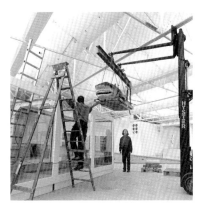

Momart at the Saatchi Gallery in 1992 installing **The Physical Impossibility of Death in the Mind of Someone Living** (1991, tiger shark, formaldehyde solution, glass, steel, 213 × 518 × 213 cm) by Damien Hirst (right)

Photo: Anthony Oliver

Most people never become aware of the intricate procedures that lie behind the mounting of an art exhibition. Indeed, if the installers have done their job properly, they shouldn't. And the most invisible but ubiquitous of all art handlers is Momart. You name it – a bisected cow and calf, a head made from frozen blood, or the V & A's Raphael Cartoons – Momart will transport it, install it, take it down, put it back or keep it in storage. From a single blue Austin van, bought for £150 in 1971 and kitted-out with some carpet off-cuts and pieces of string, to today's fleet of climate-controlled, custom-built 'Fine Art vehicles', complete with jolt-free air suspension and padded leather panels, Momart has come a long way in providing the continuous road show that is a crucial but unsung part of the art world.

Pretty much every major art exhibition, contemporary and otherwise, both within and emanating out of the UK, from the Royal Academy's Poussin show, to *'Brilliant! New Art from London* at the Walker Art Center in Minneapolis, has involved the services of Momart. Their east London warehouses contain all the major names – racked, packed, labelled and kept at a steady 20°C. (Never mind what they hold, the crates themselves are works of art, hand-constructed in wood, painted in different colours – one for every major gallery – and lined with acid-free foam specially carved to fit each object.)

Every piece Momart handles poses particular and sometimes substantial problems. In 1992, in order to place Richard Serra's massive steel slabs in the Saatchi Gallery, part of the space had to be demolished. When Richard Wilson's *20:50* was installed at Matt's Gallery, and later at the Saatchi Gallery, the oil had to be pumped in from a tanker. The tiger shark for Damien Hirst's notorious *The Physical Impossibility of Death in the Mind of Someone Living* arrived from Australia deep-frozen ('like a giant fishfinger' as a Momart staffer has memorably described it) and could only be installed after it had been defrosted and fixed in a solution of formaldehyde in a gigantic holding tank by technicians wearing protective paraphernalia.

All this tender loving care goes far beyond good business practice. What distinguishes Momart from other art movers is a genuine love of and ongoing

involvement in the art with which it deals. Jim Moyes, the company's founder and guiding spirit, studied sculpture in the 1960s and took a temporary job painting gallery walls and hanging shows for the Marlborough Gallery as an ex-student with a wife and young child to support. When he was asked to make plinths for sculpture and to carry out various technical jobs for gallery artists such as R.B. Kitaj and Barbara Hepworth, Moyes spotted a gap in the market and in 1971 'Jim Moyes' Compendium of Working Possibilities' was born. True to its name, the company entered into and 'muddled round' every problem of the exhibition process, and Momart, as it was re-christened in 1980, has evolved into today's high-tech enterprise, employing more than eighty people, and becoming in 1993 Transporter of Fine Arts by Appointment to Her Majesty the Queen.

Even though he has recently restructured the company so that he can go back to the studio and make his own work, Moyes continues to be a very hands-on boss, and his down-to-earth presence is felt throughout every part of the art world. As well as shifting art he also promotes it: Moyes is deputy chairman of the Contemporary Art Society, his offices are lined with works by friends such as Gillian Ayres and Bruce McLean (he made a memorable appearance in McLean's film *Urban Turban* as 'The Hatless Shipper'), and many artists supplement their income by working part-time at Momart. There has been a Momart Fellowship at Tate Gallery Liverpool for an artist every year since the opening of the building; and among the many organisations and events supported by Momart have been *The Whitechapel Open*, the 1995 *British Art Show* and the 1996 Lucian Freud exhibition at Abbot Hall, Kendal. He may not have a high public profile, but within the art world Jim Moyes continues to be the provider of a compendium of working possibilities.

MICHAEL SMITH

M.J. Smith Design and Fabrication

Mike Smith has made some of the most talked about pieces of contemporary British art. His work is currently on display in major museums and collections worldwide. Yet, outside a small circle, he is virtually unknown. For Smith is what the art world calls a 'fabricator' – he's the man who actually makes the stuff. Ever since the Renaissance, artists – when they could afford it – have employed workshops of skilled assistants and craftsmen to paint parts of their canvases or to cast their sculptures. Today it is Smith who is the man behind

key pieces by artists such as Damien Hirst and Mona Hatoum – they bring him the ideas, and he turns them into finished art works.

These ideas may sound simple, but the logistics can be nightmarish. For Damien Hirst's 1996 New York exhibition at Gagosian Gallery, Smith was asked to construct two mechanised glass and steel tanks that would contain two and a half tons of bisected pig and formaldehyde solution and be capable of making consistent slicing movements without disrupting the contents. He also designed and made the gizmos that enabled Hirst's two-metre spin paintings to whirl on the wall and the twelve tanks that housed the sliced-up cows in the sculpture *Some Comfort Gained from the Acceptance of the Inherent Lies in Everything* (1996).

Smith and his assistants have also made the glass-walled, stone-floored chamber, *Confessional* for Cathy de Monchaux, metal chairs and beds for Mona Hatoum and a giant shredder for Michael Landy's *Scrapheap Services* installation, among other well-known works. 'What I'm doing is solving problems of design and problems of aesthetics within a set of parameters, a sort of specialised engineering', he says. Even as a fine art student at Camberwell, when he won a *New Contemporaries* sculpture award, Smith always helped other artists with fabrication difficulties. Now, more than a decade on, he works for over fifty artists worldwide and the number is increasing.

MARK STEPHENS
Founder, Stephens Innocent

When artists need legal advice – and in these censorious and hard-nosed times they frequently do – they tend to head for Stephens Innocent, the law firm that specialises in artists' needs. When, in 1987, the Bank of England prosecuted American artist J.S.G. Boggs under the 1981 Forgery and Counterfeiting Act, it was Mark Stephens who organised the case, appointed Geoffrey Robertson QC to defend him, and accepted five of Boggs' limited edition £1 notes in payment for his successful defence. Unfortunately however, when the police seized Rick Gibson's pair of freeze-dried foetus earrings from the now defunct Young Unkowns Gallery in 1988 under an ancient common law offence of 'outraging public decency' Stephens and Robertson were less successful, revealing an ominous chink in art's armour: work can be withdrawn without having recourse to expert opinion or discussions around the defence of the public good.

Mostly, the work carried out by Mark Stephens and partner Robin Fry is on more mundane (but no less crucial) commission agreements, gallery contracts, copyright infringements, compensation for damaged works and public commissions.

Stephens, the son of a painter, began his law career representing musicians, and first became involved with the legal needs of artists in 1976 when he was made Legal Director of an organisation called Art Law set up by long-term artists' supporter Henry Lydiate. When the Art's Council's core funding for what had become a national legal advice centre for artists was cut in 1984, it was incorporated into Stephens Innocent as a private law firm, and, as Stephens remembers, 'artists came and we gave them advice which, instead of being free, was funded by legal aid, as all of them qualified!' Many still do, although the artistic scope of Stephens Innocent now spans the representation in this country of the estates of Picasso and Matisse, the legal underpinning for such public projects as Rachel Whiteread's *House,* or the defence of Anthony Noel Kelly, accused of stealing dead bodies for the purpose of taking casts from them.

BEN WEAVER

Communications Manager, Habitat

There's nothing novel in the relationship between art and shopping. Most major department stores sell pictures of some kind or other – Harvey Nichols in London's Knightsbridge has even launched a supermarket-style 'Art Market' where shoppers can browse through open stacks of paintings, prints and drawings. However, Habitat, the chain founded in the 1960s by design evangelist Terence Conran, is now going back to its original vision of blending art, design and commerce with its rolling programme of contemporary art exhibitions in stores across the country. These combine some of the big names of current British art with young newcomers, often from local art schools.

In the early 1970s Habitat had perked up the British aesthetic consciousness by commissioning special prints from Peter Blake, Eduardo Paolozzi and David Hockney. In the 1990s it has resurrected this practice with a collection of limited edition prints from Gary Hume, Gillian Wearing, Gavin Turk, Martin Maloney and Anya Gallaccio. But the difference is that all these artists, along with many others, have each made conspicuous contributions to Habitat's exhibition programme: Anya Gallaccio has threaded chains of

Gary Hume
**My Aunt and I
Agree**
1995
200 × 1100 cm
installed at
Habitat, King's
Road, London

gerberas throughout the Tottenham Court Road branch; Tracey Emin has written heartrending sentiments on Habitat pillows, and recounted incidents from her early life while standing at a till; while Gary Hume's massive eleven-metre painting *My Aunt and I Agree* (1995), now in the Saatchi Collection, was made specifically for the stairwell leading up to the bedding section of Habitat's store in London's King's Road. Like any gallery, Habitat has exhibition openings, a mailing list and takes 40 per cent commission on sales.

The man responsible for this new context for art is Ben Weaver, who, after studying History of Design at the Royal College of Art, was appointed as Habitat's Art Co-ordinator in September 1995 when the company wanted to improve its range of prints and posters. Now Habitat's Art programme is burgeoning, and Weaver has given up his other life as a lecturer in Art and Design at Kingston University to become head of the store's Communications department and one of the art world's more influential, if low-key figures. In addition to the exhibitions, Weaver-inspired art interventions include Habitat's good-looking, give-away quarterly Arts Broadsheet, listing exhibitions in venues across the country; an increasing number of sponsored shows and art-school scholarships nationwide; and even, in the year of the Tate's Centenary, a special Habitat range of house paints with suitably artistic (if art historically mysterious) colours such as Abstract Green, Minimal Blue and, of course, Pure White.

EDWARD WOODMAN

Photographer

While the whole point of an art installation is first-hand experience, if you can't manage a direct encounter, the next best thing is to look at a picture by one of the specialist art photographers such as Hugo Glendinning, Anthony Oliver, Stephen White, or the longest established of them all, Edward Woodman.

Photographing art is an art in itself, and photographing installations is the hardest task of all. Yet the temporary nature of this multifarious area of art practice means that it relies more strongly than any other on the photographic

image for its place in posterity, and Edward Woodman is the photographer chosen by many British artists to immortalise their pieces. Perhaps it was a childhood spent watching movies from the projection box of an east London cinema, where his father was manager, that gave Woodman an affinity with intense visual experience, leading to a job producing TV stills. It wasn't until 1981, when he received a commission to produce photos for the catalogue of the ICA and Bristol Arnolfini's enormously influential *Objects and Sculpture* exhibition (which provided an early launchpad for Richard Deacon, Antony Gormley, Edward Allington, Anish Kapoor and Bill Woodrow) that he started working first with sculptors and then with artists in all media, both helping them to make and record their work.

Woodman has been responsible for pinning down some of the most elusive, ephemeral and evanescent artworks made in this country over the last decade. Whether Helen Chadwick's *Blood Hyphen* (1988), where a single red laser beam in a London chapel pierced the darkness to illuminate a photographic panel of the artist's blood cells; Anya Gallaccio's twenty-one whistling metal kettles installed in the chimney of an old pumping station in east London (*in spite of it all* 1990); Ron Haselden's strings of flashing LED lights that defined their surrounding space in his *Coliseum* (1989); or the perfectly reflecting oil surface of Richard Wilson's *20:50* (1987), it was Woodman who had the necessary technical know-how and ability to work with the artist to produce the images that captured the piece.

When the precocious Damien Hirst and his Goldsmiths contemporaries wanted to put on the slickest possible exhibition of their student work, Edward Woodman was the obvious choice for the catalogue images, and the subsequent reputation of *Freeze* relies more on Woodman's pictures than the memories of the few people who actually visited the show. The cluster of high-profile, high-production-value exhibitions of the early 1990s – *Gambler* (1990), *Modern Medicine* (1990) and Michael Landy's *Market* – relied on the camera of Edward Woodman to make the work continue to live up to its reputation

Not only does Edward Woodman record the work and exhibitions of innumerable artists both in Britain and internationally, he also helps many of them to make their art. The artists may have the ideas, but Woodman provides the equipment and technical expertise to turn those ideas into images (he calls himself 'the camera operator'). The striking pictures of flattened objects in Cornelia Parker's artist's book *Lost Volume, a Catalogue of Disasters* (1993) rely for their almost physical presence and impact on Woodman's lens; and other crucial collaborations include producing the Cibachromes for sculptor Edward Allington's *Pictured Bronze* series in 1990;

travelling to Cairo with Hannah Collins in 1987 to make desert photographs on a large-format camera for her *Heart and Soul* series; and producing all the images for Helen Chadwick's *Meat Abstract*, *Meat Lamps* and *Wreaths to Pleasure* photopieces. If these artists were film directors, Woodman would be their cinematographer – without whom the picture could not be made.

JOHN WYVER
Chairman, Illuminations Television

With their shared desire to feed off and engage with all forms of our culture, it would seem that contemporary art and television should be a match made in heaven. Instead, the relationship is frequently either one-sided (celebrity presenter dominates proceedings and art barely gets a look-in); patronising (art is subsumed by gimmicky packaging); or just plain abusive (art is treated as elaborate joke at the public's expense). One of the few programme-makers to explore the creative potential of representing the visual arts on TV is John Wyver, who, since he co-founded his production company Illuminations in 1982, has been responsible for producing programmes on subjects ranging from Sandy Nairne's six-part series on the art and ideas of the 1980s ('State of the Art', 1987) to a profile of Sarah Lucas ('Two Melons and a Stinking Fish' 1996) and a two-hour, live broadcast from the opening of *Documenta* 1992 ('Round IX').

John Wyver began his career as Television Editor of *Time Out* magazine, and his passionate interest in the medium is reflected by his extensive writings and lectures on television and new media technologies. Although, in person, Wyver comes over more as a benign academic than a high-tech media whizz- kid, it's easy to be deceived by his unassuming presence. In fact, this man has his finger firmly on the various pulses of the communications future. His interest in new art and ideas extends across the various disciplines and is reflected in the programmes he has produced for BBC2 since 1994 as editor of its arts strand 'Tx' and in the ground-breaking computer series 'The Net'. The latter has pioneered innovative linkups between television and the Internet, including an interactive, on-line, virtual world called 'The Mirror', co-created by Wyver himself.

Wyver and his team not only break new ground with their choice of subjects, but they also use television as an artistic medium in its own right. It was Illuminations that gave international video artists their first airing on

British television, with its two-series of 'Ghosts in the Machine' for Channel 4 (1986 and 1988) and with 'White Noise', a selection of video and electronic work for BBC 2 (1990), exploring innovative and appropriate ways of presenting different artists and their work. The American photographer Nan Goldin was directly involved in making the film about her life and work 'I'll be Your Mirror' (1995); while the Sarah Lucas documentary was shot by director Vanessa Engle on a hand-held digital camera, which allowed an appropriately immediate, intimate and rough-edged view of Lucas and her milieu. It is this dedication to exploring the innovative presentation of different artists and their work that, since 1993, has given Illuminations the prestigious job of making Channel 4's Turner Prize documentaries where the quality of the films on the shortlisted artists are one of the few things about the prize upon which pretty much everyone can agree.

THE COMMENTATORS

CONTEMPORARY ART IS DEPENDENT FOR ITS
DOCUMENTATION, CRITICAL AND PUBLIC
PROFILE, EVEN ITS SPONSORSHIP, ON THE
PEOPLE WHO WRITE ABOUT IT IN THE POPULAR
AND SPECIALIST PRESS. THE FOLLOWING
CRITICS ARE ITS MOST INFLUENTIAL,
SUPPORTIVE AND PERCEPTIVE CHAMPIONS.

RICHARD CORK

Chief Art Critic, *The Times*

Richard Cork is a rare species among newspaper art critics of his generation:
he gives the very latest in contemporary art as much consideration as he allots
to established artists who have already acquired a reputation. This may seem
the obvious – indeed the only – thing for an art critic to do, but many of his
colleagues in the national press still feel that art should know its place, which
is firmly on a plinth, or in a frame, credible only if it displays as much perspira-
tion as inspiration on the part of its maker. It is therefore especially important
for radical art to have an ally at the heart of the establishment – in addition to
being chief critic for the *Times* since 1991, Richard Cork has a three-year
voluntary commitment to chair the Arts Council of England's Visual Arts
Panel. This standard art-world practice by which a few figures perform a
variety of interconnected roles – Cork has also curated exhibitions – has been
criticised by some, but is seen by those in question as a labour of love for which
they receive unjustified flak.

Cork's training is as an art historian, and his great passion is European art
of the first half of the twentieth century (he has written books on Vorticism

and David Bomberg and curated a major exhibition about art and the First World War, *A Bitter Truth: Avant-Garde Art and the Great War*, which was held in Berlin and London in 1994). However, an early encounter with Richard Long's work during the 1960s pointed him towards modern British sculpture, and an enduring support for the work of Tony Cragg, Richard Deacon, Bill Woodrow and Anish Kapoor as well as more recent arrivals such as Cornelia Parker, Anya Gallaccio and Rachel Whiteread.

Both in his column in the *Times* and in previous posts on the *Listener* and as art critic for the *London Evening Standard* (a job he held from 1969 to 1983, when, on a black day for contemporary art, he was succeeded by Brian Sewell), Richard Cork has consistently turned a clear eye and lucid prose towards the latest in art practice. In addition, he has nailed his avant-garde colours to the mast by being one of three selectors for the *British Art Show 4*, which toured Great Britain between 1995-6 with twenty-six artists (many of whom are in this book) described by Cork as thriving on a 'bracing diet of irony and scepticism'.

MEL GOODING
Writer and curator

'I hate the notion of interpretation, I hate the notion of explanation' declares Mel Gooding in what might sound like a surprising statement for an art critic. Just for the record, he isn't that wild about art history either and feels that art should not be looked at as evidence of something else outside it: 'art isn't about issues it is about realities, art creates realities.' It is this passionate dedication to art not just as a part of life but as a force of life itself that comes through Mel Gooding's writing. He is as informed about the history of art as anyone, and as aware of the surrounding cultural and political terrain, but what sets Gooding apart from many visual arts writers is his adamant belief that the starting point for a critic should be looking carefully at the work itself to see how its overall effect is dictated by its specifics, independent of any historical setting.

This approach has its origins in Gooding's early career when, throughout the 1970s, he taught literature and poetry. His roots, therefore, are in the written word, and although he has been concentrating on art since the late 1970s he continues to subscribe to the view of the literary critic F.R. Leavis that the critic must first and foremost examine the text, or in this case, artwork, and provide no answers, only clues. This strategy is especially conducive to the

examination of paintings, and despite the fact that his interests spread into all media (he was on the Turner Prize jury in 1996 when it awarded the prize to Douglas Gordon, the first artist using the moving image to win), it is painting that is Gooding's greatest love.

Whether he is discussing the wryly subversive painted texts of Simon Patterson, the lyrical images of St Ives artist Patrick Heron, or the vivid, flamboyant gestures of abstract painter John Hoyland, Gooding's ability to make his style of delivery reflect and illuminate his subject matter is particularly important in the context of today's artistic climate. Unlike so many writers who try to pin down in prose the most elusive qualities of painting, Gooding does so in a way that is devoid of nostalgia, with his enthusiasm for the medium couched in terms of possibilities, rather than the staking out of territories.

For his own part, Gooding himself is not restricted to one medium. As well as writing for art magazines (especially *Art Monthly*), contributing to exhibition catalogues, and sitting on several panels and committees, he also collaborates on a variety of projects, both within and around the art world. In 1985 he set up Knife Edge Press with Bruce McLean, where he worked on eight original artists' books and other print-related projects. He has also teamed up with the architect Will Alsop on a number of projects, including radical proposals for a new Tate Gallery at Bankside. Since 1996, Gooding has been the director of 'A', a ground-floor space at the London offices of Alsop and Störmer which, in the words of its launch statement: 'provides space for actions, events, installations or presentations in any appropriate media, especially for work that might not find a subsidised or commercial venue.'

SARAH KENT

Visual Arts Editor, *Time Out*

Over more than twenty years of covering visual art for London's *Time Out* magazine, Sarah Kent has been an energetic chronicler of the contemporary, hoofing off to the most obscure and inaccessible venues long before it became fashionable for art to be exhibited in unusual places, and championing both young artists and writers at the beginning of their careers. Now, thanks to Kent's continuing support of the latest and the experimental, the magazine lists several categories of 'alternative' spaces, and a review in its pages carries far more weight than you'd imagine from the capital's weekly listings guide.

Kent's personal influence also extends beyond this outlet: she curates exhibitions, sits on panels, and on television and radio she is often pitched against more conservative elements as a animated advocate of the wilder shores of today's art.

Sarah Kent's roots are in the radical era of the late 1960s and 1970s, in which Feminism emerged as a fully fledged movement and polemic wasn't a dirty word. After studying painting at the Slade she worked as an artist until 1977 when she became Exhibitions Director at the ICA, writing for *Time Out* at the same time. In her two years at the ICA, exhibitions of Andy Warhol, Allen Jones and Christo were mounted as well as more overtly political shows, such as an exhibition of paintings by the feminist artist Alexis Hunter, and the show *Berlin a Critical View: Ugly Realism*, which compared the satirical art of Berlin in the 1920s with that of the 1970s. During this period she gave up painting and began taking photographs, mainly of male nudes.

Kent has described her role as that of 'spokesperson, especially for women artists, in a country that essentially is hostile to contemporary art'. This stance was underlined in the book *Women's Images of Men* (1985) co-authored with the artist Jacqueline Morreau, as well as in the more recent women-only exhibitions she has curated such as *Peripheral States* (Benjamin Rhodes Gallery, 1993) and *Whistling Women* (Royal Festival Hall, 1995), which included an installation by Anya Gallaccio, a reading by Tracey Emin, and videos by Lucy Gunning, Tacita Dean, Sarah Lucas, Gillian Wearing, Jane and Louise Wilson and Catherine Yass.

As regards the gender issue, Kent now says that her 'partisan approach is giving way to ... a passionate neutrality'. Over the last decade her passions have become focused on the new wave of young British artists that began to emerge in the late 1980s. Many of these artists are represented in the collection of Charles Saatchi, and Kent is unapologetic about the fact that, since 1991, she has written a number of catalogues for their shows at Saatchi's gallery whilst reiterating her enthusiasm for their work in *Time Out*. It was in the first exhibition of Saatchi's open-ended series *Young British Artists* in 1982 that Damien Hirst's infamous shark made it debut appearance, and this iconic artwork inspired the title of *Shark Infested Waters* (1994), Kent's informative account of thirty-five artists from the eclectic holdings of Britain's best-known contemporary art collector.

MARTIN MALONEY
Artist, curator and writer

Martin Maloney
with his
**Untitled Portrait
(Orange)**
1996
oil on canvas
110 × 173 cm
Photo: Andrew
Montgomery

Martin Maloney is one of the latest and most blatant members of an increasingly mongrel British art scene that no longer considers it bad taste to draw attention to yourself – and where artists simultaneously write, curate and create in order to do precisely that. All Maloney's activities feed into each other in a way that reflects an increasing tendency for art to merge with milieu and lifestyle. After studying art at Central St Martins and Goldsmiths (with additional educational sojourns at University of Sussex, London College of Printing, School of Visual Arts, New York, and the Novia Scotia College of Art and Design), he has boosted his own career as an artist by identifying, writing about and curating shows of a new movement that he dubs 'Wannabe' art. These exhibitions, showcasing his own work and that of his contemporaries, were often held in the grungy surroundings of his flat and employed unforgettable titles such as *Multiple Orgasm*, *White Trash*, *Gothic*, and *Guess Who's Coming to Dinner*.

According to Maloney, Wannabe art is 'made with a simplicity of materials and an imagination spawned in the boom-times. Everything is relaxed: it's okay to be dumb and to like things just because they look good ... desire, difference and the body are alive, but have let down their hair to party'. There's nothing reticent or tasteful about Maloney's lapel-grabbing approach: his paintings are deliberately 'bad' ('they hover half way between colouring-in and expressive painting' he has said); and his writing is unashamedly blunt ('I look at the work of Jake and Dinos Chapman and I feel deep embarrassment and utter boredom', he stated in *Flash Art* in Jan/Feb 1996, sparking an infamous spat with the artists).

So far these tactics seem to have achieved their aim. From April to December 1995, the art world trecked out to Maloney's home-gallery 'Lost in Space' and now his squiffy portraits and sloppy flower paintings are given solo shows in real, white-walled galleries, while many works by fellow Wannabes such as the pin-up-meets-Manga-cartoon cut-out figures of Jun Hasagawa, the text and pattern paintings of Peter Davies, and the painted guinea pigs of Dan Hays have been snapped up by leading dealers and are housed in major collections. Charles Saatchi is a particular fan, and in September 1997 Maloney put on his writer's hat to contribute to the catalogue of *Sensation*, the Saatchi collection's

airing at the Royal Academy that also included Maloney's own paintings. Maloney has described the work that he shows, makes and writes about as 'Neo Naive art – simple art for clever people', but in the breezy, low-rent and often nihilistic world of today's art, nothing is quite as simple as it seems.

STUART MORGAN
Critic

Stuart Morgan (left) and Adrian Searle (see p 150)
Photo: Cindy Palmano

In 'Homage to the Half Truth', a paper delivered to an art-writing conference in 1990, Stuart Morgan said that 'critics should be respected for their capacity for intuition, sympathy and imagination ... And no definition of criticism should omit this element of artistic inspiration'. Later on, however, he adds a destabilising note: 'Critics operate as double agents, at an interface between artist and audience, seeming to speak for both sides while making both equally mistrustful. But suspicion is in order. Whose side are critics on, after all? ... The critic is on the critic's side, for criticism means reserving the right to take any side at all'.

It is Stuart Morgan's rare ability to fulfil all the above criteria that makes him our pre-eminent art critic. Although he may be little known outside the art world, Morgan has undoubtedly been one of the most original and influential writers within the contemporary art scene. He is as inventive as an artist in what and how he writes, but doesn't get in the way of the art itself; he can be deadly serious without ever taking himself too seriously, and he combines awesome erudition with easy accessibility and a relish for the subversive. (In one short catalogue essay his references span physicist David Bohm, Situationist Guy Debord, Post-Modernist Jean-Francois Lyotard, James Gleick's book on Chaos Theory and Yogi Bear.)

Nowhere is Morgan's rigorous playfulness more evident than in his many published interviews, which are lively, informal exchanges, gripping in their own right, while at the same time drawing out important and often unexpected insights about how artists from Joseph Beuys to Louise Bourgeois to Damien Hirst and Tracey Emin think and work. His interview with Richard Wentworth for his first Lisson Gallery exhibition in 1984 still stands as the most revealing account of the thinking behind his sculpture. It is rare for a writer to be this creative in allowing others to expose their creativity.

An unpredictable and irreplaceable presence within British art, for more than fifteen years Morgan has written some eighty one-person catalogue essays for public institutions, commercial galleries and artist-run venues, and has taught in most of our leading art schools. (He is currently a tutor at the Ruskin School in Oxford.) His writings have been published by virtually every major British art magazine, as well as many in Europe and America. During the 1980s he made his mark contributing to – and for a time editing – the now defunct *Artscribe*, which, before it folded in 1990, was Britain's leading magazine of contemporary art; and he continues to be a major contributor to its 1990s successor *Frieze*, which, in 1996 launched its own publishing arm with a volume of Morgan's writings under the typically droll title of *What the Butler Saw*.

With characteristic perversity, Stuart Morgan continues to be both at the centre of the art world yet doggedly independent of it. Like one of his favourite artists, Louise Bourgeois, he dislikes conformity and consistency, and this is probably why he continues to be treated with some suspicion by the arts establishment. (He co-curated the Tate's only major exhibition of contemporary art in the 1990s, the 1995 *Rites of Passage*, yet he has twice refused to be a judge of the Turner Prize, and is one of its most vehement critics.) However, although they may not always admit it, Morgan's opinion is one of the few that today's artists respect and take notice of.

JAMES ROBERTS

Exhibition curator and writer, Reviews Editor, *Frieze* Magazine

The same age as many of the artists he writes about, since leaving the Courtauld Institute in 1988 James Roberts has made a point of examining the successive waves of artists emerging during the 1980s and 1990s, pointing to areas of common ground, significant shifts of emphasis and drawing distinctions with intellectual acuteness and lucidity.

There are many young writer/curators currently making their mark within the art world, but Roberts is particularly important, not just for showcasing the most recent work but also for presenting it within a broader context. The catalogue he edited and co-authored for the British Council's *General Release* exhibition of fifteen young British artists for the 1995 Venice Biennale, for example, gives a definitive account of the social, economic and cultural climate surrounding their work, while some of Roberts' best early writings

focused on older artists such as Simon Linke, Julian Opie and Richard Wentworth, whose playful and cerebral investigations of our seemingly banal surroundings continue to have a strong resonance for many younger artists working today.

Roberts based his MA thesis on post-war Japanese art, and, as well as writing extensively on the contemporary Japanese art world, he has curated a number of exhibitions of British art in Japan. His three-part *High Fidelity* at the Kohji Ogura Gallery not only introduced a range of British artists to a Japanese audience but also, by presenting Thomas Gidley with Douglas Gordon, Rachel Evans with Georgina Starr and Adam Chodzko with Simon Patterson threw up new links and differences between the individual artists. In *Beyond Belief* at London's Lisson Gallery in 1994, Roberts presented more artistic interconnections, juxtaposing the work of British artists such as Jane and Louise Wilson or Thomas Gidley – whose work patrols the territory between incident and phenomenon – with kindred-spirits from France and the United States.

Both as a curator and a writer, Roberts is unerringly deft in his ability to clarify without simplifying. He is the master of the unexpectedly pertinent analogy: an essay on Julian Opie, for example, begins with a celebration of Tintin the modern hero; or a discussion of Adam Chodzko's navigation of the classified columns is prefixed by an analysis of Sherlock Holmes' quest for greater and darker truths. As a result, he adds a new richness and depth to our understanding of British art.

ADRIAN SEARLE

Chief art critic, *The Guardian*

Very few writers make the crossover from the meditative pace of specialist arts press criticism to the pithier delivery of a newspaper column. However, Adrian Searle is an exception. Both his regular pieces for *Frieze* magazine and his weekly articles in the *Guardian* are required reading, not just for their refreshing directness and sometimes hilarious ability (especially in the newspaper) to deliver a savage put-down; but also for his genuine creative skill as a writer.

Like many apparent cynics, Searle is a romantic at heart. When he permits his sardonic guard to fall and lets his emotions off the leash he can be almost achingly poetic. Reading his response to the late works of Willem De Kooning,

the photographs of Craigie Horsfield or the paintings of Luc Tuymans it is not surprising to learn that he also writes fiction. Unlike so many newspaper critics Searle is capable of evoking the appearance and impact of even the most elusive artwork, and clarifying the most cerebral of gestures in a way that is always personal and never pompous. His essay for Michael Craig-Martin's 1997 exhibition at Waddington Galleries for instance, is a study in how to make writing style work in tandem with artistic subject matter.

This clarity of delivery is perhaps in part due to the fact that commenting has been combined with the direct experience of communicating: like many of our best writers on contemporary art, Searle has a long history of teaching in art schools, including Central St Martins from 1981-94; Chelsea from 1991-6 and Goldsmiths from 1994-6. As well as curating several exhibitions (most recently *Unbound: Possibilities in Painting* at the Hayward Gallery in 1994), Searle has also spent many years actually making the stuff. As an artist, his troubled, troubling paintings were widely exhibited both in the UK and in Europe and it was only when he took the *Guardian* job that he left the studio: 'I was always torn between making art and writing. Writing won.'

THE GEOGRAPHY

ART SCHOOLS

British art schools are the seedbeds for the country's art responsible in part, for the current boom. Their most distinctive quality is their widespread and enduring policy of employing both part-time and visiting tutors who are not just prac-tising, but also often prominent, artists or art-world figures in their own right. Goldsmiths College, for example, the Slade, and Glasgow School of Art – who are each particularly known for their promotion of the experimental and the innovative – make a point of exposing their students to a wide range of artists, writers, curators and thinkers within the art world and beyond. Additionally, unlike many art schools elsewhere in the world, where spaces are shared, students in the UK are invariably provided with their own personal studio areas in which to work unimpeded.

In recent years funding cuts and administrative upheavals have led to a glossier, more entrepreneurial climate and some schools have been accused of placing presentation over innovation. But Britain's art schools, where students tend to be treated from the beginning as artists in their own right within an atmosphere of debate and discussion, continue to be admired and envied world wide.

The make-up of the graduate and post-graduate Fine Art courses in Britain's fifty or so art schools is a moveable feast, but to get an idea of the variety, visit the degree shows (held in May/June), look at the work on show, and check out the year's roster of visiting tutors. Below is just an indication of some of the most significant establishments.

Architectural Association

34-36 Bedford Square
London WC1B 3ES
t 0171 887 4000 f 0171 414 0782
Website: http://www.archinet.co.uk/aa/
Director: Mohsen Mostafavi

While the AA is not a Fine Art school, its ongoing programme of public talks given by leaders in the contemporary art scene, and its series of adventurous exhibitions have made it a popular forum for the discussion of issues in art, as well as architecture.

Byam Shaw School of Art

2 Elthorne Road, Archway
London N19 4AG
t 0171 281 4111 f 0171 281 1632
e-mail:
info@byam-shaw-artschool.ac.uk
Website: http://www.byam-shaw.ac.uk
Principal: Alister Warman

Originally founded in 1910 as a private school of drawing and painting, during the 1980s Byam Shaw shed its genteel image and opened up its facilites to cover all media and art forms. It continues to retain independent status, has an impressive roster of visiting artists and lecturers and attracts a large number of foreign as well as British students – many of whom have gone on to achieve international careers.

Duncan of Jordanstone College of Art & Design, School of Fine Art University of Dundee

Perth Road, Dundee DD1 4HT
t 01382 345306 f 01382 200983
e-mail: fineart@dundee.ac.uk
Website:
http://www.dundee .ac.uk/FineArtRes/
Head of School: Professor Alan Robb

The School of Fine Art has achieved substantial status as one of Scotland's leading art schools. This has been a crucial factor in the award of a £5.3 million lottery grant for a new Arts Centre in Dundee (opening in August 1998), which will comprise gallery spaces, cinemas and a café, and will also house the Duncan of Jordanstone's Visual Research Centre.

Glasgow School of Art

167 Renfrew Street, Glasgow G3 6RQ
t 0141 353 4500
e-mail: d.cameron@gsa.ac.uk
Website: http://www.gsa.ac.uk
Director: Professor Dugald Cameron

Housed in Charles Rennie Mackintosh's landmark building, this is one of the few remaining independent art schools in the UK. A commitment to innovation and experiment is evidenced by the presence of many ex-students in the international art world, and an imposing list of artist-tutors of all ages promises continued success in this field.

Goldsmiths College
University of London

New Cross, London SE14 6NW
t 0171 919 7671 f 0171 919 7673
e-mail: visual-artsatgold.ac.uk
Website: http://www.gold.ac.uk
Head of Visual Arts:
Brian Falconbridge
Millard Professor of Fine Art:
Michael Craig-Martin

Goldsmiths' recent reputation as the
alma mater of many of today's high-
profile young artists is the result of a
longstanding commitment to
encourage the international and the
intellectual (John Cage, Robert
Rauschenberg and Clement Greenberg
were among the college's visitors in the
1960s), to abolish divisions between
departments, and to promote an
atmosphere of discussion and debate.

The London Institute: includes
Camberwell College of Arts;
Central St Martins College of Art
and Design; Chelsea College of Art

Main office: 65 Davies Street
London W1Y 2DA
t 0171 514 6000 f 0171 514 6131
e-mail: marcom@linst.ac.uk
Website: http:www.linst.ac.uk
Rector: Sir William Stubbs

When these three art schools merged
under the central umbrella of the
London Institute in 1986, none
benefited from the experience.
Camberwell suffered the most,
completely losing its Fine Art
Department (now reinstated). Central
St Martins College of Art and Design still
has a lively Fine Art Department with
particular strengths in film/video and
photomedia but it has never reclaimed
its erstwhile status as the centre for
British sculpture in the 1960s and
1970s. Lately, however, Chelsea seems
to have revived itself with an
atmosphere of artistic and intellectual
vigour and a particularly strong painting
department.

Royal Academy Schools

Royal Academy of Arts, Piccadilly,
London W1V ODS
t 0171 300 5650 f 0171 434 0837
Principal: Leonard McComb

A location at the heart of the historical
art establishment and corridors
crammed with antique plaster casts in
mahogany cases hasn't prevented a
spirit of artistic enquiry from pervading
the RA schools. Nowhere is this more
evident than in the student-run 'Red
Square' public programme of talks by
contemporary artists.

Royal College of Art

Kensington Gore
London SW7 2EU
t 0171 590 4444 f 0171 590 4500
e-mail: info@rca.ac.uk
Website: http://www.rca.ac.uk/
Rector: Professor Christopher Frayling

Entirely devoted to postgraduate
studies in art and design, during the
Thatcher years the RCA was criticised
for slicking up its image and scaling
down its courses with rather too much
of a commercially conscious spirit.
There's still an air of pragmatism at the
RCA, and since 1992 it has extended its
activities into the presentation,
interpretation and management of
contemporary art with a special MA in
Visual Arts Administration: Curating
and Commissioning Contemporary Art,
run in partnership with the Arts Council.

University College London,
Slade School of Fine Art

Gower Street,London WC1E 6BT
t 0171 504 2313 f 0171 380 7801
e-mail: slade.enquiries@ucl.ac.uk
Website: http://www.ucl.ac.uk/slade/
Slade Professor: Bernard Cohen

Time-honoured Slade traditions of
drawing and painting from the live
model have been augmented during the
1990s by an extensive programme of
expansion and refurbishment that
ranges from a new Slade Centre for
Electronic Media and Fine Art to an
outstanding programme of public and
open lectures. A group of full- and part-
time teaching staff includes artists of all
generations working in all media.

University of Oxford, Ruskin
School of Drawing and Fine Art

74 High Street, Oxford OX1 4BG
t 01865 276940 f 01865 276949
e-mail: stephen.farthing@

ruskin-school.ox.ac.uk
Website:
http://www.ruskin-sch.ox.ac.uk/
Master: Stephen Farthing

The Ruskin School treats the boundaries
between its painting, print-making and
sculpture departments as permeable
and open for investigation. It also
benefits from a strong academic
foundation, with a particular emphasis
on prominent visiting lecturers.
 Of particular note is **The Laboratory**,
a unit at the Ruskin that was founded in
1994 to support the production of new
work in the visual arts by promoting
collaborations between artists and
experts from the worlds of science,
technology and the humanities. Its
administrators Paul Bonaventura and
Antonia Payne invite artists at all stages
in their career to apply for attachments.
These have included Richard
Wentworth, Stefan Gec, Cornelia Parker,
Martha Fleming, Kathy Prendergast and
Simon Callery as well as 1994-6 artist in
virtual residence, Jake Tilson, whose
continually evolving website, *the cooker*,
can be found at http://www.thecooker.com.
Having no physical exhibition space of
its own, The Laboratory collaborates
with a range of organisations and sites
both in Oxford and beyond. It also
organises The Joseph Beuys Lectures in
Oxford and London and The Helen
Chadwick Fellowship in Oxford and
Rome on an annual basis.

ORGANISATIONS
FUNDERS AND FACILITATORS

The Arts Council of England,
The Arts Council of Northern
Ireland, The Scottish Arts Council,
The Arts Council of Wales

Most of the organisations and venues
listed in this section are on the receiving
end of some form of Arts Council
funding. The Arts Council of Great
Britain was founded in 1946 with the
aim of 'developing a greater knowledge,
understanding and practice of the fine
arts exclusively, and in particular to
increase the accessibility of the fine arts
to the public throughout our Realm'.

Although its remit still remains pretty much the same, in 1994 it was split into three separate bodies: the Arts Council of England, the Scottish Arts Council and the Arts Council of Wales. (The Arts Council of Northern Ireland was already an independent organisation, receiving its funding from the Department of Education for Northern Ireland.) Each of these has close links and overlaps, and collectively combine to form a ubiquitous (if under-resourced) cultural behemoth whose presence permeates most aspects of the contemporary art world.

The Arts Council of England (ACE)
14 Great Peter Street
London SW1P 3NQ
t 0171 333 0100 f 0171 973 6590
e-mail: info.visualart.ace@artsfb.org.uk
Website: http//www.artscouncil.org.uk
Director of Visual Arts:
Marjorie Allthorpe-Guyton

Throughout the English contemporary art-world administrators spend much of their time filling in applications to the Arts Council for grants, most of which are serviced by the Visual Arts Department. The organisations and galleries that it funds range from inIVA, the Whitechapel, the Serpentine, Ikon, MOMA, Oxford and the Arnolfini (who all rely on its grants to exist), to a number of educational and training projects including the postgraduate course on Commissioning and Curating Contemporary Art at the Royal College of Art. It also gives money to innumerable one-off exhibitions and individual curators needing R&D funds for a multiplicity of projects. Additionally, the Combined Arts Department supports less easily categorisable venues such as SBC and the ICA, as well as projects ranging from Artangel's extravaganzas to the performances of Bobby Baker.

ACE's Visual Arts Department is currently headed by Marjorie Allthorpe-Guyton, previously the editor of *Artscribe* and a well-known writer of essays, reviews and papers on contemporary art. Although it states that 'our funding is mainly focused on leading-edge contemporary work' the ACE gears its funding for the visual arts towards spe-cific organisations and projects, with no

grants being directly available for artists. Instead, artist funding – albeit on a modest scale – is one of the remits of England's ten Regional Arts Boards.

Regional Arts Boards (RABs)
While constitutionally independent from the Arts Council of England, the RABs nonetheless rely for the majority of their funding on the ACE, all ten RAB chairs being members of the Arts Council of England. Each Regional Arts Board can also dole out a modest range of funding to the different art forms within specific geographical boundaries. This includes a number of awards made directly to individual artists, which can vary regionally.

Eastern Arts Board
Cherry Hinton Hall, Cherry Hinton Road
Cambridge CB1 4DW
t 01223 215355 f 01223 248075
e-mail: info@eab.eastern-arts.co.uk
Website:
http://www.arts.org.uk/rab-nf.html
(Bedfordshire, Cambridgeshire, Essex, Hertfordshire, Lincolnshire, Norfolk, Suffolk.)
Director of Visual Arts and Media:
Rosy Greenlees

East Midlands Arts Board
Mountfields House, Epinal Way
Loughborough, Leics LE11 0QE
t 01509 218292 f 01509 262214
e-mail: firstname.surname followed by: .ema@artsfb.org.uk
Website:
http://www.poptel.org.uk./arts
(Derbyshire – excluding High Peak – Leicestershire, Northamptonshire, Nottinghamshire, Rutland)
Visual Arts Officer: Janet Currie
Crafts Officer: Gill Wilson

London Arts Board
Elme House
133 Long Acre, Covent Garden
London WC2E 9AF
t 0171 240 1313 helpline: 0171 240 4578
f 0171 240 4580
e-mail: lab@lonab.demon.co.uk
Website: http://www.poptel.org.uk/arts
(The thirty-two London Boroughs and the City of London)
Principal Visual Arts and Crafts Officer:
Holly Tebbutt

Northern Arts Board
9-10 Osborne Terrace, Jesmond
Newcastle-upon-Tyne NE2 1NZ
t 0191 281 6334 f 0191 281 3276
e-mail: norab.demon.co.uk
Website:
http://www.poptel.org.uk/arts/
(Cleveland, Cumbria, Durham, Northumberland, metropolitan districts of Newcastle, Gateshead, North Tyneside, Sunderland and South Tyneside)
Head of Visual Arts: James Bustard

North West Arts Board
Manchester House, 22 Bridge Street
Manchester M3 3AB
t 0161 834 6644 f 0161 834 6969
e-mail: nwarts-info@mcrl.poptel.org.uk
Website: http://www.arts.org.uk
(Lancashire, Cheshire, Merseyside, Greater Manchester, High Peak District of Derbyshire)
Director, Visual Arts and Media:
Aileen McEvoy

South East Arts Board
10 Mount Ephraim, Tunbridge Wells
Kent TN4 8AS
t 01892 515210 f 01892 549383
e-mail: info.sea@artsfb.org.uk
Website: http://www.poptel.org.uk/arts
(Kent, Surrey, East and West Sussex)
Director of Visual and Media Arts:
Margaret O'Brien

Southern Arts Board
13 St Clement Street
Winchester SO23 9DQ
t 01962 855099 f 01962 861186
e-mail:
phil.smith.southarts@artsfb.org.uk
Website: http://www.poptel.org.uk/arts
(Berkshire, Buckinghamshire, Hampshire, Isle of Wight, Oxfordshire, Wiltshire, South East Dorset)
Visual Arts Officer: Phil Smith

South West Arts Board
Bradninch Place, Gandy Street
Exeter EX4 3LS
t 01392 218188 f 01392 413554
e-mail: swarts@mail.zynet.co.uk
Website: http://www.swa.co.uk
(Cornwall, Devon, Dorset – excluding Bournemouth, Christchurch and Poole – Gloucester and Somerset and the unitary authorities of Bristol, South

Gloucestershire, Bath and North East Somerset and North Somerset)
Director of Visual Arts: Val Millington

West Midlands Arts Board
82 Granville Street, Birmingham B1 2LH
t 0121 6313121 f 0121 6437239
e-mail: west.midarts@midnet.com
Website: http://www.arts.org.uk/
(Hereford & Worcester, Shropshire, Staffordshire, Stoke-on-Trent, Warwickshire,the metropolitan districts of Birmingham, Coventry, Dudley, Sandwell, Solihull, Wolverhampton)
Director of Visual Arts, Crafts & Media: Caroline Foxhall

Yorkshire and Humberside Arts Board
21 Bond Street, Dewsbury
West Yorkshire WF13 1AX
t 01924 45555 f 01294 466522
e-mail: yharts-info@geo2.poptel.org.uk
Website: http://www.arts.org.uk
(North Yorkshire; metropolitan districts of Barnsley, Bradford, Calderdale, Doncaster, Kirklees, Leeds, Rotherham, Sheffield, Wakefield. Unitary authorities of York, Hull, East Riding, North Lincolnshire, North East Lincolnshire)
Head of Visual Arts:
awaiting appointment

ACE Collection
Curator: Isobel Johnstone
Not only does the ACE fund contemporary art, it also buys it. The Arts Council Collection was founded in 1946, the same year as the original Arts Council of Great Britain, with the aim of showing 'innovative work by British artists through touring exhibitions and long loans' and its function remains the same

today. The ACE collection forms an integral part of National Touring Exhibitions, a service administered by the Hayward Gallery on behalf of the Arts Council of England. (See Hayward Gallery.)
Now, with about thirty new works being added each year, the collection consists of over 3,000 paintings, sculptures and drawings, 1,500 artists' prints and 2,000 photographs. Artists, critics and curators (as well as Arts Council officers) are invited to act as purchasers for the collection for eighteen months at a time. Examples of works bought in 1995-6 were Shirazeh Houshiary's sculpture *Cube of Man* (1992), Antony Gormley's *Field for the British Isles* (1993), Lucy Gunning's video *The Horse Impressionists* (1994), Christine Borland's *Berlin Blanket* (1993), and Michael Craig-Martin's *History Painting* (1995).

Arts Council of Northern Ireland (ACNI)
77 Malone Road,Belfast BT9 6AQ
t 01232 385200 f 01232 661715
Director of Creative Arts Director:
Nóirín McKinney; Visual Arts Officer:
Paula Campbell

Following restructuring in 1995, Visual Arts is now part of a larger Creative Arts department that embraces painting, sculpture and installation, architecture, craft, and photography. Through the department, the Council funds a network of galleries across Northern Ireland, notably the Orchard Gallery in Derry and the Ormeau Baths Gallery in Belfast. Other departmental aid is allocated to artists' studios and to organisations, as well as to an annual

fellowship in New York and a bi-annual residency in Rome. The department also makes modest but crucial awards directly to individual artists in any of the above disciplines to 'buy time' to complete creative work, pursue specific projects or undertake specialist training. This artist-friendly policy includes working closely with the Irish Arts Council in Dublin on such perks as the Airflight Scheme, which allows individual artists to travel free to North America and Europe for professional and/or creative purposes.
The Arts Council of Northern Ireland Collection acquires works of art by living artists from Northern Ireland, which it lends to public bodies throughout the region.

The Scottish Arts Council (SAC)
12 Manor Place, Edinburgh EH3 7DD
t 0131 226 6051 f 0131 225 9833
e-mail: SAC@artsfb.org.uk
Director of Visual Arts:
Susan Daniel-McElroy

In spite of a limited number of showcases for contemporary art in Scotland, the Scottish arts scene goes from strength to strength. This is enhanced and acknowledged by the Scottish Arts Council's Visual Arts Department, which puts a particular emphasis on directly assisting artists to make work, as well as funding exhibitions and projects at galleries such as Fruitmarket and Portfolio in Edinburgh, the Transmission in Glasgow and the Pier Art Centre in Orkney. Visual Artists Awards of £2,000, £5,000 or £8,000 recognise artists' achievements and enable them to continue to extend their

own creative development, while smaller grants help them with the more immediate costs of creating and presenting their work. Past beneficiaries include Douglas Gordon and Christine Borland. There are also fellowships in Amsterdam, at the British School at Rome and in Australia, as well as a scheme to assist organisations in Scotland to host artists in residence. (In 1996 Julie Roberts went to Rome, Ross Sinclair to Amsterdam and Claire Barclay to Australia.) The Combined Arts department also supports organisations that programme important contemporary art shows, such as the Centre for Contemporary Arts and the Tramway in Glasgow.

The Scottish Arts Council Collection, consisting of over 2,000 works built up over forty years is currently being gifted to a variety of Scottish Museums and Galleries.

The Arts Council of Wales (ACW)
Museum Place, Cardiff CF1 3NX
t 01222 394711 f 01222 221447
Senior Visual Arts and Crafts
Development Officer:
Isabel Hitchman

A major restructuring has merged the six different art form departments into an Arts Services sector. The Artform Development Division, one of its sub-sections, encompasses the visual arts. As well as supporting key exhibition spaces such as Ffotogallery, Oriel Mostyn and Oriel, ACW also offers interest-free loans of up to £1,000 to artists to buy materials and equipment and to prepare work for exhibitions. Artists' bursaries allow their recipients to take time away from their usual employment or circumstances in order to devote themselves to work, and travel grants are also available. A recent recipient was Susan Butler, artist and writer in residence at Chapter Arts Centre, whose studies of Italian Baroque sculpture resulted in a multimedia installation that examined past and present readings of its imagery.

The National Lottery
For the time being at least, 20 per cent of the National Lottery's net proceeds is directed towards the arts. These funds,

managed by the UK's four Arts Councils, are divided between all art forms, but already lottery money is making its presence dramatically felt within the British visual art world, with £20 million going on the commissioning of new works and approximately £90 million given to building projects. These include the new Ikon Gallery in Birmingham; Dundee's purpose-built visual arts centre; a customised museum and gallery for Walsall; and a new, international centre for contemporary art in the refurbished Baltic Flour Mills in Gateshead. Lottery money is also responsible for a crop of public sculptures currently being built throughout Britain and Northern Ireland.

Recently, the original restriction of lottery grants to capital projects only has been lifted to include one-off funding for particular projects, and each Arts Council is introducing new schemes such as ACE's Arts 4 Everyone, ACW's Arts for All and SAC's New Directions, which set priorities for innovative work and fresh audiences.

The British Council, Visual Arts Department
11 Portland Place, London W1N 4EJ
t 0171 930 8466 f 0171 389 3101
e-mail: hymie.dunn@britcoun.org
Website: http://www.britcoun.org/
Director of Visual Arts: Andrea Rose

Since its foundation in 1934 as part of British foreign policy 'to encourage both cultural and educational interchanges between the United Kingdom and other countries', the British Council is now represented in 109 countries and is an integral part of the UK's overall diplomatic and aid effort. It is still primarily funded by the Foreign and Commonwealth Office, but reliance on the mandarins of Whitehall hasn't prevented the British Council's Visual Arts Department from being one of the country's most significant promoters of progressive contemporary art. Also acknowledging more historical figures, the British Council mounts some sixty major exhibitions overseas a year.

Whether it is organising a touring retrospective of Francis Bacon (starting at the Centre Pompidou, Paris, 1996); co-ordinating a Festival of British

Contemporary Art (including Adam Chodzko, Ceal Floyer, Douglas Gordon, Gary Hume, Steve McQueen, Gavin Turk, Jane and Louise Wilson and Cerith Wyn Evans) in fifteen galleries throughout Rome (1996), or providing grant aid for an exhibition of Sam Taylor-Wood in Barcelona (Sala Moncado 1997), the British Council has often been responsible for giving British artists a higher profile abroad than they have received at home.

Crucially, it is the British Council (assisted by an advisory committee chaired by Nicholas Serota and including curators, critics and gallery directors from across the UK) that is responsible for British participation in the regular round-up of international art events such as the Venice Biennale, the São Paulo Bienal, the Istanbul Biennale, the Johannesburg Biennale and the Indian Triennale exhibitions.

British artists who have received a firm invitation to travel abroad can apply for support in meeting their transport costs, and the Grants to Artists and Subsidies Scheme assists private and independent galleries to exhibit the work of British artists, or directly helps the artists themselves.

The British Council Collection was started in 1938 and now consists of some 7,000 works: 2,500 paintings, sculptures, and works on paper, as well as 4,400 limited-edition prints photographs and multiples. These works are hung in British Council offices throughout the world and loaned to galleries in Britain and abroad, or make up touring exhibitions such as *Dimensions Variable* (Helsinki Art Museum, 1997), a show of work using new technology including a sound piece by Martin Creed, Mat Collishaw's digitally altered flower photographs, and videos by Willie Doherty and Mark Wallinger.

Contemporary Art Society
17 Bloomsbury Square
London WC1A 2LP
t 0171 831 7311 f 0171 831 7345
Director: Gill Hedley

With the official purchasing climate for contemporary art in this country still erring on the cautious side, the CAS is a welcome presence. Other organisations

like the National Art Collections Fund may assist museums in buying works for their collections, but the CAS uses its funds, generated by its subscribers, to purchase and hand over pieces outright, thus enabling many British museums to acquire riskier pieces of contemporary art that might have had problems getting past their purchasing committees. The CAS also advocates and encourages all kinds of art collecting by advising both member museums and companies on collections and commissions, as well as organising a range of events – talks, trips, studio visits – to introduce its individual members directly to the most up-to-the minute British and international art.

CAS was founded in 1910 in response to a lack of official support for young artists in Great Britain. Prominent members of its first committee were the artist and critic Roger Fry, Bloomsbury doyenne Lady Ottoline Morrell and DS MacColl, painter, critic and keeper of the newly established Tate Gallery. Its first purchase was *The Smiling Woman* (c 1908) by Augustus John, now in the Tate, and since then the CAS has acquired over 4,000 works including pieces by Matisse, Gauguin, Bonnard, Vuillard, Moore, Bacon and Hockney as well as by Gillian Wearing, Helen Chadwick and Douglas Gordon, all of which have been presented to member museums throughout Britain. Every year, three different individuals – private collectors, critics, independent experts – are each given a budget and sent off to galleries and studios to buy fine and applied art on behalf of the CAS. The range and scope of the purchases reflects the personal (and often idiosyncratic) tastes of each very distinct member of this constantly changing roster.

In addition to pieces being given to CAS member museums, there are also plans afoot for the CAS to establish an ongoing fund for its Collection Purchases. This Special Scheme allows curators from a few selected galleries to work in tandem with the CAS on the commissioning and purchase of works to augment and complement their collections. (Wolverhampton Art Gallery, the Towner Art Gallery in Eastbourne and the Ferens Art Gallery in Hull have so far benefited from this scheme, adding works to their collections by Georgina Starr, Tacita Dean, Anya Gallaccio and Craigie Horsfield, amongst others.) The CAS raises its funds through Members' subscription fees, assistance from other charitable bodies, monies earned from its commissioning and advisory work, and from its annual Art Market where both emerging and established artists often confirm their belief in the importance of this organisation by making their work available at unexpectedly low prices.

The Elephant Trust
PO Box 5521, London W8 4WA
Secretary: Julie Lawson

The origins of the Elephant Trust lie in *Elephant of Celebes* 1921, a painting by Max Ernst from the collection of the Surrealist painter and poet Roland Penrose, one of the founders of the ICA and the Trust's first president. In 1976 Penrose and his wife Lee Miller sold the painting to the Tate and used the proceeds to establish a fund 'to develop and improve the knowledge, understanding and appreciation of the fine arts in the United Kingdom'. Since Penrose's death in 1984 the Trust has been augmented by other funds and now hands out one-off grants of around £2,000 'to encourage the experimental, unconventional and imaginative' both from artists and those presenting artistic projects.

The grants may not be lavish, but they can be crucial. An award of £1,500 received by Rachel Whiteread in 1989, for example, enabled her to launch her career by making *Ghost* (1990), her cast of an entire room. In 1991 the Elephant Trust supported *Show Hide Show*, an important early exhibition of Sam Taylor-Wood, Abigail Lane, Alex Hartley, and Jake and Dinos Chapman. Other young artists who received assistance to make new work were Mona Hatoum, Cathy Prendergast and Cornelia Parker.

The Henry Moore Foundation
Dane Tree House, Perry Green, Much Hadham
Hertfordshire SG10 6EE
t 01279 843333 f 01279 843647
e-mail: director@henry-moore-fdn.co.uk
Website: http://www.henry-moore.fdn. co.uk/hmf
Director: Tim Llewellyn

In 1977, when Henry Moore discovered that he was paying over £1 million in tax, he established and endowed a foundation not just to handle his own work but to act as a funding body with a remit 'to advance the education of the public by the promotion of their appreciation of the fine arts and in particular the works of Henry Moore'.

Today the Henry Moore Foundation (HMF) is one of the most important and multifaceted supporters of contemporary art in this country, and it is a fitting (if somewhat confusing) tribute to Britain's best-known twentieth-century sculptor that his name should appear in connection with such a variety of art projects.

Broadly, the HMF has three areas of activity. Firstly, it looks after Henry Moore's work, archive and the studios at Perry Green and mounts shows of his sculpture around the world. Secondly, in 1988 the HMF set up the **Henry Moore Sculpture Trust (HMST)**, based in Yorkshire and with a broad remit to support the showing and under-standing of sculpture. HMST has administered both the Henry Moore Institute in Leeds since 1993, and the Henry Moore Studio at Dean Clough since 1989 (see VENUES), both of which mount important shows of contemporary art. The HMST also acts as an agency that goes beyond these two venues to encourage public knowledge and appreciation of sculpture – from collaborating with Yorkshire Sculpture Park on their 1994-5 exhibition of Anthony Caro's *Trojan War* sculptures or joining forces with Tate Gallery Liverpool to mount *Art Transpennine '98*, an exhibition of international visual art held across the North of England between May and August 1998. Thirdly, the HMF's **Donations Programme**, administered by the HMF from Perry Green, provides grants and financial support ranging from bursaries and fellowships to assisting with acquisitions (in 1996 it helped the Arts Council to purchase Damien Hirst's *He Tried to Internalise Everything* 1992-4).

Virtually every institution in the UK applies to the Henry Moore Foundation for assistance with its exhibitions. In 1996-7 the fifty or so shows that benefited from HMF support included Mark Dion at Ikon Gallery, Birmingham, John Frankland at Matt's Gallery, London, Rachel Whiteread at Tate Gallery Liverpool, Eric Bainbridge at Manchester Cornerhouse, Sol LeWitt at Pier Arts Centre, Stromness, Edward Allington at Yorkshire Sculpture Park, Jake and Dinos Chapman at the ICA, London, Cathy de Monchaux at the Whitechapel, London, and Richard Hamilton at Documenta X, the international arts festival held every five years in Kassel, Germany.

Patrons of New Art

Tate Gallery, Millbank
London SW1P 4RG
t 0171 887 8743 f 0171 887 8755
e-mail: patrons@tate.org.uk

With the Tate Gallery's annual budget from the government for the acquisition of artworks frozen since 1982 at around £2 million, and with every likelihood that it will remain there until the year 2000 and beyond, the Patrons of New Art have a vital ongoing role in the Tate's purchases. Founded in 1982, the Patrons now number around 250 collectors, dealers and interested individuals who are prepared to pay between £350 and £750 per annum 'to develop wider understanding of the contemporary visual arts', which basically translates as providing and apportioning funds for purchasing artworks for the Tate.

Every year the names of twelve current Patrons of New Art are drawn out of a hat to sit on an acquisitions committee, which works with the Tate's Modern Collection curators to select the works of art to be purchased from the Patrons' funds. In the past these have included Bill Viola's *Nantes Triptych* (1992), Matthew Barney's *OTTOshaft* (1992), and Michael Landy's *Scrapheap Services* (1995). In addition, a Special Purchase Fund exists for members who contribute an additional £1,000, which goes towards the purchase of work by emerging artists, such as Cornelia Parker's *Cold Dark Matter: An Exploded*

View (1991); Dorothy Cross' *Virgin Shroud* (1993), or Angus Fairhurst's *Gallery Connections* (1995).

In 1984 the Patrons established the Turner Prize, and although it is now sponsored by Channel 4, the Executive Committee of the Patrons of New Art still works with Tate staff to select the Turner Prize jury, on which one Patron always sits.

INDEPENDENT EXHIBITION ORGANISERS

The Annual Programme

The Loading Deck, 7 Constance Street Knott Mill, Manchester M15 4JQ
Project details: t 0161 237 9925
e-mail: nick@index.u-net.com
or: martin.vincent@mcr1.poptel.org.uk
Programmers: Nick Crowe/
Martin Vincent

This is a continuing programme of artist-run projects that usually take place outside the gallery. It began in 1995 with *ha!*, a warehouse show of ten young Manchester-based artists, devised to compensate for the distinct dearth of artists living in the North West involved in Manchester's concurrent *British Art Show 4*. Since then, The Annual Programme has gained momentum with a series of ten, month-long exhibitions in the homes of artists in Manchester (who each took a turn to be host/curator and then guest/ exhibitor), as well as a range of shows in sites throughout the Manchester area. Collaborations with similar organisations throughout the UK include *Young Parents*, in association with City Racing in London, Transmission, Glasgow, and the now defunct Three Month Gallery in Liverpool; and Bank *TV*, an exhibition/ performance /video project with Bank in London, where all events were recorded on video and shown simultaneously at the ICA in London, Transmission, Glasgow, and Castlefield Gallery, Manchester.

Artangel

36 St John's Lane, London EC1M 4BJ
t 0171 336 6801 f 0171 336 6802
e-mail: artangel@ecna.org
Website: http://www.ecna.org/artangel

Co-Directors: James Lingwood/
Michael Morris

Artangel's quest to commission, produce and document new work beyond the white cube of the gallery or the black box of the theatre has introduced artists, art forms and – crucially – audiences to some extraordinary and unexpected locations throughout the UK. Since its establishment in 1985 by Roger Took, Artangel has probably done more than any other arts organisation to break down public preconceptions about the making and viewing of art.

It was Artangel that was responsible for commissioning and negotiating the many obstacles standing in the way of Rachel Whiteread's concrete-cast *House* (1993) in east London. It also commissioned Japanese artist Tatsuo Miyajima to make his flickering LED installation *Running Time* (1995) in the seventeenth-century Queen's House in Greenwich. For their multifarious installation *Self Storage* (1994), Brian Eno and Laurie Anderson worked with Royal College of Art students throughout the labyrinthine acres of a storage complex on a Wembley industrial estate; while in 1997, American choreographer Bill Forsyth collaborated with writer and performer Dana Caspersen and digital musical pioneer Joel Ryan to fill London's Roundhouse with a giant, white, bouncy castle (*Tight Roaring Circle*).

Although Artangel often leans towards large-scale and spectacular projects, it has also sponsored more elliptical interventions in different media and beyond the metropolis. Matthew Barney's *Cremaster 4* (1995), for example, commissioned by Artangel, was filmed on location on the Isle of Man, and Neil Bartlett's *Seven Sacraments for Nicholas Poussin* (1997) consisted of seven performances in a medical lecture theatre at the Royal London Hospital in Whitechapel. In 1993 Helen Chadwick produced *Bad Blooms*, an AIDS-awareness insert for magazine and cd box distribution; and in the same year artist Bethan Huws worked with a Bulgarian choral group, the Bistritsa Babi, who stood on the Northumbrian coastline and sang out to sea (*A Work for the North Sea* 1993). With their trail of sculptures and audio

William Forsythe/
Dana Caspersen/
Joel Ryan
**Tight Roaring
Circle**
1997
Roundhouse,
London
Commissioned by
Artangel and Beck's
Photo: Matthew
Antrobus

transmitters across Wiltshire, *Listening Ground, Lost Acres* (1995), Graeme Miller and Mary Lemley created a series of walks mapping a landscape and the people within it.

The Arts Catalyst

28A Brightwell Crescent,
London SW17 9AE
t/f 0181 672 1090
e-mail:
supanova@artscat.demon.co.uk
Website:
http://www.artscat.demon.co.uk
Director: Nicola Triscott

The Arts Catalyst was set up in 1993 to make new connections between science and the arts with the aim of improving understanding between the two disciplines. To this end it commissions visual artists and performers to create new work in collaboration with scientists and technologists. *Body Visual* (1996), an exhibition touring hospitals and venues throughout the UK, combined works by Helen Chadwick, Letizia Galli and Donald Rodney that explore key areas of medical research arising from associations with specialists in assisted conception, neuropharmacology and haematology. In 1999 *Total Eclipse* celebrates the eclipse with a series of artists' projects culminating in a show of Peter Fink and Anne Bean at the London Planetarium.

Commissions East

St Giles Hall, Pound Hill
Cambridge CB3 0AE
t 01223 356882 f 01223 356883
e-mail:

info@comseast.eastern-arts.co.uk
Director: David Wright

Acting as a public art resource specifically for the East of England has led Commissions East to advise, commission and implement every possible permutation of public art from sculptures, projections, and installations to bus shelters, paving and sea walls. A recent example is Tim Head's *Light Curtain* (1998) of 9,000 prismatic road reflectors for Bute Street Arts and Media Centre, Luton.

With so much current art practice increasingly blurring the distinction between 'public' and other art, Commissions East is also involving itself in special projects such as *Quadratura* (1995), a collaboration between artist Edward Allington and architects Catrina Beever and Robert Mull (founder members of the radical 1980s architecture group NATØ). Working in Cambridge with selected members of the public, they embarked on a complex and demanding exploration of physical and conceptual space that involved experimentation with hatches, apertures and service entrances in ceilings of buildings throughout the city, including the eleventh-century church of St Peters.

Foundation for Art & Creative Technology (FACT)

Bluecoat Chambers, School Lane
Liverpool L1 3BX
t 0151 709 2663 f 0151 707 2150
e-mail: fact@ fact.co.uk
Website: http://www.fact.co.uk
Director: Eddie Berg

Established in 1989 under the name of Moviola, FACT is the UK's leading development agency for artists and exhibitors working with creative technologies. It has commissioned, supported, resourced and presented technology-based artworks such as Tony Oursler's *Triune* at the Bluecoat Gallery in 1994, and Simon Robertshaw's *The Order of Things* (1997), a large-scale interactive installation in Liverpool's docks featuring an autopsy table. As well as putting on Video Positive, Liverpool's international biennale of electronic arts, in 1998 FACT is one of the hosts of the prestigious International Symposium of Electronic Arts, for which it is curating the exhibition programme, *Revolution*.

Institute of International Visual Arts (inIVA)

Kirkman House, 12-14 Whitfield Street
London W1P 5RD
t 0171 636 1930 f 0171 636 1931
e-mail: institute@iniva.org
Website: http://www.iniva.org
Director: Gilane Tawadros

In name and form, inIVA is an institution that deliberately avoids easy definition. It describes itself as an organisation that 'seeks to reflect a culturally diverse spectrum of artistic practices, curatorial voices and critical perspectives in contemporary art through collaborations and commissions'. Since its foundation in 1994, inIVA has operated as a production company, collaborating with other organisations both in the UK and abroad, arranging seminars, research projects and exhibitions, producing publications and 'extending the intellectual, social and geographical boundaries of debate on contemporary visual art and art history'.

This broad and ambitious brief has resulted in some memorable exhibitions that, in a variety of ways, have shifted long-standing cultural assumptions of Europe and North America in refreshing new directions. *Time Machine* (1994), for instance, allowed a range of artists from the UK and elsewhere to respond to, and work within, the Egyptian Collection of the British Museum in London – resulting in Marc Quinn's cryogenically frozen

frog, among other works. *Mirage: Enigmas of Race, Difference and Desire* at the ICA (1995) gave Steve McQueen his first mainstream showcase; and *Offside! Contemporary Artists and Football* (1996) provided a range of artistic responses to Britain's hosting of the European Cup. Other notable inIVA shows have included *The Visible and the Invisible: Re-presenting the Body in Contemporary Art and Society* (1996), which brought new commissions by Louise Bourgeois, Bruce Nauman, Donald Rodney and Yoko Ono to public sites throughout the Euston area of London; and Keith Piper's *Relocating the Remains* (1997). Held at the Royal College of Art, the latter employed touch screens, virtual corridors and other state-of-the-art technologies to re-explore Piper's familiar themes of policing, surveillance and the representation of black masculinity.

Locus+

Room 17, 3rd Floor, Wards Building
31-39 High Bridge
Newcastle-upon-Tyne NE1 1EW
t 0191 233 1450 f 0191 233 1451
e-mail:
locusplus@newart.demon.co.uk
Website:
http://www.locusplus.org.uk
Directors: Jon Bewley/Simon Herbert

The name Locus+ (site, plus the input and imagination of the artist) sums up the aims of this artist-run commissioning agency that has operated out of Newcastle-upon-Tyne since 1993. Locus+ describes itself as 'a visual arts facility that places the artist at the centre of production and provides logistical and financial support to those who wish to work in different contexts and/or across formats'. Although its events often take place in the North East of England, Locus+ has also facilitated work across the globe and has provided logistical and financial support for an enormous range of activities whether in buildings, on billboards, on video, CD, or over the airwaves.

Examples include Stefan Gec's huge commemorative portraits of firemen killed after the Chernobyl disaster *Natural History* (1995); Lloyd Gibson's figurative sculpture *Crash Subjectivity*, which combined the physical attributes

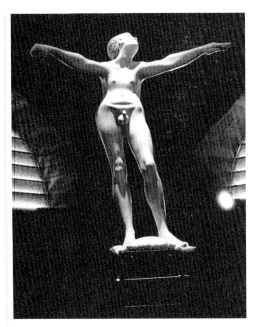

Lloyd Gibson
Crash Subjectivity
(detail)
1993
Fibreglass, resin, leather, silk, wooden ladder
366 × 183 × 183 cm
Installation at All Saints Church, Newcastle
Locus+
Photo: Jon Bewley

of male and female, adult and infant and was shown in three sites in Newcastle, Dublin and Belfast from 1993-5; *Search* by Pat Naldi and Wendy Kirkup (1993), a series of videos captured on surveillance cameras and broadcast on Tyne Tees TV; and Cornelia Hesse-Honegger's paintings of mutated insects collected from the perimeters of nuclear power stations: *Nach Chernobyl* (1996) and *The Future's Mirror* (1997). Locus+ also owned one twelfth of Mark Wallinger's equine art work, *A Real Work of Art*.

More recently, Locus+ have commissioned Richard Wilson's neon artwork *The Joint's Jumping*, a proposal for the north side of the new centre for contemporary visual art to open in spring 1999 in the former Baltic Flour Mills on the banks of the Tyne at Gateshead.

London Electronic Arts

Lux Centre, 2-4 Hoxton Square
London N1 6NU
t 0171 684 0101 f 0171 684 1111
Website: http://www.easynet.co.uk/lea/
Gallery: Tues – Fri 10-6, Sat 12-6
Director: Michael Maziere

As well as making its thirty-year archive of artists' videos available to galleries, museums, international festivals and broadcasters, LEA also facilitates their production by commissioning projects and providing high-tech facilities. Some of these, by Gillian Wearing, Jaki Irvine, Keith Tyson, Michael Curran and Mark Wallinger, could be seen in the ICA's 1996 *Pandemonium* festival of moving images. In addition, LEA mounts shows of contemporary film, video and new media in its new, purpose-built gallery within the Lux Centre, and commissions 'curated' compilations of new video work, which tour to other venues. *Speaking of Sofas* (1995) is an eclectic programme of video works by young British artists; as is *A Small Shifting Sphere of Serious Culture* (1996), both compiled by writer/curator Gregor Muir. *Such is Life* (1997), curated by Jonathan Watkins, combines work from the UK and abroad.

Public Arts Commissions Agency

Studio 6, Victoria Works, Vittoria Street
Jewellery Quarter, Birmingham B1 3PE
t 0121 212 4454 f 0121 212 4426
Director: Vivien Lovell

In 1987 PACA was appointed to act as consultant to the International Convention Centre and Centenary Square in Birmingham. This was one of the first major Percent for Art schemes

(whereby a percentage of the budget of new developemnts is donated to the arts) in Britain. Since then PACA has handled many large-scale, mainstream, Public art projects throughout the UK. Among the works finally installed in Birmingham after a lengthy process of competition and commissioning were Antony Gormley's *Iron Man* (1993) and Ron Haselden's neon flock of birds *Birdlife* (1991). PACA was also responsible for the selection process and installation of Jean-Luc Vilmouth's giant resin shoal of *Channel Fish* (1993) at Waterloo International Terminal, which dangle outside the arrivals area, gathering wriggling momentum every time a train leaves for Europe.

The early emphasis on permanent 'landmark' commissions has evolved to include temporary installations, PACA initiatives and research projects, and collaborative partnerships between artists, architects and other creative disciplines. *Host* by Pierre d'Avoine, Heather Ackroyd and Dan Harvey, for example, was a temporary installation over four sites during the Venice Architecture Biennale (1996).

Since 1995 PACA has managed a number of commissions for London Docklands Development Corporation, including Richard Wentworth's *Globe* (1997), fifteen internally illuminated clocks each indicating the time in different cities worldwide, and Anthony Caro's gates for a new ecology park, which opened in 1996. PACA is also responsible for organising *Out of Darkness*, an ambitious programme of permanent and temporary artworks using light, sited throughout the city of Wolverhampton during 1997-9.

Public Art Development Trust

3rd Floor, Kirkman House
12-14 Whitfield Street, London W1P 5RD
t 0171 580 9977 f 0171 580 8540
e-mail: padt@padt.demon.co.uk
Director: Sandra Percival

Since the Public Art Development Trust was established in 1983 as the first organisation for Public art in the UK, the scope of both public art and the organisations that facilitate it has increased beyond measure; and PADT has been niftier than most in moving with the times. Early projects show PADT towing a fairly traditional Public art line, albeit with progressive artists. These include Tess Jaray's terrazzo floor for Victoria Station (1988); Bruce McLean's *Platform Painting* for Tottenham Hale Railway Station (1991); and Hannah Collins' light-box work *Shelf /Situation/ Shrine* (1985) for Colindale Hospital.

However, as what is meant by 'Public' art becomes less and less clear, PADT's one-off projects are increasingly giving way to longer-term strategies that relate to a single location, and its role is becoming closer to that of curator than enabler. An ongoing association with the BAA Art Programme has, since 1994, resulted in an annually changing series of new installations by Irish artists within the Pier 4A walkways of Heathrow airport's Terminal 1. In 1997, Julian Opie's four light-boxes and fifteen video monitors were also installed in Terminal 1's Flight Connections Centre. Another major, multifaceted programme is the three-year Thames and Hudson Rivers Project. Working with local authorities and community groups, arts and civic organisations, PADT is enabling artists to create public projects for the River Thames waterfront between Hampton Court and Greenwich in London, and the Hudson River waterfront between Battery Park City and 59th Street in New York City. Angela Bulloch's *From the Chink to Panorama Island* (1995), for example, has involved the official renaming of an old loading pier, and a temporary light projection. Throughout, the programme relates as much to artistic process as to a final product and often – as in the case of Hamish Fulton's *The Thames: a walk from source to sea* (1996) – the two are one and the same.

Rear Window

48-50 Redchurch Street, London E2 7PD
t 0171 739 3707 f 0171 729 7943
Directors: Peter Cross/
Jean Paul Martinon

Since 1992 Rear Window has focused on site-specific exhibitions of new or commissioned work by both young and established artists in a selection of temporary venues across London.

These have ranged from the basement of a brewery, a nineteenth-century block of artists' studios in Kensington, to a fully functioning psychiatric hospital in Hackney (where work by artists including Catherine Yass, Jordan Baseman, Donald Rodney and Jo Spence was shown as part of the ambitious *Care and Control* 1995). For *The Look of Love* (1997), artists and film-makers placed work in all media throughout three floors of the Approach Tavern in Bethnal Green, London. Among them were David Medalla, Isaac Julien, Jordan Baseman, and Stephanie Smith and Edward Stewart.

Space Explorations

5 Albert Street, London NW1 7LV
t/f 0171 380 0543
e-mail: louis.nixon@btinternet.com
Directors: Daniel Sancisi/Louis Nixon

Founded in 1989 by two Slade School postgraduates with the aim of supporting artists whose work may not be ideally placed within conventional exhibition venues, Space Explorations utilises the large number and wide variety of sites left empty and redundant throughout London. These have ranged from an empty railway arch in Hackney, East London (*The Beck Road Project*, 1990); to various sites within the perimeter of The Old Royal Observatory in Greenwich (*Greenwich '91*); Holborn Town Hall (*One Million Cubic Feet* 1994); and a derelict power station in Shoreditch, east London (*Electric House* 1992). However, what really put Space Explorations on the art map was *High Rise* (1996) where seven artists occupied an empty 1970s towerblock just off the Euston Road with works that used a variety of strategies both to draw attention to, and play off, their surroundings. On the roof were Markus Eisenmann's stacked pine logs and recorded birdsong – *Prototype for an Amene Landscape (Black Forest)* 1997; and projected into the pitch-black basement was Melanie Counsell's haunting film of a camera lurching around the roof and hurtling fifteen storeys to the ground (*110 Euston Road, London*, 1996).

PRIZES AND EVENTS

PRIZES

The recent proliferation of art prizes, which are usually commercially sponsored, testifies to the profile-raising power of contemporary art and to a post-recession improvement in the relationship between new art and money. But, as everyone knows, this is a volatile and fragile relationship in which artists don't necessarily emerge the winners, even if they pick up the cheque. The prizes listed below may not award the largest purse (or indeed any purse at all) but they do not blanch at challenging and problematic art, whilst extending the opportunities throughout the UK in which to see it.

Citibank Private Bank Photography Prize
Details: Photographers Gallery
5 Great Newport Street
London WC2H 7HY
t 0171 831 1772 f 0171 636 9704
e-mail: info@photonet.org.uk

First awarded in 1997, this major new prize acknowledges the importance and diversity of photographic images in contemporary art with a £10,000 award for individuals who have made a contribution to the medium as a result of an exhibition or body of published work in the UK. The first winner was Richard Billingham for *Ray's a Laugh*, a series of intimate, affectionate and discomfiting images of his family living in poverty-stricken chaos on an estate outside Birmingham, which attracted international attention in 1996.

EAST International
Details: Norwich Gallery
Norwich School of Art and Design
St George Street, Norwich
Norfolk NR3 1BB
t 01603 610561 f 01603 615728
e-mail: nor.gal@nsad.ac.uk
Website: http://www.nsad.ac.uk/gallery/index.htm
Submissions invited early spring.

The largest annual international exhibition of contemporary art held in Britain, *EAST International* is organised by the Norwich Gallery. The heavyweight selectors have included Konrad Fischer, Richard Long, Helen Chadwick, Nicholas Logsdail and Giuseppe Penone. No rules of age, status, place of residence or media limit those who may enter. Each selected artist installs major works in a space of their own in and around Norwich School of Art and Design and the Sainsbury Centre for the Visual Arts. Every year one artist will win the EAST award of £5,000.

Jerwood Painting Prize
PO Box 279, Esher, Surrey KT10 8YZ
t 01372 462190 f 01372 460032

Established in 1993, the Jerwood Painting Prize (part of a private philanthropic foundation set up in 1977 by pearl and precious stone magnate John Jerwood) 'celebrates the vitality and excellence of painting in this country' and is the most valuable award for a professional artist in Britain. The prize of £30,000 is open to artists of all ages, provided they live in the UK and wield a paintbrush. In the past the Jerwood has been won by established – even veteran – figures such as Craigie Aitchison (1994), Maggi Hambling and Patrick Caulfield (joint 1995); but increasing numbers of younger artists – Gary Hume, Jane Reilly, Jason Martin – are now cropping up in its exhibitions of seven or so shortlisted artists.

John Moores Liverpool Exhibition of Contemporary Painting
Details: Walker Art Gallery
William Brown Street, Liverpool L3 8EL
t 0151 478 4615 f 0151 478 4777
e-mail: public@nmgmepp2.demon.co.uk
Website: http://www.merseyworld.com/museums

There are many prizes solely devoted to painting, but the John Moores (named after its founder, the late Sir John Moores of Littlewood's) is the longest-standing and, so far, the most forward looking. Its remit is 'to encourage contemporary artists, especially the young and progressive'. Established in 1957, this biennale of contemporary painting appoints a different panel every time to award a £20,000 prize. Works by the winning artists (Patrick Heron, David Hockney, Richard Hamilton, Bruce McLean, Lisa Milroy and Peter Doig amongst them) are acquired for the John Moores Collection. Some sixty or so runners-up – such as Peter Blake, Sean Scully, Howard Hodgkin, Gillian Ayres, Chris Ofili – are awarded smaller prizes and/or inclusion in the John Moores exhibition at the Walker Art Gallery, Liverpool.

Mostyn Open
Details: Oriel Mostyn, 12 Vaughan Street
Llandudno LL30 1AB
t 01492 870875 f 01492 878869
Handling fee: £15.00

This yearly prize is open to all artists, working in any media, and is not restricted to those based in the UK. The winner receives a purchase prize of £6,000 and inclusion in an exhibition of up to fifty fellow entries. The 1996 prize was split between photographer Peter Finnemoore and installation/performance artist Kevin Francis Gray.

Prudential Awards
Details: Helen Durham
Prudential Corporation PLC
142 Holborn Bars, London EC1 2NH
t 0171 548 3485 f 0171 548 3725
e-mail: helen.durham@prudential.co.uk
Website: http://www.prudentialcorp.com

The most substantial of all the art prizes, this award is for five non-profit-making organisations based in the UK and active in one of the following art forms: dance, music, opera, theatre or visual arts. Each award is for £50,000 and entries are judged on four criteria – innovation, creativity, excellence and accessibility. Two runners-up in each category get a handy consolation prize of £5,000 each. The money must be spent on furthering the winner's artistic programme. Past awards to visual arts organisations went to Chisenhale Gallery (1992), Portfolio Gallery (1993), Camden Arts Centre (1994), Tramway (1995) and Book Works (1996).
 From 1998 ABSA will take over the

management of the Awards, but Prudential will continue to fund them until 1999.

Turner Prize

Details: Tate Gallery, Millbank
London SW1P 4RG
t 0171 887 8000 f 0171 887 8007
Website: http://www.channel4.com.

The combination of the Tate Gallery as organisers and Channel 4 as sponsors ensures that this is the highest profile – and therefore the most controversial – of all the contemporary art prizes. After several redefinitions since the Prize's foundation in 1984, the criteria seem to have settled as 'a British artist under fifty for an outstanding exhibition or other presentation of their work' in the preceding year.

The work of four shortlisted artists is exhibited at the Tate and there is always furious speculation as to which one will win the £20,000 prize money in a media-friendly, but artist-unfriendly, first-past-the-post format. The judging panel of five is chaired by Tate Director Nicholas Serota (who has the casting vote) and each year comprises a member of the Tate's Patrons of New Art, a curator from overseas, and a writer and a curator from the UK. Winners include Gilbert and George (1986); Richard Deacon (1987); Anish Kapoor (1991); Rachel Whiteread (1993); Antony Gormley (1994); Damien Hirst (1995); Douglas Gordon (1996).

EVENTS

The British Art Show

Details: Hayward Gallery, SBC
London SE1 8XX
t 0171 960 4208 f 0171 401 2664

Every five years National Touring Exhibitions (administered by the Hayward Gallery on behalf of the Arts Council of England) organises a survey show of recent developments in British art. Each exhibition features distinctly different selectors, criteria and composition. The last, in 1995-6, toured to Manchester, Edinburgh and Cardiff and took place in various venues throughout each city, where it presented

work in all media but with a particualr emphasis on film and video installation.

The London Contemporary Art Fair

Business Design Centre
52 Upper Street, London N1 0QH
t 0171 359 3535 f 0171 288 6446
Admission charges

Compared to the art fairs of Europe (Berlin, Cologne, ARCO in Madrid, FIAC in Paris and especially the Basel art fair with its various youthful offshoots) or America (Chicago, and the young-art Hotel Fairs in the Gramercy Hotel, New York and the Chateau Marmont in Los Angeles), Britain's contribution to the commercial scene is more brantub than cornucopia. Progressive galleries cluster anxiously amidst a welter of nudes, flower paintings and animal pictures and their works are not much enhanced by the encounter.

New Contemporaries

Details: Manchester Office
127F Liverpool Road, Castlefield
Manchester M3 4JN
t 0161 839 9453 f 0161 835 1698

Originally known as Young Contemporaries but changing its name in 1974, New Contemporaries is Britain's most important annual touring exhibition of work in all media by students and recent graduates from UK art schools. The work is selected by open submission and judged by a guest panel of artists, writers and curators from the international art world. Since its foundation in 1949 its fortunes have been at the mercy of changing sponsorship, but it has consistently given early exposure to many of the major names in British art including Gillian Ayres, Frank Auerbach, RB Kitaj, David Hockney, Allen Jones and Patrick Caulfield, and more recently, Damien Hirst, Abigail Lane, Gillian Wearing, and Jane and Louise Wilson.

Whitechapel Open

Details: Whitechapel Art Gallery
Whitechapel High Street
London E1 7QX
t 0171 522 7888 f 0171 377 1685

Organised by the Whitechapel and held

every two years, the Whitechapel Open is testimony to the high concentration of artists working in east London, from whom the selection is made by open submission. The approach, and therefore the format, tends to vary from year to year but there's always an exhibition at the Whitechapel Art Gallery accompanied by a plethora of related events taking place in galleries and artists' studios throughout the surrounding area.

PUBLICATIONS

SPECIALIST PUBLISHERS

Audio Arts

6 Briarwood Road, London SW4 9PX
t/f 0171 720 9129
e-mail: audioarts@aol.com.
Editor: Bill Furlong

With the increasing use of sound in artworks, an art magazine that takes the form of a cassette tape is particularly appropriate. However, *Audio Arts* has been combining interviews, artworks, and historic recordings (or recordings that subsequently become historic) since its foundation in 1973, its brief being simply the pursuit of whatever seems interesting to the magazine's founder-editor Bill Furlong. It is Furlong's shifting role as editor/ interviewer/artist/ and – crucially – collaborator that helps *Audio Arts* to exploit the immediacy and versatility of sound more creatively than most magazines use text and images – less a vehicle for discussion than 'a space for art and the critical discourse that surrounds it'.

Not only does *Audio Arts* deliver the voices (and therefore the presence) of Marcel Duchamp, Joseph Beuys, Noam Chomsky and pretty much every major artist of the last twenty or so years, it also allows direct access to artworks, often, specially commissioned. Recent examples are Georgina Starr's remix of *Mentioning* (1997), using lyrics from a conversation recorded on the London Underground; and Cornelia Parker's *Brushes with Fame: or Seven Little Frictions* (1997), which presented the sounds of Freud's keys rattling, a record

that belonged to Adolf Hitler, and the rustling of Vivien Leigh's petticoats.

Book Works
19 Holywell Row, London EC2A 4JB
t 0171 247 2536 f 0171 247 2540
e-mail: jr@ bookwks.demon.co.uk
Directors: Rob Hadrill/Jane Rolo

Since 1984 *Book Works* has contrived to commission and produce new work in collaboration with artists that goes beyond the craft-based or illustrative traditions of artists' books. Each publication represents an exploration both into the conceptual nature of its own subject matter and into the scope of what a book might be. This has resulted in the production of multiples, videos and CD ROMs, as well as extending into installations, mixed-media or time-based work.

The Reading Room (1994), for example, took the form of a series of new commissions by artists and writers on the theme of books, reading and knowledge, and included multimedia installations by Joseph Kosuth in the Bodleian Library, Oxford *(Say: I do not Know)*; Susan Hiller in the Freud Museum, London *(At the Freud Museum)*; Douglas Gordon at the Dolphin Gallery, Oxford *(Something Between my Mouth and your Ear)*; Brian Catling's installation *The First London Halo* and performance, *Scroll*, in the British Library; as well as the publication of books by Kosuth, Hiller and Catling. Other recent projects include *Itinerant Texts* (1996), a series of slide-projected text works by twelve artists: Judith Barry, Robert Barry, Angela Bulloch, Tacita Dean, Jimmie Durham, Tracey Emin,

Liam Gillick, Douglas Gordon, Susan Hiller, Joseph Kosuth, Tracy McKenna and Simon Patterson.

Imprint 93
18 Edgar House, Kingsmead,
London E9 5QE
t/f 0181 985 6373
Director: Matthew Higgs

Imprint 93 was established in September 1993 with the aim of making low-key publications/artists' editions and distributing them by mail. Economy is the only criterion for production: works are all made for virtually no cost, weigh less than 60g (so they can be mailed second class), and run to editions of around 200 copies that eventually go out of print. Describing itself as 'lacking an ideology but not an identity' *Imprint 93* is distinguished by the now impressive line-up of artists who have produced work for its mail-outs: Martin Creed's elliptical torn-up A4 *Work No 140*; Paul Noble's *Artist's Books* of drawings and a catalogue of books belonging to himself and his artist friends; Jeremy Deller's trans-criptions of graffiti in the men's toilets of the British Museum; and Chris Ofili's *Black*, which reproduced his local paper's reports of crimes attributed to black suspects.

Imprint 93 is mailed unsolicited to an audience of artists, writers and curators, and its impact has been such that the Museum of Modern Art in New York has bought an entire run. Annual *Imprint 93* exhibitions at such venues as the Cabinet Gallery and City Racing are not so much presentations of the projects as 'uncurated' shows of recent work.

Billy Childish
This Purile Thing
1995
A5 xeroxed booklet
Imprint 93

The Paragon Press
92 Harwood Road, Fulham
London SW6 4QH
t 0171 736 4024 f 0171 371 7229
Director: Charles Booth-Clibborn

Launched in 1986 when the current director was still a student at Edinburgh University (in the same year that he also co-organised the ambitious 'New Art New World' charity auction with fellow students Jay Jopling and Greville Worthington), *Paragon Press* has taken the making and publishing of prints to the heart of contemporary art practice. Most of the artists who have worked with *Paragon* are internationally well known, but few have had much experience of print-making.

Paragon Press has provided an eclectic range of artists with access to the best printing studios and technicians in order to experiment in a multitude of print techniques, often for the first time. Its first book/portfolio edition was *The Scottish Bestiary* (1986) where artists including Bruce McLean, Steven Campbell, John Bellany and Peter Howson worked in print media ranging from screenprint, etching, woodcut and lithography. In 1993 the sculptor Grenville Davey made *Eye* – screenprints taken from digitally manipulated images of a glass eye and stopper; and in *Screen* (1997), Paragon collaborated with *Ridinghouse Editions* on the list of twelve artists invited to make a portfolio of screenprints, including Jake and Dinos Chapman, Cerith Wyn Evans, Gillian Wearing, Mat Collishaw, Siobhán Hapaska and Abigail Lane. Because *Paragon* specialises in portfolios and books, what emerges is not a series of one-offs, but portable exhibitions where the latest in progressive art and, often, the most advanced technology, is harnessed to older traditions of printing, bookbinding and typography.

Ridinghouse Editions
c/o 38 Powis Square, London W11 2AY
t 0171 229 6063 f 0171 792 2430
e-mail: charles.asprey@btinternet.com
Directors: Charles Asprey/
Thomas Dane/Karsten Schubert
Part publisher, part gallery, *Ridinghouse Editions* describes itself as a 'release valve' for artists' ideas. Concentrating

Marc Quinn
**Template for my
Future Plastic
Surgery**
4-colour
screenprint with
varnish, made for
the group portfolio
London
1992
86 × 68 cm
The Paragon Press

Britain's oldest contemporary art magazine (founded in 1976 by Peter Townsend and Jack Wendler) is comprehensively informative about the many modes of the British art world. Printed in black and white, and designed for clarity, *Art Monthly*'s appearance reflects its no-nonsense approach. Main international shows are reviewed, yet readership is primarily British, and this is reflected in extensive national exhibition coverage, monthly columns on artists' editions, saleroom reports, art law, news, awards, and exhibition and events listings.

The Art Newspaper
27-29 Vauxhall Grove, London SW8 1SY
t 0171 735 3331 f 0171 735 3332
Editor: Anna Somers Cocks
£4.50

The Reuters of the art world, this international paper, published monthly and devoted to 'Events, Politics and Economics', covers the art world in terms of news. It provides useful information on art scams, scandals and upcoming artists' projects, as well as comprehensive listings and helpful round-ups of art events across the world and occasional in-depth surveys into particular art scenes or subjects.

Creative Camera
5 Hoxton Square, London N1 6NU
t0171 729 6993 f0171 729 7568
e-mail: info@ccamera.demon.co.uk
Website: http://www.channel.org.uk/creative/index.htm
Consultant Editor: David Brittain
£3.95

Founded in 1968 by a group of idealistic photographers, this bi-monthly publication intelligently examines the best new examples of contemporary photography, as well as work by classic figures. Everyone who is anyone has been in its pages – often years before they become well known. Each issue contains essential information (interviews, news, reviews) for all those interested in contemporary photography and new media.

Dazed & Confused
112 Old Street, London EC1V 1BD

predominantly on the publication of editions, multiples and books that are often very different from the artists' usual output, *Ridinghouse* operates outside the traditional gallery system (it doesn't represent artists but works on specific projects with them).

It was with *Ridinghouse*, for example, that sculptors Jake and Dinos Chapman made a porno film *Bring Me the Head Of...* (1995), in which a sculpture edition of a phallic-nosed head (also made for *Ridinghouse*) 'performed' with two actresses; and Mat Collishaw published an edition of photographs and 3-D light-boxes depicting languorously posed *Ideal Boys* (1997) taken in Naples. *Ridinghouse* was especially important to Michael Landy, editioning numerous props from his vast installation *Scrapheap Services* (1995-6), which enabled him to raise funds for the completion of the project and to show it in its entirety at Chisenhale Gallery in 1996.

Words & Pictures
35b Jerningham Road
London SE14 5NQ
t/f 0171 252 8609
Directors: Iain Forsyth/Jane Pollard
Described as 'Ultra-Paranoid (Extra-Spatial) Portable Art!', *Words & Pictures*, founded in 1994, is another example of

artists choosing to make and show work in forms that are cheap to produce and collect. Published three times a year, *Words & Pictures* is part magazine, part book and part portable art exhibition, with each signed and numbered edition of 100 bringing together artworks from twenty artists in an A5-sized cardboard box. As well as artworks by recent graduates and young artists such as Matthew Higgs, Jessica Voorsanger and Bob and Roberta Smith, each edition of *Words & Pictures* is also fronted by a preface and an introduction written by critics and artists. Andrew Wilson's catalogue of artists' boxes past and present put issue No 6 into both contemporary and historical context; while Simon Bill's 'Rabbit Droppings' preface for the same edition gives Beatrix Potter's *Peter Rabbit* a new, scatological airing.

UK ART MAGAZINES

Art Monthly
Suite 17, 26 Charing Cross Road
London WC2H 0DG
t 0171 240 0389 f 0171 497 0726
Editor: Patricia Bickers
£2.85

t 0171 336 0766 f 0171 336 0966
e-mail: dazed @ confused.co.uk
Website: http://www.confused.co.uk
Arts editors: Mark Sanders/
Roger Tatley
£2.50

Dazed & Confused is not only Britain's leading style magazine of the 1990s, but also one of the few non-specialist publications that doesn't treat art in terms of connoisseurship or curiosity, acknowledging its place at the centre of contemporary culture. Every monthly issue carries articles on, and interviews with, a range of British and international artists, as well as frequent artists' projects. *Dazed & Confused* even runs its own art gallery at 112 Old Street, London EC1V 9BD.

Frieze

21 Denmark Street, London WC2H 8NA
t 0171 379 1533 f 0171 379 1521
e-mail: editors@frieze.demon.co.uk
Editors: Matthew Slotover/ Amanda
Sharp/Tom Gidley
£4.50

Britain's best-looking art magazine was founded in 1991 and devoted to the very latest in 'contemporary art and culture'. It has had a key role in promoting the *Freeze* generation of artists, along with their predecessors and successors. *Frieze* often commissions artists' projects for its pages and overall design is a major priority. Content is international in scope and goes beyond art to encompass zeitgeisty investigations of music, fashion, books, movies and TV, written by some of the best writers/ commentators from Britain and abroad. Light relief is provided by the coverage of such topics as Kenneth Williams' diaries, Victor Lewis-Smith's television reviews and Nike trainers. Even the advertisements provide a résumé of the international art world.

Publishing: The imprint *Frieze* was launched in 1995 with *What the Butler Saw* – the collected writings of the magazine's leading critic, Stuart Morgan.

Modern Painters

Universal House
Tottenham Court Road
London W1P 9AD

Frieze covers

t 0171 636 6058 f 0171 580 5615
Editor: Karen Wright
£4.95

This glossy 'Quarterly Journal of the Fine Arts' was founded by the late Peter Fuller in 1988 as part of a personal quest to promote figurative and landscape traditions in British art, and to fend off the dangerously modernist 'International Art World Inc.' (Prince Charles was a contributor to the first issue). Since Fuller's death, *Modern Painters* is less polemical, but is still the mouthpiece for the conservative camp with an increasingly eccentric list of contributors who range from such respected elder statesmen of twentieth-century art writing as Robert Hughes, David Sylvester and Bryan Robertson, to non-art-world celebs like Michael Parkinson and Jeremy Isaacs. *Modern Painters'* special protégé is Sister Wendy Beckett, and David Bowie sits on the editorial board.

Publishing: Although links with *Modern Painters* are vigorously denied, three of the four partners behind '21' Publishing have strong ties with the

magazine – editor Karen Wright, gallery owner Bernard Jacobson, and David Bowie . It was launched in 1997 with *Blimey! From Bohemia to Britpop: The London Artworld from Francis Bacon to Damien Hirst*, a personal odyssey through the capital's art world by writer/artist/ broadcaster/ boulevardier, Matthew Collings.

Tate

Christ Church, Cosway Street
London NW1 5NJ
t 0171 706 4596 f 0171 479 8515
e-mail:
charlotte.mullins@aspenmags.co.uk
Editor: Tim Marlow
£2.95

It is difficult for a magazine named after the Tate Gallery and with the majority of its covers devoted to that venue's exhibitions to stress that it is an independent publication with 'its own voice and vision', over which the Tate has no control. Since its launch in 1993, however, *Tate* has gone a long way towards resolving its identity crisis. The range and depth of its articles on both

Tate and non-Tate related subjects, which, unlike most magazines dealing with contemporary art, span through art history and across the globe, is helping to dispel the in-house image.

INTERNATIONAL ART MAGAZINES

Artforum
65 Bleeker Street, New York NY 10012
t 212 475 4000 f 212 529 1257
e-mail: artforum@aol.com
Website: http://www.artforum.com
Editor: Jack Bankowsky
£5.95

Not only is this the magazine most read by the international art world, it has been a prominent supporter of the current British art scene, both in exhibition reviews and profiles of individual artists.

Parkett
Quellenstrasse 27, CH 8005 Zurich
t 411 271 8140 f 411 272 4301
e-mail: Parkett@access.ch
Editor: Bice Curiger
£18

The most prestigious contemporary art publication for those who can afford it, *Parkett* is as much a book as a magazine. Each issue focuses on three artists who contribute special artists' editions and whose work is explored in a range of articles by top writers. If an artist is chosen for this treatment by *Parkett*, they've really made it. Texts are printed both in English and German.

UK VENUES

(Admission to all venues free unless otherwise stated)

ENGLAND

BERWICK UPON TWEED
Berwick Gymnasium Gallery
The Barracks, The Parade
Berwick upon Tweed, TD15 1DF
t/f 01289 303243
Apr – Oct: Daily 10-6

Nov – Mar: Wed – Sun 10-4
Admission charges
Head Custodian: Marie Johnstone

Located in a disused gymnasium adjoining Berwick barracks and close to the town ramparts, this gallery offers an annual fellowship for an artist to use the space during the winter months as a studio in which to conceive work for a summer exhibition. Recipients have included Marcus Taylor and Mike Nelson, and the gallery also programmes shows and collaborations in all media with other progressive contemporary arts venues across the country.

BIRMINGHAM
Ikon Gallery
Oozells Square, Brindley Place
Birmingham B1 2HS
t 0121 643 0708 f 0121 643 2254
Website: http://www.dialspace.dial.pipex.com./ikon/
Tues – Fri 11-7, Sat – Sun 11-5
Director: Elizabeth A. Macgregor

One of Britain's leading contemporary art venues, since its foundation in 1963 the Ikon has remained the only gallery in the Midlands devoted to major exhibitions of contemporary visual art. Early on it showcased international figures such as Chris Burden and Denis Oppenheim and helped to further the careers of Richard Wilson, Rose Garrard and Susan Hiller. Throughout the 1980s and 1990s it has consolidated this commitment to the experimental work of both established and emerging artists with the first, large-scale European exhibitions of Adrian Piper, Victor Grippo, Mark Dion and Martha Rosler, as well as solo exhibitions of British artists including Keith Piper, Amikam Toren, Zarina Bhimji, Lucia Nogueira, Mark Wallinger, Parmindaur Kaur, and Yinka Shonibare. A particular concern is the examination of issues of identity and cultural diversity; mixed shows have included *InFusion: New European Art* and *Distant Relations: A Dialogue Between Chicano, Irish and Mexican Artists.*

In early 1998 Ikon relocates into Oozells Street School, a Victorian, grade II listed building, restored and

converted for the purpose by Levitt Bernstein Architects in collaboration with artist Tania Kovats. Not only has she advised the team on all aspects of refurbishment ('de-designing' as she calls it) but she has also made an explicit artistic intervention: the cladding of the wedge-shaped perimeter wall in black slate, creating a form of pedestal that signals the building itself as an object of attention.

BRADFORD
National Museum of Photography, Film and Television
Pictureville, Bradford
West Yorks BD1 1NP
t 01274 727488 f 01274 723115
e-mail: initial.surname followed by:
@nmsi.ac.uk
Website: http://www.nmsi.ac.uk/nmpft
Tues – Sun 10-6
Head: Amanda Neville

This venue is currently undergoing major expansion to create state-of-the-art galleries dedicated to the new digital media. The £13.25 million development will expand museum space by 25 per cent, enabling it to tell the developing story of film, photography, television and how these interact with the new media. A major new gallery space will allow the NMPFT to show the largest of international touring shows or can be subdivided for smaller exhbitions. These may range from major retrospectives to solo shows by leading photographers such as Richard Billingham, Nick Waplington and Martin Parr, as well as exhibitions reflecting current or emerging trends in contemporary photography.

BRIGHTON
Brighton Museum and Art Gallery
Church Street, Brighton BN1 1UE
t 01273 290900 f 01273 608202
Mon – Sat 10-5, Sun 2-5, closed Wed
Head of Exhibitions: Nicola Coleby

Many of Brighton Museum and Art Gallery's temporary exhibitions are devoted to contemporary art. A range of progressive touring shows are accompanied by exhibitions instigated by the gallery such as Mark Power's photographs of coastlines inspired by

BBC radio's shipping forecast (The Shipping Forecast, 1997); shows spanning eras and cultures like Les Sixties (1997), which examined French and English Pop art; or Fetishism: Visualising Power and Desire (in collaboration with SBC), which ranged from African fetish figures to Dorothy Cross' sculptures using cows' udders.

BRISTOL
Arnolfini

16 Narrow Quay, Bristol BS1 4QA
t 0117 929 9191 f 0117 925 3876
e-mail:
arnolfini@arnolfini.demon.co.uk
Website:
http://www.channel.org.uk/arnolfini
Galleries: Mon – Sat 10-7, Sun 12-6
Director: Tessa Jackson

A former tea warehouse refurbished by architect David Chipperfield and artist Bruce McClean provides an elegant setting for one of Europe's leading centres for contemporary art, which presents major initiated shows, touring exhibitions, collaborations with other institutions, and commissions new work. Early shows of Rachel Whiteread, Vong Phaophanit and Mona Hatoum have combined with exhibitions of Jannis Kounellis, Annette Messager, Richard Long, Perminder Kaur, Dorothy Cross, and video installation work from the artistic partnership of Matthew Dalziel and Louise Scullion.

CAMBRIDGE
Cambridge Darkroom Gallery

Dales Brewery, Gwydir Street
Cambridge CB1 2IJ
t 01223 566725 f 01223 312188
e-mail:
cambridge.darkroom @dial.pipex.com
Tues – Sun 2-5
Director: Ronnie Simpson

A key centre for the latest photographic art, Cambridge Darkroom Gallery exhibits photography and new digital and electronic media in the gallery, as well as commissioning work and organising public art and education projects. Notable recent shows have included The Beyond and the Ridiculous with John Hilliard, Naomi Salaman and Hermione Wiltshire, and Just an Illusion

with work by Jonathan Bennett, Melanie Jackson, Richard Land and Alexa Wright.

Kettle's Yard Gallery

Castle Street, Cambridge CB3 0AQ
t 01223 352124 f 01223 324377
e-mail:
kettles-yard-gen@lists.cam.ac.uk
Gallery: Tues – Sat 12.30-5.30
Sun 2-5.30
House: Tues – Sat 2-4
Director: Michael Harrison

This series of eighteenth-century cottages with an extension designed by Sir Leslie Martin contains a unique collection of twentieth-century art, furniture and natural objects gathered over fifty years by HS Ede, assistant curator at the Tate Gallery in the 1920s and 30s. The selection reflects Ede's friendship with Ben Nicholson and Constantin Brancusi and includes major holdings of St Ives artists as well as a unique body of sculpture and drawings by Henri Gaudier-Brzeska. The adventurous programme of the adjoining purpose-built galleries distinguishes it as the only venue in East Anglia currently capable of exhibiting important twentieth-century and cutting-edge contemporary exhibitions.

CANTERBURY
The Herbert Read Gallery

Kent Institute of Art and Design at Canterbury, New Dover Road
Canterbury CT1 3AN
t 01227 769371 f 01227 451320
e-mail: bferrell@kiad.ac.uk
Mon – Fri 10-5

Exhibitions Officer: Christine Gist
The largest of the three galleries situated in art schools in Canterbury, Maidstone and Rochester, The Herbert Read Gallery reflects in its programme the South East region's links with Northern Europe. Belgique, for example, was a show of mixed-media work by six Belgians, and Despite/Difference, comprised photography, installation and video work by Polish women artists.

COLCHESTER
Firstsite at the Minories

74 High Street, Colchester
Essex CO1 1UE

t 01206 577067 f 01206 577161
e-mail: info@firstsite.eastern-arts.co.uk
Mon – Sat
Apr – Oct: 10-5, Nov – Mar: 10-4
Director: Katherine Wood

A programme of touring and self-generated shows of contemporary art by established and emerging figures at local, national and international levels takes place within this historical town-house and its gardens as well as in a variety of locations throughout the area.

COVENTRY
Mead Gallery

Warwick Arts Centre
University of Warwick,
Coventry CV4 7AL
t 01203 524524 f 01203 523883
e-mail: arts.centre@csv.warwick.ac.uk
Website:
http://www.warwick.ac.uk/artscentre
Mon – Sat 12-9
(term-time only)
Director: Sarah Shalgosky

Situated on the campus of Warwick University, the Mead Gallery presents a broad programme of twentieth-century visual culture with one-person, group and theme exhibitions of work in all media. Some shows are conceived by the gallery itself, including those of recent work by Paumindar Kaur, David Austen and Jo Stockham, while others are drawn from national and international tours.

EASTBOURNE
Towner Art Gallery & Local Museum

High Street, Old Town, Eastbourne
East Sussex BN20 8BB
t 01323 417961/725112 f 01323 648182
Tues – Sat
Apr – Oct: 10-5, Nov – Mar: 10–4
Sun 2-5 .
Curator: Fiona Robertson

The Towner is one of the recipients of a three-year (1993-6) partnership scheme with the CAS and ACE to purchase new work from contemporary artists. Its recent acquisitions complement its existing collection by addressing and extending ideas and perceptions of landscape. These have ranged from

Anya Gallaccio's *preserve (chateau)* 1995, a temporary installation of 100 gerberas placed between sheets of glass; to Tacita Dean's 16mm film/audio piece *A Bag of Air* (1995). They have also included two ambitious commissions: David Nash's permanent sculpture of reclaimed timber groynes in the gallery grounds, and a four-part photographic work by Thomas Joshua Cooper. There is also a lively programme of temporary exhibitions such as Richard Wilson's installation *Room 6 Channel View Hotel* (1996).

EXETER
Spacex Gallery
45 Preston Street, Exeter EX1 1DF
t/f 01392 431786
Tues – Sat 10-5
Exhibitions organiser: Alex Farquharson

The region's main venue for contemporary art has achieved an inventive programme alternating recent work by established figures like Bridget Riley and Richard Long with challenging mixed shows and important solo exhibitions of younger figures. Group shows have included *Life is Elsewhere* featuring Hadrian Piggott, Carl Hopgood and Elizabeth Wright, and *Finish*, paintings by Ian Davenport, Alexis Harding, Jane Harris and Jason Martin. A significant solo exhibition was Keith Coventry's 1997 display of new work, which saw a departure from his characteristic white canvases to a range of media such as video, bronze, found objects and installation.

GATESHEAD
Baltic Flour Mills
t 0191 477 1011 f 0191 477 5855
Website: http://www.gatesheadmbc.gov.uk/baltic.htm

A familiar landmark on the banks of the Tyne, the vast brick bulk of the derelict Baltic Flour Mills has already been the temporary site of a number of artworks, whether emblazoned with banners by Bruce McLean and Les Levine, or backdrop to a 2,000 metre light sculpture by Jaume Plensa. By the year 2000, not only will its facade provide a setting for many more major works, but with the help of £35 million lottery money it will provide the North East with a major, much-needed international centre for the visual arts.

HALIFAX
Dean Clough Galleries
Halifax, West Yorks HX3 5AX
t 01422 250250 f 01422 341148
e-mail: linda@design-dimension.co.uk
Website: http://www.DeanClough.com
Daily 10-5
Gallery Director: Doug Bindler

This complex of nineteenth-century mills, which once housed one of the world's largest carpet factories, was purchased by philanthropist Sir Ernest Hall in 1983 to create 'a practical utopia'. Along with some 100 companies and organisations now occupying the site are artists' studios and a network of galleries that show a range of contemporary art and design, giving priority to artists from the region.

The Henry Moore Studio
Gate 1, Dean Clough, Halifax
West Yorks HX3 5AX
Information line: 0113 234 3158
Open during exhibitions
Tues – Sun 12-5

Administered by the Henry Moore Sculpture Trust since 1989, this 10,000 square feet of stone-flagged, ground-floor space in one of the mills has earned a global reputation for its role as a studio space. Two or three major

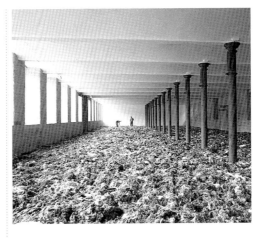

artists are invited annually to make new work in the studio with as little compromise as possible, which often leads to subsequent installations. These have included Giuseppe Penone (Italy); Richard Long (UK); Bruce McLean (UK); Jannis Kounellis (Italy); Christian Boltanski (France); Tony Cragg (UK); Andrew Sabin (UK). Also notable was *The Cauldron*, selected by Maureen Paley, a mixed show of young British artists: Christine Borland, Gillian Wearing, Jake and Dinos Chapman, Stephen Pippin, Georgina Starr and Angela Bulloch.

HULL
Ferens Art Gallery
Queen Victoria Square
Kingston-upon-Hull HU1 3RA
t 01482 613902 f 01482 613710
Mon – Sat 10-5, Sun 1.30-4.30
Admission charges to non-Hull residents
Curator: Ann Bukantas

An important permanent collection of twentieth-century British art has recently been augmented by a three-year purchasing collaboration (1994-6) with the CAS and ACE that has focused on the collection's strengths in portraiture and extended the theme into new works in a variety of different media dealing with issues of the body and identity. These include Nina Saunders' manipulated furniture, Mark Wallinger's *Passport Control* (1988), video installations by Marty St James, Anne

Wilson and Georgina Starr, and photopieces by Helen Chadwick, Craigie Horsfield and Boyd Webb.

The Ferens is also the home of a significant loan collection of over 200 pieces of British art from the 1980s and 1990s put together by Paul Wilson. **The Mag Collection** consists mainly of two-dimensional pieces – paintings, photographs and works on paper – spanning several generations, of which over seventy-five per cent are by women – from Elizabeth Blackadder and Wilhemina Barns-Graham to Cornelia Parker, Angela Bulloch, Gillian Wearing and Tracey Emin.

KENDAL
Abbot Hall Art Gallery
Kirkland, Kendal LA9 5AL
t 01539 722464 f 01539 722494
Mon – Sun
Feb, March, Nov, Dec 10.30-4
Jan, Apr – Oct 10.30 -5
Admission charges
Director: Edward King

An impressive Georgian house with an extensive permanent collection ranging from eighteenth- and nineteenth-century watercolours, modern British paintings and Kurt Schwitters' collages, Abbot Hall Art Gallery has recently put itself on the contemporary art map with a programme aimed to complement the permanent exhibits with, for example, shows of Lucian Freud, Estelle Thompson and Alison Wilding.

LEEDS
Henry Moore Institute
74 The Headrow, Leeds LS1 3AH
t 0113 246 7467 f 0113 246 1481
Mon – Sat 10-5.30, Wed 10-9
Director, Henry Moore Sculpture Trust:
Robert Hopper
Curator, Centre for the Study of
Sculpture: Penelope Curtis

These three early Victorian wool merchants' houses were dramatically converted in 1993 by architects Jeremy Dixon and Edward Jones into an international centre for the promotion, study and appreciation of sculpture of all periods and nationalities.

The shiny granite entrance looks like a piece of Minimalist sculpture in its own

right and the purpose-built galleries serve as a more traditional space to offset the experimental Henry Moore Studio at Dean Clough in Halifax (see above). Both are administered by the **Henry Moore Sculpture Trust**, which also organises sculpture projects in venues throughout the UK and abroad. Temporary exhibitions at the Henry Moore Institute have included *Robert Morris Recent Felt Pieces and Drawings*, as well as the smaller *In Focus* shows featuring sculptors like Richard Long. *At One Remove*, 1997-8 is a mixed show of contemporary artists from the UK and abroad (for example, Pierre Bismuth, Adam Chodzko, Tacita Dean, Kathy Prendergast, Graham Gussin and Elizabeth Wright) using projections, photos, casts, models and moulds to examine how it is possible for sculpture to function even when it has little or no material substance.

The **Centre for the Study of Sculpture** with its library, archive and exhibition spaces acts as a physical bridge between the Henry Moore Institute and adjoining Leeds City Art Gallery (see below). In the galleries one can see significant study exhibitions such as *Jasper Johns: The Sculptures*, as well as the work of younger figures including David Batchelor's *Polymonochromes*. The link between the Centre and the City Art Gallery is reinforced by their mutual curator.

Leeds City Art Gallery
The Headrow, Leeds LS1 3AA
t 0113 247 8248 f 0113 244 9689
e-mail: evelyn.silber@leeds.gov.uk
Website: http://www.leeds.gov.uk
Mon – Tues, Thurs – Sat 10-5
Wed 10-8, Sun 1-5
Director, Leeds Museums and Galleries:
Dr Evelyn Silber

Exhibitions Organiser: Nigel Walsh
This key permanent collection is strong in English watercolours and twentieth-century British art (especially Surrealism), and embraces the work of established living artists such as Susan Hiller, Paula Rego and Gillian Ayres, and photographic work by Richard Long, Boyd Webb, Hamish Fulton and Gilbert and George. Thanks to the City Art Gallery's relationship with the Henry

Moore Foundation, a strong sculpture collection extends from Rodin through to Alison Wilding and Grenville Davey. In addition to exhibitions shared with the Henry Moore Institute's Centre for the Study of Sculpture, (which extend into the City Art Gallery's mezzanine floor), one survey show of the newest in contemporary art is usually held annually. A recent example is *Small Truths: Repetition and the Obsessional in Contemporary Art*, curated by Nick de Ville in collaboration with the John Hansard Gallery, Southampton.

LIVERPOOL
Bluecoat Gallery
School Lane, Liverpool L1 3BX
t 0151 709 5689 f 0151 707 0048
Tues – Sat 10.30-5
Exhibitions Officer: Janice Webster

Part of the arts centre that for most of this century has occupied the eighteenth-century former Bluecoat School – the oldest building in Liverpool's city centre – this gallery boasts a reputation extending well beyond Merseyside for its promotion of innovative art by local, national and international artists. It is one of the host spaces for the *Video Positive* biennale of video and electronic art, as well as for shows such as *Ripe* – a collection of installations and videos by young artists working in new technologies – and solo exhibitions of work by emerging artists, notably Emma Rushton's figure sculptures and the manipulated furniture pieces of Nina Saunders.

Tate Gallery Liverpool
Albert Dock, Liverpool L3 4BB
t 0151 709 3223 f 0151 709 3122
e-mail: information@tate.org.uk
Tues – Sun 10-6
Admission charges for temporary exhibitions
Curator: Lewis Biggs

In the ten years between its estab-lishment in a nineteenth-century bonded warehouse and its re-opening in May 1998 after more refurbishment and the addition of a top floor of galleries, Tate Gallery Liverpool has notched up an impressive line-up of contemporary exhibitions. Retrospectives of Rachel

Whiteread, Susan Hiller, and Paula Rego have alternated with exhibitions of Alison Wilding, Ann Hamilton, Robert Gober, Gary Hill and Andreas Gursky. There have also been significant mixed shows of contemporary Irish, Japanese and African art.

An annual artist-in-residence fellowship sponsored by Momart has, over the years, given extra exposure to younger artists including Maud Sulter, Laura Godfrey-Issacs, Hermione Wiltshire, and Emma Rushton.

LONDON
COMMERCIAL GALLERIES

'A'
Bishop's Wharf, 49 Parkgate Road
London SW11 4NP
t 0171 978 7878 f 0171 978 7879
e-mail: alsop@dial.pipex.com
Website: http://www. archinet.co.uk/
alsop&stormer
Mon – Fri 10-5
Director: Mel Gooding

Sited in the offices of architectural practice Alsop and Störmer, 'A' has given itself the admirably open-ended brief to provide space for all kinds of artistic activity in any appropriate medium, whether photographs of artists by Gautier Deblonde, a sound installation by Bill Furlong of Audio Arts, or an installation by David Proud.

The Approach
1st Floor, 47 Approach Road
London E2 9LY
t/f 0181 983 3878
Thurs – Fri 1-7, Sat – Sun 12-6
Director: Jake Miller

Located on the first floor of a Bethnal Green pub, The Approach attracts mixed and solo shows by emerging and established artists such as Liz Arnold, Jane Simpson and Kerry Stewart, as well as inviting host curators like Rear Window (who organised their lively *Look of Love* exhibition) and the Tate's youngest artist-trustee Peter Doig, who selected a show of paintings.

Bank at Gallerie Poo Poo
34 Underwood Street, London N1 7JX
t/f 0171 336 6836

Fri – Sun 12-6
Directors: Simon Bedwell/John Russell/
Milly Thompson/Andrew Williamson

This artists' co-operative founded in 1991 curates and collaborates on a series of flamboyant shows. Originally, these took place in different spaces ranging from a disused bank to a swimming pool. Now, exhibitions are focused on their current site, Gallerie Poo Poo, in part of the Underwood Street complex and have included *Cocaine Orgasm*, a group show in a polystyrene Santa's grotto, *Charge of the Light Brigade*, in which a papier-maché battalion charged upside down across the ceiling; *Fuck Off*, with work by Gavin Turk, Rebecca Warren and Lolly Batty; or *Winkle*, which featured Jake and Dinos Chapman's glove puppet studio tour and a voodoo still life by John Cussans and Ranu Mukherjee. You haven't made it in the art world until you've been sent up in their monthly tabloid, *The Bank*.

Beaconsfield
Newport Street, Vauxhall
London SE11 6AY
t 0171 582 6465 f 0171 582 6486
e-mail: beaconsfield@easynet.co.uk
Website: http://www.metamute.com/
groundcontrol
Founders: David Crawforth/
Angus Neill/Naomi Siderfin

Beaconsfield's aim to 'fill a niche between existing public establishments, commerical enterprises and "alternative" ventures' disguises an international outlook (there have been collaborations with artists in Finland, Lithuania and the United States) and an agenda dedicated to placing strategic spanners in art-world works. Thematic shows held in this Neo-Classical, nineteenth-century, former 'Ragged School' for the poor of Lambeth, including *Cottage Industry* and *Maps Elsewhere* (co-curated with inIVA), have been complemented by performance marathons and an event in cyberspace.

Crawforth and Siderfin are also organisers of **Nosepaint**, which curates time-based events in a range of locations, often in collaboration with Beaconsfield. These include *Nosepaint at the Ministry of Sound,* and *Disorders –*

Art from Dawn to Dawn at St Thomas' Hospital, London.

City Racing
60 Oval Mansions, Vauxhall Street
London SE11 5SH
t/f 0171 582 3940
Fri – Sun 12-6
Organisers:
John Burgess/Keith Coventry/Matt
Hale/Paul Noble/Peter Owen.

Sited in three rooms above and behind a former betting shop in the Oval, south London, City Racing has become a leading showcase for rising and risen artists. Established in 1989, it has now extended beyond showing work by its core founders and mounts an increasing number of collaborations with international artists and curators. In 1991, Sarah Lucas, in her first solo show, presented *Penis Nailed to a Board*, a custom-made board game based on the notorious 'Spanner' case that outlawed consensual sado-masochism. Other artists to benefit from the space's 'experimental and relaxed approach' are Gillian Wearing, Roddy Buchanan, Lucy Gunning and Ceal Floyer.

Cubitt
2-4 Caledonia Street, London N1 9DZ
t/f 0171 278 8226
e-mail: cubittltd.demon.co.uk
Fri – Sun 11-6
Organisers: change annually

A move from Cubitt Street in 1994 to a former laundry in an even dodgier part of King's Cross just near the station means that the name of this exhibition space attached to artists' studios no longer reflects its location. However, this confusing detail hasn't prevented Cubitt from gaining a reputation – and attracting sizeable audiences – as one of the most important artist-run spaces in the capital, or indeed, the UK.

Run by an annually changing committee of studio holders, Cubitt doesn't have the specific identity or focus of a gallery like say, City Racing, and has made a virtue of its diversity by collaborating with guest curators. Stuart Morgan, Gareth Jones, Penelope Curtis and Antony Wilkinson have all organised shows here; Martin Creed,

Chris Ofili, John Stezaker and Tacita Dean are among the many artists shown. More recently, however, the programme has been curated by the gallery committee only, who aim to concentrate more on commissioning. A talks and events programme accompanies each exhibition and provides an important platform for debating art issues.

Delfina

50 Bermondsey Street, London SE1 3UD
Mon – Fri 10-5, Sat – Sun 2-5
t 0171 357 6600 f 0171 357 0250
e-mail: admin@delfina.org.uk
Curator: David Gilmour

Victorian warehouses provide the setting for this studio complex with a gallery space, situated in one of the oldest parts of London. Delfina's emphasis is on awarding artists' residencies: foreign artists – such as Pierre Bismuth, Karen Kilimnik and Michael Joo – can receive free studio space and accommodation for nine months, while eleven British artists receive a two-year studio residency. The beneficiaries between 1996-8 include Eric Bainbridge, Tacita Dean, Anya Gallaccio, Lucy Gunning, Shirazeh Houshiary, Mark Wallinger and Catherine Yass. Some of these artists exhibit in the gallery space, but there is no obligation to do so.

Gasworks

155 Vauxhall Street, London SE11 5RH
t 0171 587 5202 f 0171 582 0159
Fri – Sun 12-6
Gallery Committee:
Rebecca Fortnum/Beth Harland/Sean Cummins/ Jim Mooney/Eve Muske

The Gasworks is a three-storey building in Vauxhall providing rented studio space for London-based artists and three additional studios for visiting artists attached to its residency programme. The ground-floor gallery runs a continuous programme that aims to offer a platform to emerging artists as well as an experimental space for more established ones, spanning a wide range of media. The work of artists taking part in the residencies can also be seen here.

Milch

144 Charing Cross Road
London WC2H 0LB
t/f 0171 379 4338
e-mail : milch@easynet.co.uk
Tues – Fri 2-7, Sat 12-6
Directors: Fred Mann/Lisa Panting

Building on its radical reputation gained under the directorship of the late Lawren Maben with early shows of Simon Patterson, Douglas Gordon, Sarah Staton and Hamid Butt, Milch has moved from its Bloomsbury, Georgian squat to a Victorian warehouse with artists' studios and a three-room gallery space a block south of Centrepoint in London's West End. Memorable shows have included Jane and Louise Wilson's *Normapaths,* and *I Beg to Differ,* a roomfull of plinth-based television sets, each showing a different artist's film loop.

Museum of Installation

175 Deptford High Street
London SE8 3NU
t 0181 692 8778 f 0181 692 8122
Directors: Nicola Oxley/Nicolas de Oliveira/Michael Petry

Founded in 1990 with the ironic title of Museum of Installation, this venue claims to be 'the first and only museum of its kind in the world'. Its exhibition spaces are devoted exclusively to commissioned installations (Ron Haselden and Phyllida Barlow have each contributed notable pieces). However, far from subverting the notion of the museum, MOI is almost institutional in its compiling of a comprehensive archive and its publication of the historical survey *Installation Art.*

Tannery

57 Bermondsey Street, London SE1 3JG
t 0171 234 0587 f 0171 394 0545
Thurs – Sun 12-6
Exhibition co-ordinator: Katharine Stout

Associated with Tannery Arts, which houses artists in the adjoining studio complex, the three floors of exhibition space in this Victorian warehouse host six theme-based shows a year selected by invited artists and curators. These have included works by international figures such as Paul McCarthy, Georg

Herold and Georgina Starr, alongside newly emergent artists like Simon Starling, Rachel Evans and Sean Dower. The Tannery also operates a project space and hosts a progamme of recent graduate exhibitions over the summer.

30 Underwood St Gallery

30 Underwood Street, London N1 7XJ
t 0171 336 0884 f 0171 250 3045
Fri – Sun, 1-6
Director: Simon Hedges

Attached to a complex of artists' studios and workshops, this space focuses particularly on live/multi-disciplinary art and its historical context. It has mounted first solo UK shows of Fluxus artist Tatsumi Orimoto, and Viennese Actionist Hermann Nitsch, the greatgranddaddy of performance art. Young artists who have shown work in all forms here include Padraig Timoney and Damien Duffy.

Tracey Emin Museum

221 Waterloo Road, London SE1 8XH
t/f 0171 261 1116
Website: http://www.whitecube.com
Phone for opening times

This 'museum' is part of Tracey Emin's ongoing self-as-art project, and what takes place here is dependent on the artist. Activities range from video screenings, performances, the showing of Emin's work in other media, or a first-hand view of work in progress. The experience is described by the artist as 'very comfortable almost domestic – a place where people can take on the ideas of life and art. In that order'.

COMMERCIAL GALLERIES

The Agency

35-40 Charlotte Road
London EC2A 3DH
t/f 0171 613 2080
e-mail: schepke@mailbox.co.uk
Tues – Fri 11-6, Sat 11–4
Directors: Bea de Souza/ Charlotte Schepke

Founded in 1992 as a 'gallery walking the tightrope between commerce and art', this venue maintains its reputation

for the precise and rigorous presentation of work, focusing on innovation rather than familiarity, particularly in the form of concept-based work and experimentation with new media. Such shows have included a programme of films by Paul McCarthy, and Douglas Gordon and Graham Gussin's collaborative *Jukebox*. The mixed exhibition *Strange Days* combined the work of Glenn Brown, Julia Sher, Christine Borland and Raymond Pettibon.

Annely Juda Fine Art
23 Dering Street, London W1R 9AA
t 0171 629 7578 f 0171 491 2139
Mon – Fri 10-6, Sat 10-1
Directors: Annely and David Juda/
Ian Barker

This long-established gallery and its founder Annely Juda are widely admired and respected throughout the art world. One of London's most beautiful daylit spaces, it was designed by the late Max Gordon who also converted the Saatchi Gallery. An abiding concern with the great historical abstract movements – de Stijl, Russian Abstraction and Constructivism – is complemented by well-established living artists – Anthony Caro, Hamish Fulton, Christo and Jeanne-Claude, Eduardo Chillida – and, more surprisingly, David Hockney. The gallery also has a long association with the Far East, regularly exhibiting artists such as Katsura Funakoshi, Tadashi Kawamata and Yoshishige Saito.

Anthony d'Offay Gallery
Dering Street, London W1R 9AA
t 0171 499 4100 f 0171 493 4443
Mon – Fri 10-5.30, Sat 10-1
Director: Anthony d'Offay

Anthony d'Offay's formidable stable of international heavyweights, dead and alive, from Kiefer to De Kooning, Warhol to Koons, is now being spiced up by an increasingly adventurous investment in the future, spearheaded by ex-Southampton City Art Gallery Director, Margot Heller. Younger additions to the roster are Scottish video artists Stephanie Smith and Edward Stewart; Mexican master of the elliptical Gabriel Orozco; US painter Ellen Gallagher; provocative potter and fabric artist

Grayson Perry, Richard Patterson, a British painter of hauntingly molten moments; and Rachel Whiteread, who left Karsten Schubert for Anthony d'Offay Gallery amid some controversy in 1996.

Anthony Reynolds
5 Dering Street, London W1R 9AB
t 0171 491 0621 f 0171 495 2374
Tues – Sat 10-6
Director: Anthony Reynolds

This small space enjoys a solid reputation, good international connections and an important line-up of gallery artists working in all media who include Mark Wallinger, Steve McQueen, Georgina Starr, Richard Billingham, Alain Miller, Paul Graham, Keith Tyson and Lucia Nogueira.

Bernard Jacobson Gallery
14a Clifford Street, London W1X 1RF
t 0171 495 8575 f 0171 495 6210
e-mail: bernard-jacobson@slad.org
Website: http://www.slad.org/
bernard-jacobson-gallery
Mon – Fri 10-6, Sat 10-1
Director: Bernard Jacobson

The ebullient Bernard Jacobson (who persuaded Peter Fuller to found *Modern Painters* and who brought his friend and fellow Modern British enthusiast David Bowie onto the magazine's board) has been an extremely vocal opponent of Modernism and its spawn. His gallery is known as a bastion of traditional British landscapes by both young and older established names, but he does allow occasional aberrations such as Sue Stockwell's installation, which filled the gallery with delicate layers of toilet paper, or the polemical artworks of South African Kendell Geers. Recently, the gallery's orientation seems to have been broadening out towards blue-chip Modernists, with vintage sculptor Philip King and American artists Robert Rauschenberg and Frank Stella recent acquisitions to the gallery stable.

Cabinet Gallery
8 Clifton Mansions
429 Coldharbour Lane
London SW9 8LL
t/f 0171 274 4252

Thurs – Sat 12-6
Directors: Andrew Wheatley/
Martin McGeown

Since 1992 when *From Hell* unleashed the encaustic ghouls of Simon Bill and the prosthetic fantasies of Rod Dickenson, this three-room tenement flat in Brixton has established itself as a leading venue for rigorously curated shows of maverick art production from across the globe.

Obsessiveness is the keynote, whether in mixed shows such as *Please Don't Hurt Me*, or in single exhibitions like those of the subversive US art-bomb maker Gregory Green, LA surfer-artist Russell Crotty, who presented Biro drawings of waves and constellations, and Jeremy Deller from the UK. His show tapped into mainstream youth culture with drawings by Manic Street Preacher Fans and the performance and CD release of acid house music played by a traditional brass band.

Entwistle
6 Cork Street, London W1X 2EE
t 0171 734 6440 f 0171 734 9966
Mon – Fri 10-5.30, Sat 11–4.30
Exhibitions Director: Mark Sladen

Whether with the beetle-encrusted figures of Flemish sculptor Jan Fabre, the arresting surf video and photographs of Peter Newman, or the eerily pristine mutant sculptures of Siobhán Hapaska, this space is quickly establishing a reputation as a significant showcase for new art.

Frith Street Gallery
59-60 Frith Street, London W1V 5TA
t 0171 494 1550 f 287 3733
Tues – Fri 10-6, Sat 11-4
Director: Jane Hamlyn

A labyrinth-like series of immaculately designed spaces behind the facades of two Georgian houses in Soho provides a conducive setting for a group of gallery artists that combines mid-career heavyweights such as Callum Innes, Craigie Horsfield, Cornelia Parker and Bernard Frize, with younger figures including Dorothy Cross, Fiona Banner, Tacita Dean and Jaki Irvine. The gallery also regularly shows works on paper by

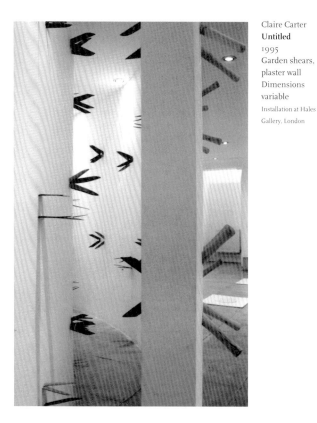

Claire Carter
Untitled
1995
Garden shears,
plaster wall
Dimensions
variable
Installation at Hales
Gallery, London

major international artists such as Juan Muñoz, Giuseppe Penone, Marlene Dumas and Thomas Schütte.

Hales Gallery
70 Deptford High Street
London SE8 4RT
t/f 0181 694 1194
Mon – Sat 10-4
Director: Paul Hedge

It's no mean feat to get major collectors like Charles Saatchi and Stuart Evans to come and buy from a space in deepest south east London that really is an ace caff with not a bad gallery attached. Profits from the café, which attracts traders from the street market outside, have helped to fund installations in the basement by John Frankland, Claire Carter, and Jake and Dinos Chapman. Gallery artists' shows have ranged from the breezeblock sculptures of Jonathan Callan to the paintings of 1995 John Moores prize-winner, David Leapman.

Interim Art
21 Beck Road, London E8 4RE
t 0171 254 9607 f 0171 254 6445
Fri – Sat 11-6
Director: Maureen Paley

Although it is still situated in three small rooms in a Hackney terrace, the space that launched a multitude of home-based galleries has evolved from a collaborative project site into a more streamlined commercial gallery with a monthly programme of exhibitions. These showcase the work of younger artists from Britain and the USA – sometimes straight from art school. Among the gallery artists are Sarah Jones, who makes immaculate photographs, Gillian Wearing, painter Mark Francis, and Paul Noble whose dark and disquieting humour is conveyed through a number of vehicles: paintings, drawings, photographs, or the ironic, survival-in-the-nineties board game, *Doley*.

Laure Genillard
82-84 Clerkenwell Road
London EC1M 5RJ
t 0171 490 8853 f 0171 490 8854
Website: URL:http://ourworld.
compuserve.com.homepages/
Tues-Fri 11-6, Sat 11-3
Director: Laure Genillard

Work by young artists from the UK and Europe operating in all media and methods finds a home here, including Simon Tegala's video projections on metal with burning gas, the paintings of Dan Hays, the sculptures of Italian artists Maurizio Catellan and Giuseppe Gabellone, and the hauntingly solarised photoworks of Catherine Yass. This was also one of the first venues for Sarah Staton's ongoing, shop-till-you-drop, art-for-every-income experience, *Art Superstore*.

Laurent Delaye Gallery
22 Barrett Street, St Christopher's Place
London W1M 5HP
t 0171 629 5905 f 0171 491 1248
e-mail: delayegallery@clara.net
Tues – Fri 10–6, Sat 12 – 6
Director: Laurent Delaye

As well as representing a lively line-up including American artist and film-maker Beth B, and the increasingly prominent painter James Rielly (1995 Tate Liverpool Fellow, shortlisted for the 1997 Jerwood Prize), this gallery displays a refreshing attitude to collaboration with a range of artists and organisations. The energetic programme of mixed exhibitions and events takes place both within and beyond the rough-edged industrial space in the heart of London's most chi-chi shopping area. *Dissolution*, for example, was a mixed painting show featuring new work by Keith Tyson, Simon Bill, Gavin Turk, Mark Wallinger and Alain Miller; *Jam in the Park* was a programme of short experimental artists' films.

Lisson Gallery
52-54 Bell Street, London NW1 5DA
t 0171 724 2739 f 0171 724 7124
Mon -Fri 10-6, Sat 10-5
Director: Nicholas Logsdail

Not only has the Lisson Gallery launched the careers of sculptors such as Bill Woodrow, Tony Cragg, Richard Deacon, Richard Wentworth, Edward Allington, and Anish Kapoor, and later Julian Opie and Grenville Davey, it has also held on to these artists by growing along with them. Now a series of museum-like spaces with a programme that perpetuates the house preference for minimalist rigour, the Lisson augments its stable of blue-chip elders from home and abroad with more youthful additions. Douglas Gordon's dark, psychological investigations, Christine Borland's forensic experiments, the slyly subversive tweakings at Conceptual and Minimalist traditions of Simon Patterson's language games, and the deceptively low-key pieces of Ceal Floyer can all be found here.

London Projects

47 Frith Street, London W1V 5TE
t 0171 734 1723 f 0171 494 1722
Fri – Sat 10-6
Director: Marc Jancou

This organisation offers the rare chance to see work by a roster of influential international artists, some of whom are represented by the gallery (Uta Barth, John Coplans, Mark Dion, Mike Kelley, Alexis Rockmann, Carroll Dunham), as well as others (Chris Burden or the late Martin Kippenberger, for example) whose work is rarely seen in this country.

Lotta Hammer

51 Cleveland Street, London W1P 5PQ
t 0171 636 2221 f 0171 436 6067
e-mail: clever@easynet.co.uk
Tues – Fri 11-6, Sat 12-4
Director: Lotta Hammer

Although it opened as recently as 1996, with an exhibition of Graham Gussin's sci-fi landscapes and sculptures, this gallery is fast eclipsing more established spaces with its shows of young British artists. Examples are anthropomorphic insect painter Liz Arnold, Glaswegian urban sportsman Roddy Buchanan, and Adam Chodzko, who showed his disquieting interventions into the marginal world of classified ads, film extras and strange phenomena here.

International art by both leading and emerging names can also be seen in this venue.

Robert Prime

60-61 Warren Street, London W1P 5PA
t 0171 916 6366 f 0171 916 6369
Tues – Fri 11-6, Sat 11 –3
Directors: Tommaso Corvi Mora/
Gregorio Magnani

This is another recently opened space (1996) that is providing a valuable showcase for artists from Britain, Europe and the USA who often enjoy a major international reputation but are rarely seen in the UK. Exhibitions have presented writer/curator/ artist Liam Gillick's intellectual workout-cum-sculptural installation *The What If? Scenario*; Angela Bulloch's audience-activated environment of sound and furniture; Martin Maloney's large, 'genre paintings' of loosely painted slackers slacking; and new pieces from the veteran of bad behaviour, Los Angeles artist Paul McCarthy.

Sadie Coles HQ

35 Heddon Street, London W1R 7LL
t 0171 434 2227 f 0171 434 2228
Tues – Sat 10 – 6
Director: Sadie Coles

This new, first-floor space was opened in 1997 by an ex-d'Offay Director with a sharp eye for talent and a keen nose for the scene. An inaugural show of busty, blighted pinups by American painter John Currin was followed by two Sarah Lucas exhibitions – one in an appropriately roughed-up warehouse, pointing to a gallery policy of initiating projects in a variety of spaces – and a show of Simon Periton's intricately subversive cut-out 'doily' works.

Stephen Friedman

25-28 Old Burlington Street
London W1X 1LB
t 0171494 1434 f 0171 494 1431
e-mail: frie@dircon.co.uk
Tues – Fri 10-6, Sat 11-5
Director: Stephen Friedman

This gallery's international programme manages to be both lively and weighty with younger figures who are already

cutting a swathe like British artists Kerry Stewart and Yinka Shonibare, as well as more established names such as Laotian-born sculptor Vong Phaophanit, Canadian Geneviève Cadieux and German sculptor Stephan Balkenhol.

Victoria Miro Gallery

21 Cork Street, London W1X 1HB
t 0171 734 5082 f 0171 494 1787
Mon – Fri 10-5.30, Sat 11-1
Directors: Victoria Miro/
Glenn Scott-Wright

After the recession closed down much of Cork Street, this was one of the few contemporary art spaces that made the area still worth a visit. Now the Piccadilly environs are active again, but this gallery still leads the field with a selection of artists that includes miracle machine-maker Stephen Pippin, Peter Doig, Chris Ofili, Brad Lochore, Abigail Lane, Jake and Dinos Chapman, the film-maker Isaac Julien, and veteran poet-artist Ian Hamilton Finlay.

Waddington Galleries

11, 12 & 34 Cork Street, London W1X 2LT
t 0171 437 8611/439 6262 f 0171 734 4146
Mon – Fri 10-5.30, Sat 10-1
Director: Leslie Waddington

Although it has shed a few spaces since the boomtime years, this is still the gallery that dominates Cork Street. The roster of Modernist masters are augmented with such elder statesmen as Patrick Caulfield and Michael Craig-Martin, and, under the aegis of Hester van Roijen, a smattering of young painters: Fiona Rae, Ian Davenport and Zebedee Jones.

White Cube

44 Duke Street St James's
London SW1Y 6DD
t 0171 930 5373 f 0171 930 9973
e-mail: jjopling@whitecube.com
Website: http://www.whitecube.com
Fri – Sat 12-6
Directors: Jay Jopling/Julia Royse

A 'temporary project space for contemporary art', White Cube's pristine four square meters have been transformed with specially made work by artists ranging from Brian Eno to

Gary Hill. It is also the HQ of a multi-layered and wide-reaching operation that has had a crucial role in the current British art boom. Its impressive stable of British artists boasts Tracey Emin, Damien Hirst, Angus Fairhurst, Antony Gormley, Mona Hatoum, Marc Quinn and Sam Taylor-Wood. White Cube also enjoys an ongoing relationship with major international names – Lari Pittman, Nobuyoshi Araki, Gary Hill, Sean Landers, Jeff Wall – and works with others – Richard Prince, Brian Eno, Karen Kilimnik – on a one-off basis.

Jay Jopling is the high-profile director, but it is White Cube's co-founder Julia Royse – who trained as an artist and then worked at London's Chisenhale Gallery before joining forces with Jopling when he was still working out of a terrace in Brixton – who actually works with this wide variety of artists on White Cube's fast-turnover programme. However, with the five-year lease soon up for renewal, it is likely that White Cube will soon be changing its location – and maybe its dimensions.

PUBLIC GALLERIES

Camden Arts Centre
Arkwright Road, London NW3 6DG
t 0171 435 5224/2643 f 0171 794 3371
Tues – Thurs 11-7, Fri – Sun 11-5.30
Director: Jenni Lomax

It may have to find funding for every exhibition it puts on, but that hasn't prevented Camden Arts Centre from mounting an ambitious and thoughtful programme whose dedication to innovative works by both established and emerging artists can encompass huge new canvases by veteran St Ives painter Patrick Heron, Mat Collishaw's ventures into the phenomenological, or the architectural sculptures of Dan Graham. Mixed shows have contrasted works by Ad Reinhardt, Felix Gonzales-Torres and Joseph Kosuth, or looked at the multicultural range of artists currently working in Paris (Parisiennes, 1997). The Centre's judicious splicing of the influential older generation with rising youth, its global outlook and its light-footed but resolute dedication to raising issues in art, and disseminating

them through an intelligent education programme has won it universal respect from audiences across the world, as well as within its local community.

Camerawork
121 Roman Road, London E2 0QN
t 0181 980 6256 f 0181 983 4714
e-mail : cam@camwork.demon.co.uk
Website: http://www.camerawork.net
Tues – Sat 1-6, Sun 12-5
Director: John Roberts

For twenty years this gallery and darkroom has provided an important resource for the production, exhibition and discussion of contemporary photography and image technology. Through its recently revamped exhibitions programme, Camerawork has analysed the role of photography in early Conceptual art, and shown specific pieces emerging out of artist's residencies. Pals and Chums (1997), surveyed young British artists dealing with the photographic document, subjectivity and popular culture.

Chisenhale Gallery
64 Chisenhale Road, London E3 5QZ
t 0181 981 4518 f0181 980 7169
Wed – Sun 1-6
Director: Judith Nesbitt

This 2,500-square-foot space in a former factory for Spitfire propellers has become established as an influential testing ground and launchpad for younger artists to achieve international reputations. Rachel Whiteread had her first solo show at Chisenhale, which commissioned Ghost (1990), the cast of a room that preceded her famous House. Cornelia Parker's exploded and reconstituted shed was also a Chisenhale commission, and Simon Patterson and Cathy de Monchaux both held their debut major solo shows in its one large room. Chisenhale is also known for giving international artists such as Pipilotti Rist (1996) and Wolfgang Tillmans (1997) their initial major UK showing; and recently it has confirmed the importance of video for a generation of artists by commissioning and showing new video installation pieces from British artists Jane and Louise Wilson, Sam Taylor-Wood and Gillian Wearing.

Hayward Gallery
SBC, London SE1 8XX
t 0171 960 4208
Advance booking: 0171 960 4242
f 0171 401 2664
Website:
http://www.hayward-gallery.org.uk
Thurs – Mon 10-6
Tues – Wed 10- 8
Admission charges
Director: Susan Ferleger Brades; Head of Exhibitions: Martin Caiger-Smith

This purpose-built gallery, opened in 1968, is both loved and loathed as a classic example of 1960s 'brutalist' architecture, but its large spaces have proved surprisingly adaptable for presenting a wide range of ground-breaking exhibitions over thirty years. Examples of living artists who have received shows here are Bridget Riley, Jasper Johns, Richard Long, James Turrell, Julian Opie, and in 1998, Bruce Nauman and Anish Kapoor. Key survey exhibitions have been the international Doubletake; Unbound: Possibilities in Painting; Spellbound: Art and Film and the sculpture show Material Culture: The Object in British Art of the 1980s and 90s. These complement other exhibitions in the programme devoted to historical themes and artistic movements, and to non-Western cultures.

Managed by the Hayward Gallery on behalf of the Arts Council of England, National Touring Exhibitions present a continuing, varied programme of around twenty shows a year. Available to venues across the UK these range from the five-yearly British Art Show to an exhibition devoted to Fetishism, or Drawing the Line – artists' drawings from the Renaissance to the contemporary, selected and provocatively juxtaposed by Michael Craig-Martin. National Touring Exhibitions also draw on the holdings of the Arts Council Collection.

Institute of Contemporary Arts (ICA)
The Mall, London SW1Y 5AH
t 0171 930 3647 f 0171 873 0051
e-mail: info@ica.org.uk
Website: http://www.ica.org,uk
Sat – Thurs 12-7.30, Fri 12-9
Admission charge for non-members

Director: Philip Dodd; Director of
Exhibitions: Emma Dexter

Described by one of its founders, the
writer Herbert Read, as 'an adult play
centre' that would unite the arts inter-
nationally and provide a meeting place
for poets, artists, actors, musicians,
scientists and the general public, the
ICA has, since its establishment in 1947,
been a crucible for the most experi-
mental and avant garde in all art forms.
Its first exhibition, *40 Years of Modern
Art* included early work by Bacon, Freud,
Picasso and Balthus, and the ICA was
also the headquarters of the Independent
Group who invented British Pop art.
 More recently, however, it has seen
energetic newcomers in all disciplines
threaten to steal its revolutionary
thunder and has been criticised for
responding to, rather than initiating
trends. Nevertheless, it has mounted
important shows of artists from the UK
and internationally: from the first major
public exhibitions of Damien Hirst, Jake
and Dinos Chapman and Steve
McQueen, to Darren Almond's live
satellite link-up to a Pentonville prison
cell, along with such boundary-testing
mixed shows as *The Institute of Cultural
Anxiety*, curated by writer-artist Jeremy
Millar, and *Pandaemonium*, its impor-
tant festival of film and cyberspace.
 There is much speculation as to how
the ICA will redefine itself in the future,
and whether it will move from its elegant
Nash terrace at the heart of the
establishment to a new location.

Matt's Gallery
42-44 Copperfield Road London E3 4RR
t 0181 983 1771 f 0181 983 1435
Wed – Sun 12-6
Director: Robin Klassnik

Perhaps the only gallery to be named
after a dog, this two-space, East-End
venue is run by two people and a
computer but still manages to maintain
a uniquely experimental profile. Its
policy of allowing artists the scope and
time to develop new ideas while making
work specifically for the space has been
much imitated, but the status of the
artists and quality of the projects that
continue to emerge from this
collaboration, including Richard

Wilson's oil piece *20:50* , Susan Hiller's
An Entertainment, Tony Bevan's giant
head, and important new works by
Willie Doherty, Jimmie Durham, Lucy
Gunning and Kate Smith confirm that
so far, this gallery's formula has not
been bettered elsewhere.

Photographers Gallery
5 & 8 Newport Street
London WC2H 7HY
t 0171 831 1772 f 0171 836 9704
e-mail: info@photonet.org.uk
Mon – Sat 11-6
Director: Paul Wombell

Britain's first independent gallery to be
devoted to photography, this space has
maintained its reputation as a primary
venue for contemporary photographic
work, both initiating exhibitions and
commissioning new work. It has been
instrumental in encouraging the
inclusion of photography in the
programmes of leading galleries and
museums, and its recent programme
has reflected the interchangeable
relationship between photography and
contemporary art.

Royal Academy of Arts
Piccadilly, London W1V 0DS
t 0171 300 8000
Advance booking: 0171 300 5676
f 0171 300 5774
Website:
http://www.royalacademy.org.uk
Daily 10-6
Admission charges
Exhibitions Secretary:
Norman Rosenthal

This bastion of the English art
establishment received an unlikely blast
of the new when it appointed the feisty,
indomitable Norman Rosenthal in 1977.
He had already made his mark as
Exhibitions Director at the ICA (his
bloodstains from some skirmish with a
colleague can still be seen on the walls
of the Institute's mezzanine offices,
lovingly preserved behind Perspex), and
in 1979 he relaunched his career at the
Academy with the exhibition *Post
Impressionism*. *A New Spirit in Painting*,
which he co-curated with Christos
Joachimides and Nicholas Serota, has
gone down in history as one of the key
triggers of the 1980s painting revival.
Since then, as well as organising major
historical exhibitions ranging from
Medieval treasures to Monet, he has
continued to put himself in the hot seat
and the Academy on the international
contemporary art map with a series of
big-theme survey blockbusters of
twentieth-century German (1985),
British (1987), Italian (1989), and
American (1993) art; and, more
audaciously, the recent show *Sensation*
(1997), which featured some 150 works
by many of the more flamboyant young
British artists from the Saatchi
Collection. In this context, the Royal
Academy's annual Summer Show
seems increasingly anachronistic.

Saatchi Gallery
98a Boundary Road, London NW8 0RH
t 0171 624 8299 f 0171 624 3798
Thurs – Sun 12-6
Admission charges (free Thurs)
Curator: Jenny Blyth

*Young British
Artists VI*
1996
Installation at
Saatchi Gallery,
London
(foreground John
Isaacs, background
Nina Saunders)

The vast dimensions and stunning impact of this series of dazzling white spaces, as well as its programme of shows that has spanned the grandest of American High Modernism (Cy Twombly, Richard Serra, Andy Warhol, Frank Stella) and the most daring of the up-to-the-minute contemporary (Damien Hirst, Marc Quinn, Sarah Lucas, and the sinister, hybrid mannequins of John Isaacs), make it hard to remember that this is a privately run gallery and not an official institution. Everything looks good in this pristine setting, conjured out of a derelict paint factory in 1985 by the architect Max Gordon, especially the kind of large-scale, spectacular young art that Saatchi seems to favour. Installations by Richard Wilson and John Frankland on semi-permanent view add to the gallery's status both within the British art world and beyond.

Serpentine Gallery

Kensington Gardens, London W2 3XA
t 0171 402 6075 f 0171 402 4103
Daily 10-6
Director: Julia Peyton-Jones
Curator: Lisa Corrin

Few galleries forced to close for refurbishment have been as creative as the Serpentine during the year of its lottery-funded redevelopment: artists from Richard Wilson to Richard Deacon, Rasheed Areen and Anya Gallaccio have been invited to make work in and around the site. By re-opening its revamped building in 1998 with a major exhibition of Piero Manzoni, the avant-garde pioneer of Conceptual art, Performance and Arte Povera, whose enduring influence can be felt on many of the young British artists who have already exhibited in the gallery (Damien Hirst, Simon Patterson and Rachel Whiteread among them), the Serpentine confirms its commitment to the experimental in both old and new art. Memorable shows were Brian Catling's *The Blindings* (1994) and the famous collaboration between Cornelia Parker and Tilda Swinton, *The Maybe* (1995). Major one-person exhibitions have included Richard Wentworth, Mark Wallinger and Richard Wilson.

The Showroom

44 Bonner Road, London E2 9JS
t 0181 983 4115 f 0181 981 4112
Wed – Sun 1-6
Director: Kim Sweet

This venue increasingly lives up to its name with its commitment to commissioning important and often ambitious new work by young artists at a crucial stage of their careers. Sam Taylor-Wood's four-part projection *Killing Time* was initiated here, as were Stephanie Smith and Edward Stewart's two video projections *Sustain* and Elizabeth Wright's life-size reconstruction of a 1950s bungalow inside the gallery space *(Untitled* 1996).

South London Gallery

65 Peckham Road, London SE5 8UH
t 0171 703 6120 f 0171 252 4730
e-mail: slg@artsouthwark.org.uk
Tues, Wed, Fri 11-6, Thurs 11-7
Sat – Sun 2-6
Director: David Thorp

Purpose built in 1891 to introduce an impoverished area of London to the improving qualities of art, this gallery has fulfilled its remit plus interest by metamorphosing from a shabby local arts centre into a uniquely versatile venue for major shows of contemporary art. The wraparound *Naked Shit Pictures* of Gilbert and George, Tracey Emin's reliquary of personal memorabilia, the giant projected face of Brian Catling, and the epic seed-encrusted images of Anselm Kiefer have all been shown here, as well as a number of guest-curated mixed exhibitions of the hottest work from across the world (Carl Freedman's *Minky Manky*, the Cabinet Gallery's *Popocultural* and *Some Kind of Heaven*, organised by Sadie Coles and Eva Meyer-Hermann). All look (and are sometimes worth) a million dollars in the single chamber of this perfectly proportioned, top-lit Victorian gallery.

Whitechapel Art Gallery

Whitechapel High Street
London E1 7QX
t 0171 522 7878, recorded information:
0171 522 7878 f 0171 377 1685
Tues – Sun 11-5, Wed 11-8
Director: Catherine Lampert
Curators: Felicity Lunn/James Peto

The result of another turn-of-the-century attempt to bring the local community into contact with major works of art, the Whitechapel boasts an auspicious history that embraces the exhibition of Picasso's *Guernica* in 1939, major shows of US and UK abstract art in the 1960s and 1970s, and a programme of international heavyweights throughout the 1980s. Now, it is established as an important venue for worldwide contemporary art with shows of Bill Viola, Christian Boltanski, and Marie-Jo Lafontaine. There has also been a special emphasis on artists from outside Britain and the US such as Frida Kahlo, Tina Modotti, Lygia Clark and more recently Tunga and Francis Alys. Leading British artists presented here – Tony Bevan, Lucian Freud, Tony Cragg, Cathy de Monchaux – along with the bi-annual Whitechapel Open, show that this gallery also has its roots in home ground.

PUBLIC MUSEUMS

Science Museum

Exhibition Road, London SW7 2DD
t 0171 938 8000 f 0171 938 8118
Website: http://www.nmsi.ac.uk
Daily 10–6
Admission charges
Director: Sir Neil Cossons OBE

The Science Museum's progressive attitude towards contemporary art has resulted in a policy by which every time it opens a new gallery it will solicit the input of an artist. Each commission comes about through the artist's research into the collection with the curator. Projects range from a mosaic floor by Tim Head for the basement area, to *Oak Repels Lightning* 1997, responses by Jordan Baseman, Brian Catling and Tacita Dean to the Challenge of Materials Gallery.

Tate Gallery

Millbank, London SW1P 4RG
t 0171 887 8000 f 0171 887 8007
e-mail: information@tate.org.uk
Daily 10-5.50
Admission charges for exhibitions
Director: Nicholas Serota

The Tate Gallery was established in 1897 on the site of Millbank Penitentiary to house the collection of the Liverpool-born sugar magnate and philanthropist, Henry Tate. Since then it has evolved into a hybrid beast, committed to accommodating the national collection of British art from the sixteenth century to the present day, as well as being the national gallery of modern and contemporary art from around the world. Even with the addition of the Clore Gallery in 1987 as the new home for the Turner Bequest, and the opening of Tate Galleries in Liverpool (1988) and St Ives (1993), there is still little room for up-to-the-minute contemporary art – especially the kind of space-hungry pieces that so many artists are currently producing. Apart from the annual exhibition of shortlisted Turner Prize candidates, the only consistent airplay given to the work of young artists in the 1990s has been the bi-monthly 'Art Now' programme of British and international artists (including Georgina Starr, Tacita Dean, Marc Quinn and Paul Graham as well as Matthew Barney, Geneviève Cadieux and Michal Rovner) in a special-projects room based on that of the Museum of Modern Art, New York, but on a smaller scale. Little wonder, then, that the Saatchi Gallery has established a quasi-institutional status as the main venue for contemporary art.

Tate Gallery of Modern Art, Bankside

All this is set to change, however, now that funding has been secured for Sir Giles Gilbert Scott's 1947 Bankside Power Station to be converted into Tate Gallery of Modern Art by the year 2000. Speculation is already rife as to how Serota and the curators Iwona Blazwick and Frances Morris will orchestrate the variously dimensioned exhibition spaces designed by Swiss architects Herzog and de Meuron, which will be arranged over three floors on the north side of the 500-metre-long central Turbine Hall. What is emerging from discussions within the Tate is that the collection will continue to move around more permanent elements such as the Rothko room, as well as between the different Tates at Liverpool and St Ives

and – after the year 2001 – the Tate Gallery of British Art at Millbank.

Janet Wolfson de Botton Gift

Despite the fact that the Tate already has substantial holdings in classic modern and contemporary art, and although – often with the help of its increasingly active Patrons – it has been able to acquire some significant pieces by younger British artists such as Rachel Whiteread, Cathy de Monchaux, and Michael Landy, its representation of recent artists has also been massively boosted by the gift to the Gallery of fifty-six works by British and American artists collected by Tate Trustee Janet de Botton between the late 1970s and early 1990s, and valued at around £2.3 million. There are paintings by Sean Scully, Robert Ryman, Julian Schnabel, Francesco Clemente, Frank Stella and Andy Warhol, photographic works by Cindy Sherman and Gilbert and George, and pieces tracing the redefinition of sculpture, begun in the 1960s by Carl Andre, Donald Judd and Sol LeWitt, and continued by Richard Long, Richard Wentworth, Bill Woodrow and Grenville Davey.

Add to this various long-term loan arrangements with the extensive Froehlich Foundation of German and American Art and it seems that Bankside's spaces are filling up nicely. However, to what extent the new Tate Gallery of Modern Art's programme will reflect the artistic energy currently emanating from the UK's younger artists remains to be seen.

LYMINGTON
ArtSway
Station Road, Sway, Near Lymington Hampshire SO41 6BA
t 01590 682260 f 01590 681989
e-mail: info@artsway.demom.co.uk
Wed – Sun 12-4
Director: Linda Fredericks

A converted coach house at the back of a hotel in the middle of the New Forest is an unlikely venue for contemporary art, but there's nothing quaint about this small gallery, which opened in 1997 and was designed by Tony Fretton – the architect of the Lisson Gallery in London. Its remit to show challenging

work has resulted in exhibitions of drawings by Antony Gormley and Alison Wilding, works by John Dewe Mathews Deanna Petherbridge, Ana Maria Pacheco, and a website and video installation by artist in residence Julie Myers. An exhibition of contemporary narrative photography also showed the gallery's committment to young artists.

MANCHESTER
Castlefield Gallery
5 Campfield Avenue Arcade
Off Deansgate, Manchester M3 4FN
t 0161 832 8034
Tues– Fri 10.30-5
Sat – Sun 12-5
Organisers: Artists' committee

One of the oldest artist-run initiatives in the UK, the Castlefield Gallery's policy is to give young artists their first solo exhibitions and to show artists from the region alongside more major names that have included Bridget Riley, Antony Caro, Patrick Heron and Anya Gallaccio.

Cornerhouse
70 Oxford Road, Manchester M1 5NH
t 0161 228 7162 f 0161 236 7323
Tues – Sat 11-6, Sun 2-6
Exhibitions Director: Paul Bayley

Cornerhouse is among the key venues for contemporary art in the UK. Its remit is to juxtapose UK artists with major international figures like American Conceptualist John Baldessari (who received his first UK retrospective here). Annette Messager's debut exhibition was at Cornerhouse, as were major shows of Rita Donagh, Rose Garrard, and Edward Allington. Commissions have included Damien Hirst's *Isolated Elements all Swimming in the Same Direction* (1991) – his first work made for a public space – and Bruce McLean's 1996 film *Urban Turban*.

Manchester City Art Gallery
Mosley Street, Manchester M2 3JL
t 0161 236 5244 f 0161 236 7369
e-mail: cityart@mcrl.poptel.org.uk
Website: http://www.u-net.com/set/mcag/cag.html
Mon 11-5.30, Tues – Sat 10-5.30
Sun 2-5.30
Director: Richard Gray

A complex of fine Victorian buildings designed in Greek-revival style by Charles Barry – architect of the Houses of Parliament – Manchester City Art Gallery contains a permanent collection of British and continental old masters that extends to the twentieth century. A programme of contemporary exhibitions, often generated by the gallery, has showcased the work of Cindy Sherman, Tony Oursler and Sean Scully, among others. The main Princess Street space is closed for lottery-funded extension and refurbishment from 1998.

Whitworth Art Gallery

Oxford Road, Manchester M15 6ER
t 0161 275 7450 f 0161 275 7451
e-mail: Whitworth@man.ac.uk
Website: http://www.man.ac.uk/wag/
Mon – Sat 10-5, Sun 2-5
Director: Alistair Smith

Changing displays from the extensive permanent collection of historic and modern British works on paper, textiles and wallpapers are accompanied at the Whitworth by regular exhibitions including modern and contemporary sculpture in the recently opened Mezzanine Court sculpture galleries.

NAILSWORTH, GLOUCS
Cairn Gallery

The Old Stamp Office
George Street, Nailsworth
Gloucestershire GL6 0AG
t 01453 832483
Wed – Sat 10-1, 2-5
Directors: Laurie and Tom Clark

Since its foundation in 1986, this non-profit-making gallery run by and artist and a poet has mounted over 100 shows, roughly divided between established artists (Hamish Fulton, Roger Ackling, Kate Whiteford, Richard Long, Ian Hamilton Finlay, for example), and lesser-known figures, all of whom reflect a particular interest in Land, Minimal and Conceptual art. A priority is to give artists a space in which to try out new ideas, as well as to provide the visitor with an ordered but informal environment in which to take time out for contemplation.

NEWCASTLE-UPON-TYNE
Zone Gallery

83 Westgate Road
Newcastle-upon-Tyne NE1 1SG
t/f 0191 232 8833
e-mail. zone@zonefoto.demon.co.uk
Website:
http://www.unn.ac.uk/~dex7/zone
Director: David Sinden
Curator: Michelle Hirshhorn

The only gallery in Newcastle devoted to progressive contemporary art, Zone specialises in lens-based artworks and the use of new technologies and digital media, and through gallery exhibitions, publications, commissions and residencies has played a major part in pushing the boundaries of photographic practice. With its continuous programme of contemporary photography exhibitions by nationally and internationally known artists (ranging from Andres Serrano, Helen Chadwick, Sally Mann, Nobuyoshi Araki, Orlan, Stellarc and Digital Therapy Institute), Zone initiates and commissions at least 50 per cent of its shows and is often the only UK venue for major international touring exhibitions.

NORWICH
Norwich Gallery

Norwich School of Art and Design
St George Street, Norwich NR3 1BB
t 01603 610561 f 01603 615728
e-mail: nor.gal@nsad.ac.uk
Website: http://www.nsad.ac.uk/
gallery/index.htm
Mon – Sat 10-5
Curator: Lynda Morris

With a higher profile than many galleries attached to art schools, Norwich Gallery is probably more recognised internationally than locally. This is not only because it acts as host gallery for the prestigious annual *EAST International* competition, but also due to its adventurous programme, which can range from a show of artists' projects made in collaboration with *Imprint 93*, to an exhibition of drawings featuring Rachel Evans, Graham Gussin and Thomas Schütte, or *One Night Stand*, two weeks of twenty-hour events with contributions from Jeremy Deller, Brian Catling and Ross Sinclair.

Sainsbury Centre for Visual Arts, University of East Anglia

Norwich, Norfolk NR4 7TJ
t 01603 456161/01603 456060
f 01603 259401
e-mail: scva@uea.ac.uk
Tues – Sun 11-5
Admission charges
Exhibition Officer: William Jeffett

Norman Foster's metallic structure houses a significant permanent collection of twentieth-century Modernist greats such as Bacon, Epstein and Giacometti as well as a large group of Ancient and Non-Western artworks. Temporary exhibitions of current art have spanned a retrospective of Derek Jarman and photographs by Hiroshi Sugimoto.

7 Alexandra Mansions

Prince of Wales Road, Norwich NR1 1NJ
(door code C2480Z)
t 01603 662419 f 01603 615728
By appointment
Director: Kirsty Ogg

Invited artists from Norwich, the UK and across the world are free to use any part of this one-bedroom flat above the ABC cinema, run by Glaswegian artist and curator Kirsty Ogg. Despite the domestic setting, there is nothing home-spun about shows such as *We Are the Cultural Tourists*, which included Toby Webster and Simon Starling; *Glamour Wounds*, where Karen Kilimnik, Christine Hill and Phillippe Meste examined the impact of fashion and beauty; or *Let's Rock!* with Simon Periton and Eva Rothschild.

NOTTINGHAM
Angel Row Gallery

Central Library Building, 3 Angel Row
Nottingham NG1 6HP
t 0115 947 6334 f 0115 947 6335
Mon – Sat 11-6, Wed 11-7
Director: awaiting appointment

Although based somewhat inauspiciously on the first floor of the Central Library Building, since its establishment in 1991 with a specific remit to show contemporary visual art, this gallery is now regarded as a leading contemporary art space. It was the first showcase

for Helen Chadwick's *Piss Flowers* sculptures, and more recent exhibitions have included Roger Ackling and Katrine Herian, and a site-specific commission from Judith Cowan.

Nottingham Castle Museum and Art Gallery
Nottingham NG1 6EL
t 0115 915 3700 f 0115 915 3653
Daily 10-5
Admission charges weekends/
bank holidays
Keeper of Fine Art: Neil Walker

An adventurous acquisitions policy for the Castle Museum's permanent collection ensures that old masters are accompanied by works from the 1980s and 1990s including pieces by Ron Haselden, Tony Bevan, Helen Chadwick, Lisa Milroy, Nick Waplington and Mat Collishaw. A temporary exhibitions programme combines significant touring shows of contemporary art with those initiated by the gallery such as Nick Waplington's photographs *Living Room*, and commissions by John Newling and Permindar Kaur.

OXFORD
Museum of Modern Art (MOMA)
30 Pembroke Street, Oxford OX1 1BP
t 01865 722733
recorded information: 01865 728608
f 01865 722573
Tues, Wed, Fri – Sun 11-6, Thurs 11-9
Admission charges (free Wed 11-1
Thurs 6-9)
Director: Kerry Brougher

Since its foundation in 1965, MOMA has gained a worldwide reputation for presenting work of up-and-coming British artists and for introducing internationally known figures to the UK – Joseph Beuys, Carl Andre, Donald Judd and Richard Wilson and, more recently, Sol LeWitt and Gary Hill. *About Vision: New British Painting in the 1990s* (1997) assembled leading young artists such as Gary Hume, Chris Ofili, Ian Davenport, Lisa Milroy, Damien Hirst and Fiona Rae.
 MOMA is also the largest provider of touring exhibitions of contemporary art in Britain outside London. Recent shows are *Scream and Scream Again:*

Film in Art, featuring Douglas Gordon, Tony Oursler, Isaac Julien and Lisa Roberts; and a major exhibition of the sculpture and drawings of Louise Bourgeois. An emphasis on new research has also focused attention on art of other cultures with shows from the former Soviet Union, Mexico, India, Japan, South Africa, China and Argentina.

PENZANCE
Newlyn Art Gallery
New Road, Newlyn, Penzance TR18 5PZ
t 01736 363715 f 01736 331578
Mon – Sat 10-5
Director: Emily Ash

The Newlyn Art Gallery is dedicated to placing new work in all media by artists living in the South West alongside a broader programme of national and international work. In 1997 it helped initiate the first St Ives International, *A Quality of Light*, in tandem with Falmouth College of Arts, inIVA, South West Arts and Tate Gallery St Ives.

PORTSMOUTH
Aspex Gallery
27 Brougham Road, Southsea
Portsmouth, Hants PO5 4PA
t 01705 812121 f 01705 874523
e-mail: 101661.3472@compuserve.com
Wed – Sat 12-6, Sun 2-5
Director: Les Buckingham

The Aspex Gallery's policy is to show younger or emerging artists in solo, group or theme shows. Artists who have shown early work include Richard Wilson, Helen Chadwick, Yoko Terauchi, Shanti Panchal and Cornelia Parker.

PRESTON
Harris Museum and Art Gallery
Market Square, Preston PR1 2PP
t 01772 258248 f 01772 886764
e-mail: harris@pbch.demon.co.uk
Mon – Sat 10-5
Museum and Art Officer:
Alexandra Walker

This imposing nineteenth-century temple of art is raised on its own plinth above the market place and embla-zoned with friezes, sculpture reliefs, stained glass and even its own

Foucault's pendulum. Alongside a fine collection of Victorian paintings, which extends to living artists, this gallery is also committed to showing the most progressive of contemporary art from photopieces of pre-implantation embryos by Helen Chadwick to specially commissioned video installations by Lucy Gunning and Michael Mazière.

READING
Open Hand, Open Space
571 Oxford Road, Reading
Berkshire RG30 1HL
t/f 0118 9597752
e-mail: ohos@patrol.i-way.co.uk
Fri – Sun 12–6 and by appointment
Artists' committee

These artist-led studios and gallery in a former Victorian army barracks, whose refurbishment will be complete in early 1999, pursue an ambitious exhibitions programme and provide much-needed exposure to contemporary art in the Reading area.

ST IVES
Tate Gallery St Ives
Porthmeor Beach, St Ives Cornwall
TK26 1TG
t 01736 796226 f 01736 794480
Apr – Sept: Mon – Sat 11-7, Sun 11-5
Oct – Mar: Tues – Sun 11-5
Admission charges
Curator: Mike Tooby

Designed in 1993 by Eldred Evans and David Shalev, the Tate Gallery St Ives is dramatically sited on the cliffs above Porthmeor Beach. Its changing exhibitions of twentieth-century art associated with Cornwall are presented both in the displays, which focus especially on the modern tradition with which St Ives is closely identified, and in the fabric of the building itself – there is a dramatic stained-glass window by Patrick Heron. Works by Barbara Hepworth, Ben Nicholson, Naum Gabo et al are drawn from the Tate's collections and supplemented by long-term loans from private collections, and collaborations with other institutions.
 The aim is to provide an introduction to central artists and works as well as a programme of themed exhibitions and artists' projects related to the collection

Tate Gallery St Ives
Photo: Marcus Leith

and its surroundings. The most ambitious of these to date has been the first St Ives International, *A Quality of Light* (1997), in tandem with Newlyn Art Gallery, Falmouth College of Arts, South West Arts and inIVA, in which fourteen internationally recognised artists from all over the world, including Bridget Riley, Mona Hatoum and David Medalla, were commissioned to make and show new work inspired by the Cornish landscape at venues around the Penwith Peninsula.

SHEFFIELD
City Museum and Mappin Art Gallery

Weston Park, Sheffield S10 2TP
t 0114 276 8588 f 0114 275 0957
Wed – Sat 10-5, Sun 11-5
Keeper of the Mappin Art Gallery:
Julie Milne

The Mappin's programme of contemporary art exhibitions can encompass the responses of invited artists and curators to a single sculpture by Cathy de Monchaux, or a touring show investigating the crossovers between art, technology and science. Often, projects are mounted in collaboration with the City Museum and Site Gallery in Sheffield.

Site Gallery

1 Brown Street, Sheffield S1 2BS
t 0114 272 5947/0114 281 2077
f 0114 281 2078
e-mail: gallery@ site-map.u-net.com
Website:
http://www.fdgroup.co.uk/neo/site/
Director: Carol Maund

Site offers gallery space and facilities for lens-based work – film, video and installation by national and international figures – with an emphasis on originating solo and mixed shows and special artists' commissions. Examples are *Virtue and Vice: Derivations of Allegory in Contemporary Photography*; or Andrew Stone's *Crowd Control*. Courtesy of the National Lottery, ERDF and English Partnerships, from January 1998 Site expands into refurbished gallery space.

SOUTHAMPTON
John Hansard Gallery

University of Southampton, Highfield
Southampton SO17 1BJ
t 01703 592158 f 01703 594192
e-mail: foster@soton.ac.uk
Tues – Fri 11-5, Sat 11-4
Director: Stephen Foster

The John Hansard Gallery is committed both to exhibiting the work of British and foreign artists and to encouraging younger artists by providing them with opportunities to exhibit in a wider critical context.

Southampton City Art Gallery

Civic Centre, Southampton SO14 7LP
t 01703 832277/632601 f 01703 832153
Tues, Wed, Fri 10-5, Thurs 10 -7
Sat 10-5, Sun 1-4
Director: Stephen Snoddy

In addition to an extensive historical collection, Southampton City Art Gallery houses the most important group of British contemporary artworks in a public gallery outside London, with strong works by Helen Chadwick, Antony Gormley, Rachel Whiteread, Richard Patterson, Gillian Wearing, Douglas Gordon and Ian Davenport. (Southampton's curators seem to have an uncanny ability to snap up the work of Turner Prize nominees just before they are recognised by the jury and their prices rise accordingly.)
 This progressive collecting is complemented by a policy of initiating challenging exhibitions including Chris Ofili's first solo show in a public gallery in Britain; *Real Art: A New Modernism*, an exhibition of young painters in the 1990s; and *Co-operators*, a tribute to the importance of collaborations in the current art scene involving Henry Bond and Liam Gillick, Andrea and Phillippe, Jane and Louise Wilson, Jake and Dinos Chapman, and Langlands and Bell.

SOUTHEND
Focal Point Gallery

Southend Central Library
Victoria Avenue, Southend-on-Sea
Essex SS2 6EX
t 01702 612621 f 01702 469241
e-mail sos@ dial.pipex.com
Mon – Fri 9-7, Sat 9-5
Director: Peter Kent

Focal Point is committed to providing access to, and promoting an understanding of, photography, video and new media with a roster of self-initiated shows like Sunil Gupta's *Trespass 3*, David Hiscock's *Strokes* and mixed shows of the latest in contemporary art such as *Kiss This*, with work by nearly eighty artists.

WALSALL
Walsall Museum and Art Gallery
Lichfield Street, Walsall WS1 ITR
t 01922 653116/653196
f 01922 32824
Website: http://www.earl.org.uk/earl/
members/walsall/
Tues – Sat 10-5, Sun 2-5
Museums and Galleries Manager:
Sheila McGregor
Senior Exhibitions Officer:
Deborah Robinson

As a result of its ongoing partnership
with the Arts Council of England, the
Walsall Museum prioritises programmes
that support new work by contemporary
artists. This has led to commissions
from David Mach, Hermione Wiltshire
and Keith Khan, as well as from emerging
artists, many from the West Midlands.
The gallery also initiates a number of
touring shows. With a new, lottery-
funded gallery currently under construc-
tion and scheduled to open in September
1999, Walsall is set to extend its coverage
of contemporary art still further.

WOLVERHAMPTON
Wolverhampton Art Gallery
Litchfield Street
Wolverhampton WV1 1DU
t 01902 552055 f 01902 552054
Mon – Sat 10-5
Senior Curatorial Officer: Brendan Flynn
Head of Arts and Museums:
Nicholas Dodd

Another of the three beneficiaries of the
Collection Scheme partnership with the
Contemporary Art Society and the Arts
Council of England, the Wolverhampton
Art Gallery, already boasting a
permanent collection strong in Pop art
and work with socio-economic themes,
has been expanded by contemporary
contributions from the photopieces of
Helen Chadwick, Willie Doherty and
Paul Graham, to paintings by Tony
Bevan and Lisa Milroy. There is also a
programme of temporary exhibitions
both connected with, and independent
of, the gallery's collections.

YORK
Impressions Gallery
29 Castlegate, York YO1 5RN
t 01904 654724 f 01904 651509

e-mail: matt@impressions-gallery.com
Mon – Sat 9.30-5.30, Sun 10-5
Director: Cheryl Reynolds

Since opening in 1972 as one of the first
photography galleries in Europe,
Impressions Gallery is now widely
known as a dynamic producer of
contemporary photography and new
media exhibitions, some of which tour
internationally. Notable examples are
Atom, which explored scientific and
military investigations into atomic
energy, Britta Jaschinski's *Zoo*, and Kate
Mellor's *Island: The Sea View*, which
looked at Britain as an island race.

NORTHERN IRELAND

BELFAST
Catalyst Arts
5 Exchange Place, Belfast BT1 2NA
t 01232 313303 f 01232 312737
e-mail: catalystarts@dnet.co.uk
Mon – Fri 11-6
Directors: Brian Patterson/ Niamh
O'Malley/Eoghan McTigue/Peter
Richards/Dan Shipsides/Heather Allen

The first artist-run space in Ireland,
Catalyst Arts was founded in 1984 in
response to a demand from the Belfast
arts community for a lively organisation
that would provide exposure for local
artists as well as setting Northern Irish
art within an international context.
Catalyst continues to fulfil this remit
with a programme of events both in and
out of the newly renovated gallery that
has featured artists from over twenty
different countries. Recent projects
include *On the Buses*, a touring live art
event involving six galleries in Ireland,
Scotland and England.

Ormeau Baths Gallery
18A Ormeau Avenue, Belfast BT2 8HQ
t 01232 321402 f 01232 312232
Tues – Sat 10-6
Director: Hugh Mulholland

Opened in 1995 on the site of a disused
Victorian swimming baths, this gallery
is dedicated to presenting innovative
contemporary work by artists of national
and international standing, including
Lili Dujourie, Ana Maria Pacheco and

Bill Woodrow. The gallery is also com-
mitted to the promotion of Northern
Irish art in a wider international context,
showing leading Irish artists such as
Rita Duffy, Brian Kennedy and David
Crone as well as offering a platform to
younger emerging artists.

Proposition Gallery
Unit 22, North Street Arcade
Belfast BT2 8HQ
t 01232 234072
Thurs – Sat 1-5
Directors: Ian Charlesworth/
Matthew Walmsley

A non-profit-making, artist-run space,
Proposition Gallery exhibits work in all
media by Belfast artists and interna-
tional figures as well as offering
residencies to live in Belfast whilst
producing work for shows. Past
exhibitions have showcased London-
based Melinda Coulcher's paintings
based on bus and tube travel; Scott
Barden's large Cibachrome prints of
mocked-up Napoleonic war scenes; and
New York sculptor Michael Buckland's
work with sponges and playing cards.
The gallery also has access to five empty
vacant shop units for more flexible
presentations.

DERRY
Context Gallery
5 Artillery Street, Derry BT48 6RG
t 01504 373538 f 01504 261884
e-mail: james@eurocat.com
Mon – Sat 10-5.30
Director: James Kerr

Context Gallery is devoted to providing a
platform for young and emerging Irish
artists and to supporting their work on
an international level with solo and
mixed theme shows, and international
touring exhibitions. These take place in
the gallery itself and at the nearby
McLoone's Factory and have included
Goal, which brought together Irish
artists with international figures such as
Carles Guerra from Spain and London-
based Simon Patterson. A quarterly
publication, *inContext*, provides an
outlet for young art critics to develop
their style and voice opinions about
issues relating to international
contemporary art practice.

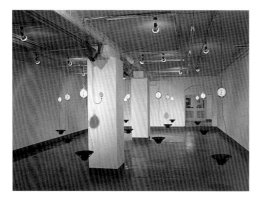

Philip Napier
Guage
1997
Mixed media
Installation at Orchard
Gallery, Derry

Orchard Gallery
Orchard Street, Derry BT48 6EG
t 01504 269675 f 01504 267273
Director: Liam Kelly

Since it opened in 1978 the Orchard has established itself as one of Ireland's key contemporary art galleries. Leading artists from Ireland such as Nigel Rolfe and Willie Doherty, and international figures including Richard Long (UK), and Nancy Spero and Ida Applebroog (USA), present work in all media both within the gallery and in sites throughout Derry in an active liaison programme with the city and its communities. Additionally, the Orchard Gallery regularly curates thematic and issue-based shows at international venues, such as *Mapping and Power*, Paris 1996.

SCOTLAND

ABERDEEN
Aberdeen Art Gallery and Museums
Schoolhill, Aberdeen AB10 1FQ
t 01224 646333, f 01224 632133
Website:
http://www.cityscape.co.uk/users/grb2
/artgal.htm
Mon – Sat 10-5, Sun 2-5
Exhibitions officer: Deirdre Grant

With a permanent collection that features the latest in Scottish art – Julie Roberts, Ken Currie and Callum Innes are recent additions – AAG is a major host of *Fotofeis*, Scotland's biennial photo-based art festival, and takes touring exhibitions from elsewhere in Scotland and the UK.

Iain Irving projects
Greenwards, by Hatton, Peterhead
Aberdeenshire AB42 0RS
t/f 01779 841311
By appointment
Director: Iain Irving

Specially commissioned new projects by young Scottish artists such as Dalziel and Scullion and Ross Sinclair respond to the rural setting of this small space in a farmhouse that puts the latest in contemporary art in a rural context. Irving (formerly an exhibitions officer at CCA, Glasgow) also invites artists to make work in unexpected locations throughout the North East of Scotland.

Peacock Gallery
21 Castle Street, Aberdeen AB11 5BQ
t 01224 639539 f 01224 627094
Exhibitions Co-ordinator:
Colin Greenslade

In addition to providing specialist facilities for a long line of printmakers both from Scotland and internationally, the gallery reflects and extends the scope of on-site operations with a programme of exhibitions that extends to artists working in all media across the North East of Scotland.

AYR
Maclaurin Art Gallery
Rozelle Park, Monument Road
Ayr KA7 4NQ
t 01292 443708 f 01292 412065
Mon – Sat 10-5 (April – Oct 2-5 Sun)
Director: Liz Kwasnik

Maclaurin offers a collection containing established figures from Scotland and the UK (John Bellany, Callum Innes, Bridget Riley and Michael Craig-Martin included). It also has a wide-ranging programme of temporary shows initiated by National Touring Exhibitions at the Hayward Gallery in London, and a policy of showing recent art school graduates from throughout the UK.

DUNDEE
Dundee Contemporary Arts
Nethergate, Dundee DD1
t 01382 434000 f 01382 432052
Mon – Sat 11-6, Sun 12 – 6
Director: Andrew Nairne

Opening in October 1998 DCA will boast spacious galleries, two cinemas and extensive artists' production facilites managed in partnership with the University of Dundee's Faculty of Art and Design. DCA is a major lottery-funded investment in the most experimental and innovative in

Iain Irving projects,
Greenwards by
Hatton, Peterhead,
Aberdeenshire

contemporary art and confirms the Dundee area as a thriving artistic centre.

EDINBURGH
Collective Gallery

22-28 Cockburn Street
Edinburgh EH1 1NY
t/f 0131 220 1260
Tues – Sat 11-5.30
Director: Sarah Munro

One of Scotland's leading spaces for launching up and coming artists working in all media. Exhibition programme includes shows by local, national and international artists.

The Fruitmarket Gallery

45 Market Street, Edinburgh EH1 1DF
t 0131 225 2383 f 0131 220 3130
e-mail: fruitmarket.co.uk
Mon – Sat 10-6, Sun 12-5
Director: Graeme Murray

One of the UK's major contemporary art galleries, the Fruitmarket has a world-wide reputation for bringing to Scotland the work of leading artists – whether Sol Lewitt, Lisa Milroy or Nobuyoshi Araki – and for presenting new work from Scottish artists like Ross Sinclair and Graeme Todd in an international context.

Inverleith House, Royal Botanic Garden

20A Inverleith Row. Edinburgh EH3 9LR
t 0131 552 7171 f 0131 552 0382
Website: http//www.rbge.org.uk/inverleith-house/index.html
Wed – Sun 10-5
(times can vary seasonally)
Director of Exhibitions: Paul Nesbitt

These are probably the only gardens in the world to hold a continuous prog- ramme of major contemporary art shows. The aim is to develop under- standing of the natural world, and to commission new works in order to tease the boundaries between art and science. These can range from major solo exhibitions by Callum Innes and Richard Tuttle, to group exhibitions in the seven rooms of the eighteenth-century house featuring Anya Gallaccio, Damien Hirst and Phillip Taaffe. Work can also be made for the surrounding seventy-three acres, such as Lothar Baumgarten's text works in the Glasshouses.

Portfolio Gallery

43 Candlemaker Row,
Edinburgh EH1 2QB
t 0131 220 1911 f 0131 226 4287
Tues – Sat 12-5.30
Admission charges during Edinburgh Festival
Director: Gloria Chalmers

Small but perfectly formed, the Portfolio showcases the very latest in British and international photographic work by the likes of Andres Serrano, Orlan and Helen Chadwick. The gallery also maintains ongoing relationships with artists such as Calum Colvin and Catherine Yass, who are given an additional showcase in the form of *Portfolio*, a glossy bi-annual photographic periodical that reflects and extends the gallery's programme.

Scottish National Gallery of Modern Art

Belford Road
Edinburgh EH4 3DR
t 0131 556 8921 f 0131 343 3250
Mon – Sat 10-5, Sun 2-5
(during Edinburgh Festival Sun 11-5)
Admission charges for special exhibitions
Keeper: Richard Calvocoressi

Although it does accommodate a number of living artists, the main strength of the permanent collection is in the big names of modern British painting and sculpture and its world-class holdings of Dada and Surrealist art and literature. However, exhibitions such as a retrospective of the innovative *Paragon Press* or the first Scottish showing of Matthew Dalziel and Louise Scullion's installation *Endlessly* (1997) confirm a policy of exhibiting imagina- tively selected examples of the very newest art being made in Scotland and throughout the UK.

Stills

23 Cockburn Street
Edinburgh EH1 1BP
t 0131 622 6200 f 0131 622 6201
e-mail: info @ stills.demon.co.uk
Artistic Director: Kate Tregaskis

Re-opened in 1997 after major refur- bishment, Scotland's best- established photography gallery has a solid reputation for giving classic figures like Paul Strand, Man Ray and Alfred Steiglitz their first Scottish shows, along with exhibitions of major contemporary figures such as Wolfgang Tillmans, Ken Lum, Barbara Ess and Hermione Wiltshire. Recently the gallery has extended its scope both to enable and to host artistic projects based on all forms of digital and photographic images.

GLASGOW
CCA

350 Sauchiehall Street Glasgow G2 3JD
t 0141 332 7521 f 0141 332 3226
e-mail: gen@cca-glasgow.com
Website: http://www.cca-glasgow.com
Mon – Sat 11-6, Sun 12 -5
Head of Programme: Francis McKee

Contemporary shows at this well-established venue for upcoming and well-known international and national figures have spanned a survey of sculpture by Kerry Stewart, a re-creation of a slice of Scottish mountainside by Glasgow-based Ross Sinclair (*Real Life*), and new photographs by Hannah Collins. Innovative touring exhibitions from elsewhere hosted by CCA have included *Boxer* (organised by inIVA) and *Lovecraft* (1997), curated by Tony Webster and Martin McGeown, which invited experimental young artists to explore their attitudes to the value of craft.

The Gallery of Modern Art Glasgow

Queen Street, Glasgow G1 1DT
t 0141 229 1996 f 0141 204 5316
Website: http://www.goma.gov.uk
Mon, Wed, Thurs, Fri, Sat 10-5, Sun 11-5
Director: Julian Spalding

Art-world lips have curled in unison ever since GOMA opened in 1996 with a collection devoted to the work of living – and especially Scottish – artists under the remit of 'Art For People'. GOMA is the only modern art gallery to give a prominent place to Beryl Cook, and the director's idiosyncratic definition of 'genuinely popular, not narrowly elitist' results in an abundance of muscular Scottish figuration fashionable in the

1980s, and an eclectic selection of works by established figures – Bridget Riley, David Hockney, Anthony Caro and Andy Goldsworthy – as well as Mexican, Ethiopian, Russian and Australian aboriginal art and photographs by Henri Cartier-Bresson and Sebastiao Salgado. These are all arranged over four floors perplexingly devoted to the elemental themes of fire, earth, water and air.

Glasgow Print Studio

22 King Street, Glasgow G1 5QP
t 0141 552 0704 f 0141 552 2919
e-mail: gallery@ gpsart.co.uk
Website: http://www.gpsart.co.uk
Mon – Sat 10–5.30
Director: John Mackechnie

Since its establishment in 1972 the print studio has extended its scope both within and beyond Scotland with a gallery programme that ranges from graphic work by legendary American Pop artist Jim Dine, to unorthodox prints of everyday objects by Tim Mara, Professor of Printmaking at London's Royal College of Art. Also notable was *Blueprint* (1997), a mixed media exhibition of innovative new work with a portfolio of prints by internationally recognised young artists from Glasgow and London including Kenny Hunter, Keith Coventry and Nathan Coley.

A second gallery (the original print shop) at 25 King Street displays Glasgow Print Studio publications and showcases printmaking by Scottish-based artists.

Street Level Photoworks

26 King Street, Glasgow G1 5QP
t 0141 552 2151 f 0141 552 2323
e-mail:
info@sl-photoworks.demon.co.uk
Tues – Sat 10–5.30
Director: Malcolm Dickson

This showcase for the latest in lens-based media, whether photography, video, sound installation or new technology, also provides facilities for the production of new work. Recent shows have included a historical survey of Dada collagist Raoul Hausmann's photoworks and an anthology exhibition looking at the history of art magazines.

David Mach
Here to Stay
1990
Newspapers
Sculpture in progress at
Tramway, Glasgow
Photo: Alan Wylie

Tramway

25 Albert Drive, Glasgow G41 2PE
t 0141 422 2023 fo141 287 5533
e-mail: first name.surname followed by:
@dpav.glasgow.gov.uk
Website:
http://www.glasgow.gov.uk/pav/
Wed – Sun 12-6
Director: Robert Palmer

Since its establishment in 1990, this cavernous former tram depot has acquired a formidable international reputation as one of Britain's most innovative venues for contemporary art. Tramway's commitment to inviting young Scottish artists to make works in response to the space has led to the commission of *24 Hour Psycho* by Douglas Gordon (1993), Christine Borland's *From Life* (1994), and *Sustain* by Stephanie Smith and Edward Stewart (1995). Established international and British artists are also invited to make or show work, including the Canadian Mark Lewis, Dutch artist Niek Kemps, and Scot, Bruce McClean, whose video *The Complete Contempt* (1997) received its world premiere here.

Transmission Gallery

28 King Street, Trongate,
Glasgow G1 5QP
t 0141 552 4813 f 0141 552 1577
e-mail: 101346.422@compuserve.com
Tues – Sat 11-5
Organisers: changing committee

Founded in 1983 by four ex-art students in response to the then moribund local situation, Transmission is still run by an unpaid committee of practising artists

who each work at the gallery for a maximum of two years. It attracts more than local attention, however, with exhibitions and events involving well known and unknown artists from Glasgow and around the world as well as exchange projects in Barcelona, Antwerp, Belfast, Toronto, London and Chicago. Artists who have worked with this seedbed for the thriving artistic scene in Glasgow are Christine Borland, Nathan Coley, Jacqueline Donachie, Douglas Gordon, Roddy Buchanan and Julie Roberts.

STORNOWAY
An Lanntair

Town Hall, South Beach, Stornoway
Isle of Lewis HS1 2BX
t/f 01851 703307
e-mail: lanntair@sol.co.uk
Website: http://www.lanntair.com
Director: Roddy Murray

An Lanntair opened in 1985 and is the premier public arts facility in the Western Isles. Although culturally rooted in Gaelic, it provides a broad forum for local, national and international, inno-vative touring exhibitions. Among these have been *As an Fhearann: From the Land* on the Centenary of the 1886 Crofting Act, *Acts of Faith* by Steve Dilworth, created from the avian and marine detritus of the Isle of Harris, and *Calanais: the Atlantic Stones,* an award-winning show on megalithic culture across Northern Europe.

STROMNESS
The Pier Arts Centre

Victoria Street, Stromness
Orkney KW16 3AA

The Pier Arts
Centre, Stromness

t 01856 850 209 f 01856 851 462
Director: Neil Firth

Former fishermen's sheds form an appropriately maritime backdrop for an important collection of twentieth-century paintings from St Ives artists donated by founder Margaret Gardiner, a long-time friend of Ben Nicholson and Barbara Hepworth. Temporary exhibitions in the Pier Gallery and The House Gallery (an adjoining eighteenth-century merchant's residence) complement the permanent collection, often with the presentation of major contemporary figures – Sol LeWitt, Richard Long and Anthony Caro as well as exhibitions of Scottish and Orcadian artists.

WALES

CARDIFF
Chapter Arts Centre
Market Road, Canton
Cardiff CF5 1QE
t 01222 396061
f 01222 225901
e-mail: enquiry@chapter.org
Website: http://www.chapter.org
Tues – Sun 12-5, 6-9
Exhibitions programmer: Karen McKinnon

Wales' centre for innovative and challenging contemporary art, Chapter has gained a reputation for introducing major figures from the British and international art world to a Welsh audience. Exhibitions often emerge as a result of residencies from invited artists – Cornelia Parker's *Avoided Object* 1996 was a notable example – and Chapter is

also committed to commissioning a series of new, on-site installations by figures including Mona Hatoum (1992) and Max Fenton (1996). Where possible, Chapter encourages programming across its three spaces – cinema, theatre and gallery – as in *Body Radicals* (1997), which featured Orlan, Stelarc, Franco B, Annie Sprinkle and Ron Athey.

Ffotogallery
31 Charles Street, Cardiff CF1 4EA
t 01222 341667 f 01222 341672
Tues – Sat 10.30-5.30
Director: Christopher Coppock

Founded in 1978, Ffotogallery is the only venue in Wales solely devoted to the exhibiting and promotion of photo-based art. Examples of exhibitions originated by the gallery are Catherine Yass' *Steel* (1996), a specially commissioned body of work based on her experiences at British Steel's Port Talbot Plant that subsequently toured all over the UK; and Peter Fraser's *Deep Blue* (1997), a series of photographs taken at places of international high technology, including NASA and CERN.

Oriel
The Arts Council of Wales' Gallery
The Friary, Cardiff CF1 4AA
t 01222 399477 f 01222 398500
Mon – Sat 9-5.30
Exhibition organiser:
Jenni Spencer-Davies

The Arts Council of Wales' own gallery, this venue initiates exhibitions of emerging and established artists in a national and international context, often

collaborating with other venues in Wales and the UK. Exhibitions have included established figures such as David Nash and Bill Woodrow, as well as emerging artists David Garner, Reiko Aoyagi, and Siobhán Hapaska.

LLANDUDNO
Oriel Mostyn Gallery
12 Vaughan Street, Llandudno LL30 1AB
t 01492 879201 f 01492 878869
Mon – Sat 10-1, 1.30-5
Director: awaiting appointment

Oriel Mostyn is the main space for contemporary art in North Wales, taking touring shows of major figures who range from Dorothy Cross to Ian Hamilton Finlay as well as initiating exhibitions of its own. It also hosts the annual Mostyn Open Prize.

NEWTOWN
Oriel 31
The Park, Newtown, Powys SY16 2NZ
t 01686 625041 f 01686 623633
Mon – Sat 10-5
Director: Michael Nixon

Oriel 31's varied programme is devoted to both contemporary and historical shows. Self-originated exhibitions include *Creating Utopia* (1997), with designs by Will Alsop, David Chipperfield and Zaha Hadid, and Christine Boshier's monumental sculptural pieces made from metal, stone, wood and concrete (1995).

SWANSEA
Glynn Vivian Art Gallery and Museum
Alexandra Road, Swansea SA1 5DZ
t 01792 655006 f 01792 651713
Tues – Sun 10-5
Curator: Alison Lloyd

Purpose-built in 1911, but with a 'white cube' space added in the 1970s, Glynn Vivian Art Gallery's remit is to show the work of Wales-based artists such as Tim Davies (1997). These exhibitions are augmented by received and initiated shows – like *Some Organising Principles* (1993), which was the only major solo exhibition of the work of Peter Greenaway in the UK to date – as well as a wide variety of touring shows.

Swansea Arts Workshop Gallery

Gloucester Place, Maritime Quarter
Swansea SA1 1TY
t 01792 652016
Daily 11-5
Gallery Co-Ordinator: Jane Phillips

This converted nineteenth-century seamen's chapel now houses an independent art gallery with a programme dedicated to showing progressive work in all media by artists from Wales and elsewhere – including many site-specific installations.

WREXHAM
Wrexham Arts Centre

Rhosddu Road, Wrexham LL11 1AU
t 01978 292093 f 01978 361876
e-mail: gallery@wrexhamlib.u-net.com
Mon – Fri 9.30 -6.45
Sat 9.30-5
Visual Arts Officer: Stephen West

Wrexham Arts Centre's diverse programme of self-initiated and touring exhibitions displays a commitment to international and local artists, as well as a remit to reflect cultural diversity that has exposed Lesley Sanderson's *These Colours Run* (1994), Lubaina Himid's *Beach House* (1995), and contemporary art from South Africa (1996) to Welsh audiences.

OUTDOOR GALLERIES

Forest of Dean Sculpture Trail

c/o Forest Enterprise, Bank House, Bank Street, Coleford, Gloucs GL16 8BA
t 01594 833057 f 01594 833908
Daily 8–dusk
Chairman: Martin Orrom

In the mid-1980s a number of artists, including Magdalena Jetalova, Ian Hamilton Finlay and Cornelia Parker were invited to create a series of sculptural works for and inspired by the Forest of Dean. These remain on site, along with a changing selection of other projects and works in progress, either in a state of production or sometimes, of natural disintegration.

The Grizedale Society

Grizedale, Hawkshead, Ambleside, Cumbria LA22 0QJ
t 01229 860291 f 01229 860050
Sculpture in the Forest: permanently open; Gallery: daily, Easter – Nov 11-5
Director: David Penn

This is not so much a sculpture park as a working forest that doubles up as an external project-space for local, national and international sculptors. Since 1977 artists have worked in the forest on a series of residencies. Works in progress can be seen alongside sculptures by established environmental artists like Andy Goldsworthy, David Nash, Sally Matthews, Shigeo Toya and Richard Harris. The result is the largest collection of site-specific work in the UK, on display on the society's two trails, as well as in its gallery (converted from a sawmill), which includes works by resident artists and drawings, maquettes and prints relating to the art outside.

Sculpture at Goodwood

Goodwood, West Sussex PO18 0QP
t 01243 538449 f 01243 531853
e-mail: w@sculpture.org.uk
Website: http://www.sculpture.org.uk
Apr – Oct, Thurs – Sat 10.30-4.30
Admission charges
Administrator: Marian Whitcomb

This changing collection of around forty contemporary sculptures by young and established artists, set in twenty acres of woodland walks on the Goodwood Estate, makes a point of pushing to the limits what art out of doors can do. Works of the highest quality, in a diverse variety of media are commissioned, displayed, and often sold. These have ranged from Vong Phaophanit's *Azure Neon Body* (1994-5), to David Mach's *The Garden Urn* (1996) made from hundreds of galvanised wire coathangers. Some pieces, such as Edward Allington's *Fallen Pediment (Piano)* (1994), Shirazeh Houshiary's *The Extended Shadow* (1994) or Cathy de Monchaux's *Confessional* (1997) are commissioned by Sculpture at Goodwood. Others, like Richard Long's *Six Stone Circles* (1981) or Richard Deacon's *When the Land Masses First Appeared* (1986) are on temporary or semi-permanent loan.

Yorkshire Sculpture Park

Bretton Hall, West Bretton
Wakefield WF4 4LG
t 01924 830302 f 01924 830044
e-mail: ysp@globalnet.co.uk
Daily
Summer: grounds 10-6, galleries 10-2
Winter: grounds 10-4, galleries 11-4
Director: Peter Murray

As Britain's first sculpture park, situated in the eighteenth-century estate of Bretton Hall, Yorkshire Sculpture Park has pioneered the curating and promoting of open-air exhibitions and related events, often in close partnership with the Henry Moore Foundation. In addition to a permanent collection that embraces Henry Moore, Barbara Hepworth, Anthony Caro, Richard Serra, Sol LeWitt and Grenville Davey, there is also a changing programme of exhibitions by established international figures. These have featured Barry Flanagan's large bronze hares and works by Christo and James Turrell, as well as by comparative newcomers like Kerry Stewart.

INDEX

Page numbers in *italic* type denote main entries